Nadar

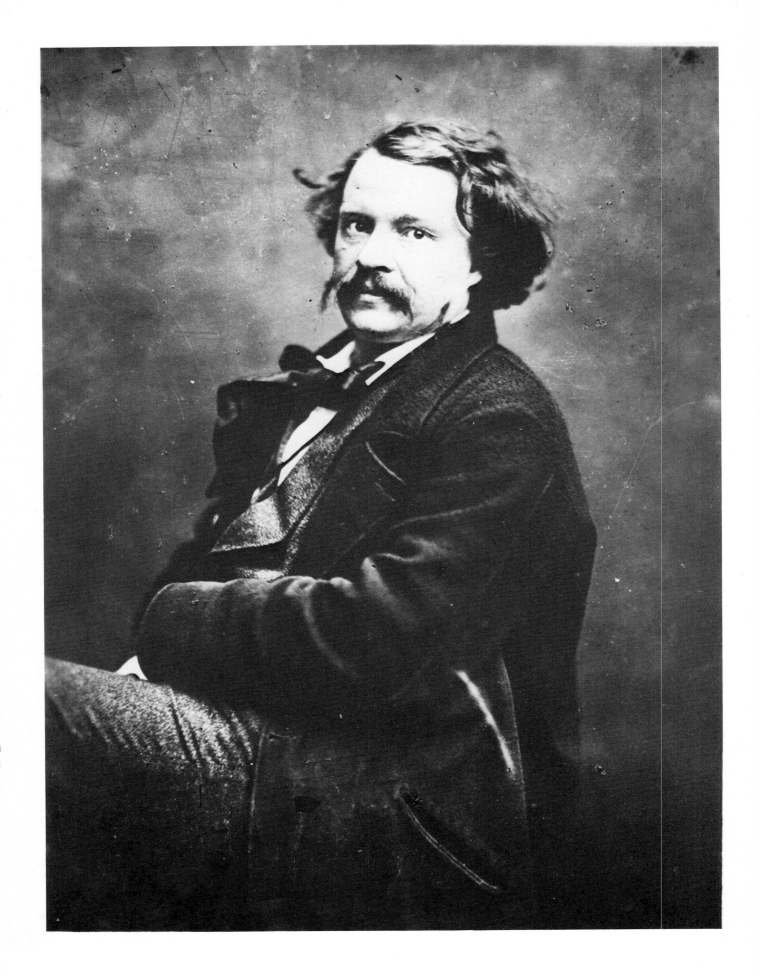

Félix Tournachon (Nadar) about 1854: probably photographed by his brother Adrien.

NIGEL GOSLING

ALFRED A. KNOPF
NEW YORK
1976

This is a Borzoi book
published by Alfred A. Knopf, Inc.

*Many people have helped me in preparing this book, which is
based, as any future study of Nadar must be, on the authoritative
monograph published in 1966 by Monsieur Jean Prinet and
Mademoiselle Antoinette Dilasser. I would also like to record my
particular gratitude to Monsieur Georges Adhémar, Director of the
Bibliothèque Nationale, and to Monsieur Philippe Neagu, Director of
the Archives Photographiques at the Caisse Nationale des Monuments
Historiques, in Paris, both of whom were unstinting in invaluable
advice and cooperation; and to Monsieur Georges Poulet of the
Archives Photographiques for his patient and efficient responses to my
enquiries. I am deeply indebted to Mr Christian Larson for his
tenacious researches in Paris; to Mr Weston Naef of the
Metropolitan Museum of Art, New York, for clues to
the Atelier Nadar in South America; and to my wife,
who greatly exceeded normal conjugal cooperation throughout.*

ISBN: 0-394-41106-4
Library of Congress Catalog Card Number: 76-27546
First American Edition

CONTENTS

Félix Tournachon – 'Le bon Nadar' I

Nadar in the Studio 29

The First Nadar 39

Eighty Portraits by Nadar 49

The Atelier Nadar 211

 The Arts of the Belle Epoque

 Leading Figures of the Day

 La Vie Parisienne

Index 303

Félix Tournachon – 'Le bon Nadar'

O N 12 December 1871, Victor Hugo wrote a
letter to a friend in Paris. Putting it in an
envelope, he stuck on a 15-centime stamp,
scribbled his initials in the corner, and then added
a single word: 'Nadar'.

It was good enough. Every postman in Paris
would be familiar with the exotic pseudonym
which concealed – if that word can be used in a
context which included a strong element of pub-
licity – the identity of the eccentric son of a
Lyon printer, Gaspard-Félix Tournachon. For
over fifteen years it had been blazoned across a
whole building in the fashionable heart of the
city, announcing activities on the upper floors
which were familiar to every cartoonist. Nadar
was a born polymath with enthusiasms covering
many fields; his name crops up in any account of
caricature and aeronautics, and even in literature
he earned a modest footnote. But it was to be the
photographs, taken in that studio in the Boule-
vard des Capucines, which were to preserve the
name 'Nadar' into our own days.

It is an appropriate fate. Nadar was plagued
through a long life by a normal ration of private
griefs – financial disasters, a severely invalided
wife, and bitter quarrels with both his only
brother and his only son. But 'le bon Nadar', as
he appears again and again in the memoirs of his
contemporaries, remained essentially outgoing.
There was no trace of introspective meanness in
his nature. It is right that he should be remem-
bered best not for his adventures and inventions
nor for personal recollections, but for the sensitive
records he left of his friends.

Gaspard-Félix was born on 6 April 1820 at
195 rue Saint Honoré des Arts in Paris, son of
Victor Tournachon, printer and shopkeeper, and
Thérèse Mailliet, both from Lyon. From the
first his background was free-thinking and radical.
His father and mother had not gone through the
formality of marriage, and he was not baptized
until he was over a year old (at the Eglise Saint
Roch). A brother, Alban-Adrien, was born when
he was 5, and the following year his parents
decided at last to get married, thus legitimizing
their two sons. The household, which was pretty
well off – Victor Tournachon had transferred a
flourishing little printing business from Lyon to
Paris – now also became respectable, the only

handicap being that some of Victor's politically
leftish books were looked on by the authorities
with suspicion.

The young Gaspard-Félix was given a conven-
tional middle-class education. He started his
schooling in Versailles,[1] moving after a year to the
Collège Bourbon, which later became the Lycée
Condorcet. From there he proceeded (as a non-
paying pupil) to the Collège de Versailles.

But meanwhile the family business was doing
less well. When Félix was 18 his father began to
fail; the family moved back to Lyon, and there
Victor died. According to his own later account,
young Tournachon now began to study medicine.[2]
What he demonstrably did embark on straight
away was journalism, contributing drama criti-
cism – based presumably on his experiences in
Paris theatres – to three local papers.[3]

He continued to pay his way in this capacity
when he returned to Paris the next year with his
mother and brother, covering several theatres for
La Vogue and the *Revue et Gazette des Théâtres*.
One of them was the Porte Saint Antoine theatre
where he saw and admired (as he later described)
an exotic black actress, Jeanne Duval. She was to
pass into history as the dark muse of Baude-
laire's *Fleurs du Mal*.[4]

But journalism was poorly paid, and he found
himself in a circle of colleagues and friends who
lived not much above – and sometimes below –
the starvation line. It was the group to be des-
cribed a few years later by his friend Henri
Mürger in the semi-autobiographical novel *Scènes
de la Vie de Bohème*. A band of young and eternal-
student artists, writers, musicians, and aspiring
philosophers would sit up half the night in a café
or a rented room under the roof (by now young
Félix had moved out of the family home and was
living in the Petit Hôtel de Normandie in the
rue Jean de Beauvais), arguing about life, religion,
art, politics, and girls, sharing a windfall in a cheap
restaurant or undermining their constitutions
with endless glasses of absinthe.

Tournachon was living almost as miserably as
most of his friends.[5] He was later to list, among
the jobs he tried at this period, poacher, smuggler,
bookshop-assistant (these may have been in
Lyon), clerk, sculptor, peat-seller, secretary, and
even peddler of pipes made from roots dug up

surreptitiously in the Bois de Boulogne. At the age of 23 he was far from established. Living by then in the rue de Monsieur le Prince, a friend described seeing him in the street:

> . . . in a grey hat and a short green coat, hands in pockets and pipe in mouth, his head bent thoughtfully, plunged in what seemed painful meditation. He was not alone – behind him a long-haired spaniel followed in his footsteps, thin and elongated as its master, with tail and ears dragging They passed on the other side of the street and I was afraid to greet them, not for my own sake but for theirs. Joking apart, I was moved to pity.[6]

But friendship and lively company made up for material discomforts. Paris was still a small, compact community, and through the habit of congregating regularly in cafés or at social soirées the intellectuals were mostly known to each other. The whole cultural centre of Paris (thus of the Western world) was contained in a few square kilometres; in this artistic hot-bed creativity and invention were a normal way of life. Painters wrote and writers drew, journalists composed dramas and dramatists composed songs; everybody wrote to or for the papers, shared girl friends, and held vaguely benevolent socialist ideals.

Tournachon slipped naturally into the circle. His tall, wildly gangling figure, topped by a mane of red hair above a pair of very round, bright eyes, was a familiar part of the bohemian scene – and in fact seems to have made up half of the character of Marcel in the story of *La Bohème*.[7] Even more omnivorous in his interests than most, he oscillated between two circles of friends, the wild and carefree group led by Mürger which he found entirely sympathetic, and the brilliant but more refined members of the clan of writers and artists who clustered round the magnetic personality of Charles Baudelaire.

Félix was glad to pick up scraps of journalism[8] and soon, with characteristic impetuosity, embarked on an absurdly grandiose scheme. Armed with the sum of 6,000 francs, a legacy left to a friend, he set out with an engraver called Léon-Noel to found a series of luxurious literary albums – a genre very popular at the time – which would include the greatest names: called *Le Livre d'Or*, it was to appear every Sunday. Among the list of future contributors, announced in the first number by the hopeful 19-year-old editor, were Alexandre Dumas, Théophile Gautier, Gérard de Nerval, Alfred de Vigny, and a whole list of lesser luminaries, besides a good sprinkling of active socialists. The biggest catch of the ambitious editor was Honoré de Balzac. The celebrated novelist agreed to let Tournachon publish a chap-

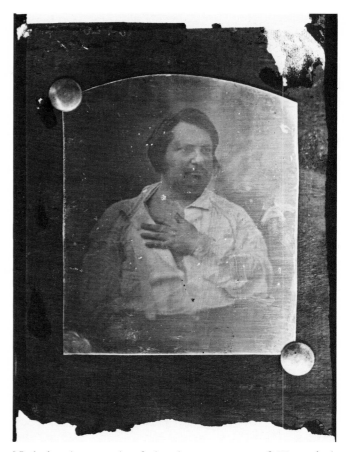

Nadar's photograph of the daguerreotype of Honoré de Balzac in his collection.

ter from a forthcoming novel, *La Frélore*. Unfortunately, the project folded before Balzac's writing appeared, but the great man's violet-papered apartment in the rue Richelieu made an unforgettable impression on the young visitor; he was to describe it sixty years later (in *Quand j'étais Photographe*), dwelling on Balzac's fear of the camera. He had a theory – shared by Gautier and de Nerval – that each time the shutter clicked a layer was peeled off the personality of the sitter. 'He had nothing to fear; his abdominal contours allowed plenty of latitude for shedding ghosts', the photographer was to comment unkindly: however he became the proud owner of a daguerreotype of Balzac (now in the Chantilly Museum) made by an unidentified photographer around 1845, shortly before they met. It had belonged to a fellow-artist, Gavarni, and then to a fellow-photographer, Silvy, and must have come into Félix's possession before 1854, as it served as model for the caricature in his 'Panthéon' lithograph that year. It was later to be used for a much greater purpose. Among the mass of detail which Rodin painstakingly collected for his famous statue of Balzac which he began to model in 1891, this image played an important part. 'For the expression I used a unique daguerreotype belonging to Nadar', he told *Le Gaulois*. 'It is Balzac in his

last days, serious and suffering, his hand stretched over his breast as though to show the illness of which he is dying.'

Meanwhile, however, the young editor was encountering difficulties: after three numbers *Le Livre d'Or* expired. Undismayed, he followed it with another publication, this time for children, neatly entitling it *L'Age d'Or*. This too succumbed after nine numbers. But Félix was now launched into journalism.

It was around this time that the honest Lyonnais name of Tournachon mysteriously transformed itself into the more exotic 'Nadar'. Pseudonyms were widely adopted at this period, and puns and word-games were a popular pastime. One of these was the schoolboy trick of adding a new suffix (in this case 'dar') to the end of every syllable. Tournachon thus became 'Tournadar' and so, by contraction, simply 'Nadar'. His intimates began to write to him by this name in 1839, and three years later – perhaps in deference to the remark in the 1841 *Biographie des Journalistes* that: 'M. Tournachon should really adopt a more presentable name' – he was signing it publicly. He also on occasion used the name 'Nadarchon' – and a drawing of 1849 was advertised by the *Journal pour Rire* as by 'Nadard'.[9]

Journalism was still his main means of support, and in 1842 he joined a successful publication, *Le Corsaire-Satan*, as one of two general correspondents, even acting at one time as secretary to its editor, Charles de Lesseps, brother to the famous engineer. It was a vigorously left-wing paper, and Félix quickly acquired the distinction of a police dossier, in which he was described as 'one of those dangerous characters who spread highly subversive doctrines in the Latin Quarter He is under close observation.' His duties (and doubtless also his radical inclinations) led him to attend debates in the Chambre des Deputés where, for a brief period, he joined the secretariat of one of the deputies, Victor Grandin.

Nadar, as he now regularly signed himself, seemed all set for a literary career. In 1842 he became a member of the Société des Gens de Lettres and in 1845 published a story in *Le Commerce*, as well as his first novel, *La Robe de Déjanire*, a rather rambling tale of four students which foreshadowed Mürger's *Vie de Bohème*. He was to be a prolific writer all his life; besides publishing fifteen books, he was a ready correspondent and a frequent contributor to journals and papers. But his inborn distaste for authority, coupled with a certain untaught graphic dexterity and the collapse (under Government pressure) of *Le Commerce*, led him into another form of journalism – cartoon and caricature. Soon he was contributing sketches and portraits to *Le Corsaire-Satan* and *La Silhouette,* which, while not very original in style nor strikingly brilliant in execution, were always professional and lively and showed that sharp eye for the link between appearance and character which was to mark his photographs.

Another journal to which he contributed was de Banville's *La Démocratie Pacifique,* a title which aptly summarizes Nadar's political standpoint. Like most of his friends in the 'bohemian' world he believed fiercely in freedom, according to the vague definitions of the French Revolution. However, when it came to practical application he was more indecisive. Though he was ready enough to censure Balzac for remaining too aloof, the revolutionary riots in Paris in February 1848 seem to have left him on the sidelines. He later admitted that he was totally immature politically at this age: 'February woke me up', he declared.

The awakening led, in characteristic style, to immediate if not well-judged action. One of his friends was Karol d'Anelle, son of the proprietress of a restaurant frequented by Polish *émigrés*. Here the denunciations of Lamartine and Lamenais, which fanned the still glowing embers of French sympathy for the Warsaw uprising of 1830, were eagerly discussed, and a new burst of pro-Polish enthusiasm was created by the eloquent speeches of Adam Mickiewicz at the Collège de France. Nadar was carried away by his oratory and, with his young brother Adrien and an engraver friend called Antoine Fauchery, he enlisted in the Polish Legion. This was a band of about 500 *émigré* and French (mostly Parisian) volunteers sworn to the rescue of Poland from her foreign suppressors.

On 30 March 1848 he set out for Strasbourg *en route* for Poland, with a passport bearing the unconvincing name of 'Tournaczewski' in his pocket. At the head of the gallant but nondescript column marched an old colonel in a cap of false astrakhan, and two top-hatted priests. The pay was 1 franc a day and free billeting.

On 15 April they reached Strasbourg via Nancy. Nadar composed a rousing proclamation to the citizens of Posnan, which was their first target for liberation; this was to be followed by the whole of Galicia and then 'the Poland of 1789 will be restored'. Unfortunately they were all arrested the moment they crossed into Germany, and were set to work for a humiliating week in a coal mine at Eisleben. By 12 May he was back in Aix, and on 1 June he walked into the Café de l'Europe in Paris, still resplendent in his green Polish cap edged with astrakhan.

He may have been crestfallen, but he was not downhearted. He immediately approached an acquaintance, Jules Hetzel, private secretary to the Minister for Foreign Affairs, with an offer of further clandestine foreign duty. Hetzel rather surprisingly accepted, and in July Félix was off once more – this time with a passport describing him as 'Frederic Haak, artist, travelling to Memel'. After six weeks of rather desultory wandering between Berlin, Stettin, and Danzig, resulting in very scanty official reports, he was summoned back to Paris – with honour, but no great credit as a secret agent.

On his return he relaxed his principles enough to begin working with the conservative *Le Journal*. Its editor, Alphonse Karr, recorded his first meeting with the new contributor:

> One day Gérard de Nerval brought in a kind of giant, with immensely long legs and arms, a long torso and on top of all that a head bristling with red hair, his eyes lively, intelligent and nervous 'This is Tournachon', said Gérard as he introduced him. 'He is very witty but very stupid. You must find him something on *Le Journal*; he has a mother whom he worships. But you must look out; he may play you some very bad tricks, though at heart he is a good chap with a heart of gold.'

He seems to have been content with routine editorial jobs on this paper, but soon he was offering his services again to Hetzel. Once more he was accepted, but this time as cartoonist on a new satirical paper, *La Revue Comique*. This too expired, but Nadar was becoming known in his new field and he even applied (to the distress of Gavarni, who appreciated his spontaneity) for a couple of drawing lessons with the worthy academic painter, Auguste Couder.

In 1849 he joined the highly successful comic magazine *Le Journal pour Rire*, edited by Charles Philipon, and found himself working alongside artists like Johannot and Gustave Doré – with whom he sometimes collaborated on a drawing. He quickly became a regular contributor, though evidently not a very conscientious one; Philipon had to complain of the poor work carried out by the assistants in his studio. At the same time he began the common but rather dubious practice of selling the same cartoons to other editors.

So far he had not strayed outside the exceedingly active but still somewhat parochial circles of Paris. 1849 was to widen his horizon. Possibly for reasons of diplomacy – several socialists had been driven to leave France after the 'Manifestation du 13 Juin' – or in his professional capacities as reporter, or simply to observe a country famous in France for its caricaturists, Nadar this year

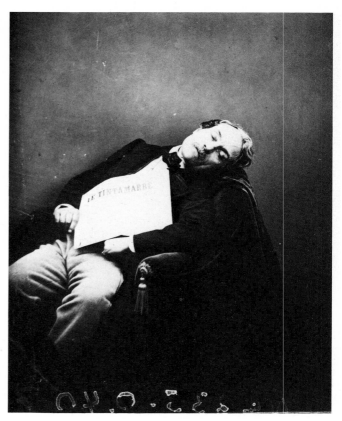

Commerson with his paper *Le Tintamarre, c.1856.*

made his first trip to London. He must have found there a whole clan of sympathetic left-wing refugees from home, and also colleagues of the graphic scene such as Gavarni. He was certainly stimulated by the visit. On his return to Paris he flooded Philipon with cartoons (a hundred in a single month), and with caricatures for Commerson as well. But the journey seems to have extended his finances unduly: the following year, 1850, he was to spend August in that haunt of so many of his bohemian friends – the Debtor's Prison in Clichy.

The next year was marked by the Great Exhibition in London, an international affair which provided work for journalists all over Europe. One of them was a friend of Nadar, Charles Bataille, who found himself in London working on a project for a French edition of *The Illustrated London News*. Its editor was to be an already celebrated illustrator, Constantin Guys, 'an old Frenchman who has attained the height of anglomania' as Bataille described him in a letter to Nadar, whom he hoped to introduce in the magazine. The project never took shape (the French Government disapproved), but he sent for Nadar all the same, to work on a more frivolous record of the exhibition. With two engravers, Nadar duly arrived in London, which he later described with a typical mixture of mockery and

In a London Omnibus: drawing by Nadar, *c*.1851.

The Stage Manager: lithograph by Nadar, *c*.1854.

affection (while admiring the pretty babies he found the men coarse) in an essay in *Le Miroir aux Alouettes*: he stayed at the St Katharine Docks Hotel (frequented by Gavarni and perhaps later drawn by Doré). He dutifully made a few sketches,[10] but the paper never appeared. The only profitable result of the visit – a very real one – was a meeting between Nadar and Guys, who were to become lifelong friends.

Back in Paris, Nadar found himself moving in new and slightly superior circles. *L'Eclair,* a magazine concerned with the cultural scene, had just been founded by a distinguished team of editors, Villedeuil, Gavarni, and the Goncourt brothers. Nadar was invited to join them. His offering was a well-established feature, a comic survey of the Salon exhibition under the title 'Nadar - Jury'. It was so successful that he was to repeat it for many more years, though it appeared in several different publications before finally finding a home in *Le Journal Amusant*.

But Nadar was evidently ill at ease in this atmosphere and was soon in trouble with the management. The cause was a scheme which he set up, apparently without obtaining proper authorization, under the paper's auspices. It was an enterprise which was to make him a celebrity and, simultaneously and inadvertently, launch him on the career which brought him

international fame – the 'Panthéon-Nadar'.

This gallery of celebrities in caricature had been brewing in Nadar's mind for some time. In the still tightly-knit society of mid-nineteenth-century Paris, personalities loomed large, and in the absence of photography illustrated clues to their appearance and character were in general demand. Following earlier examples in England, caricatures of even the most exalted figures had been popular ever since the restoration of the monarchy; artists like Daumier had brought them to a high pitch. In the very month when *L'Eclair* was founded Philipon had begun in his *Journal pour Rire* a feature by Nadar called 'La Lanterne Magique', in which he presented a series of caricatures of the eminent together with thumbnail literary sketches of their personalities.

Following his own interests, Nadar concentrated on cultural figures – writers, painters and, musicians – and his basic good humour made the humour more disrespectful than sharp (though he did, curiously, describe one of his closest companions, Baudelaire, as 'a young poet – nervous, choleric, irritable and irritating and often highly disagreeable in his private life'). This spirit of mockery was to be the source of Nadar's artistic career.

Its first offshoot was an attractive booklet compiled in collaboration with the editor Commerson,

5

called *Les Binettes Contemporaines*; it was published in 1854, and consisted of a blown-up version of the 'Lanterne Magique' in which he used the same drawings but expanded the text in his usual rather flowery style. But all the time Nadar had his eye on a more ambitious project; this was to be a huge pictorial compendium of a thousand celebrities of his age. There were to be four lithographed sheets devoted respectively to literature, drama, art, and music – a 'Panthéon' to include every god in the Parisian Olympus.

It was a huge task, more than one man could achieve. Nadar ended by employing a whole team of assistants, including his young brother Adrien. The drawings began to pile up in his studio. Some were drawn from life by Nadar himself (about half of them bear his signature); some of the victims, such as Alfred de Vigny, submitted flattering self-portraits as a guide; sometimes one celebrity would send a caricature of another, such as a sketch of Jongkind, probably sent by Baudelaire. Nadar evidently communicated his own excitement to his friends, who began to drop in to admire and comment; one of them, Polydore Millaud with whom he had founded a crime magazine at the age of 18 and who had prospered financially, offered him 15,000 francs for the collection as it stood.

Progress was steady but slow. Under a curious paternalistic law, nobody could be publicly caricatured without his own written permission, and sometimes this could be obtained only with difficulty. Some of the subjects were coy, others hard to reach. Nadar himself was obliged to pay a trip to Jersey to sketch the exiled Victor Hugo. But after two years the prospectus was finally published. The price was to be 7.50 francs by advance subscription for each sheet, or 12 francs after publication. Advertisements were placed in the papers and Philipon gave it a puff in the *Journal pour Rire*. In March 1854 the first sheet appeared in the shops – a procession of 300 literary manikins parading down the page towards a bust of George Sand.

Its success was immediate and Nadar became a celebrity overnight. But the financial profits were small, even allowing for the windfall from M. Millaud. Only 150 sheets were sold in advance, and in the first six months 541 in all came off the stone. By the time he had paid the printers, the artists and the lithographers no funds were left to finance the three promised sequels. In the end a few figures from the world of music and the arts – among them Rossini, Meyerbeer, Berlioz, Offenbach, Delacroix, and Doré – were added to the original lithograph or drawn in over eliminated and effaced characters, for reproduction

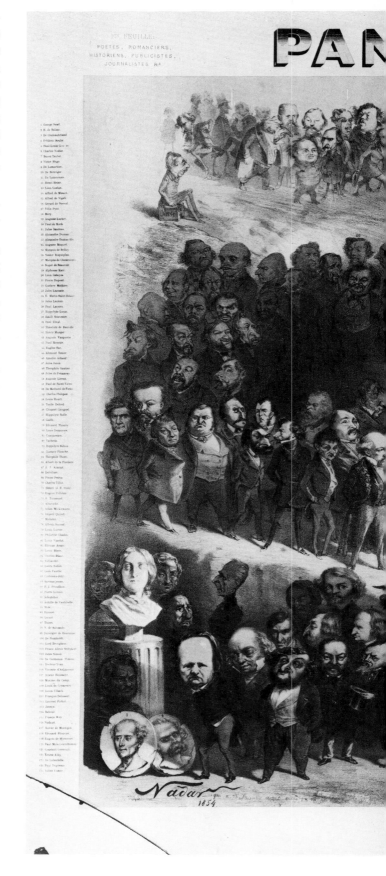

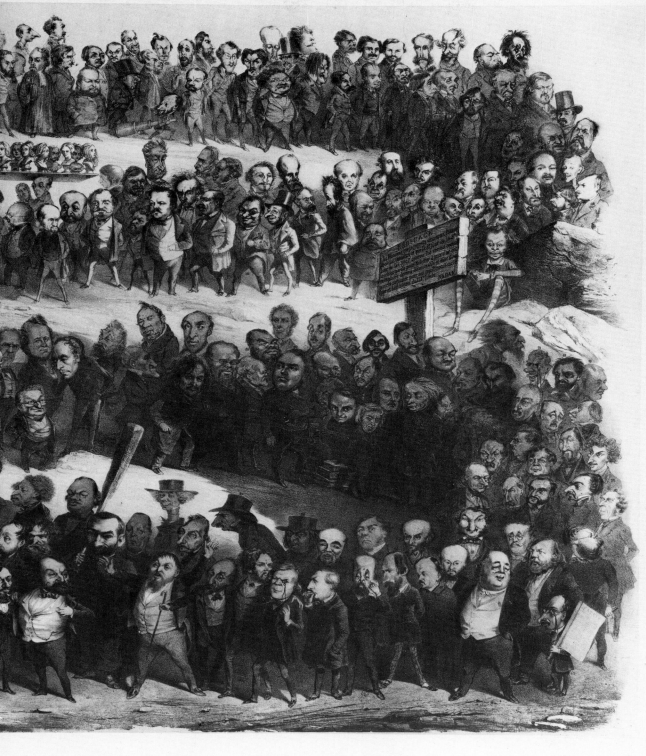

Le Panthéon Nadar: lithograph by Nadar, 1854.

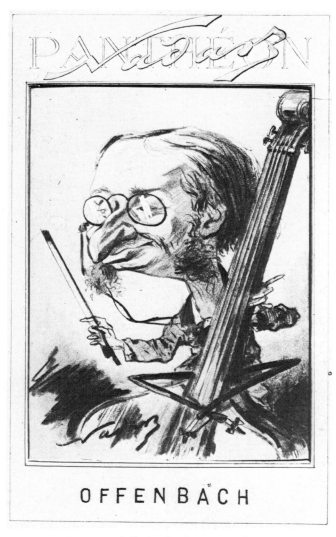

Drawing of Jacques Offenbach. *Crayon, c.*1850.

(four years later) in the *Figaro*. In this form, and through later distribution in various publications and reproductions, the work may eventually have brought a return. But for the moment Nadar found himself famous but no nearer to prosperity.

It was no doubt for money and not out of enthusiasm that he was to continue his journalism for several more years. He became one of the contributors to a new venture of the fecund Philipon, *Les Petits Albums pour Rire*; he was engaged for another Philipon publication, the *Musée Français-Anglais*; and when the *Journal pour Rire* finally expired in 1855 he actually became editor of its successor, the *Petit Journal pour Rire*. With his many outside interests – the next year saw the publication of a lively book of memoirs and sketches called *Quand j'étais Etudiant* – he was a somewhat intermittent organizer, and this journal failed too, whereupon he moved into the editor's chair of a sister publication, the *Journal Amusant*, in 1859.

But Nadar's restless enquiries had by then transferred themselves to other fields. He was nearly 40 and no longer found satisfaction merely in poking fun at other people. His insatiable curiosity and quick intelligence had suggested an altogether different sphere of activity. Philipon died in February 1862, and by that time a supplement to the *Journal Amusant* called *Le Musée Français* was already benefiting from Nadar's new passion, photography.[11]

NADAR seems to have strayed into photography with a characteristic blend of nonchalance and impetuosity. During the preparation of his 'Panthéon' he had several times had recourse to photographs as raw material for his drawings (for the later ones he may even have taken some deliberately[12]) and he evidently became interested in the still experimental but rapidly expanding craft.

It was probably this interest which caused him, even before the publication of the 'Panthéon', to set up his brother Adrien – whose career as a painter was not going as well as he had hoped – as a photographer. Nadar persuaded Adrien to take a few lessons and installed him in a studio in the fashionable Boulevard des Capucines, at No.11.

Nadar himself, though fully occupied with his drawing, seems to have contemplated becoming a partner in the business. Already another friend, Vachette, had sold him some abandoned equipment and now he tried it out. Immediately fascinated, he began to take lessons himself, with a pupil of the well-known photographer Bertsch.

Very soon – between December 1854 and January 1855 – he had set up a studio of his own on the roof of the house he shared with his mother, 113 rue Saint Lazare. Prophetically, the future aeronaut ascended to his work in one of the first lifts to be installed in Paris.

His domestic arrangements were drastically changed at this moment by his marriage to a Protestant girl, Ernestine Lefèvre, who moved in with him (a year later his mother was to move out). Meanwhile he shared his time, not only between journalism and preparations for the 'Panthéon' but between his own photographic studio and that of his brother. Adrien's few surviving photographs are remarkable (see p.39) but he seems to have had an indecisive character and lacked his brother's ebullient charm. His business fared badly, and at the end of a year he was in difficulties. He persuaded Nadar to resume the partnership and from September 1854 until the following January Nadar was working in both studios, doubtless collaborating on some photographs with his brother as he was later to collaborate with his son Paul (born in 1856).

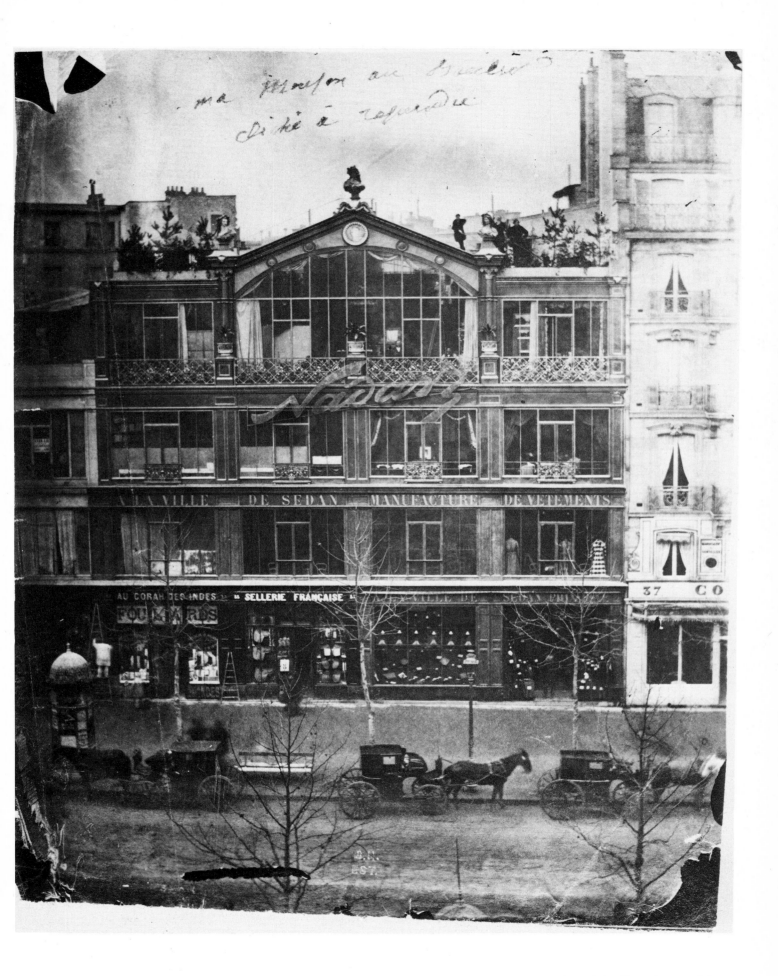

Nadar's studio at 35 Boulevard des Capucines, *c.*1860.

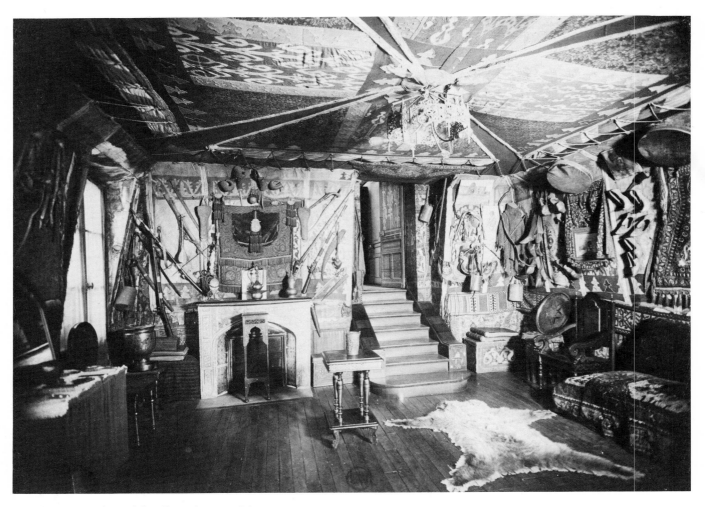

Interior, 35 Boulevard des Capucines, c.1860.

It certainly took two men to manage a photographic portrait at this time. Even the new 'wet-plate' method was still very slow and cumbersome, demanding long exposures as well as deft handling. But the collaboration did not work smoothly, and in January 1855 Nadar walked out. Adrien rashly tried to set up on his own, and Nadar found himself compelled to bring a legal action to protect his working signature. The case dragged on for nearly two years.

Meanwhile, with his schoolboy passion for societies, clubs, and patent inventions he formed himself into a limited company, 'The Society for Artistic Photography', with an eccentric list of shareholders drawn from his friends, ranging from the Péreire brothers, two railway tycoons, to Jacques Offenbach. It was a short-lived but perhaps useful venture which dissolved after a single year, by which time Nadar had won a gold medal on his own (at Brussels) and the studio was flourishing.[13]

By 1860 business was so good that he had outgrown his home studio. He rented instead spacious premises at a more elegant address, at 35 Boulevard des Capucines, a large building in the still aggressively new thoroughfare which Baron

Haussmann had just driven through the heart of eighteenth-century Paris.[14] Here he installed himself with a panache which may have been partly aimed at overwhelming his sibling rival. He was well-known for his flaming red hair and moustaches and affected a passion for this colour. He had the whole of his new premises painted red, both inside and out, and received his clients in a red robe; in case this was not enough, an enormous version of his signature stretched across the façade, made of some transparent material which was illuminated at night by gas.[15]

He now had the run of a studio which had been occupied by the well-known photographers Le Gray (Adrien's teacher) and the Bisson brothers. It was on the two top floors with access to the roof (an important consideration at a time when photographers depended entirely on daylight) and he used part of the space for living quarters, filling them with a collection of *objets d'art* which overflowed into his workrooms. 'Connoisseurs crowd into his salons and studios,' wrote Alfred Delvau,[16] 'probably less out of love for photography than from curiosity about the curiosities which are heaped around in confusion; rare porcelain, fine furniture, valuable paintings –

10

a real museum!' There must also have been a library; Edmond de Goncourt describes a nightmare in which he watches Nadar absentmindedly tearing up the pages of a rare edition of Dante's *Inferno*.

Now securely established, he continued a modified version of his old bohemian style of life – gregarious, hospitable, unconventional, and fusing an alarming variety of interests in the heat of his enthusiasm; one of the few criticisms which annoyed him was to be accused of dilettantism.[17] His parties were grand enough to be reported in the *Courier de Paris*. 'There was always open table at Nadar's', wrote one of his assistants later:

Alexandre [Dumas] would be rubbing shoulders with Offenbach, Sardou sitting next to Gustave Doré, and actors from the Comédie Française next to Rochefort. Between the poses there would be fencing. There was always a noble clash of arms in the huge studio I was there the famous evening when he asked Offenbach to play 'La Marseillaise'. And Offenbach did so with all the windows open, ornamenting it and inventing variations with such fantastic virtuosity that even the imperial police could not stop him.[18]

There was something perpetually youthful, at times almost adolescent, about Nadar. He was one of those characters who simultaneously typify a whole period and yet remain completely unique. Even in an age of teeming creativity he was notorious for his energy; Baudelaire called him 'an astonishing expression of vitality' and de Banville[19] described meeting him at 7.00 am one morning in the Jardin du Luxembourg: 'A giant drunk with happiness and crowned by a living flame who had already quartered Paris two or three times, appeared among the blue and mauve lilacs, under the flowering acacias, a novelist and caricaturist hunting for his prey; it was Nadar'.

In his youth this dashing figure with his unruly shock of hair had not only held down three or four jobs at once; he was by night an assiduous frequenter of cafés like the Momus, where Baudelaire and de Nerval capped each other's half-imaginary tales of the East; the Fleurus, haunt of Corot and his friends; the fashionable Tortoni, and the Brasserie des Martyrs, much patronized by Courbet. His favourite meeting place was perhaps the Hotel Marciol in the rue des Canettes where Mürger could be found with his 'Musette' and his 'Mimi'. He was particularly proud of belonging – unofficially – to a little band who called themselves 'Les Buveurs d'Eau' (the water drinkers), claiming that in fact he was the only one among them who did not drink wine. His name appears in a list of *noctambules* or

Nadar at a fancy-dress ball, about 1860. He later photographed George Sand in the same wig. *Photo: Collection Sirot.*

night-prowlers, the 'true nobility of Paris'[20] which included de Musset, de Banville, Courbet, and Baudelaire.

But, although free and easy in his habits (he continued to take the occasional mistress after he married[21]), he seems to have been disorderly rather than disreputable. His editor Philipon wrote in 1859:

Nadar is and always will be the lovable Bohemian we knew in our youth. A man of wit without a shadow of rationality; enthusiastic about everything, wanting to do everything, taking on everything – and then always losing interest and giving up. His life has been, still is, and always will be incoherent. He could have left his son a good reputation and a fine

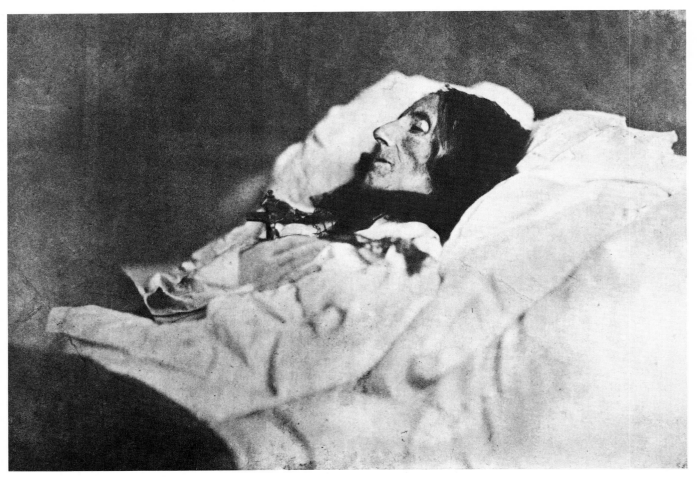

Marceline Desbordes-Valmore on her deathbed, 1859.

fortune, but he will leave him nothing but an example to avoid.

In a career sense he certainly lacked continuity. But seen in perspective his life takes on a perfectly comprehensible shape, all the more attractive for being instinctive and moulded round his own character. This proved to be stronger than his exuberant cheerfulness and charm suggested. He was a steady friend to Constantin Guys in his last lonely years, the most devoted attendant at Mürger's ghastly deathbed, a faithful visitor to Baudelaire long after he had lost the power of speech, and one of the very few who followed the coffin of the forgotten Daumier to his grave.

His compassion was wide as well as deep, and characteristically practical. It was he who organized the first exhibition of drawings by Guys after his death;[22] he was always quick to spring to the defence of any of his friends; he was violently anti-racialist,[23] and later in life he was to become an active member of the Society for the Prevention of Cruelty to Animals, going so far as to take out two summonses against what he considered unacceptable treatment of horses (with no success). One side of his character was that of a gentle giant with a bluff charm which leaned towards

exhibitionist gestures and schoolboy jokes.[24] His anti-authoritarian views led him to hang his old red jacket out of his window every Republican anniversary and to make rude noises when he passed a policeman in the street.

He was a typical 'good fellow', welcome everywhere and omnivorously friendly. But he was far from being merely an amiable companion. His political views were not only sincere (he steadily refused all official honours) but also strong enough to lead him to risk his life during the Commune. Nor was he a mere dabbler in literature. He was no intellectual but he was well educated – able to quote a Latin tag or refer to a character in a Mozart opera – and he liked to discuss ideas and to back up his strong feelings with a semblance of reason (as when he supported his theories of 'heavier-than-air' flight by quoting the example of a man wetting a sponge to throw it up a ladder).

His sentimental temperament overflowed in memoirs and tributes, and his high spirits bubbled up in comic sketches and parodies.[25] He had little sense of literary structure and his prose tended to wander after a few chapters in the course of a long story. But some of his short pieces show a genuine insight, betrayed only by a fatal delight in a fanciful vocabulary and irrelevant

flights of imagination. When he wrote from the heart, as in his blood-freezing description of a famous doctor casually pronouncing death sentence on his patient in a story called *La Mort de Dupuytrien*, his compassionate understanding of character joined with his sharp journalist's eye to produce real literature.

This was the combination which was to inspire his photographic work from the very beginning. It may have been mere curiosity which led to his original experiments; but the results were consistently serious. He was rarely tempted (as his son was later to be) to exploit his talent in banal journalism and publicity pictures, and rarely accepted commissions for the ever-popular deathbed pictures (Victor Hugo and the gentle poetess Mme Desbordes-Valmore were exceptions). He aimed at once at sincerity and – as part of a culture in which this attitude was endemic – at a feeling of eternal truth.

The portraits he made were mostly of friends, or of friends of friends (usually radical in politics) and he found a way of presenting them – as any good portraitist does in any medium – poised halfway between ephemeral individuality and universal permanence. He quickly began to explore the effects of reflectors and artificial light, and fired by these discoveries he organized a well-publicized descent with his camera into the creepy depths beneath the city – first into the sewers and then into the catacombs,[27] from which he emerged with a set of eerie pictures of skulls and bones lit up by galvanic arcs.

He had plumbed the depths. Now his restless imagination began to strain upwards. The new trajectory was to carry his interests far out of the studios in which, within fifteen years, he had forged a national reputation. Like many of his generation he became obsessed with the prospect of human flight.

BY a paradox of the kind he himself enjoyed, Nadar's name was to be linked not only with caricature and photography, arts which he admired and enjoyed, but also with something which in theory he violently opposed – the balloon. He was to spend a lifetime championing the theory that the 'heavier-than-air' machine would replace it, yet ballooning was just the kind of activity to attract him – a mixture of science and fun. It was all the rage at this time (he himself had made a cartoon on the subject) and the future of 'lighter-than-air' flight was the subject of much learned discussion. Could the passive floating bubble be improved on? Nadar believed it could. The argument was neatly summed up one day by Victor Hugo in a conversation with him. 'Raise your eyes to the heavens,' exhorted the poet. 'There I see two kinds of flight – that of the cloud and that of the bird. One is the plaything of the wind; being lighter than the air it cannot resist it. The bird, heavier than the air, opposes the wind and dominates it. Let our aeronauts be inspired by nature!'[28]

The same reasoning was advanced – though probably less eloquently – by two friends who came to call on Nadar in 1863. Both were passionate champions of the heavier-than-air theory, and one of them, Ponton d'Amécourt, was also an expert in a fifty-year-old invention, the propeller (see p.33). In July 1863 his studio became the headquarters of 'The Society for the Encouragement of Aerial Locomotion by means of Heavier-than-Air Machines'. Meetings were to be held every Friday. Jules Verne – who was later to use Nadar, thinly disguised under the anagram 'Ardan', as the hero of his adventure story *De la Terre à la Lune* (1865) – was secretary. Nadar became an honorary president (with Baron Taylor, a well-known benefactor, and Dr Babinet of the Institute), provided most of the funds and issued a resounding manifesto.[29] 'To command the air', it asserted, 'one must be stronger than the air.'

Within a few weeks the Society had launched its own journal, *L'Aéronaute*, also financed by Nadar. It was to be an important publication, but expensive to produce and it did not exactly reach a large audience; after five weeks there were only forty-two paying subscribers. Some means had to be found to raise more funds and attract more attention. Nadar's eccentric answer was to make use of the very phenomenon they were fighting to abolish – the balloon. A monster big enough to catch the eye of even the most terrestrially inclined, with a two-storey basket to hold eighty passengers (and a small printing press for handouts) was to be designed and constructed by the experienced balloonists, the Godard brothers. Nadar was to foot the bill.

Work on *Le Géant*[30] went forward at an incredible speed. Not much more than six weeks later the huge contraption was set up in the centre of Paris on the Champ de Mars (not yet occupied by M. Eiffel's imposing tower). On the afternoon of 4 October 1863 Nadar and thirteen passengers – each of whom had paid a thousand francs for the privilege – climbed into the basket in front of a crowd of 200,000 onlookers, amongst whom, somewhat incongruously, copies of *L'Aéronaute* denouncing balloons were distributed. At 5.00 pm the colossal sphere rose majestically into the air and disappeared slowly over Les Invalides.

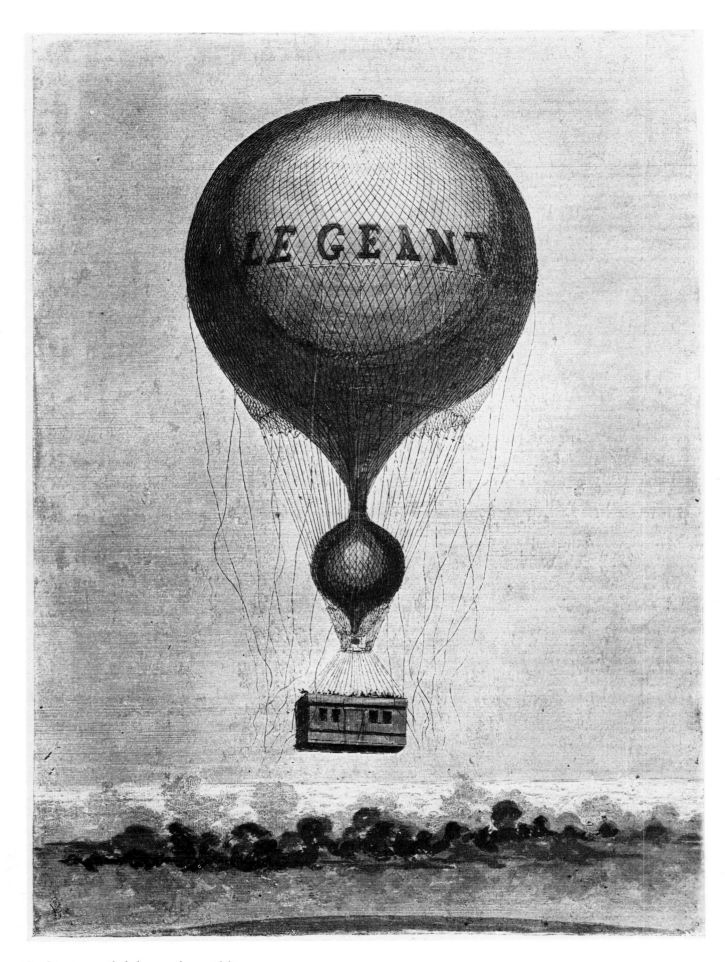

Le Géant, an artist's impression, *c.*1863.

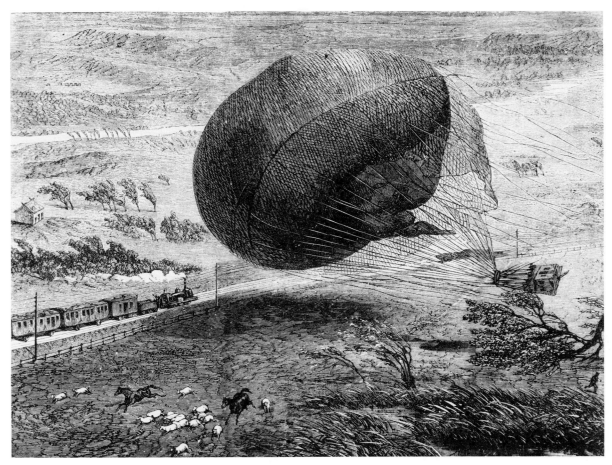

The wreck of *Le Géant* in Hanover, 19 October 1863. An artist's impression.

Five hours later it came down in the darkness forty-five kilometres away, at Meaux.

Financially the event was a failure, but it attracted wide publicity and Nadar determined to try again. Two weeks later *Le Géant* was once more on the Champ de Mars and, what is more, being inspected approvingly by the Emperor himself – while Nadar, fierce Republican as ever, withdrew to sit in a cab nearby. Mme Nadar was one of the nine passengers, who also included the Godard brothers, both experienced aeronauts, and a descendant of the ancestor of all ballooning, Montgolfier.

This time the wind was blowing from the south, and all too strongly. Seventeen hours later, at eight o'clock in the morning, the balloon was sailing across Hanover, driven by a gale. The basket struck the ground and travelled in shattering ten-metre hops for over a kilometre; after half an hour it came to rest near Neuberg. The Godards had prudently jumped out before the final crash. Mme Nadar was badly shaken and wounded in the neck while Nadar fractured a leg.

The disadvantages of ballooning had been illustrated all too vividly. It was a catastrophe, but of the most rewarding kind. The publicity was enormous, and aroused a wave of affectionately mocking sympathy. The Queen of Hanover sent fruit and flowers to Mme Nadar and invited her 7-year-old son Paul to stay (Nadar's anti-royalism seems to have stretched far enough to allow this). Offers of help poured in, including one from Victor Hugo in Guernsey. Nadar, a champion of the socialists who had been exiled to Brussels in 1851, had been one of the guests at the famous dinner which celebrated there the publication of Hugo's *Les Misérables*, and smuggled back to Paris thirty-eight copies of the poet's forbidden *Les Châtiments* and *Napoléon le Petit*, hidden in a bundle of balloon silk. During the visit Nadar photographed Hugo – one of his few portraits undertaken outside a studio.

Hugo suggested opening a list of subscribers with a personal donation of 300 francs. Nadar replied:

> For heaven's sake, do nothing of the kind. At the moment I am all but ruined in the air and on the ground; you would shame me by exposing me to the accusation of dragging in the name of 'humanity' on my behalf. I'm not dead yet; and I have always been a fighter. Leave me the hope and the honour of winning the first battle, and then it will be me who will approach you, saying: 'Let's go forward together!'

So, instead, Victor Hugo composed an open

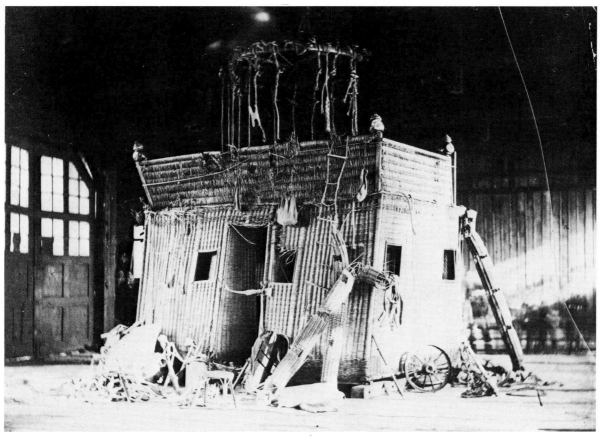

The basket of *Le Géant* after the wreck, 1863.

letter, deploying all his loftiest flights of imagination. He invoked the balloon as a symbol of liberty, a key to open the cage of tyranny. Then going further, he imagined the flying machine of the future.

> One evening I was walking in the Allée de l'Observatoire with that great pioneer thinker, Arago.[31] It was summer. A balloon which had ascended from the Champ de Mars passed over our heads in the clouds. Its rotundity, gilded by the setting sun, was majestic. I said to Arago: 'There floats the egg waiting for the bird; but the bird is within it and it will emerge.' Arago took both my hands in his and, fixing me with his luminous eyes, exclaimed: 'And on that day Geo will be called Demos!' A profound remark. Geo will be called Demos. The whole world will be a democracy.

> Visions of joy and freedom were evoked. Civilization would rain down on the globe; the exile (a personal reflection, this) would descend in his own garden and embrace his mother; a saviour would descend from the sky to strike the chains from suffering serf, slave, and fellah. Europe would be like the Archangel Michael. 'Man will become bird – and what a bird! A thinking bird. An eagle with a soul!'[32]

The campaign had received a powerful boost and Nadar threw himself into publicizing it (between sessions with his camera) with his usual energy – lecturing, writing, and arranging exhibitions. Hugo's poetic view of the flying-machine as an engine of democracy was by no means unique. Nadar's socialist friends made up a solid core of support for his ventures, which was later to strike a sympathetic chord in more aesthetic breasts. In 1866 the 600 members of his 'Société des Aéronautes' included Offenbach, George Sand, both the Dumas, and the painter Alfred Stevens; and when he crossed over to London in 1863 to lecture on his exploits in *Le Géant*, Baudelaire gave him warm letters of introduction (unused, apparently) to a pair of rather improbable aeronauts, Swinburne and Whistler.[33]

A natural marriage between Nadar's two passions had already been celebrated by the use of the balloon as a vantage point for photography. The idea had been put forward earlier by others, but it was not so simple as it sounded, owing to the amount of equipment needed, which had to include a portable darkroom for preparing and developing the plates. Nadar later declared that his first four attempts failed; the plates emerged dark and smudged. But one day in the autumn of 1858 he succeeded. Abandoning all clothing for the sake of lightness, he ascended in a captive

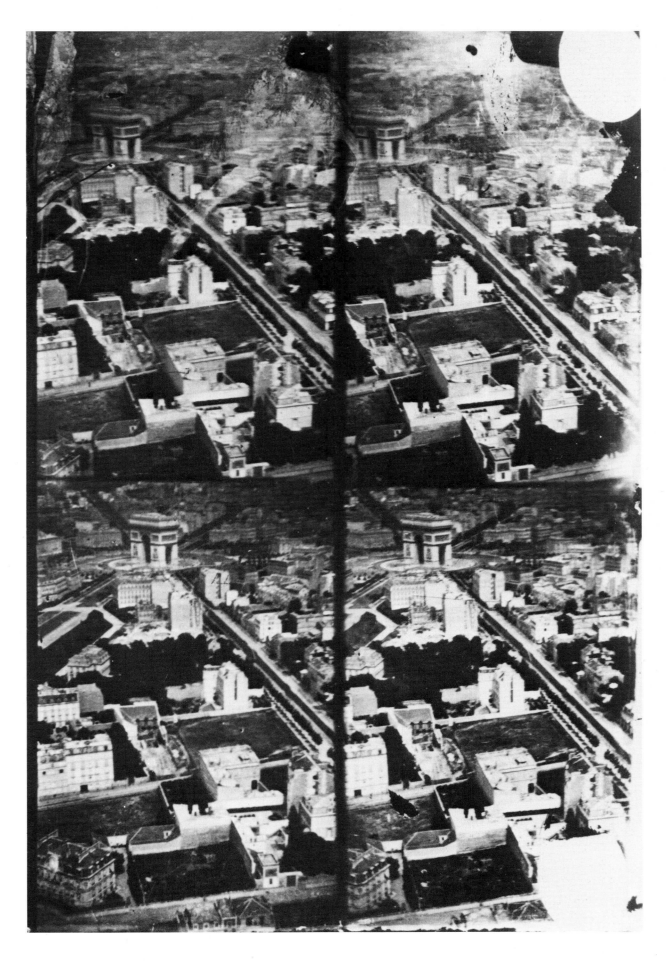

A view of the Arc de Triomphe taken by Nadar from a balloon, 1868.

balloon above Petit-Bicêtre, just outside Paris. Clutching his Dallmeyer camera with its horizontal shutter of his own invention, and concealed under a black curtain with orange blinds, he returned with a clearly identifiable image. He had discovered that sulphur in the gas escaping from the balloon was affecting the plate, and simply shut the valves.

Nadar liked to urge the usefulness of such photographs in land surveying; but he also saw its military possibilities, and in 1859 Napoléon III offered him 50,000 francs to take aerial photographs in the war against Italy (as a rabid anti-imperialist, he declined). So the sudden outbreak of war with Prussia in 1870 found him ready. On 18 August, only a few weeks after the first shot had been fired, he founded, together with two friends, the Compagnie d'Aérostiers Militaires, a balloon team to be operated with pupils of the Godard brothers. On 2 September came the disaster at Sedan. On 4 September the Emperor abdicated. At once (and at his own expense) Nadar took over 'in the name of the revolution' a site on the Place Saint Pierre in Montmartre and set up two balloons. The enthusiast who had set out on foot in his youth to liberate Poland was in action again, this time to break the blockade of Paris.

Montmartre was still half rustic and the volunteer crew had to sleep in tents on the side of the hill on straw provided by the new mayor, Georges Clemenceau. They carried out ascents religiously several times a day. But the autumn mists restricted their vision and their rather minimal reports were ignored by the authorities. Then, after a few weeks, the Prussians closed their ring round the city and for the first time balloons took on a vital rôle; they became the only link with the rest of France.

There were eight or nine of them in Paris. All were rather ramshackle, and new ones were

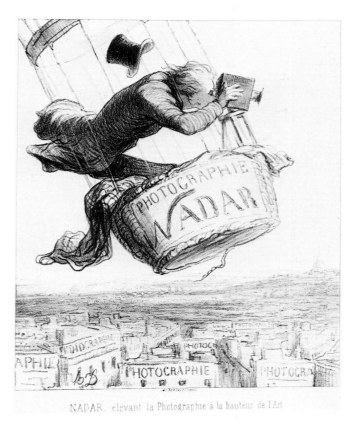

'Nadar raising Photography to the level of Art.' Lithograph by Daumier.

hurriedly ordered. But Nadar did not wait. On 23 September Duruof's old *Neptune* took off at dawn, rose to 9,000 feet and, saluted on the way by a hail of German bullets, landed a few hours later in a park in Normandy with three sackfuls of telegrams and two letters from Nadar himself. The world's first airmail had been launched.

One of Nadar's letters was addressed to *The Times* in London, which duly printed it (in full, in French) on 28 September. It was a dignified and touching message, not appealing for help but admitting the fault of the Imperial Government in declaring war and then pointing out how the Prussians had now put themselves in the wrong by attacking the whole French people. He foretold a dire fate for them. A similar letter appeared in *L'Indépendance Belge* in Brussels.

A sober note of responsibility had crept into Nadar's prose style, reflecting his genuine national importance. On 29 September the aerial postal service was officially recognized and soon the Director of the Post Office himself was making use of it. Two new balloons appeared in Montmartre, both named after old comrades, the *Armand Barbès* (a fellow-socialist) and the *George Sand*. The maiden flight of the *Barbès* carried two distinguished passengers as well as mail. In 1878 Alphonse Daudet described the scene for the Saint Petersburg *Nouveau Temps*:

Nadar's design for the jacket of his *Les Mémoires du Géant*, 1864.

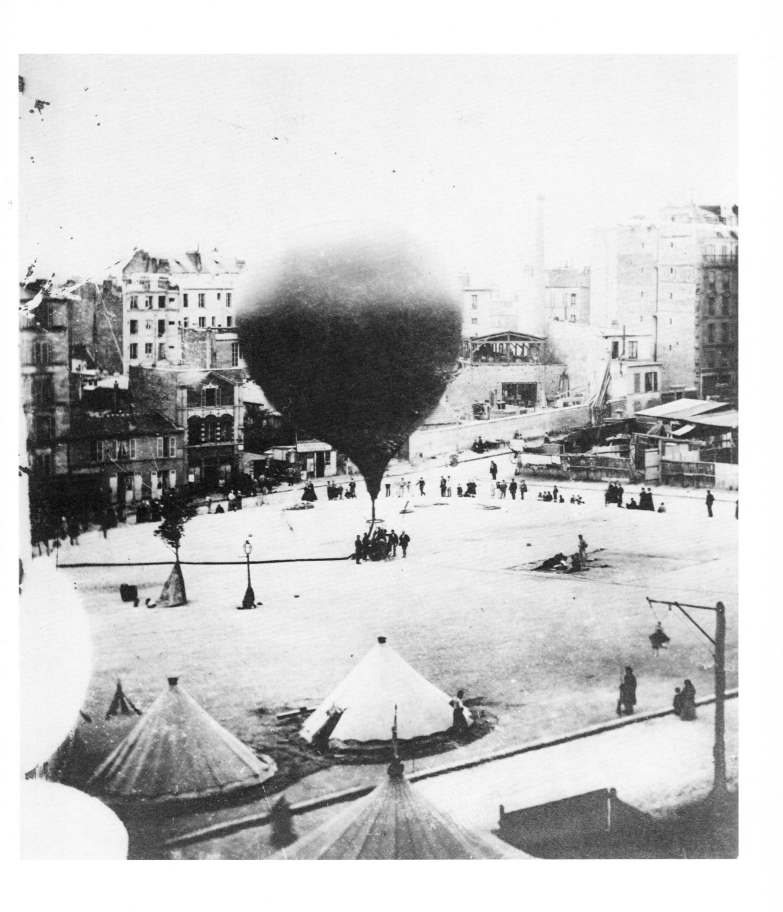

The *Neptune* in the Place Saint Pierre, 1870.

There on the square stood a little tent and, in the centre of an area marked out with ropes, a huge balloon swaying on the end of its cable. At first I noticed only Nadar, our old friend Nadar, in his flying cap among all the siege material – then, in the middle of a group, Spuller and Gambetta, both muffled up in furs. Spuller was very quiet, brave and unemotional but unable to take his eyes off the huge machine in which, as 'chef de cabinet', he was to take his place, and muttering as if in a dream: 'It's really something extraordinary!' Gambetta was chatting and rolling his shoulders as always, half-delighted at the adventure. 'Let go!' rang out the voice of Nadar. A few greetings, a shout of 'Vive la République', the balloon took off, and that was that.

Soon another balloon was added to the team, called (with permission) after Victor Hugo. The poet urged Nadar to use it to distribute millions of copies of his appeal to the two belligerent governments, a tactic which he thought would have 'an incalculable effect'. By this time there were postal balloons operating from several parts of Paris (not all fared well; some were shot down and one landed in a fjord in Norway) but Nadar himself withdrew from the operation. Once it was working smoothly, the inventor took no pleasure in it.

But his involvement in public affairs was not over. The abrupt and painful conclusion of hostilities found him ill (bad health may have been one of the causes of his withdrawal from the balloon scene) and he took no active part in the short struggle between the republican Commune and the government of M. Thiers. Though his sympathies must have been strongly aroused, he had to leave it to his 14-year-old son Paul to join the fighting as a courier. But this did not stop him from risking his neck in the cause. He openly visited friends in prison and even hid a general (General Bergerat, whom he did not know personally) in his own house for nearly two weeks. The way in which he finally disposed of his guest was characteristic. He boldly demanded an interview with the Premier, an old acquaintance, dragging along Alexandre Dumas for moral support. 'What, Nadar! Haven't they shot you yet?' asked the astonished Thiers good-humouredly. Nadar explained his plot; and a few days later the general crossed the frontier in the guise of an anonymous secretary to one of Nadar's friends.

NADAR emerged from the disasters of war a new character. The fiery young buccaneer had turned into a benevolent and respected public figure. But he was ruined financially. He had to let his sumptuous studios in the Boulevard des Capucines, and installed himself in a large and rambling old house at 51 rue d'Anjou, not far away.[34] Here he indomitably set out to reestablish his fortunes through photography. He could no longer concentrate on quality and the ideal 'intimate portrait' of old friends. He turned commercial and – with the aid of his son Paul – he made a thorough success of the business. Soon he was as busy as ever, and following as keenly the new techniques which were replacing his beloved old collodion wet-plates.

From now on he often left much of the work to his son, who was to prove a competent if uninspired craftsman who carried on the studio for many years. Nadar meanwhile had time to return to other interests. He contributed short essays and sketches to several publications and embarked on a whole succession of books of memoirs, impressions, and character studies. They included *Histoires Buissonières* (1877), *L'Hôtellerie des Coquecigrues* (1880), *Sous l'Incendie* (1882), a highly blasphemous skit on Gambetta (who had disapproved of balloons until he made use of one in 1870), *Le Monde où l'on Patauge* (1883), and a study of his old socialist friend Louis Blanc, in the same year.

Nadar had lived among writers almost all his life and he was never less than articulate in print.[35] He often found an interesting point to make, a vivid memory to record or a good cause to preach. His style reflected his own personality, and its merits are its relaxed waywardness and imaginative freedom; he allowed himself to be tempted into impromptu improvizations and irrelevancies with obvious gusto. Its weaknesses rise from a lack of overall structure and overindulgence in words for their own sake. Rarely willing to use a simple phrase when a picturesque one was available, he gave to his prose a rococo elaboration which sometimes borders on archness. But it is impossible to read through his writings without sensing the presence of a captivating personality, and when he hit the target – as in the moving *Mort de Dupuytrien* or in paragraphs where he forgets his rôle of entertainer or prophet and writes sincerely of his friends and enthusiasms – he could rank with the best.

If half of his friends were writers and thinkers, the other half were artists and photographers; his early career as cartoonist located him happily between the two worlds. Drawing seems to have come naturally to him but in spite of his two art lessons he was never more than a Sunday painter.[36] His eye was evidently keener than his brush, and the criticisms in his 'Nadar – Jury au Salon' articles were by no means obtuse.

It was one of the incongruous chances which Nadar's character seemed to attract which gave his name a place of honour in the history of painting. Just as the fervent champion of the heavier-than-air machine became a renowned balloonist, so the admirer of academic classicism was to become famous for his contribution to progressive art. In 1874 Claude Monet conceived the idea of bypassing the Salon by organizing an independent show of paintings by his friends – Manet, Renoir, Degas, Cézanne, Pissarro, Sisley, Boudin, and others. They were all *habitués* of the Café Guerbois in the rue de Batignolles, a group dominated by Manet, a particular friend of Nadar who doubtless met them there. Having himself just made a successful breakthrough into the Salon[37] Manet violently opposed the rebellious project but they pressed on without him and, in their search for spacious premises in the heart of the city, thought of Nadar's old studios in the Boulevard des Capucines, which he sometimes let out for lectures or concerts.

Nadar's taste in art was distinctly more academic than theirs but he was sympathetic to any anti-establishment gesture; he had even declared in print: 'No more juries! Free exhibitions!'[38] And so it came about that his studio became the site of an event which was to go down in the history of modern art – the First Impressionist Exhibition. It was not exactly free but it was cheap. Entry was one franc and the show was open for four weeks, from 10 am to 10 pm. There were 165 paintings hung in close ranks on the russet walls, including the one which was to give its name to the movement, *Sunrise – an Impression* by Monet. Reaction to the pictures – which were actually mostly hedonistic and cheerful, apart from those by Cézanne – was horror, even alarm. The mother of one of the exhibitors, Berthe Morisot, received a letter a few days later: 'I have seen the rooms of Nadar and wish to tell you my frank opinions at once. When I entered, dear Madam, and saw your daughter's work in this pernicious milieu my heart sank. I said to myself "One does not associate with madmen except at some peril . . ." ' The critic of *Le Figaro* claimed he had seen a visitor 'biting everyone in sight'.

But Nadar was not the sort to be frightened by disapproval. Four years later, in 1878, he was organizing – this time in the prestigious Galeries Durand-Ruel – an exhibition of work by his old friend Daumier, once the famous and popular champion of all radical Paris but now old, poor, and neglected. And seventeen years later he was to mount a large show (the first) by his friend Constantin Guys, who had just died in poverty. With Nadar affection flowered spontaneously into action.

Claude Monet, photographed by Paul Nadar in 1899.

But it was journalism, Nadar's first occupation, which was to provide him with the setting of his last creative gesture. The trapping of a man's personality had always been his obsession, both in his photography, his drawings, and his writings. In its issue of 5 September 1886 the *Journal Illustré* published a double-page spread of action photographs (by Paul) showing Nadar talking to the centenarian hero of the Post-Impressionist painters, the famous chemist and colour-theorist Chevreul, while beneath the pictures appeared a witty running dialogue by the impish little scientist on the subject of 'The Art of Living for 100 Years' (pp.22–3). The photo-interview was born.

This small success marked the beginning of a downward turn in Nadar's fortunes. It was followed by a relaxing holiday, travelling through Italy on the advice of the doctors attending Mme Nadar. Shortly after their return to the South of France she suffered a stroke on hearing the news of a fire at the Opéra Comique, imagining that Paul had been in the audience. Fresh air

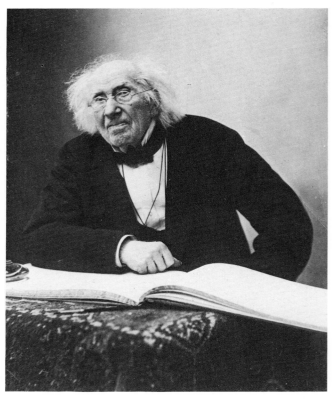

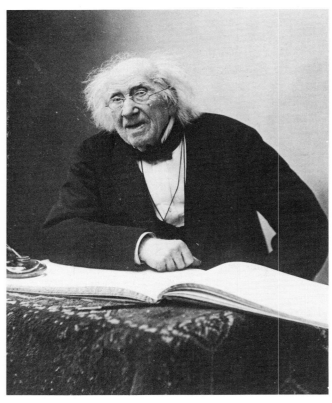

'I find here the name of Monsieur Pasteur: that is where I will write my name. Monsieur Pasteur is one of the greatest geniuses of our age because, contrary to his predecessors, he proceeds from the unknown and not from the known.'

'What would you like me to write in your album?'

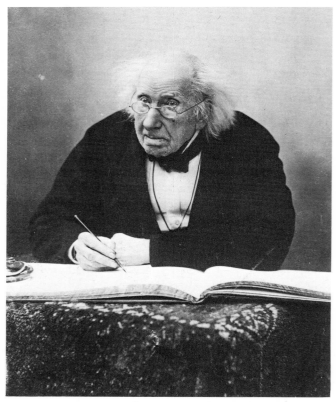

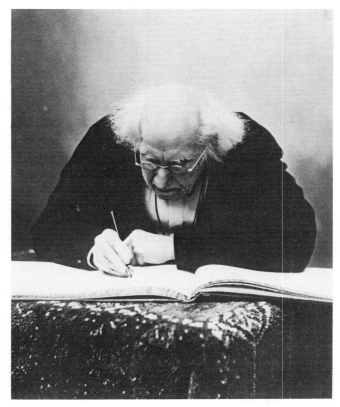

'I am going to write my first philosophical principle, it was not I who formulated it but Malebranche. I have looked hard, but I have not found a better one.'

'One should strive for infallibility without claiming to have achieved it' (Malebranche).

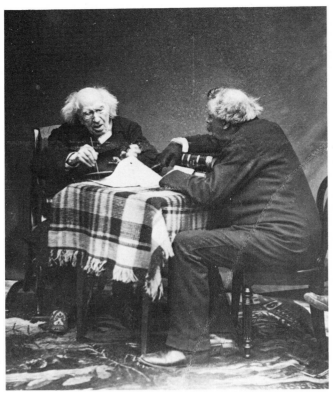

'Watch this, I am going to spin this red and white disc and you will get the impression of a uniform green.'

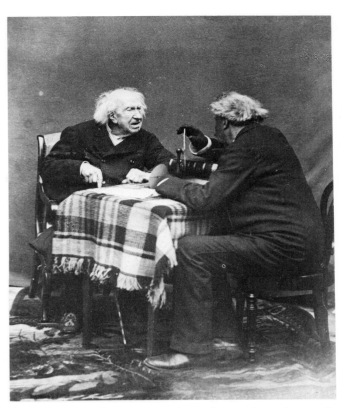

'I ran into Monsieur Hersent, the academy painter, in 1840 in the courtyard of the Institute after a lecture by Monsieur Arago . . . and I remarked to him that yellow next to blue becomes orange, while blue next to yellow becomes violet.'

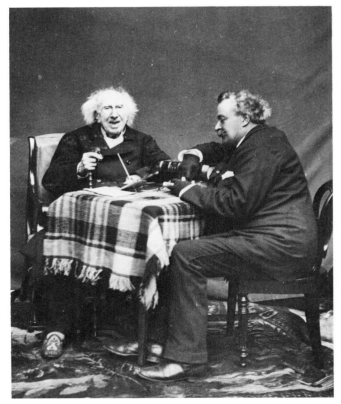

'Monsieur Hersent replied quite differently from you. If Monsieur Chevreul says that, I will say he is lying; as Monsieur Chevreul has said it, I want to see it before I believe it. I replied by inviting him to my laboratory at the Gobelins where I would show him.'

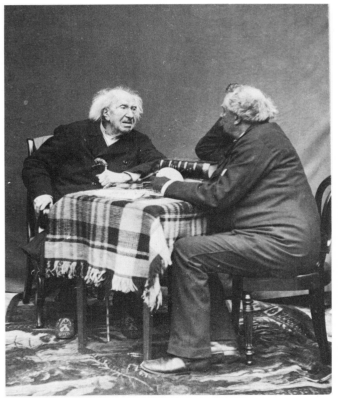

'He died twenty years later, without having come to see me at the Gobelins as I had invited him.'

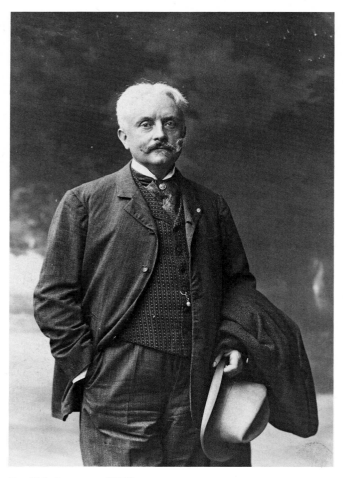

Paul Nadar, son of Félix.

which are three plums in watercolour, miracles of wash and colouring. And among the picturesque bric-à-brac come and go the white teeth, smiling black faces and brilliant turbans of two negresses who constitute the domestic staff.

In this unaccustomed rustic environment Nadar passed his time writing articles, working on his memoirs, painting in the woods, and vaguely trying to superintend from a distance the studio in the rue d'Anjou, which he had left in the hands of his son.

As could have been expected this absentee control led first to doubts, then to misunderstandings, then to outright quarrels. Business was falling off, due either to Paul's lack of talent or to more general reasons,[39] and the young photographer tried to strike out in new directions which to Nadar were unfamiliar, such as the sale of equipment, the acceptance of a position as agent of the big American firm of Eastman-Kodak, and the founding of a new magazine, *Paris-Photographe*. This was to prove a success (it was here that the American photographer Muybridge published his experiments in recording movement) but it meant spending money and Nadar did not approve. Nor did he like Paul's liaison with a married Italian actress.[40]

Added to his financial worries (Goncourt wrote of 'ruin') was the strain of looking after a wife whom he had sometimes betrayed but still greatly loved, and his own bad health. There were plenty of excuses for his lack of understanding of his son. But there are signs that his dominating personality had always been an obstacle to family harmony. Sibling rivalry crops up several times in his writing and he seems to have exerted a suffocating influence not only on his brother Adrien but on Paul's efforts to build up a career of his own. The irregular organization of the business (it officially belonged to Mme Nadar, with her husband and son as joint administrators) cannot have helped.

The results caused Nadar deep pain, and by 1894 he had cut off all connexion with the studio. 'When he conducts us to our carriage', noted Goncourt after a visit to L'Hermitage with Daudet on 5 August 1895, 'we pause for a moment in the doorway and he unbuttons his grief over the quarrel with his son. "As for me," he says, "he doesn't speak to me any more, doesn't greet me –" He lifts one finger and lets it fall. "I have never done that to him. I never punished him." And when the Daudets invite him to bring his poor paralysed wife to dinner one night, his eyes fill with tears as though from gratitude.'

Cutting himself off from his Paris studio did not, however, indicate that he had given up alto-

was held essential for her recovery. Nadar packed up immediately and withdrew to a rambling house he owned in the Forest of Sénart, south of Paris, called 'L'Hermitage'; he had acquired it on the bankruptcy of Adrien, who had gone steadily downhill, until later rescued and installed in the rue d'Anjou.

Nadar was to stay in the country for eight years, nursing his now half-paralysed wife – 'Mme La Bonne' as she was affectionately known – with the help of Gracieuse Sallenave, an illegitimate girl who had joined his household at the age of 15 and subsequently – after an unsuccessful marriage – stayed on as an unofficially adopted daughter. It was a patriarchal existence very far removed from the Parisian bohemia of his youth, surrounded by chickens and animals, with friends dropping in for a chat. On Monday, 21 August 1893 Edmond de Goncourt noted in his diary:

Visit to Nadar at L'Hermitage and exploration of the studios and rooms with their walls all covered with paintings and drawings and photographs. I notice a portrait of his son, very pale in colour, a witty *grisaille* by Daumier, some terrible Guys, a masterpiece by Manet and a letter from the artist, at the bottom of

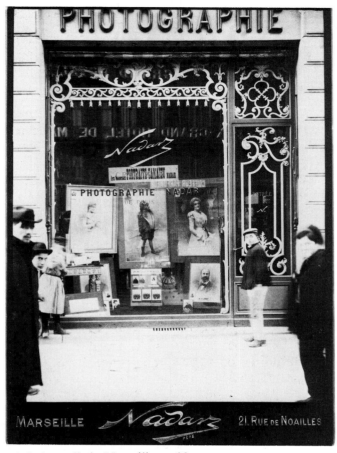

Nadar's studio in Marseille, c.1880.

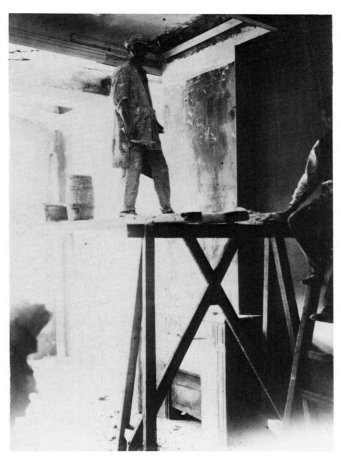

Repairs to Nadar's Marseille studio, c.1897.

gether. At the age of 77 and shortly after an operation, Nadar embarked on another new enterprise. He opened a photographic studio in Marseille, at 21 rue de Noailles. Here, with support from yet another young protegée, Marie Gilard, business began to flourish as before. By now Nadar was a celebrity (his departure from the Paris studio had made the front page of *Le Figaro*) and portrait commissions rolled in. Nor did he content himself with work in the studio; in the 1890s he embarked on extensive alterations to the building. He seems to have delighted in the confusion which resulted and took a number of pictures which reveal his appreciation of the unexpected effects made by wooden beams, falling plaster, and even piles of displaced furniture and rubbish. This eye for the beauty of chaos and discarded objects was exceptional in an age of conventional ideals. He was photographed inside an apiary, unprotected and surrounded by hundreds of bees with a friend who had assured him (correctly) that they would not sting him. And around 1900 he was organizing the taking of photographs inside the air-chambers used to deepen the harbour – 'underwater' pictures, even if procured in artificial circumstances.

His finances began to improve and were swelled by the sale of his aeronautical collection

to the Musée Carnavalet, and assured by the cession of the Marseille studio to his two protegées in exchange for a regular income. The actual running of the business was handed over to a young photographer called Fernand Detaille.

He enjoyed, too, a final taste of publicity. At the Universal Exhibition of 1900 a special section was devoted to his photographs with samples of all his various activities, and was widely praised. He felt the pull of his old haunts, and in 1904 he returned with his wife to Paris (28 rue Panquet, soon exchanged for 49 rue d'Antin). Here he continued to add chapters to his memoirs, of which he published fragments in several papers; and he even resumed his caricatures with some drawings in *L'Assiette de Beurre*. He worked hard, too, on *Charles Baudelaire Intime,* the weird tribute (in which he accused the poet of impotence) which he felt impelled to write forty-four years after the death of his friend.

By now he was 84; but something of the old impetuosity still survived. He had a new idea, and wrote off at once to a friend. 'A benefactor once set up a Museum of Religion. Isn't there a case for the complement to it? Who will provide instruction for tomorrow – for ever – through a Museum of Revolution Shall we ever proclaim quick enough the idea of Justice? Shall we

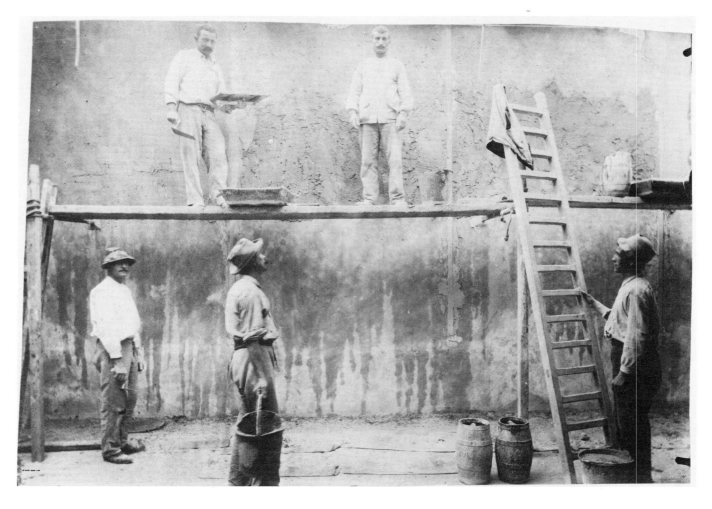

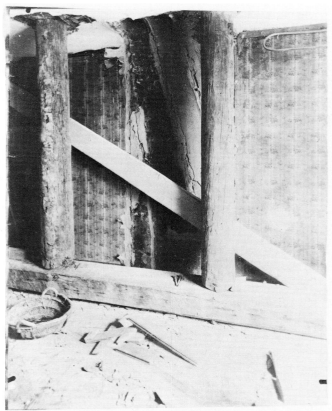

Repairs to Nadar's Marseille studio, *c.*1897.

ever acclaim loud enough the greatness and glory of Revolt? To work!'[41]

The flame still burned bright; but darkness was drawing near. A giant shadow fell in 1909 with the death of his wife; after over fifty years of marriage the blow was mortal. He struggled on gamely, fighting to the last his battle for the aeroplane. When Blériot flew the Channel in July 1909 Nadar cabled to him: 'Deep gratitude for the joy with which your triumph fills this antediluvian of the heavier-than-air machine before his eighty-nine years have sunk under the earth.' It was a farewell message. He was chronically ill with bronchitis and the winter weakened him further. On 15 March 1910 he died, two weeks short of his ninetieth birthday, surrounded by his dogs and cats. By now he had no wife and no brother; only a son with whom he had quarrelled.[42] Of all the figures at whom he had poked fun in his 'Panthéon', he was the last survivor.

'Love of life is the gift of the poet, the supreme gift, and Nadar had it more than anybody', Léon Daudet had written.[43] But it is doubtful if he would have derived any pleasure from an extra span of years. He was essentially a nineteenth-century man. He had grown up in a period of explosive expansion, when scientific discovery

and geographical explorations seemed to be pushing out the boundaries of human (or at least European) existence, and – over-hopefully as it transpired – every advance in technical knowledge was hailed as a step nearer to the ideal society. Poets and artists were passionate advocates of science, and socialists were always among the keenest supporters of Nadar's balloons.

He himself was a perfect example of the nineteenth-century progressive – energetic, optimistic, and practical. His enthusiasm for photography and aeronautics, for experiments with the telephone and gramophone, were confused with visions of moral improvement. Modern versions of his beloved socialism which diminish the rôle of the individual would have offended a temperament which was described[44] as having three over-riding characteristics – love of freedom, loyalty, and a naïve belief in goodness.

An adolescent inquisitiveness and impetuosity clung to him all his life; portraits taken in his old age show a round-eyed schoolboy with white hair. He could write:

> A superficial intelligence which has touched on too many subjects to have allowed time to explore any in depth A dare-devil, always on the lookout for currents to swim against, oblivious of public opinion, irreconcilably opposed to any sign of law and order. A jack-of-all-trades who smiles out of one corner of his mouth and snarls with the other, coarse enough to call things by their real names – and people too – never one to miss the chance to talk of rope in the house of a hanged man.

This was his description of himself,[45] and it is true that he scattered his energies. But he was very much all of a piece. His radicalism may have been woolly but it was both sincere and complete. He was anti-clerical, anti-authoritarian, anti-racialist, anti-snob, even anti-moralist. He demanded that juries should ask, not 'Is he guilty?' but 'Is he dangerous?' His flamboyant exuberance was not a pose; it arose from a quick, strong temperament which could challenge a man to a duel for admiring somebody he despised[46] or stand up in court to defend a colleague.

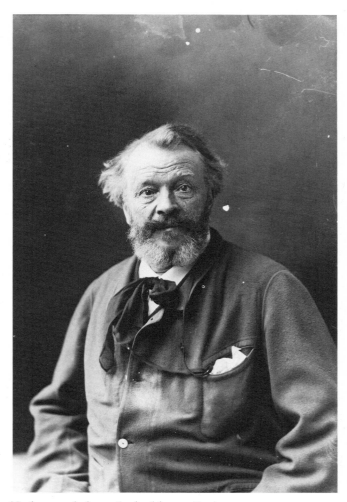

Nadar, aged about 65, by his son Paul.

A man of large and emotional judgments, he was nevertheless on the right side in every serious issue of his time – a patriot without prejudice, a revolutionary without hate, a romantic with remote ideals who was notoriously on Christian-name terms with everybody in sight. He made a genuine contribution to aeronautics through his gift of imagination and enterprise;[47] and in his photographs of others he left his own memorial. The tribute of his friend de Banville[48] still rings true. 'He did not always think straight; but he thought widely and he thought well. He deserves your complete affection.'

27

Notes

1 With a M. Herbert, at 8 Boulevard de la Reine.

2 His first book certainly contains references to conditions in hospitals.

3 His first criticism, in the Lyon *Journal de Commerce* of 4 April 1838, was of the famous ballerina Fanny Elssler; he poked fun at those who were shocked by her new dance, the 'Cachucha'.

4 It has been suggested that he too became one of her lovers.

5 Though Mürger claimed that at one time he felt too shabby to visit Félix.

6 M. Barbara, November 1843.

7 The other half was the painter Tabor.

8 With a friend he founded *Le Négociateur* and *Audience*.

9 It was in this form that he was listed as late as December 1897 by *Le Figaro* as one of the mourners at the funeral of Alphonse Daudet.

10 Four gouache drawings, 'Les Omnibus de Londres', and illustrations in his third book, *Le Miroir aux Alouettes*, 1859.

11 By an ironic coincidence, Philipon's own likeness, planned for February 1862, turned into an obituary portrait.

12 In the same way that Octavius Hill was to make photographic studies for his painting of an Assembly of Scottish Protestants.

13 Nadar did not harbour a grudge against his brother; six years later he was collaborating with him on a crazy scheme to promote a new kind of gunpowder to be christened 'Nadarpowder'.

14 It still stands today virtually unchanged. Nadar's old studios are occupied by a refugee organization.

15 It was carried out by Antoine Lumière, whose sons were to invent cinematography. His name led to a pun perpetrated by Alexandre Flam in a *Journal Amusant* of 1859: 'La photographie n'a d'art que lorsque la Grande Lumière collabore.'

16 *Les Heures Parisiennes.*

17 By Champfleury. Nadar, in old age, treated him to one of his rare bad-tempered paragraphs, in *Charles Baudelaire Intime*, 1911.

18 Louis Thiriot in *L'Est Républicain*, 24 March 1910.

19 *Mes Souvenirs*, 1885.

20 Drawn up by the artist Schanne, was was the model for Schaunard in Mürger's *Scènes de la Vie de Bohème*.

21 Léon Daudet. *Fantômes et Vivants*, 1931.

22 At the Galerie Petit, 17 April 1895.

23 'I hear street cries advertising the disgusting name of an abominable paper, *L'Anti-Juif*. In Paris! In 1882!' *Le Monde où l'on Patauge*, 1883.

24 He coined the pun 'le Second Tant-Pire' and Baudelaire had to beg him to stop sending comically addressed letters.

25 According to the Preface by 'A. P-M', one of them, 'La Grande Symphonie des Punaises' of 1877, was set to music by Offenbach, who used some of the themes in his *La Belle Hélène*.

26 Part of Nadar's evidence in the case against his brother Adrien in 1856, and his only comment on his own work.

27 The public was admitted four times a year from the rue Denfert-Rocherau to gape at the thousands of skeletons deposited there since the late eighteenth century.

28 Quoted by Raymond Escholier in an article in *Les Nouvelles* of June 1909.

29 In a supplement to Girardin's *La Presse*.

30 It was originally to have been called the *Quand-même* (Nonetheless), Nadar's defiant motto – later adopted also by Sarah Bernhardt.

31 François Arago, a famous astronomer (1786–1853).

32 Letter of January 1864 in the Musée Victor Hugo, Paris.

33 Quoted in Nadar's *Charles Baudelaire Intime*, 1911.

34 He seems also to have sold his photographs from 53 rue des Mathurins, presumably through an agency.

35 He published fifteen books besides innumerable articles.

36 His impression of the balloons on the Place Saint Pierre hangs in the Musée de l'Air, Paris.

37 With *Le Bon Bock*, a scene in the Café Guerbois.

38 *La Grande Revue*, 6 May 1866.

39 By his popularization of the miniature 'carte-de-visite' photograph, Disdéri was proving a formidable rival.

40 Elisabette André Degrandi of the Opéra Comique.

41 Letter to Gustave Geffroy, 27 July 1904.

42 In his last years there was a reconciliation.

43 Preface to *Quand j'étais Photographe*, 1900.

44 Georges Grimmer, *Cinq Essais Nadariens*, 1956.

45 *Mémoires du Géant*, 1864.

46 Barbey d'Aurevilley, whom he called 'the old beauty'. As Félix was too old, Paul was to have represented him but the fight never took place. A Dr Delvaille, writing in *Le Chronique Medicale* of 15 April 1904 claimed that he too had had an aborted duel with Nadar, who noted in pencil in the margin: 'I never could get the cowardly wretch into the field.'

47 'The real inventor of the aeroplane was not Icare but Nadar', joked *Le Charivari* in 1909.

48 Quoted by Georges Grimmer, *op. cit.*

Books by Nadar

1845 *La Robe de Déjanire*

1856 *Quand j'étais Etudiant*

1859 *Le Miroir aux Alouettes*

1864 *Les Mémoires du Géant*
 La Grand Symphonie des Punaises

1865 *Le Droit au Vol*

1870 *Les Ballons en 1870*

1877 *Histoires Buissonnières*

1880 *L'Hôtellerie des Coquecigrues*

1882 *Sous L'Incendie*
 Faits du Chier Cyre Gambetta

1883 *Le Monde où l'on Patauge*
 Louis Blanc Intime

1900 *Quand j'étais Photographe*

1911 *Charles Baudelaire Intime*

Nadar in the Studio

WHEN Nadar embarked on photography, almost by chance in 1853, the new process was in the flower of its youth. A generation had passed since Niépce had obtained his first shadowy impression of a rooftop in 1827. Eleven years later his collaborator, Daguerre, had devised a way of fixing the picture permanently on a silvered copper plate (known as a daguerreotype), and in 1835, an English gentleman, W. Fox-Talbot, invented the negative-positive system which enabled several copies to be made from a single image. This enormously expanded the popularity of the craft (legally it was still not recognised as an art) and photographs soon became collectors' items. The Goncourts recorded the first sale of them at the Hôtel Drouot auction rooms in September 1857, and prophetically commented (for at this time all prints were sepia-tinted): 'Everything is becoming black in this century; photographs are the black clothing of things.'

This was also the period when the relationship between photography and painting became the subject of anguished debate, epitomized by a fierce (anti-photograph) manifesto by Baudelaire. Some artists, such as Ingres and Delacroix, cheerfully made use of the new invention in preparing studies for their paintings, and photography undoubtedly contributed to the rising new school of Realists. But other painters were alarmed at the incursion of a mechanical technique into the world of imagination and lofty ideals.

The most important champion of the opposition was none other than Nadar's close friend Baudelaire. Though very ready to be photographed, as could be expected in such an egocentric character (he sat at least twice for Nadar and also for Carjat), he was a passionate enemy of photography's artistic pretensions. A dandy and a romantic, he had little sympathy with the realist middle-class visions of painters like Courbet and Manet and the intrusion of the mechanical eye of the camera into art horrified his aristocratic instincts. In a review of the Salon of 1857 (which for the first time included a photographic section – which Baudelaire did not visit) he launched a violent attack on photography as 'art's mortal enemy'. He demanded that it should be content to document the ephemeral and humbly minister to science and the arts. 'If photography is permitted to trespass on the domain of the impalpable and the imaginary, the domain of all those values which require that man should contribute something of his soul, we are lost.'

Nadar must have been pained by Baudelaire's views, especially as he had personally campaigned for the inclusion of photography in the exhibition; but their friendship seems to have been unaffected, and Nadar persisted with his new passion.

The technique which Nadar learned was a new process invented by an Englishman, F. Scott Archer. It was called the 'wet plate' technique, and involved coating a glass sheet with collodion, and sensitizing it in a solution of silver nitrate. While the mixture was still wet the plate was exposed to the light in the camera; on the parts most affected by the light the silver (as any housewife would expect) turned black. The wet plate was then rapidly developed, producing a sharp

Les Bouffes Parisiens. Lithograph poster by Nadar, about 1854. The portrait of Darcier with a glass is based on the photograph reproduced on p.83.

29

negative which could be printed onto ordinary writing paper, prepared with a coating of white of egg, to which salt and silver nitrate had been added. (After 1861 he used the easier dry collodion process.)

The procedure involved the use of a variety of chemicals which were mostly smelly and often dangerous, such as cyanide and nitric acid. In Nadar's earlier years he mainly used plates of either 18 × 24 cm or 11 × 22 cm, with four exposures on each, or a single large plate of 21 × 27 cm. Later he sometimes made two exposures on 18 × 24 cm plates.

To manoeuvre the self-conscious sitter into a pose which was not only appropriate but possible to maintain for many minutes (sometimes with the aid of a hidden prop), to adjust the shades and reflecting screens to suit the shifting light of Paris, and then to handle the primitive camera and the darkroom processing, required the full attention of at least two men. Like other early photographers, Nadar can seldom, if ever, have worked alone.

Nadar submitted his impetuous nature with difficulty to this kind of laborious routine, under the guidance of a pupil of the photographer-physicist Adolph Bertsch. 'On how many mornings,' he wrote in *Quand j'étais Photographe,* 'did that implacable, unbending will insist – sometimes thirty times running – on my taking the plate-glass sheet between my finger and thumb, according to the ritual, before he allowed me to spread the collodion across it in a single sweep, as was the custom in those heroic days.'

The elaborate preparations in the richly decorated studio, and the long exposure required, must have made the sittings into social occasions. The victim had to remain motionless for several minutes while the photographer paced up and down, watch in hand, counting out the seconds aloud and trying simultaneously to keep the sitter relaxed. But Nadar left no account of the sittings, except to remark in general that afterwards wives always looked first at the portraits of their husbands while the husbands looked first at themselves. He found that soldiers and actors were the vainest models – surpassed only by a pair of English clergymen who arrived for their sitting with rouge on their cheeks. Foreigners were sometimes difficult and suspicious; the Ambassador of Siam consented to a three-quarter profile pose only if he were promised a written affirmation that in reality he had two eyes.

Nadar made several important pioneering break-throughs (in 1856 he had already dreamed up a 'daguerreotype acoustique' or talking picture). He had received an award for his experiments

Mock-up of artists photographed by Nadar, for use as an advertisement for the studio. Some of the portraits, such as the young Meissonier and the profile of Courbet, seem to have disappeared. Probably about 1870.

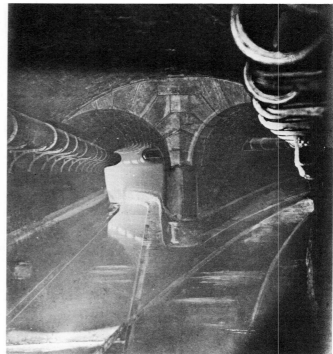

Modern-looking studies of the Paris sewers, photographed in 1861.

in artificially-lit photography in February 1861 and it now occurred to him to exploit his discoveries in a way which would attract public attention more strongly. After lengthy organization he descended, with a team of helpers, a mass of equipment and yards of cable, into the notorious sewers of Paris and returned triumphantly with a set of pictures. The venture was so successful that he embarked soon after on an even more publicity-orientated exploration of the Paris catacombs, illustrated on p.36.

Another interesting group of pictures arose from Nadar's second main passion – the promotion of the heavier-than-air flying machine. It is significant that while he seems never to have photographed his best-known creation, the great *Géant* balloon, in full flight, he made several studies of the propeller mechanism which he thought (rightly) would one day replace it. Those shown here are the result of a meeting which took place one day in July 1863 in his studio in the Boulevard des Capucines. The visitors were fellow-members of La Société des Gens de Lettres and included Gabriel de la Landelle, a fervent partisan of the 'heavier-than-air' theory He introduced a friend, the Vicomte Ponton d'Amécourt, who had been experimenting with an invention which he held to be the key to the problem – the propeller. He had been working on the mechanism ever since 1853, devising a contraption of two horizontal propellers revolving in opposite directions and propelled by a vertical propeller in the rear. At that moment a little toy propeller, put in

motion by a string, the *spiralifère*, appeared on the market and d'Amécourt thought his invention had been forestalled.

But de la Landelle encouraged him to persist and in 1861 he took out a patent on his invention and proceeded with several models, including a small helicopter with two propellers and a clockwork engine. In 1863 he finally constructed a working steam-powered helicopter, whose first flight took place in May. In August of that year Nadar watched a second test; the seven-pound apparatus became lighter by about a pound, and observers were impressed.

But his experiments seemed doomed to failure. 'Hélas!' declared a writer in *L'Aéronaute* of March 1888:

We must have the courage to say it, the trail begun by Ponton d'Amécourt will not be continued. In trying to raise himself into the air rather than transporting himself horizontally, Ponton d'Amécourt fell for a notion as false as that professed by certain partisans of the balloon who believed that, once sustained in the air, it is easy to go forward. The truth is the contrary.

Nadar never ventured out of his studio to photograph his city, like Victor Prevost in New York, or landscape, like Le Gray and the Bisson brothers, nor to record scenes of everyday life, like Charles Nègre, much less undertake battlefield reportage like Roger Fenton or Matthew Brady. He concentrated almost entirely on the studio portrait, and even here his subjects were

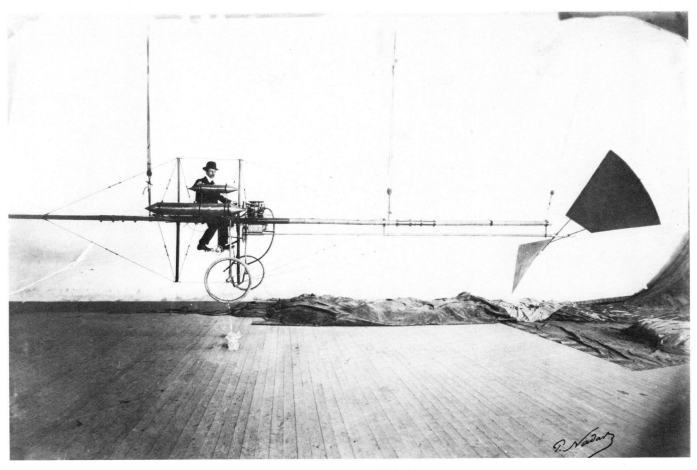

Santos Dumont in an experimental flying-machine: photo by Paul Nadar.

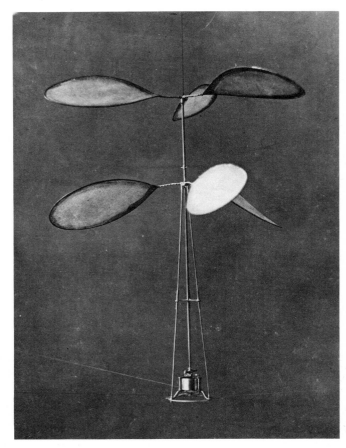

Ponton d'Amécourt's steam 'helicopter'.

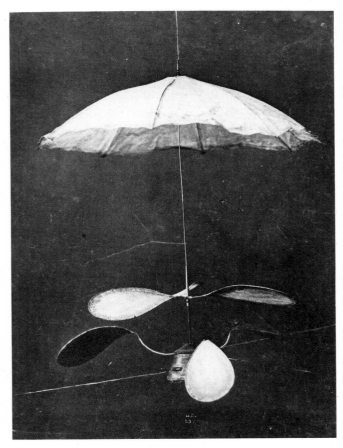

'Helicopter' descending on a parachute.

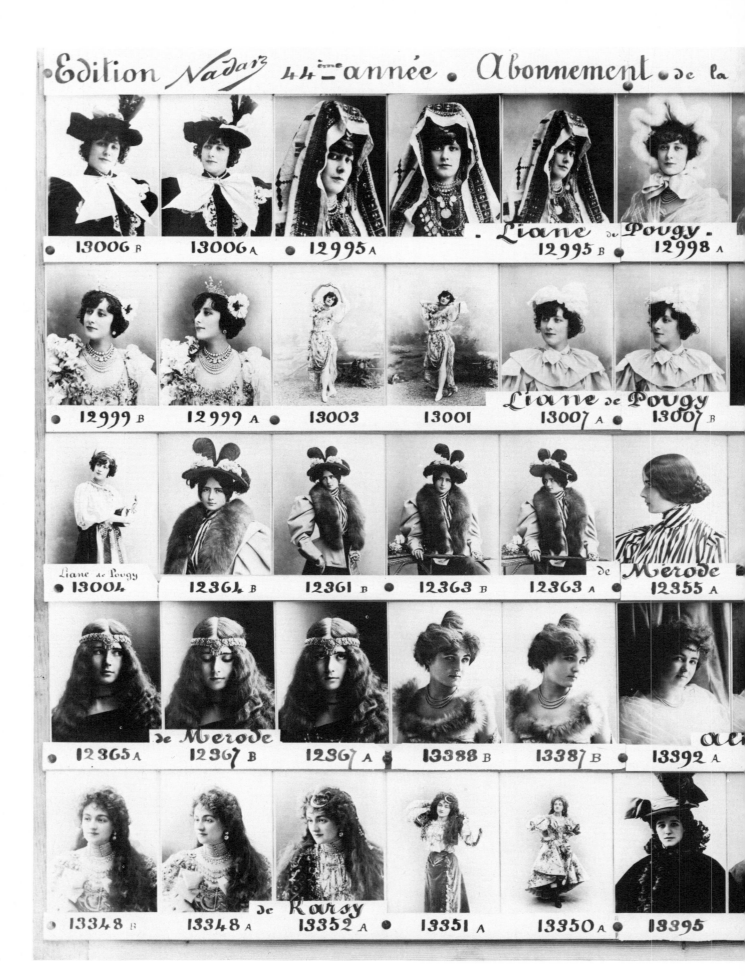

Sheet of photographs of five fashion models – Liane de Pougy, Cléo de Mérode, Alix Rozen, de Karzy, Chauna – for use

34

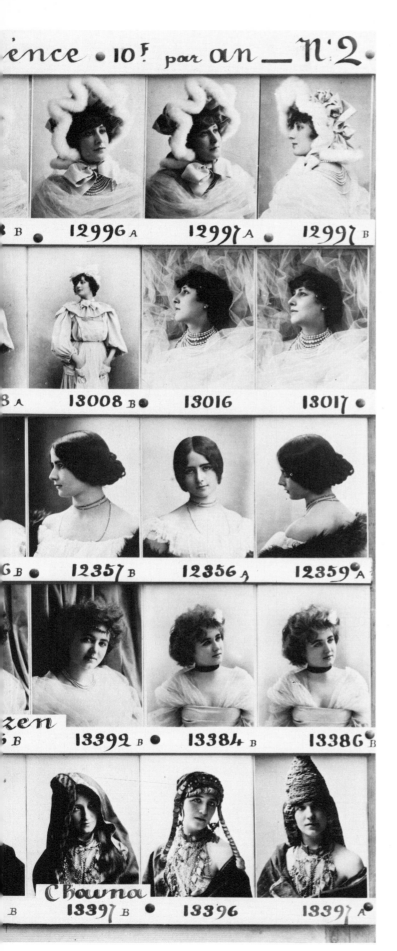

ence • 10ᶠ par an — N.°2

12996 A 12997 A 12997 B

13008 B 13016 13017

12357 B 12356 A 12359 A

13392 B 13384 B 13386 B

Chawna

13397 B 13396 13397 A

rtisement. Probably about 1900.

limited. They clearly reflected his radical sympathies – he seems to have missed Marx, but did take a portrait (since disappeared) of Engels – but they were mostly of the eminent. In his day that meant male – women, children, and the anonymous or poor are rare in his work.

Though totally sincere, Nadar was never solemnly dedicated. He accepted that he was in a commercial, highly competitive business, and jealously guarded his well-publicized signature-trademark. He seems (to judge by a photograph of around 1860 bearing a studio-stamp 'Photographie Hippique, 6 rue de la Faisanderie') to have operated through branches or dealers from an early date. In his last phase at Marseille he was selling cameras and even offering lessons for amateurs. He charged high prices – at least fifty francs per picture, which he took on the spot in cash; he was described as so weighed down by the coins in his pockets that he complained of backache. Though he did not go so far as to employ ninety assistants as did his rival Disdéri, he did not carry out personally all the small-scale commissions such as the *cartes-de-visite*; but his personal touch can be clearly discerned in his best work.

His portraits were warm, direct, and manly; it is interesting to compare them with the roughly contemporary work of Julia Cameron in England. He never catered for the sentimental demands of sitters (such as the mothers of dead children, for whom an ex-mistress of Edmond de Goncourt used to paint wings onto deathbed likenesses), and there is never a trace in his photographs of the satire by which he had made his name as a caricaturist. He aimed at something which can be interpreted as a last expression of the Renaissance vision of man.

He met his subjects head on, with a respect for eminence which was typical of his age, and an understanding of character which was his own. The relaxed gravity of his portraits is often reminiscent of Rembrandt; he achieved it by choosing a revealing but natural pose and giving it dramatic illumination, usually against a dark background. The modelling was always subtle and full – he may have been influenced by an ex-sculptor colleague, Adam-Salomon – and the lighting rich and finely graded. He used arrays of screens, veils and reflectors and experimented vigorously with artificial lamps aided by complicated arrangements of mirrors (he won several awards for technical innovations). The pose was almost invariably upright, with a monumentality partly achieved by omitting the legs and feet and sometimes draping a studio cloak over the shoulders to concentrate attention on the face. While

35

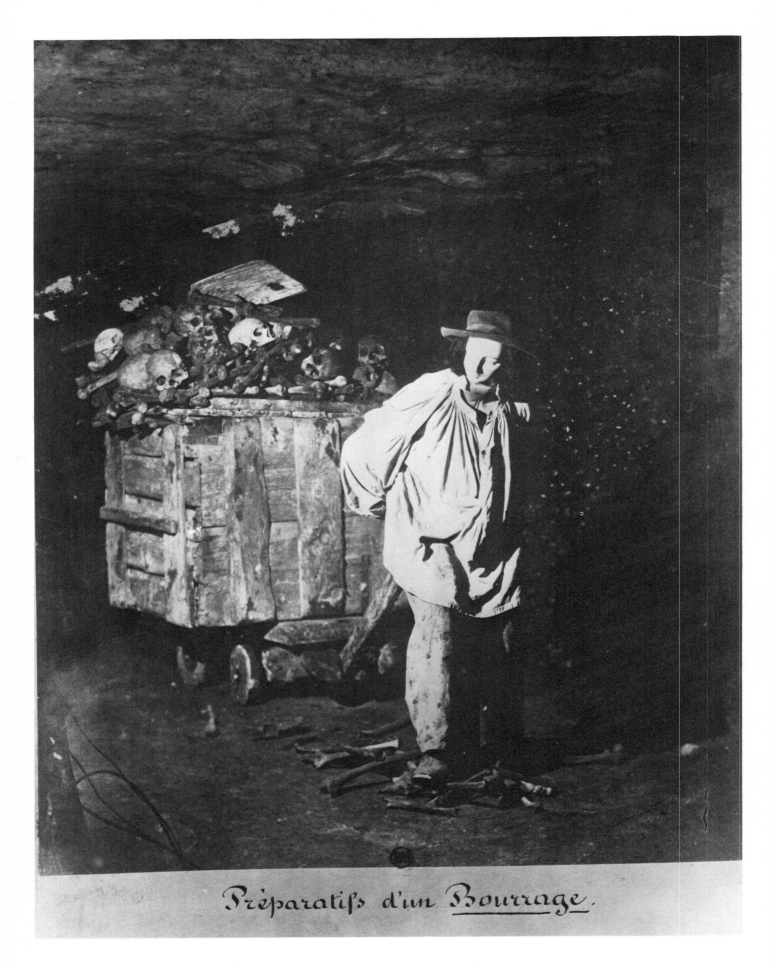

Préparatifs d'un _Bourrage_

Workmen in the Paris catacombs, 1861. Owing to the long exposure necessary, the figure posed was a dummy.

his rival Disdéri – son of a milliner – specialized in detail of dress and artful pose and became the favourite of the fashionable, Nadar (like Carjat, who was also an ex-caricaturist) was more interested in personality and character; he drew his sitters from the intellectual world in which he himself felt at home, and most of his early portraits are of his friends.

In his evidence in a lawsuit against his brother in 1856, he declared:

The theory of photography can be learnt in an hour and the elements of practising it in a day . .

What cannot be learnt is the sense of light, an artistic feeling for the effects of varying luminosity and combinations of it, the application of this or that effect to the features which confront the artist in you.

What can be learnt even less is the moral grasp of the subject – that instant understanding which puts you in touch with the model, helps you to sum him up, guides you to his habits, his ideas and his character and enables you to produce, not an indifferent reproduction, a matter of routine or accident such as any laboratory assistant could achieve, but a really convincing and sympathetic likeness, an intimate portrait.

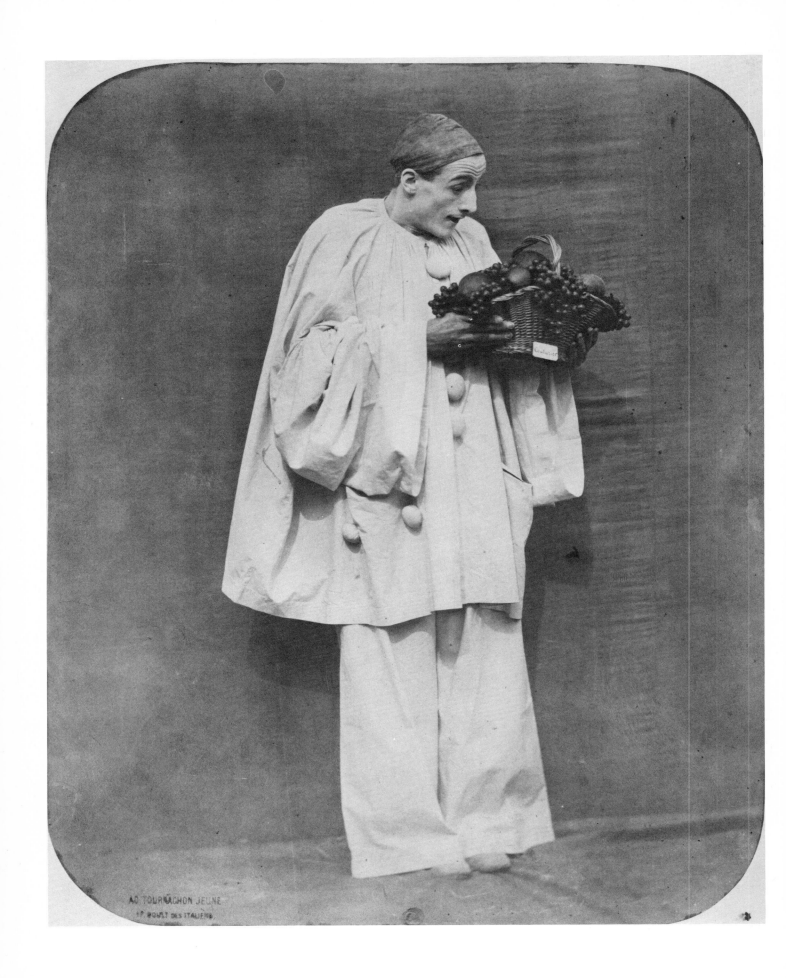

Charles Debureau (1829–73), celebrated mime, *c*.1858. A photograph by Adrien Tournachon after he had dropped the name 'Nadar'.

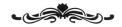

The First Nadar

THE first photographs to carry the signature 'Nadar' were not by Félix Tournachon but by his younger brother Adrien, 'Nadar jeune'. Five years younger than Félix, he began by studying art (some surviving notebooks show a methodical interest in colour theories of the kind which were to lead to Impressionism) and helped his elder brother in the preparation of his 'Panthéon' lithograph. But he did not prosper as an artist and in 1853, when he was 28, Félix – on the advice of a friend, Le Prévost – arranged for him to take lessons from a well-known photographer, Gustave Le Gray, and set him up in a studio in the fashionable Boulevard des Capucines. Félix immediately became fascinated in the new process and began to take lessons himself from a pupil of the photographer Bertsch. He seems to have intended participating fully with his brother as a partner and doubtless took part in some of the first photographic sessions. Some of Félix's own early portraits may have been taken in this studio, and he himself sat for portraits (see frontispiece and below). Characteristically, the compliment was not returned: there is no portrait of Adrien by Félix.

But the collaboration did not work smoothly. Félix's overpowering vitality, on which Baudelaire was to remark, must have made him a diffi-

Nadar poses for his brother Adrien in about 1854.

39

cult colleague; it is impossible not to feel sympathy for the smaller, younger, more retiring, less attractive, and less successful Adrien. Whatever the causes, Félix's initially open-handed attitude (he even added the dowry of his new wife to the common purse) soon changed to dissatisfaction and then to a downright quarrel. In January 1855 Félix walked out.

Unfortunately, the matter did not end with a simple separation. A set of facial studies of the celebrated mime actor Charles Debureau (see p.48), on which the brothers had collaborated, won the gold medal at the Universal Exhibition later in the year, and all the credit went to the atelier which Félix had just deserted. To make matters worse, Adrien acquired two or three new associates, moved into another studio at 17 Boulevard des Italiens, and began to operate under the label 'Nadar jeune', taking humble commissions such as illustrating a book on cattle-herding or advertising vaudeville acts (opposite).

Félix, now fully engaged as a photographer at his address in the rue Saint Lazare, was compelled in self-defence to bring a legal action to protect his working signature – a name already well known from his activities as journalist and cartoonist. The case dragged on for two years, during which time the rue Saint Lazare studio displayed the warning notice 'The only Maison Nadar; no branches'. The first judgement (February 1856)

went against Adrien; he appealed. The second supported him; Félix appealed. Finally, on 12 December 1857, the court ordered that 'three days from this order the name "Nadar" will be removed from the advertisements, cards and prospectuses and all other documents concerning the promotion of the photographic establishment at 17 Boulevard des Italiens. It is forbidden to Adrien Tournachon in person and to Adrien Tournachon, Nadar Jeune and Co., to use the name "Nadar" either directly or indirectly'.

From the few authenticated examples of his work which have survived it is clear that Adrien had genuine talent as a photographer. His pictures have a slightly theatrical flavour very different from Félix's straightforward confrontations, while his use of direct sunlight, without a protective screen, often produces striking contrasts. He may well have had a hand in some of the early pictures credited to his famous brother. But he seems to have lacked strength of character as well as business acumen. He soon had to leave Paris altogether and was declared bankrupt; later Nadar dutifully came to his rescue and employed him as an assistant in his studio in the rue d'Anjou. But he became more and more difficult to help and sank into misery. By 1890 Félix was paying for his brother's hospital expenses and in 1903 he died – a sensitive and promising artist overshadowed by an irresistible competitor.

A music-hall turn, photograph by Adrien Tournachon *c.*1853

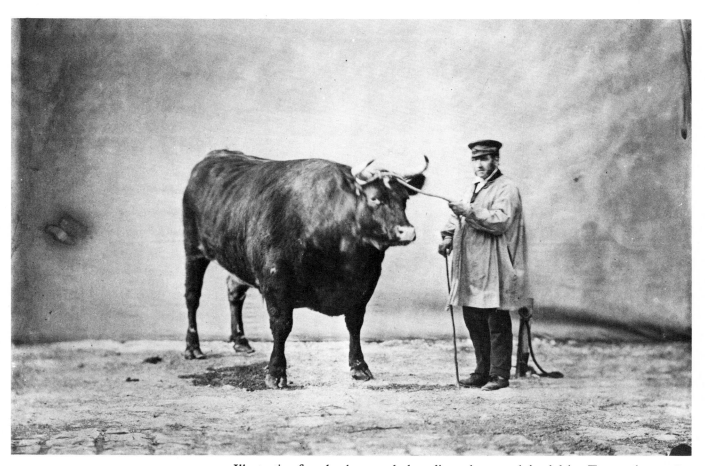

Illustration for a book on cattle-breeding, photograph by Adrien Tournachon *c.*1853

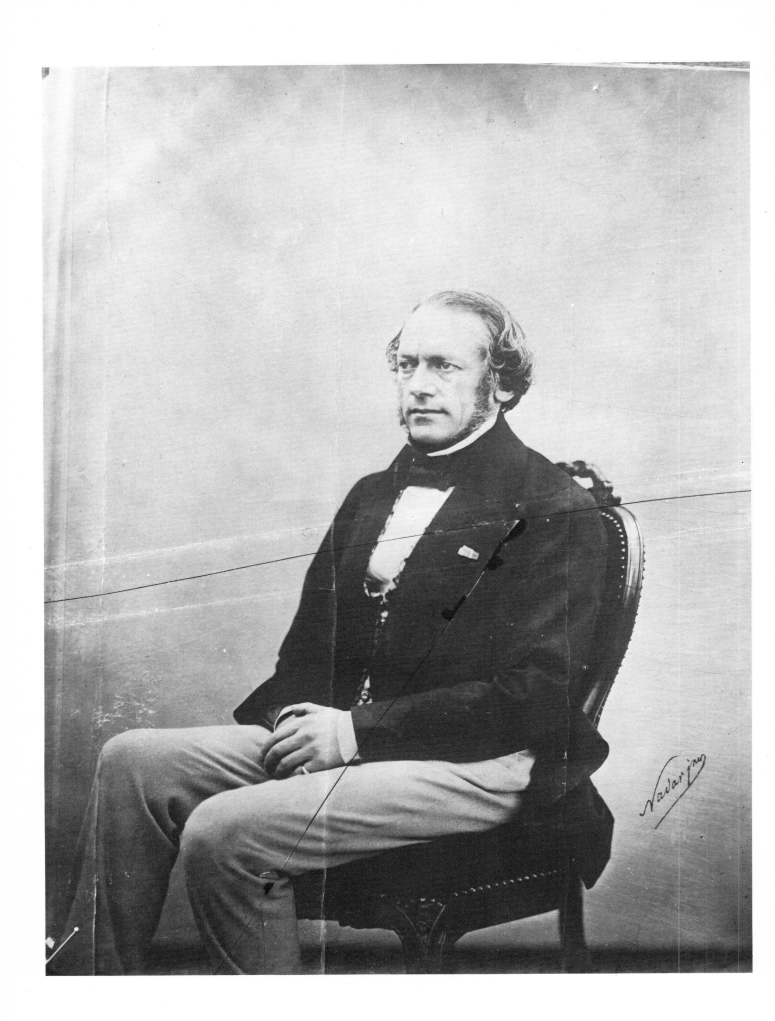

Richard Wagner

1813–1883

WAGNER was 40 when he sat for this portrait in October 1853. He was already famous: *Rienzi*, *The Flying Dutchman*, *Tannhauser*, and *Lohengrin* lay behind him and he was a widely celebrated conductor.

An exile from Germany after his involvement with an unsuccessful revolutionary demonstration in Dresden, he lived in Zurich and it was from there that he arrived in Paris on 7 October with his friend and protector Franz Liszt, descending on the Hôtel des Princes. It was by no means his first visit. He had first come there in 1839 with his wife Minna, and stayed over two years, and in 1851 he had spent some months in the city seeking financial support. This he had succeeded in obtaining from two ladies; by now he was entangled in Zurich with a married lady, Mathilde Wesendonck.

Yet another woman entered his life during this visit. The day after he arrived he called on Liszt's three children; one of them was the 16-year-old Cosima who was later to become his second wife and the faithful companion of his last years. This was followed by another fateful meeting: at a party in the home of the children's governess Wagner recited, in German, the whole text of his 'Death of Siegfried' to an audience which included Berlioz who, according to Wagner, 'listened very patiently'. The French composer's impression of the occasion is not on record.

Liszt had to leave Paris after two weeks but Wagner stayed on to meet Minna. During this time he sat for a medallion portrait and also celebrated Liszt's birthday by 'tannhausering and lohengrinning' on a hired piano. A visit from the police informed him that he would be permitted to stay for a month, but he had had enough. 'I had another sight of the Emperor; what more could you ask?' On 21 October he left for Zurich.

Wagner was worshipped by a small group in Paris, including some of Nadar's friends, but violently opposed by the traditionalists who called him – as an insult – 'the Courbet of music'. From this portrait it is easy to believe a description of him at a concert a few years later – pale and thin-lipped, with glasses, a modest charm, and 'a chin related to the galosh family'. This was written by Champfleury who was an admirer of Wagner – whom he curiously praised for his 'simple orchestration'.

But Nadar's musical tastes ran more to Rossini and Offenbach and it is possible that he and Wagner met and did not hit it off. At all events, Nadar features in a heavy-handed satirical musical sketch written by Wagner in 1873 in a patriotic hangover, poking fun at the defeated enemy. It was called *The Capitulation* and the characters also included Victor Hugo, Gambetta, and Offenbach. 'Gambetta and Nadar disappear in a balloon' ran one of the stage directions, followed by a chorus:

'*Gambetta, Nadar*	'*Gambetta, Nadar*
Gesegnetes Paar	*O blessed pair*
In lustiger Equipage	*On your jolly steed*
Wir wünschen Euch Bon Voyage.	*We wish you godspeed.*
Fahr wohl und vol au vent,	*Farewell and vol au vent,*
Gouvernement, gouvernement!'	*Government, government!*'

Why Wagner patronized Adrien and not his better-known brother is a mystery, and there have been doubts about the date of the photograph, whose large format (29 cm × 39 cm) is exceptional. From the records of Wagner's movements there are three possible dates: 1853 (the most likely) when he spent two weeks in Paris; 1855, when he stayed there for five days on his way to London, and 1858 when he stayed two weeks in January. The last date is very improbable since Adrien had just been prohibited by law from using the signature 'Nadar' as he has done here. However it has been suggested that the sitter is not Wagner.

Photograph by Adrien Tournachon circa 1853

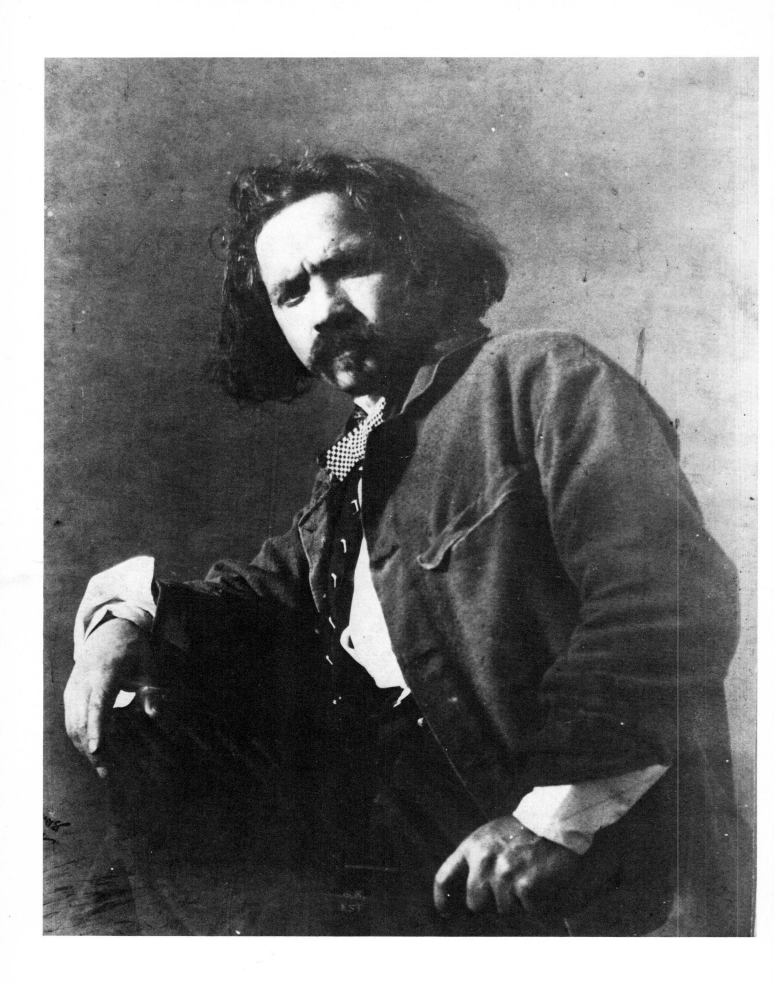

Emile Blavier

WHEN Nadar set up his studio in the Boulevard des Capucines in 1860 he ornamented the handsome pediment of the building with three large busts, the work of Émile Blavier. He was evidently attached to them for, when he moved to the rue d'Anjou eleven years later, he took them with him and erected them over the doorway.

Nadar had mentioned him in his 'Nadar – Jury au Salon' of 1857. 'M. Blavier is a small man – very small – and so he likes to enlarge and idealize his models and to clothe them in majestic draperies, so much so that he transforms a poor idiot into General Kléber and Mlle L.M. . . into a beautiful woman; but he is not to be believed.' The note was accompanied by a sketch of two busts, presumably those of the general and the lady.

This photograph, taken by Adrien Tournachon, must have been done even earlier. The dramatic lighting and satisfying composition show that he might have made a striking and individual contribution to portraiture had he been able to persist. His art-school notebooks are filled with tables illustrating theories of colour and reveal an enquiring intelligence.

Photograph by Adrien Tournachon circa 1853

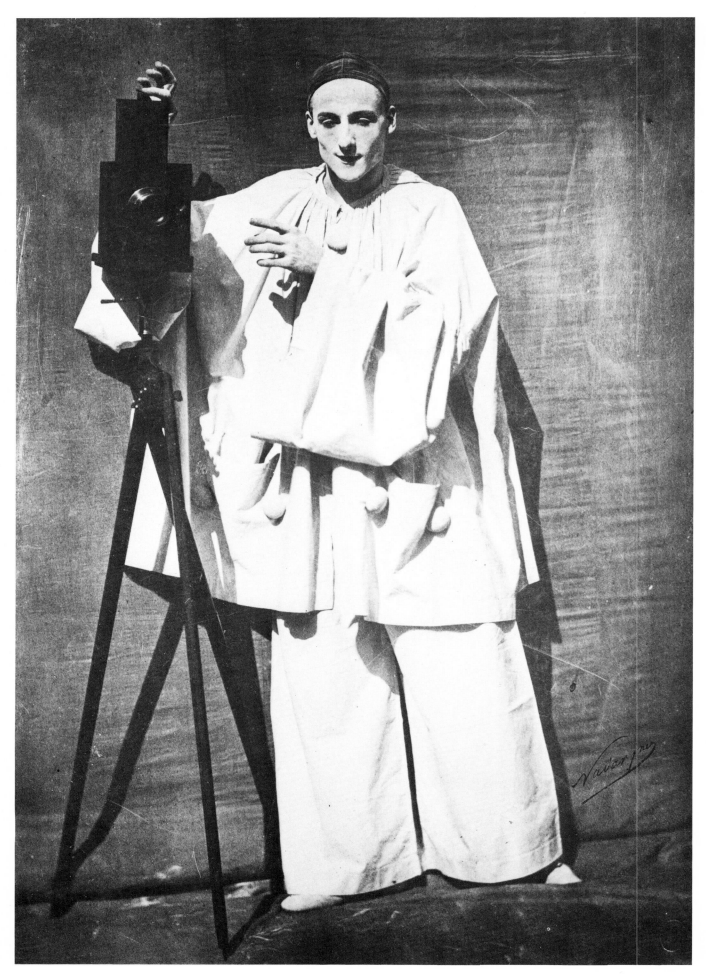

46

Charles Debureau

1829–1873

THE name of Debureau is synonymous in France with mime theatre; but that is chiefly due to the talent, not of Charles, but of his father Jean-Gaspard (1796–1846), whose family came from mixed circus-folk stock (his father was called Debro and his mother was German). Born in Bohemia (and thus one of the few genuine 'Bohemians' in Paris), Jean-Gaspard came to Paris as an actor and in 1819, encouraged by the painter Gérard, he appeared at the Théâtre des Funambules as Pierrot – a rendering which was to set the style for the character for generations. He had a period of immense success, but later had to compete with a rival, Paul Legrand, and he had the bad luck to kill a drunk with a blow from his stick. Finally, he fell on hard times and died of asthma.

All too aware of the risks of the actor's profession, he had apprenticed his son Charles at the age of 9 to a jeweller, and then to a painter on porcelain. But the boy was stage-struck. He dreamed of being a great tragedian, but lacked either the voice or the appearance. He was only 17 when his famous father died and the kindly manager of the Funambules theatre took him on. As a showman's trick he cast him in his father's most celebrated rôle – with immediate success. He proved to be an excellent comic and remained with the theatre for seven years, though at the end of them he was still earning only fifty francs a week.

In 1854 his fortunes changed abruptly when a famous – and slightly notorious – actress, Rosine Stoltz (see p.123) fell in love with him. He was 26, she was 43 and she showered money on him. He promptly bought himself out of the Funambules company and rebuilt the Théâtre des Délassements Comiques at the cost of 110,000 francs. It opened in 1856 with a programme which included a specially written mime scene, 'Petit Pierrot Vit Encore'.

But the venture proved a financial failure, and Debureau was driven to touring. In 1858 he tried his hand at production again, this time at the Théâtre Folies Marigny. This too collapsed and he set out on a long tour which took him to Egypt. In 1861 he was back in his old roles at the Funambules: but the theatre succumbed beneath the picks of the builders who were reshaping Paris under the direction of Baron Haussmann. Once again he took to the road, returning to various Paris theatres from time to time. In 1870 he was appointed Director of the Alcazar theatre in Bordeaux, and there, three years later, he died.

The date of this photograph cannot be fixed for certain, but it seems to be related to the series of 'Têtes d'Expression de Pierrot' exhibited by the Tournachon brothers at the Universal Exhibition in 1855, and also to another, full-length study made in Adrien's second studio – probably after losing the lawsuit with Félix, since he has dropped the signature 'Nadar'. The use of direct sunlight, without screens, suggests a very early date even in the output of Adrien, which is here attested by his studio stamp. The camera presumably belonged to the photographer, and the slightly posterish pose may have been the idea of his new protectress, Madame Stoltz, who was herself to sit for some striking portraits by Félix Nadar a few years later.

Photograph by Adrien Tournachon circa 1854

Eighty Portraits
by Nadar

*The eighty portraits that follow were almost all done between
1855 and 1870, when Nadar was working in his studios in the rue
Saint Lazare and the Boulevard des Capucines. Nadar left no
methodical appointments or accounts books, so that accurate dating is rarely
possible; in many cases the only guides are studio-marks, style, lighting,
props, the putative age of the sitter, or some event which may have inspired a portrait.
The selection is arranged in roughly chronological order – but the dating
must be regarded as tentative.
Apart from a few examples (duly credited) all the illustrations in this book
are drawn from two institutions in Paris. The negative plates are in the Archives
Photographiques of the Caisse Nationale des Monuments Historiques, and
the studio prints are in the Bibliothèque Nationale. There are about 450,00 plates
in all. The prints provided by the Caisse Nationale were taken direct from the
original plates, unretouched, and reproduced in actual size. The prints from
the Bibliothèque Nationale are nearly all reproduced in the shapes
to which they had been cut in the studio.
The craquelure is caused by the fact that collodion, like oil pigment,
shrinks with age.*

Alfred de Vigny

1797–1863

IT is hard to imagine two personalities more different than de Vigny and Nadar – one remote and cool, with an aristocratic refinement, the other bohemian, bustling and affable. De Vigny's career was virtually over before Nadar's began and he must have been the object of youthful admiration and awe when he was chosen by the 19-year-old Nadar as a contributor to his 'Livre d'Or'. Occupying an honoured place in the 'Panthéon', it was probably for this that he visited Nadar's studio in 1854.

De Vigny came from a noble family in the Touraine and seemed destined for a military career. But as a student in Paris he already showed signs of a scholarly and melancholy sensitivity of the kind associated with Byron. At 17 he joined the royal guard as a sub-lieutenant, but this appointment was terminated by Napoléon's attempted come-back the next year. De Vigny withdrew into literary circles, becoming a friend of Victor Hugo and contributing to his journal *La Muse Française*. In 1822 he published an inconspicuous book of poetry.

The next year he resumed army life, embarking on the Spanish campaign. But he found himself held up for months on the frontier and passed the time in writing a picturesque novel based on this experience, *Cinq Mars*. This attracted some attention and he was soon back in Paris. Here he married a rich English girl called Lydia Bunbury – a lasting but unhappy venture. He was caught up in the full spate of the Romantic movement, in which his lofty pessimism earned him from Sainte-Beuve the title of 'the divine and chaste swan'. He translated *Othello* and *Merchant of Venice*, published a study of three poet-martyrs entitled *Stello*, championed Hugo in the 'battle of *Hernani*', and in 1835 wrote a romantic play, *Chatterton*, in which the famous actress Marie Dorval (who was his mistress) scored a huge success and which aroused official disapproval for its unwholesome sentiments. He followed it up with a book based on his youthful aspirations and disappointments, *Servitudes et Grandeurs Militaires*.

In Paris he lived in considerable style. De Banville describes him conducting his wife out of their salon, with its damask walls and gilded clocks, as though she were a queen. But his reaction against all forms of action in favour of inner meditation, led him to withdraw to his estate in Le Marne. He went back to Paris in 1853 to carry out his duties as director of the Académie, but he returned to the country soon after this portrait was made. He died there in 1863.

Photograph circa 1854

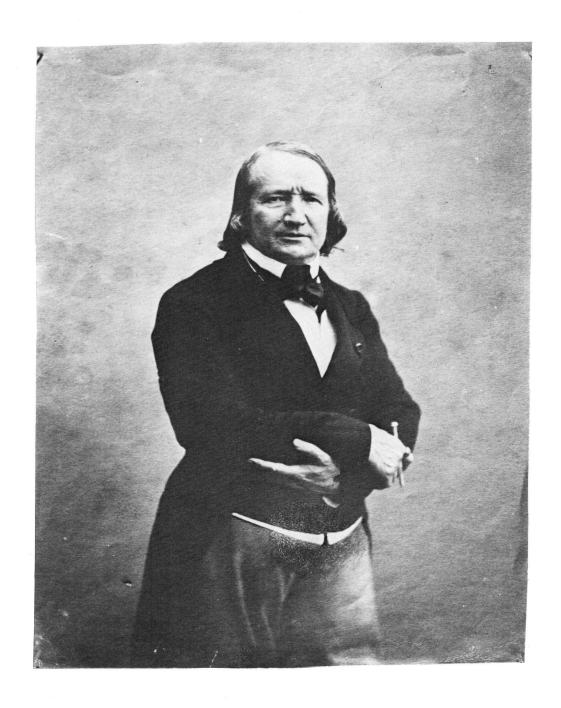

Henri Mürger

1822–1861

IN 1848 a Paris newspaper, the *Corsaire-Satan*, began publication of a series of semi-autobiographical sketches by an unknown 26-year-old writer, describing his life on the Left Bank. They were called *Scènes de la Vie de Bohème*, and their success persuaded the author to collaborate with a friend (Théodore Barrière) in turning the work into a five-act play. This was given the next year at the Variétés theatre, to public acclaim and a rave review from the influential Théophile Gautier. Suddenly Henri Mürger was famous. Nearly fifty years later Giacomo Puccini used the story for an opera, and even now the title *La Bohème* remains an expression summing up a whole philosophy and way of living. With a single work Mürger won a foothold in literary history.

He was born in 1822, the son a of *concierge* in Montmartre. Disrespect for convention was doubtless instilled in him at an early age, for his teacher at his first school, Eugène Pottier, was later to compose the lyrics for the revolutionary anthem *L'Internationale*. Evidently a bright youth, he was engaged as secretary by the rich Count Tolstoy, for whom his duties included 'making watercolour maps of human geography'. But he soon lost the job, started an affair with a married woman, and was thrown out by his father; he joined the band of homeless drifters.

He seems to have had a happy-go-lucky magnetism, for he was soon the centre of a group of impoverished young artists, writers, and musicians, who scraped a precarious existence by doing odd jobs, and living in the local cafés. Mürger's favourite haunt was the first floor of the Café Momus in the rue des Prêtres, where smoking was permitted. Here a cheerful, permissive crowd shared each other's troubles, luck, and girl friends, to the accompaniment of cheap wine and songs, with frequent outings to the dance-hall, the debtor's prison, or hospital. Many of the circle died of malnutrition, syphilis, or tuberculosis.

It was an atmosphere entirely sympathetic to the young Nadar, who became a close friend of Mürger; both were in their early 20s and they had first met in the house of a young engraver, Léon-Noel. Success changed Mürger's style of life; he bought a place in the country and became a passionate sportsman. But his health had been fatally undermined. He suffered from a distressing disease which turned his skin purple 'every week at a regular day and hour'. Stricken with syphilis, he was finally removed to the Maison Dubois where he died in horribly slow stages, literally rotting away.

Nadar stayed to the end in the distressing death-chamber, comforting his friend with optimistic plans, producing 100-franc notes to meet emergencies, and supervising the visitors. These were few, though his funeral was publicized enough to provoke a jealous comment from the Goncourts. Nadar remained a staunch supporter after his death, collaborating with Noel and another friend in a short biography, and springing in his old age to the defence of a character who was described as 'a fountain of idealism, which he splashed over every filthy skirt in sight'. 'Mürger, so delicate and scrupulous in his account of his miseries, has been transformed into a pedlar of demoralization,' he wrote. 'I find it totally insupportable.'

Photograph circa 1854

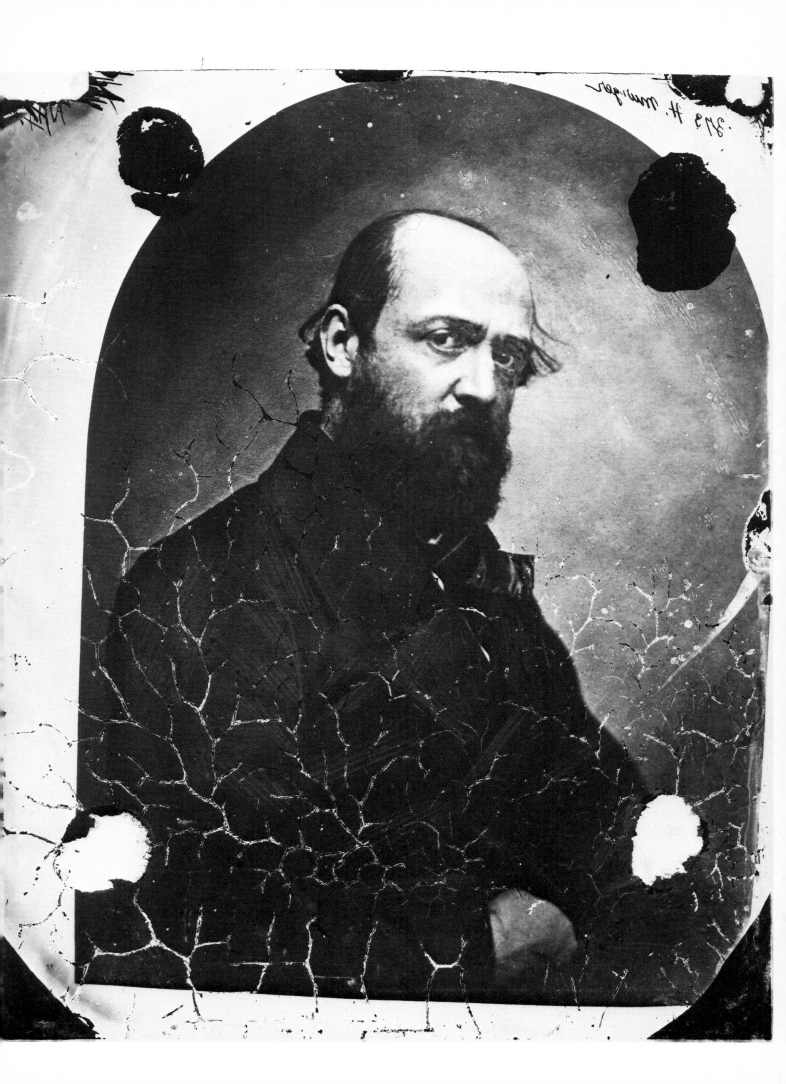

'Rachel' (Elizabeth Félix)

1821–1858

ONE of the greatest tragediennes the French theatre has ever produced was born in Switzerland, into the large family of a Jewish pedlar from Metz called Félix. At 12 Elizabeth Félix was entered into the Institut Royal de la Musique Religieuse, working in a laundry to keep herself. A friend of the director gave her drama lessons and in 1836 she was accepted into the Théâtre Français. But she left the following year to appear at the Gymnase, taking the name (actually that of one of her sisters) of the heroine of Halévy's opera *La Juive*. She had the good luck to catch the eye of the influential critic Jules Janin of the *Journal des Débats*. In 1838 she rejoined the Théâtre Français and, after a mediocre debut, was hailed decisively by Janin: 'Now at last we have the most stunning and marvellous young girl whom the present generation has seen on the stage. That child (learn her name!) is Mlle Rachel.' Other critics followed him; at 17 she was launched.

Small and slim with a restrained dignity of gesture and delivery – a contrast to the usual rhetorical style – she was a symbol of the current reaction against Romanticism, and excelled in the great classical roles of Racine and Corneille. After four years she tackled the greatest, Phèdre, and won the enthusiastic praise of Gautier.

She slipped quickly into the rôle of a star, adopting a luxurious way of life and taking a succession of lovers (including the director of the Opéra, and an illegitimate son of Napoléon, Comte Walewski, to whom she bore a son). Soon she was touring Europe with a supporting troupe which included several members of her family. In 1846 she was seen in Brussels by Charlotte Brontë who described her – disguised under the name of 'Vashti' – in her novel *Villette*: 'Her acting thrilled me with horror – an exhibition as exciting as the bullfights of Spain and the gladiatorial combats of Rome and (it seems to me) not one whit more moral.'

Theatrical to the backbone – one of her sisters later described her bent over the deathbed of her beloved old servant, intently studying her expression as tears ran down her own cheeks – she seems to have been able to convey an icy passion which inspired awe rather than affection, an emotion which she could convey even to audiences who did not understand a word of French. She toured with huge success in England (where Queen Victoria received her in spite of the scandals associated with her private life), Italy, Austria, Germany, and Poland. In Russia she had perhaps her greatest triumph, earning 300,000 francs, of which she donated 14,000 to the poor. She was entertained at a huge dinner at the Imperial Palace and, when asked to reply to the toasts, delivered a stirring speech from *Phèdre*.

This photograph (whose style is very unusual for Nadar, who could not stand her classicism) may have been made after her return to France in 1854. She was at the peak of her career. Her long absences from Paris had lost her her public and the critic Janin had turned from an ardent admirer to a persistent denigrator. In 1855 a new face attracted him; it belonged to a young actress from Italy called Adelaide Ristori. 'Recently we had an incomparable tragic actress; Italy has got one now,' he wrote ungallantly, and Dumas jumped in to join the attack: 'Like Ingres at the International Exhibition she has a hall to herself – the hall of the dead. May she stay there.'

Leaning on the arm of her new lover, Prince Napoléon, Rachel went to watch her rival and then, defiantly, prepared a long tour in America. But the visit was a failure and, downcast by disappointment and broken in health, she returned to France. A trip to Egypt followed, but it did not arrest her already far-advanced tuberculosis. In 1858 she returned to France and died in the Riviera house of the dramatist Sardou. Her career had lasted only twenty years, but she left a reputation which has not been eclipsed.

Photograph circa 1855

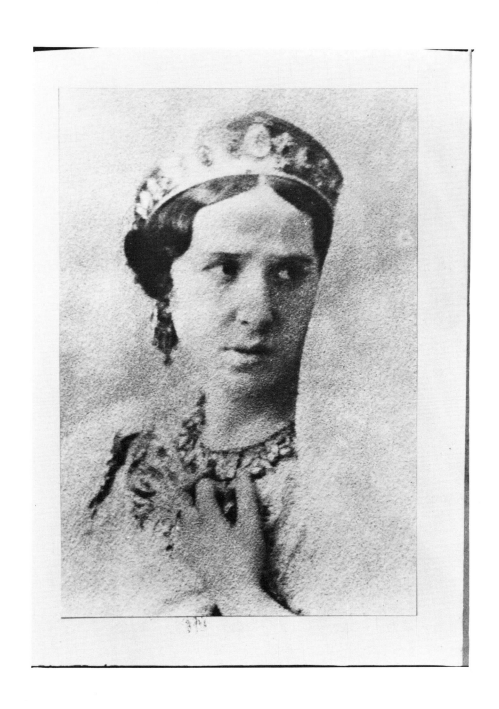

Théodore Barrière

1825–1877

BARRIÈRE was one of the horde of writers with much skill but small genius who helped to satisfy the appetite of the Paris public of the Second Empire with reasonably intelligent entertainment. He came from a family of geographical engravers employed in the ministries of war and naval affairs. His father was a confirmed versifier, and had even – in those easy-going times – had a poetic adaptation produced at the Comédie Française.

Théodore was an apt follower, and before he was 16 he had collaborated in a play *Les Pages de Louis XII* at the Renaissance. His first success came later when he was 18, with a comedy at the Beaumarchais called *Rosière et Nourrice*. From then on he was an indefatigable dramatist, rivalling Emile Augier and even Dumas *fils* in popularity.

In 1849 it was he who helped Mürger to turn his novel *La Vie de Bohème* into an instant and influential hit. In 1851 he produced a version of *Manon Lescaut*, while in 1853 he presented what was perhaps his biggest winner, an answer to Dumas' *La Dame aux Camélias*, called *Les Filles de Marbre*. It was no doubt the fame this play brought him that led him to Nadar's studio. He was to write much more for the theatre, including an opera to music by Delibes called *Le Jardinier et son Seigneur*, but he never outdid his earlier success. A new play, *Le Centenaire d'Hamlet*, was in rehearsal when he died in 1877.

Photograph circa 1854

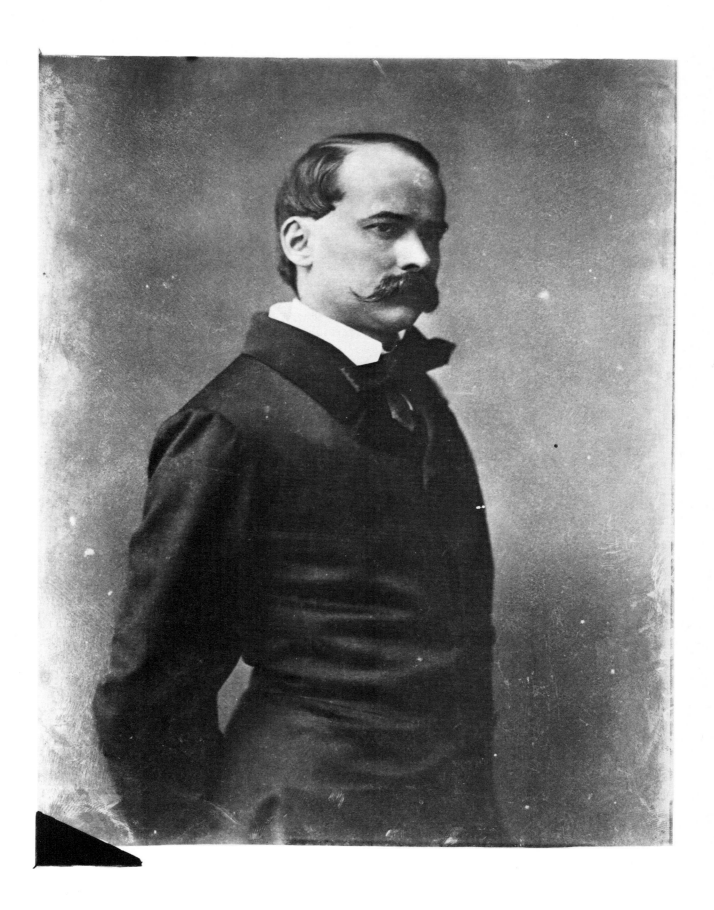

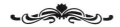

Charles Philipon

1806–1862

A MAN of immense energy and flair, who seems also to have had the equable temperament needed to deal with a horde of unreliable contributors, Philipon was an outstanding editor and a staunch friend and adviser to Nadar during his first years as a journalist. As the editor-proprietor of the popular *Journal pour Rire* (circulation 14,000) he became Nadar's employer when the latter was making a name as a caricaturist. It was he, in fact, who encouraged Nadar in this genre, and who was thus largely responsible for the 'Panthéon' which first established his reputation. Throughout all this period he was alternately prodding Nadar and trying to restrain him from taking on too many jobs at once. 'You are causing me a lot of trouble, my dear Nadar,' he wrote to him in 1857, 'and yet I love you still. The heart is made that way.'

Philipon had been born in Lyon (all his life he welcomed a Lyonnais) and started as a painter, studying in the studio of the popular Baron Gros, a precursor of Romanticism. But he became interested in the work of the English illustrators like Cruikshank and Gilray and moved into journalism. In 1830, at the age of 24, he launched the *Charivari*, to promote a vigorous republican policy which one of his artists, Daumier, finally pushed too far, resulting in the paper's suppression. He remained a fierce radical all his life, and one of the few occasions when he had words with Nadar was when the artist took a job on a royalist paper.

In 1835 he embarked on a 'Galerie de la Presse' which helped to launch the fashion for caricatures, and in 1838 he published a political pamphlet, *Aux Prolétaires*. But his career really began to flourish with the comic paper *Le Journal pour Rire* which he started in 1849, with the 16-year-old Gustave Doré as its star cartoonist, and Nadar, soon after, as one of the regular contributors. In 1857 it became the *Journal Amusant* in which an annual feature was the 'Nadar – Jury' satire on the Salon exhibitions.

His journalistic activities (in 1857 he was running five papers simultaneously) and his unrelenting Republicanism (it was he who invented the image of Louis-Philippe transformed into a pear) made him a thorn in the side of the establishment, and he was several times punished by a fine or imprisonment. But he did not give way until in 1862, worn out by overwork, his health began to fail and he handed over the editorship of the *Journal Amusant* to his son Eugène.

A delicate relationship between Philipon and Nadar developed around 1853 when the cartoonist began to give first place to photography and at the same time was launching his 'Panthéon'. The *Journal pour Rire* gave active support to this venture, with Philipon writing: 'May the cashier of the operation cry, as he counts up the subscriptions: To Nadar the Great from a grateful Fatherland!' But he was worried by Nadar's continued delays in producing drawings which were often unsatisfactory. However, he never withdrew his support, sometimes sending his friends along for a photographic portrait.

He must have seen Nadar regularly and was a natural subject as an early sitter. The direct sunlight which can be seen in this photograph suggests that it was taken by Nadar in Adrien's studio, which would indicate the date 1854 or even 1853.

Photograph circa 1854

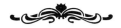

Auguste Préault

1809–1879

BORN in Paris, Préault was originally intended to be an ornament-maker and designer, but after a spell at the Lycée Charlemagne he entered the studio of the painter David d'Angers. Here he was taught in the traditional style: 'subjects must always be moral, lofty and generous', was the studio motto. This severe approach did not suit Préault's temperament, which was fiery and impetuous. He caused a minor scandal when, at the age of 24, he exhibited in the Salon a painting of two miserable women entitled *Poverty*. This was followed up the next year by an even more disturbing work, a bas-relief in plaster called *Tuerie* which showed a tangle of agonizing figures of both sexes in the throes of a massacre.

But classical restraint was everywhere giving way to Romanticism and, after a successfully well-modelled *Hecube* in 1836, he began to earn admiration for his striking and dramatic sculptures. By 1849 he was accepted, and poured out a large quantity of passionately contorted figures. The best known of these is perhaps his *Clemence Isaure* for the Jardin du Luxembourg, and the degree to which he anticipated later symbolist moods is shown in the title of a work he exhibited in 1854, *La Mort Ceuillant une Fleur*; it is not surprising that Baudelaire admired his 'painful inspiration'.

Though successful with the general public he did not always meet with approval from the critics. 'Anybody unexpectedly coming across a sculpture by M. Préault,' wrote a contemporary, M. E. Chesneau, 'would first exclaim: "That's a great work!" He would add at once "*Nearly* a great work".' His detractors considered his sculpture superficial and exaggerated; but his personality was overpoweringly attractive. 'Short, stout, solid, talkative, picturesque, enthusiastic and sarcastic, with anxious eyes and a flushed complexion' (as the writer Jules Claretie described him), he was known for his sharp tongue. Asked for an opinion of two famous colleagues, he replied: 'Ingres is constipation and Delacroix diarrhoea.'

By the time this photograph was taken he was an established success. Nadar must have been impressed by his ardent Romanticism, and added him to his procession of notables in the second version of his 'Panthéon' in 1858. The date of the photograph is uncertain. The lighting and pale background suggest that Nadar took it in Adrien's studio, that is to say about 1854.

Photograph circa 1854

Théodore de Banville

1823–1891

A FEW years younger than Nadar, and coming from a far more sophisticated background, de Banville became all the same very intimate with him, one of the little group who revolved around Gautier and Baudelaire. After a happy childhood in the country (near Moulins) in the bosom of a noble but liberal-minded family, he came to Paris at the age of 7, was installed at the distinguished Pension Sabatier, and took to haunting the theatre, variety shows, carnivals, and dancing-halls.

But he persevered with his work, took his degree at 15, and seemed set for a career as a lawyer. However, a passion for literature deflected him, and before he was 20 he had begun to publish poems which were not only skilfully turned, but which showed a strongly independent style; instead of following the prevailing romantic mood he opted for a silvery classicism, celebrating wine, women, and song in an elegant strophe: 'La Coupe, le Sein et la Lyre/Nous donnent le triple délire'. He contributed freely to publications like *Le Figaro* and *Le Corsaire*, and gave literary parties in his parents' house in the Latin quarter, receiving his guests on a silk divan.

When he was only 19 he met Baudelaire for the first time, and the two poets, similar in many ways, instantly became close friends. Baudelaire wrote an enthusiastic article on de Banville while he fought for Baudelaire when he was in official trouble; and it was to be de Banville who delivered the oration over Baudelaire's grave. Nadar, in his *Baudelaire Intime* described de Banville in his youth 'in a vast cloak hanging down to his heels like a toga . . . with carpet slippers and a little cap on the back of his head, the peak tipped forward like a horse-guard's, a loosely knotted scarf, excessively clean-shaven and that cigarette which was never to go out already hanging from his mouth'.

His first success came in 1859 with a witty and polished set of poems describing the world of La Bohème called *Odes Funambulesques*. One of them was devoted entirely to the hair-dos of his friends, as seen at a theatrical first night. The climax was Nadar's famous shock of red hair which 'like a burst of comets on his brow, proclaims a conflagration'. De Banville became one of the group of Parnassian poets encouraged by Catulle Mendès in his *Revue Fantaisiste*, and ran a literary salon every Thursday in his apartment in the rue de Buci which was frequented by Baudelaire, Daudet, Mallarmé, Verlaine, and Rimbaud. Pale and elegant, he was a delightful talker, entertaining his friends in his high-pitched voice with theatrical gossip, good-natured irony, and dazzling philosophical paradox. For him superstition took the place of religion: the Goncourts relate that he used to scatter bits of green paper round his apartment to keep bad spirits away.

In 1863 he settled for domesticity, resuming his Catholicism (which he had abandoned) and marrying a widow with two children. He continued to turn out a number of short poems, contributed articles to the press, and wrote several plays, one of which, *Gringoire*, became a popular success. After 1870 he moved to the rue de l'Eperon and divided his time between his estate at Moulins, his duties as drama critic of *Le National*, and recalling his memories in *Souvenirs*, published in 1885. In 1883 Nadar described him as 'more lively, more sparkling, more of a poet, more youthful than ever'. He died in 1891.

The style of this portrait, with its flat modelling and sharply contrasted tones, suggests an early date; the shadow on the background shows that it was taken in direct sunlight, probably when Nadar was still working in Adrien's studio.

Photograph circa 1854

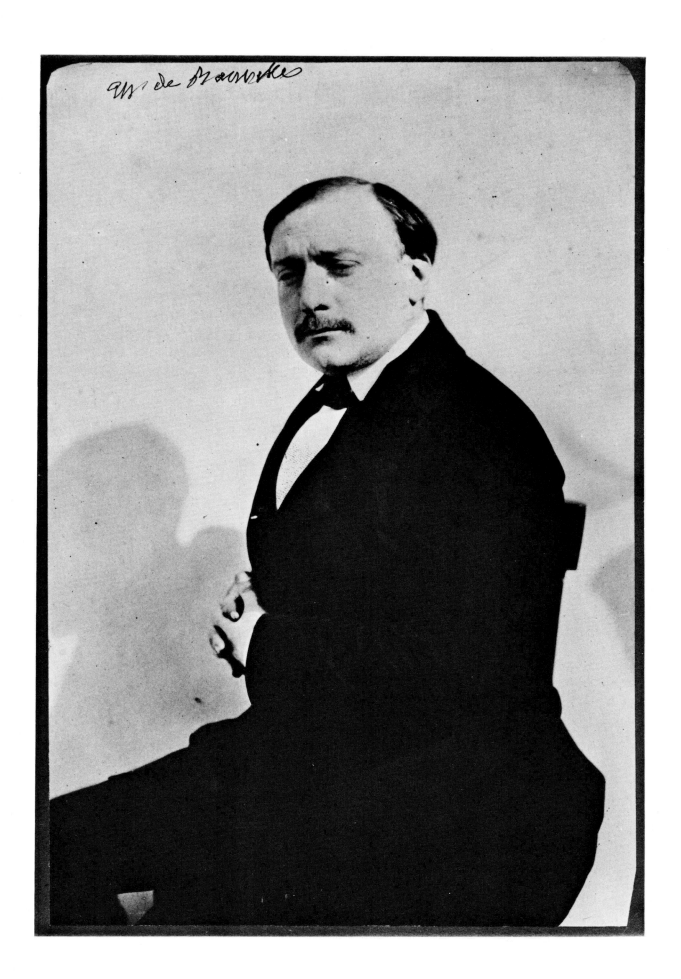

Unknown Girl

A rare example of an unidentified sitter; she may have been a young actress from the vaudeville world in which Nadar moved in his youth. The cloak was evidently part of his studio props, as he was to use it in a celebrated – and not dissimilar – portrait of the young Sarah Bernhardt.

Photograph circa 1855

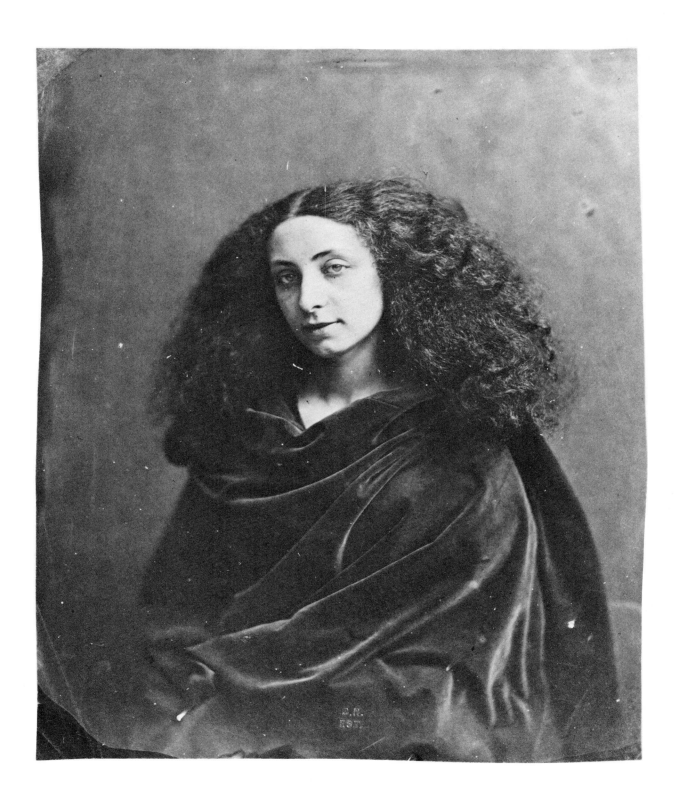

Charles Baudelaire

1821–1867

BAUDELAIRE and Nadar were almost the same age (Nadar was one year older) and became lifelong friends, but they emerged into the Bohemia of Paris from very different backgrounds. The provincial cartoonist was dazzled by the poet's glamour and forty years later, in his *Baudelaire Intime* he was to describe their first meeting in the Jardin du Luxembourg:

> Suddenly our conversation stopped, halted by the sight of a strange, ghostly figure We saw a young man of medium height with a good figure, all in black except for a russet scarf, his coat scrupulously cut, excessively flared with a roll collar from which his head emerged like a bouquet from its wrappings In his hand in its pale pink – I repeat pink – glove, he carried his hat, made unnecessary by the superabundance of curling, very black hair which fell to his shoulders – a mane like a waterfall. So we were going to meet him, this much awaited figure, this supreme attraction!

Baudelaire was already a world-weary aesthete (his father had been chaplain to the Duc de Choiseul) who had got through a sizable fortune; he had just returned from a trip to the East (he only got as far as Mauritius in spite of his stories of Africa and India) and resumed a dissolute life in a mansion on the Ile Saint Louis. 'Something of an attic,' wrote Nadar, 'but large and comfortably furnished Baudelaire used to sprinkle cheap musk on the carpet. To be honest, it smelled a bit strong.'

He was working on the collection of poems which was to rocket him to notoriety, *Les Fleurs du Mal*. On publication it was seized by the police and, in 1857, legally condemned. Nadar stuck by his friend in spite of the scandal, his attacks on photography, and the mannerisms of some of his disciples, while Baudelaire was genuinely attached to Nadar. In 1859 he wrote to Nadar from his exile in Brussels trying to persuade him to buy, for 2,400 francs, a Spanish painting he had seen in the rue Lafitte. Unfortunately, Nadar paid no attention; the picture was Goya's *Duchess of Alba*.

By 1864 the poet's health began to give way and two years later he was paralysed and unable to speak. The cause was undoubtedly syphilis, possibly inherited. Nadar maintained firmly that the poet had been impotent – a theory derived partly from conversations with the negro actress, Jeanne Duval, who inspired some of Baudelaire's most passionate poems; Nadar had spotted her while reviewing a third-rate play in a fringe theatre. She was amused by Baudelaire's distinction and eccentricities but dismissive of his efforts as a lover, and she became the mistress of one of Nadar's colleagues.

Nadar left a painful account of him in his later life. In the last stages of his illness Nadar was one of the few old friends to visit him in hospital and take him home to lunch. Nadar described one such occasion:

> He still cultivated his body. Hardly had he entered my house when he showed me his hands and I had to roll up my sleeves and scrub them with soap and rub and polish them . . . "Cré Nom! Cré Nom!" he kept repeating in ecstasy, the only words which could pass those lips from which immortal verse had flowed.

Baudelaire died in his mother's arms in August 1867. Next morning Nadar wrote to the editor of *Le Figaro*: 'Many stupid things will now be said about this greatly gifted and honourable man which will bitterly hurt those who loved and respected him. If you want the truth about him in your paper, I'm prepared to give it to you . . . ' On the margin of the letter is a note in another hand: 'Accepted with pleasure.'

Photograph circa 1855

Baudelaire

Nadar

'Musette' (Christine Roux)

1835–1860

THOUGH one of his biographers, Georges Grimmer, claims that Nadar sold pictures of 'lightly-clad' girls to the English, this nude study seems to be one of only two surviving photographs of its kind from his studio. Nude photography had, in fact, started long before Nadar bought his first camera. The exploitation of the new craft in the service of sex-titillation began almost with its invention; pornographic photography goes back to 1842, only a year after Talbot first patented his calotype process, and by 1850 coloured and stereoscopic photographs of naked girls were on the market.

This picture, however, falls into a different category. Champfleury used to keep in his room a print of this photograph of a girl 'en costume de La Source', and it may have been taken as a study for Ingres' painting of that name which was completed the next year: Ingres certainly did use photographs for such purposes. The model is traditionally claimed to be Christine Roux, the original of the character 'Musette' in Mürger's famous novel (and Puccini's even more famous opera) *La Bohème*. She was one of Mürger's many girls, and is mentioned by his friend Alfred Delvau as being a regular guest at the Hôtel Merciol in the rue des Canettes which was the original model of the drinking haunt in the drama; Nadar must have met her there, as well as another character in Mürger's story, Mimi, with her little dog and her tuberculosis, of which she died after being turned out by her landlord.

Musette also had a sad end. In 1860, as Alexandre Schanne recounts, Mürger was cheerfully singing a 'Chanson de Musette' at a dinner party; but this may have been a memorial verse, for later the same author wrote to de Banville (after reading a review of a revival of Mürger's play at the Odéon in 1878), asking him if he had not heard about the 'horrible death of Mariette, known as Musette Wishing to join her sister who was living in Algiers, she sought out a commissioner of police, D, and asked him to look after her fortune – 40,000 francs. He refused, and she boarded the *Atlas*, which left Marseille and never arrived anywhere'.

After so many years he seems to have confused the date of her death which he gave as 1853, when Nadar had hardly begun his photography and before she could have had time to amass such a considerable fortune from her charms. These were wistfully recalled by Champfleury: 'Of Mlle M only a fleeting memory remains. A few men of her generation, considering their poems or pictures or novels or sculpture, will recall . . . a smile, a joke, a turn of the head, a tune sung by a clear voice.'

Photograph circa 1855

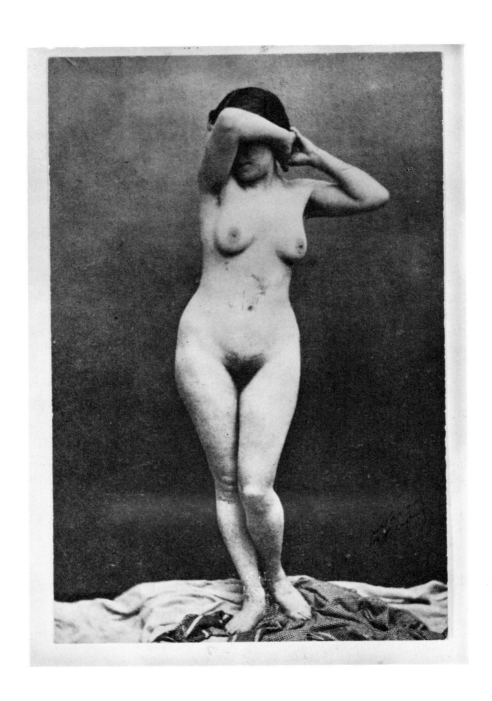

Eugène Pelletan

1813–1884

PELLETAN was born in Royan, the son of a lawyer. At 20 he was sent to Paris to carry on the same training, but took to travelling and then to writing. In 1839 he joined de Girardin's *La Presse* and they doubtless became acquainted. Pelletan developed also a passionate admiration for Lamartine, becoming a close friend of the poet-politician.

Well pleased with the revolution of 1848, he edited Lamartine's *Bien Public,* rejoined *La Presse* (which he had deserted) and made a name with his vigorously independent articles. After the *coup d'état* of 1851 he joined the strongly oppositionist *Le Siècle;* but his thinking was carrying him away from Lamartine and a book he published the next year called *Profession de Foi du IXe Siècle,* with its notion of progress as endless and inevitable, begun by nature and continued by man, caused a rift between them. The quarrel was exacerbated in 1855 when Pelletan published a violent attack on Lamartine in *La Presse* accusing him of loss of nerve and negative pessimism. It was at this time that Nadar probably took this photograph.

In 1860 he bitterly attacked Béranger for encouraging Napoléon. His radical views made it more and more difficult for him to write under the Empire and he entered politics. Elected a deputy in 1868 his fiery speeches soon made their mark. In 1868 he founded *La Tribune Française.* After the war of 1870 (when he had made a gallant ambulance-man) he served in the new government in the education department. But his fires were dying and he withdrew into private life until his death in 1884.

Photograph circa 1855

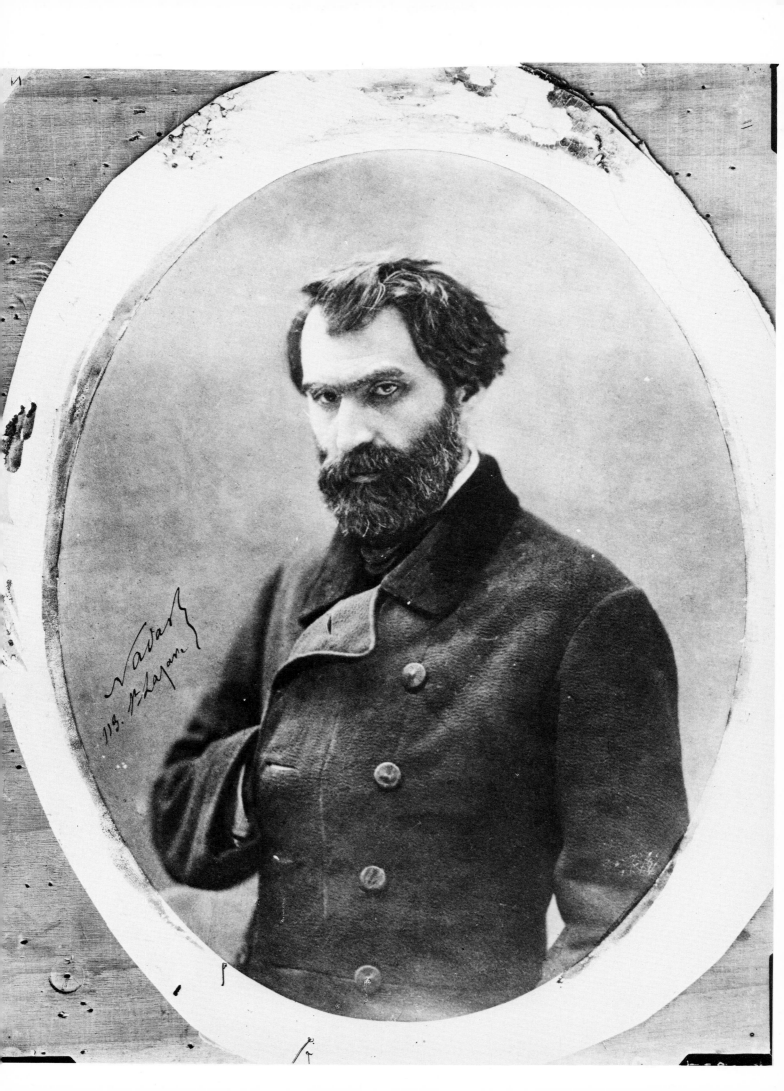

Mme O'Connell

THIS is almost certainly the artist whose painting of Rachel on her deathbed in 1858 was photographed by Nadar, as we read in the Goncourt *Journal* of that year. Nadar had already praised her work in his article on the Salon of 1853, to which she sent a self-portrait: 'Mme O'Connell's début last year made a deep sensation. This pale, warm approach, pleasantly reminiscent of Van Dyck, earned her well-deserved praise. This year's Salon brings an equal success, although we are beginning to become quite familiar with Mme O'Connell's work. Mme O'Connell is a true painter and she will surely find a way of renewing the attention which she should continue to attract.'

She was very likely the wife of the artist O'Connell – a pupil of Isabey – whom Baudelaire craftily put forward as a replacement for the ascent of the *Géant* from Brussels in 1864. Nadar had offered Baudelaire a seat, but he wrote declining the honour and suggesting instead 'this cheerful man, skilled in all kinds of gymnastics and devoted to all kinds of adventure'.

This portrait was probably taken after her Salon successes. Nadar's admiration for her art seems to have led him to engage her to work in his studio, presumably for colouring and re-touching. Her signature appears on the heavily worked-over portrait of the Tsar Alexander III (p.263).

Photograph circa 1855

Gérard de Nerval

1808–1855

ACCORDING to Nadar, writing forty-four years later, this photograph was taken in Adrien's studio in the Boulevard des Capucines, about a week before the poet's mysterious death on 22 January 1855. At the time he was 46, with a long history of mental instability. Possibly it was intended to illustrate a forthcoming publication.

His real name was Gérard Labrunie and he was born in 1808 in Germany, the son of a military doctor. When he was 2 his mother died, an event that clouded his whole life, which was dominated by the search for her ghost in visions of ideal women. He was brought up in the French countryside by an uncle charmingly recalled in books like *Sylvie, Aurélia,* and *Promenades et Souvenirs.* When his father reappeared he would not accept him.

At the age of 12 he was enrolled in the Lycée Charlemagne in Paris where he became a fellow pupil of Gautier, who was to remain a faithful friend. He was a clever boy; he failed to win the Prix d'Eloquence of the Académie Française but at 19 he acquired precocious fame with a translation of Goethe's *Faust.* Its poetic quality appealed to the internationally famous author. 'I never understood myself so well until I read you', Goethe wrote to the youth in Paris.

He was received into the bohemian circle of struggling writers and artists, contributing to several papers and even getting two comedies put on (unsuccessfully) at the Odéon theatre. He became an enthusiastic member of the Romantic group, burying himself in the world of Gothic magic, mystery, and the occult.

In 1834 he inherited a modest fortune from his grandmother, visited Switzerland and Italy, and fell passionately in love with a long-nosed English actress, Jenny Colon. He was writing fluently at this time, and in 1838 collaborated with Alexandre Dumas on an operetta, as a vehicle for Jenny, called *Paquillo*; but she did no more than lead him on, and he began to suffer hallucinations. For several years he had signed himself (referring to a small family property) 'Labrunie de Nerval' and he now imagined that the Queen of Sheba visited his bed at night and that he was the son of Napoléon.

He was a shy, dreamy, sweet-tempered character – 'gentle as a dove, free as a cloud . . . with something feminine in his features, à la Napoléon' – elusive, lovable, and melancholy, though with flashes of mischief. He was deeply suspicious of money; the theatre, half-imagined travel and, above all, poetry were more real to him than day-to-day life. He translated his visions into verses which married an exquisite sense of verbal imagery and discipline to mystical intuitions. But his hopeless love for Jenny Colon led to his first breakdown in 1841, and he was taken to Dr Blanche's hospital.

Next year Jenny Colon died. De Nerval vanished for a year to Egypt and Turkey – a voyage which he used freely in his *Voyage en Orient.* On his return he continued his writing but exaltation alternated with days of deep depression. 'I no longer savour the wine of life', he confessed.

Very early on the morning of 22 January 1855, he called on a friend, Asselineau, to borrow 7 francs to pay for a day in a public reading-room. 'I am very anxious', Nadar reports him as having said. 'For several days I have been unable to write a line. I'm afraid of being written out. I am going to have one more try today.' Next morning he was found hanging by a corset-string he kept in his pocket (he held that it had belonged to Mme de Maintenon) from the rail of a flight of steps in the rue de la Vieille Lanterne.

Photograph 1855

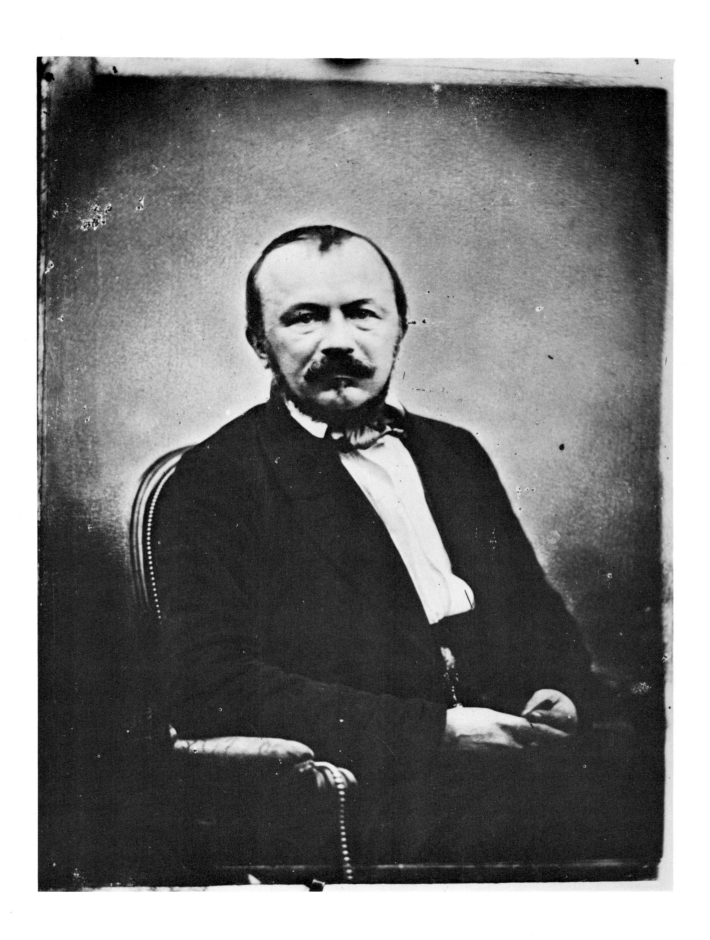

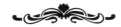

Edmond and Jules de Goncourt

1822–1896 and 1830–1870

RICH, aristocratic, and intellectually snobbish, the Goncourt brothers are improbable subjects for Nadar's camera, especially at such an early date. Their fastidious tastes would have made them hostile to such a popular and mechanical process as photography, and their few references to it in the *Journal*, which has remained their chief literary contribution, are not sympathetic.

They came from a noble Lorraine family which moved to Paris after the birth of the elder brother, Edmond, in Nancy: Jules was born eight years later. In 1834 their father died, followed by their mother in 1848, leaving them with a considerable fortune. Inquisitive and intelligent, they travelled extensively in Europe and North Africa before settling down in a house full of bric-à-brac in the rue Saint Georges in Paris, where they quickly plunged into the world of writers and artists. They were an inseparable pair – Edmond quiet, melancholy, and protective, Jules more vivacious and extrovert – and they seem never to have thought of working apart. They set themselves high standards and hoped to win fame with a fictional history published in 1851. But on the very day of publication Napoléon made his *coup d'état* and the book was lost in the confusion. Next morning they began together the diary which was to last their whole lives: after the death of Jules from syphilis in 1870 Edmond continued it alone for another twenty-six years.

Undeterred by their bad luck with their book, they carried on with their writing, concentrating especially on a period far out of fashion at the time, the eighteenth century. Their rather precious and old-maidish tastes led them to a sensitive appreciation of 'the classical age of prettiness', and they wrote perceptively on artists such as Watteau, Fragonard and Boucher; their *L'Art de XVIIIème Siècle* proved an important work. They also contributed frequently to publications like *Paris* and *L'Eclair* (where Nadar may have run across them).

Their method of research was as original as their favourite period: they revelled in detail and were the first to use trivial records like menus and playbills, from which they obtained unexpected rewards. From their successes in this field they proceeded to fiction, a progress which they described as natural: 'A novel is simply the history of people who have no history' they wrote. In 1860 their first novel, *Charles Demailly* appeared and it was followed by several more (as well as less successful plays); with their passion for documentation, they always based their characters on real people, using an aunt for *Madame Gervaisais* (1869), their servant Rose for *Germinie Lacerteux* (1864), and even themselves for *Les Frères Zemganno* (1879).

For their novels they deserted the objects and manners they loved and concentrated on subjects they detested; the result made them an important influence, both in the Realist school and on writers like Daudet and Zola, while their involved and convoluted style was developed by Proust. After Jules' death at 40, Edmond, though shattered, carried on writing; he published twelve books of his own and at his death founded the literary prize which carries his name. But it is the *Journal*, 'the confession of two lives never parted in pleasure, in work or in toil', with its detached, sometimes chilly account of contemporary manners, which has remained their finest monument.

This photograph, probably taken by Nadar in Adrien's studio (a similar chair appears in portraits of de Nerval, Louis Blanc, Mme Desbordes-Valmore and Horace Vernet), catches the withdrawn attitude of the brothers. Another pose shows Edmond's arm protectively on Jules' shoulder. There is no mention of the sitting in the *Journal*.

Photograph circa 1855

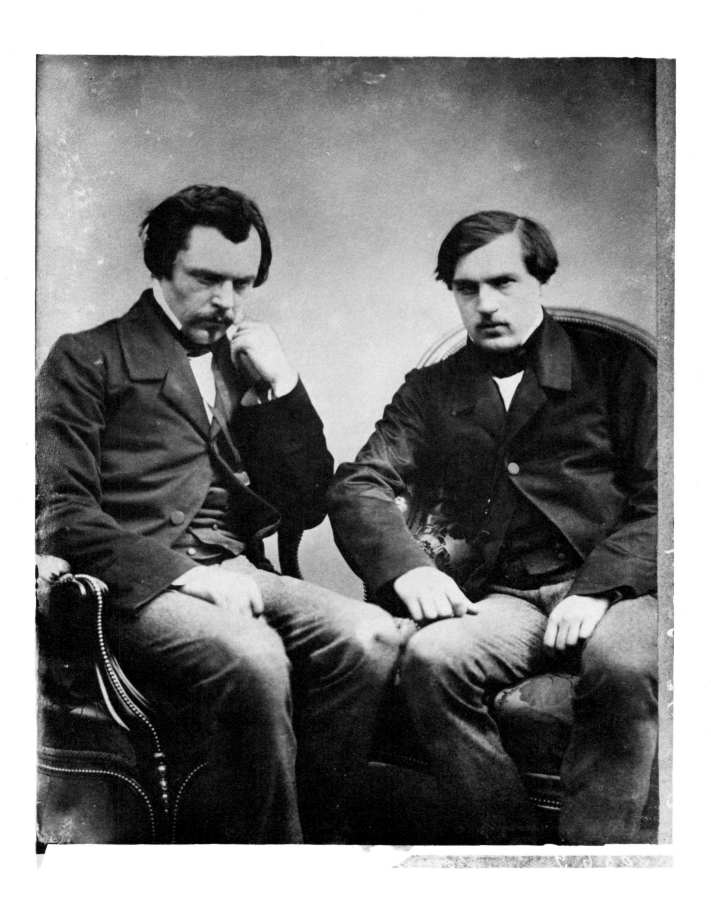

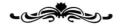

Jean-Baptiste Camille Corot

1796–1875

FEW artists can have moved in circles more remote from Nadar's exuberant bohemian environment than the quiet, retiring Corot, and it is surprising to find him such an early sitter. It is unlikely that he was a close friend of the very much younger Nadar who had, however, a special respect for his art: 'Hats off, here is Monsieur Corot! He is still, and always will be, a master because he is a creator', he had written in his 'Nadar – Jury au Salon' in 1853 (though he did not include him in his 'Panthéon' of 1858). Probably this was a commissioned portrait, for Corot, though modest in most ways, had himself photographed repeatedly in many studies, including another sitting with Nadar, to whom he sent a landscape in 1863 to thank him for his trouble. His interest in photography is very evident in his later work.

Corot came from an unassuming but solid Paris background, which gave him the financial independence to pursue his art in his early years with little regard for fashion or public recognition. A little dress shop once stood on the Seine embankment at the corner of the rue du Bac; it was run by Madame Corot, and it was here that the artist was born in 1796. After an education at the Collège de Rouen he was apprenticed to a rival dress establishment, but used to creep away to a free-style art studio, the Atelier Suisse. His father eventually yielded to his inclinations and he attended traditional teachers. A slow developer, he was 30 before he suddenly broke loose and took himself off to Rome, where he learned to match his sensitive eye and meticulous visual discipline with a free and realistic approach, 'sketching scenes from the ballet and opera inside my hat'.

He stayed in Italy for two years and from there he sent his first landscapes to the Salon. From then on he exhibited regularly, always hung but always in a corner. He was respected and well-liked by his colleagues on his return to Paris and, following the reforms of 1848, he was elected to the Salon jury. His reputation grew steadily, especially when he changed his cool, impersonal style to something more picturesque and romantic. Finally in 1855, at the special Salon which formed part of the Universal Exhibition, the Emperor not only chose him for the jury but bought one of his six paintings, *Souvenir de Marcoussis*, an example of his new arcadian idylls ('the realism of ideal weather', Gautier called them) which foreshadowed the neo-rococo style of the Second Empire. He became something of a celebrity.

Nadar has caught the genial but unshakable personality of the gentle pipe-smoking giant who was affectionately known as 'le père Corot'. His was a character of unswerving simplicity, rarely opening a newspaper, never reading a book, a stranger to museums, shunning society but invariably friendly.

His one interest outside painting was music, and it has been said that he was one of those who replaced architecture by music as the inspiration of French art. His homely blue working-smock, huge frame, pink cheeks and laconic comments ('It certainly seems that people are not entirely satisfied', he remarked of the uprising of 1848) became famous. He never married after the death of his parents – passion seems to have played no part in his life – and during the siege of Paris in 1870 he merely locked himself in his studio and worked harder than ever. He died of cancer at the age of 79, much loved and admired in France but still little known abroad. In *The Times* obituary notice he was described as a 'history painter' and compared with Delacroix.

This portrait, one of a set which inspired an engraving by Braquemond, has the strong overhead lighting typical of Nadar's rue Saint Lazare studio and was exhibited in 1859.

Photograph circa 1855

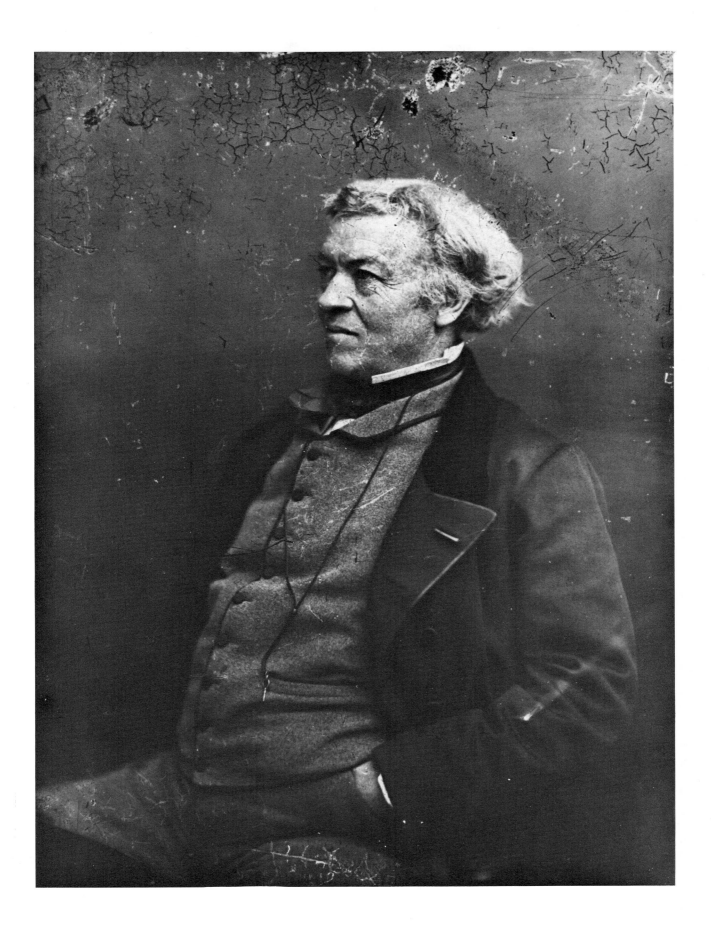

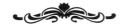

François-Louis Lesueur

1820–1876

A POPULAR comedian for thirty years, Lesueur started as a penniless apprentice in the paper trade. But soon he began to appear in the evening at the little Montparnasse theatre and in 1840 he abandoned the world of paper and joined the Saint Marcel theatre professionally, under the pseudonym of François de Saint Marcel. After a spell at the Gaieté theatre he joined the Cirque, where he scored a big success in *La Poule aux Oeufs d'Or*. In 1848 he joined the Gymnase, where he remained for twenty years, building up a solid reputation in a succession of comedy roles and aiding his career by marrying one of the stars, who was also the daughter of the director.

This photograph was probably taken during his Gymnase years. The witty, intelligent features and broad, flexible mouth suggest something puckish in his style, though one of his biggest successes was as Don Quixote in a play of that name in 1864. Towards the end of his career he abandoned comedy for pantomimes such as *Gulliver* at the Châtelet; when that theatre went bankrupt he had to return to his beginnings in vaudeville. He died in Bougival in 1876.

Photograph circa 1855

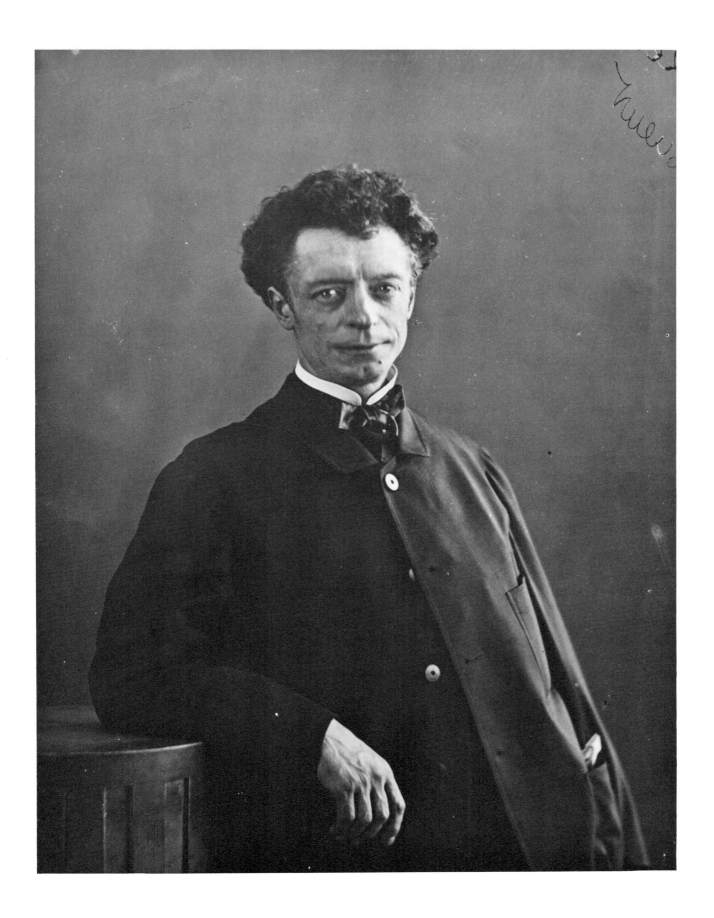

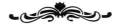

Joseph Darcier

1820–1883

DARCIER, as he called himself (he was born Joseph Lemaire), was an entertainer and singer who was probably familiar to Nadar – who was the same age – and his friends from his appearance in restaurants and cafés. This photograph was used for a lithographed poster (designed and drawn by Nadar, see p.29) to announce his engagement by Offenbach in 1855 to appear at the Bouffes Parisiens, where he created *Le Joueur de Violon* and *Nuit Blanche*.

He had started as an actor in small fringe theatres, eking out his finances by teaching and light journalism. But he became known as a ballad-singer and as a performer of astringent political songs, often written by himself, which, in the years preceding the 1848 unrest, met an appreciative audience. It may have been their radical tone which attracted Nadar to him.

After his seasons at the Bouffes Parisiens he acted at the Beaumarchais and the Delassements Comiques theatres, and in 1858 he joined the Folies Nouvelles, where he wrote, composed, and acted in three operettas. After a return to his old routines in café-concert, he wrote a final operetta in 1874, which was performed at the Eldorado theatre under the title *Ah, Divorce!* Besides his talents in the theatre, Darcier was celebrated in his youth as a duellist. The Goncourts called him (in 1858) 'the most formidable sword in Paris'.

Photograph 1854

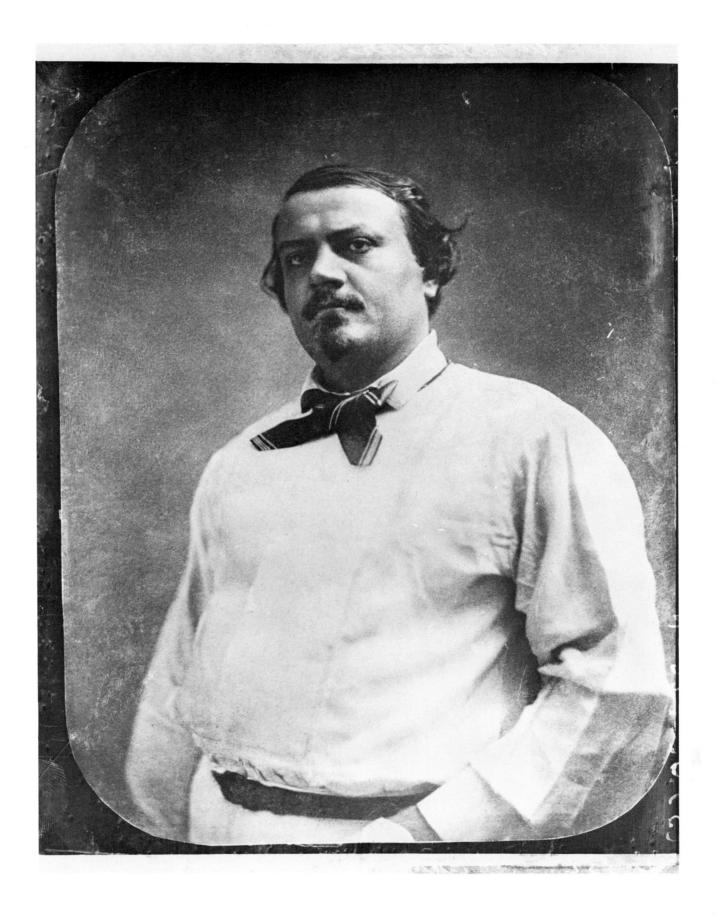

Philarète Chasles

1798–1873

NADAR was very far from scholarly or bookish, and Philarète Chasles seems an improbable friend, for he was both. Yet Chasles was one of his first sitters and only a few years later, in 1859, Nadar wrote his biography in *Le Journal Amusant* – a sympathetic study which explains their friendship. Nadar describes him as 'a restless character who was born old and will die young', a highly-strung man, witty, argumentative, charming, and unreliable, 'with something of the silkworm moth, always in motion, always agitating its wings, forever in search of something'.

Chasles came from Angers, where he had begun his education, completing it in Paris at the Lycées of Henri IV and Louis-le-Grand. He had a unlucky start. He was apprenticed to a printer in the rue Dauphine who ran into trouble with the authorities; as a result the 12-year-old Chasles spent a month in prison on a charge of 'conspiracy'. When he came out of jail he prudently left Paris for London, where he spent two years, learning the language and the literature and working on the editing of some letters belonging to the Duke of Rutland.

Back in Paris, he published a series of academic literary studies, besides co-founding, and contributing to, the *Revue Britannique*. He contributed to a number of publications including the *Revue des Deux Mondes*, *Le Temps*, and *Le Figaro* and specialized in introducing foreign writers to French readers; one of them was Herman Melville.

In 1836 his fortunes improved. He married a baroness, and the very next year Guizot appointed him as a librarian in the Bibliothèque Mazarine. Here he was entirely at home; he remained in its service all his working life. He continued his career as a literary critic and commentator on the *Journal des Débats* and the *Revue des Deux Mondes*. His articles were published under the title *Etudes* and he became well-known for his lectures, both at home and abroad. In 1855, at about the time this portrait may have been made, he was appearing in Berlin.

A break in his rather uneventful life came in 1857 when his wife (to whom he had not remained faithful) died. In 1865 he married a fellow writer known as 'Marie Sincère' (her real name was Moreau Dubreuil de Saint-Germain) and in the same year he published a characteristic book; its title was *Voyage d'un Critique à travers la Vie et les Livres*. Although he was always in demand, his writing – motivated by economic necessity rather than by scholarship – never achieved the quality to earn him a place in the Académie. At the age of 70 he retired to Meudon to work on his reputedly rather unreliable memoirs. He met his death in Venice from cholera, in 1873.

Photograph circa 1855

Léon Gozlan

1803–1866

AN assiduous, successful, and rather superficial journalist, Gozlan seems to have been a man of excellent character rather than a genius, a familiar and well-liked figure in Nadar's circle during his first years in Paris. Elegant, witty, and fluent, he was a columnist rather than a commentator; Gautier compared his criticisms to finely wrought crystal daggers which break when they strike.

The son of a rich Jewish shipowner in Marseille who had been ruined by English pirates, Gozlan began his career as a schoolmaster but soon tried his hand at a commercial gamble. He set out for North Africa with a boatload of champagne. Unfortunately, the heat and movement burst the bottles and he was finally forced to enlist as a deck-hand on a coaster operating off Senegal.

Making his way to Paris, he turned his adventures to advantage by publishing an account of them in *Le Musée des Familles* under the title 'Pour avoir voulu imiter Robinson Crusoe'. He found a job in a bookshop and made friends with a fellow southerner from Marseille, the already well-established writer Joseph Méry. Through him he placed some articles in *L'Incorruptible*, and later worked extensively on *Le Figaro*, *Le Corsaire-Satan*, and *La Revue de Paris*.

In 1836 (already 33), he joined the band of writers who helped Balzac to maintain his prodigious output – a connection which he was to put to good use thirty years later in a detailed account of the great novelist's private life called *Balzac en Pantoufles*. Meanwhile he turned out a series of light articles and some rather lurid stories about mad girls and vampires, besides several plays. Perhaps the best of these was *Le Gâteau des Reines*, a five-act comedy produced at the Théâtre Français in 1855; its success may have led to this portrait.

In his last years his colleagues did him the honour of electing him as President not only of the Société des Gens de Lettres but also of the Société des Auteurs Dramatiques. Active and restless (he had a reputation for withdrawing resignations) a friend met him, one evening in 1866, hurrying away as usual and asked where he was going. 'I am going to die', answered Gozlan; and next day he was dead.

Photograph circa 1855

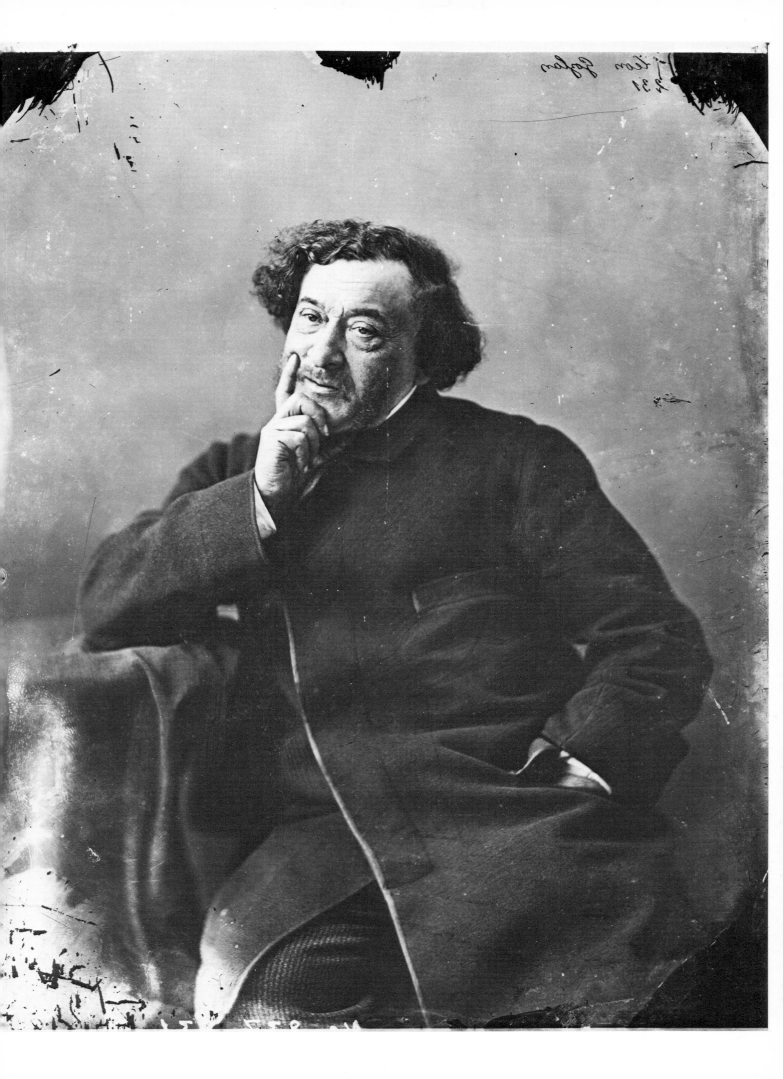

Mohammed Sa'id Pasha

1822–1863

WHEN the health of the fierce founder of modern Egypt, Mohammed Ali, began to fail in 1849, he abdicated in favour of his son, Ibrahim, who died within a few months, leaving the throne to his nephew Abbas. On his death in 1854 Mohammed's younger son Sa'id became Viceroy and took over his father's mission with energy. His ferocious mien concealed the heart of a reformer. He improved the lot of the peasants, suppressed slavery (in 1856) and encouraged the development of his country by the building of railways and dams. He also came to an agreement with Ferdinand de Lesseps to dig a canal to join the Mediterranean and the Red Sea – the Suez Canal; this fateful channel was completed in 1869 and the city on its northern end was named after its patron (and the subject of this photograph) Port Said.

The snapshot style of the portrait suggests an early date; it may have been taken when the Pasha was visiting the Universal Exhibition in Paris in 1855, or soon after, during his negotiations with de Lesseps concerning the formation of the Suez Canal company, which was set up in 1858.

Photograph circa 1855

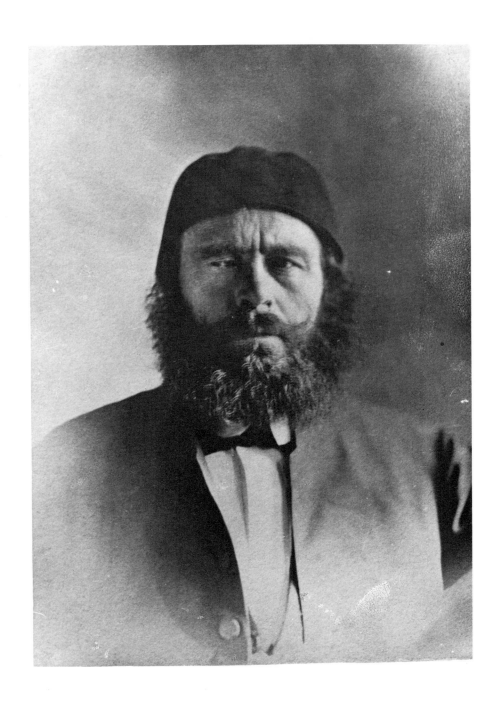

Honoré Daumier

1808–1879

DAUMIER, twelve years Nadar's senior, was in many ways a father-figure to him. He had been a left-wing caricaturist and cartoonist for Philipon for sixteen years before Nadar embarked on a similar career. His skill and fame, and the fact that he had served six months' imprisonment for a disrespectful drawing of Louis-Philippe as Gargantua, must have made him a hero to the young cartoonist-photographer.

Daumier was born in Marseille, son of a picture-framer with literary ambitions of a social-idealist nature. When his boy was 8 he moved to Paris to supervise the production of a play. Honoré was put out to work in a bookshop, but he was bent on becoming an artist; at 14 he was lucky enough to be given a few drawing lessons by a friend of his father and in his spare time he used to creep away to work at the Atelier Suisse.

More influential were some classes in the atelier of Ramelet and Belliard, where he learned the technique of lithography. It was this that led to his engagement by Philipon in 1830 to draw for his magazine *Caricature* (successor to *Charivari*); Daumier proved incredibly adept, turning out nearly 400 cartoons for the publication, sometimes completing eight in a single night. Their success was crowned by a series of caricature-sculptures, carried out under the influence of his friend Préault. 'That fellow has got a bit of Michelangelo in him', remarked Balzac on seeing them.

But caricature became steadily more hazardous. After his prison sentence (completed mainly in hospital) he left home and began to study painting. After 1835 a new law compelled him to abandon politics for social habits as a subject; he prospered and moved into a studio on the Ile Saint Louis, where he used to frequent Baudelaire's parties with Delacroix. He met an attractive young couturière, Alexandrine Dassy, and married her.

In 1850 he was hung in the Salon for the first time; his picture, *A Miller with his Son and a Donkey*, doubtless led to his success the following year when he exhibited the first of his Don Quixote pictures. He continued his journalistic graphics, and at the Universal Exhibition of 1855 showed a series of *Parisian Scenes*; an occasion which may have prompted this portrait. In exchange for it Daumier offered Nadar one of his Don Quixote paintings, which Nadar apparently declined.

He seemed set for prosperity and even fame; two years later Baudelaire devoted an article to his praise. But in 1860 he resigned from *Charivari* to devote himself entirely to painting. The result was disastrous. He fell into poverty and, to make matters worse, his eyes began to fail. Edmond de Goncourt describes him at this period: 'With white hair swept back . . . a full face, rather pale, two very black, small eyes, a little nose shaped like a potato, a large man with a sharp voice and with nothing kind nor open in his expression.'

He was suffering, in fact, but he was not forgotten. In 1868 his colleague Corot, hearing of his distress, bought the freehold of his house for him. During the short reign of the Commune in 1871 he was a member of the committee appointed to care for museums and vigorously attacked Courbet's gesture of pulling down the column in the Place Vendôme. He was hardly able to work by now. In 1878 a group of artists and journalists, including Nadar, organized an exhibition of his work at the Galeries Durand-Ruel. But an operation had left him totally blind. He had nothing left to live for, and in 1879 he died.

Photograph 1855

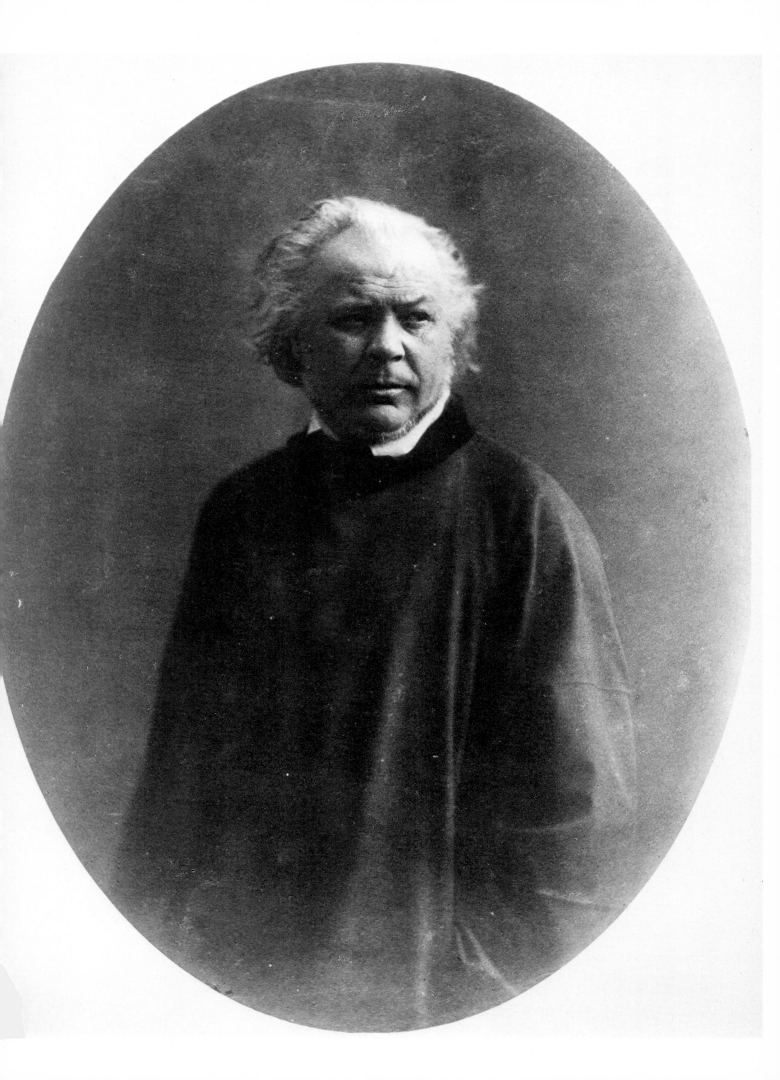

Thérèse Tournachon

1794–1860

LITTLE is known of Nadar's mother, except that she came, like her husband Victor, from a family in Lyon and was the daughter of Louis Mailliet and Françoise Beluze. Both her parents died before she came to live in Paris in 1817.

She must have been a lively and independent girl, for she lived with her husband for several years, and bore him two sons, Félix and Adrien, before their union was legitimized by marriage. She was then 32 and her husband 55. She continued to live with Félix after the death of her husband in 1837, and it was in the house they shared in the rue Saint Lazare that he set up his first photographic studio, where this portrait was presumably taken.

Though she is seldom mentioned in Nadar's memoirs, he seems to have been famous for his devotion to her. At about the period when this photograph was taken, in 1858, the Goncourts described the pianist Marchal as 'one of the Nadar types who has taken up the old theatrical gag "Mother!", who shelters behind it and boasts of it, using it to arouse public sentiment and win sympathy, flourishing their mother in front of their friends, their acquaintances, their interviewers, their creditors, even their debtors'.

When Nadar married and his new wife moved in to the rue Saint Lazare in 1854 Mme Tournachon moved out to an apartment at 26 rue de Rivoli. She died there on 21 February 1860.

Photograph circa 1855

Gustave Doré

1832–1883

ONE of Nadar's first Paris colleagues was a brilliant 17-year-old cartoonist employed, like himself, by Philipon on the *Journal pour Rire*. Gustave Doré was Nadar's junior by twelve years, but he had joined the paper some months previously, a schoolboy of genius with a mercurial temperament and a natural talent which Nadar must have envied. 'I know nobody with wider, more exceptional and more universal gifts', he wrote.

Doré was better off than Nadar but they were both newly arrived from the provinces and had many friends in common. His ebullient personality and photogenic young features – to fade all too rapidly into the 'fat, fresh, baby face with the expression of the moon in a magic lantern' which so irritated the Goncourts – made him a favourite subject for Nadar, who photographed him several times.

By the time he was 22 he had already published nine illustrated albums and books (including the popular *History of Russia*) besides about 1,000 drawings for his paper and had exhibited three times at the Salon. In the last two years massive commissions as a book illustrator had rocketed him from mere journalistic cartooning to general admiration. In 1854 he provided over 200 drawings for Rabelais' famous *Gargantua et Pantagruel*. The edition was cheaply printed and offered in 20-centime instalments; but the impact was such that Alexandre Dumas devoted a whole issue of his journal *Le Mousquetaire* to its praises. The following year, 1855, he clinched his reputation with his illustrations for Balzac's medieval *Contes Drolatiques*. Again the book was poorly produced and it was a commercial failure. But Doré's career was inexorably launched, and this portrait – probably taken soon after – is a symbol of success.

From then on Doré's rise proceeded at a pace which dazzled his companions; his facility and invention were phenomenal even in an age of prodigal creativity, combining manual dexterity with an absolutely photographic memory. He illustrated over 200 books, acquiring world fame and vast wealth. His images of *Don Quixote* (1863) supplanted all others in the popular mind, while his plates for Dante's *Inferno* (1861), though uneven, have remained unequalled.

They revealed a morbid, and even sadistic side to his character which was to replace the high-spirited mockery of his youth. This melancholy streak appears in his illustrations for *The Wandering Jew* (1856) and, later, *The Ancient Mariner* (1865), two tales about outcasts which seem to have found sympathetic echoes in this outwardly sociable, and cheerful man. He was a 'mother's darling' who never married and he nursed increasing frustrations at his failure to be accepted as a full-scale artist. His pictures in the Salon were regularly laughed at for their self-taught incompetence.

But in London his work was so popular that he was able to buy a private gallery in Bond Street (now Sotheby's saleroom) in which to exhibit and market his huge Biblical scenes and landscapes. He became a regular visitor to England and Scotland and his last important work was his contribution to a book on *London* (1873) which depicted the miseries of dockland with brilliant realism and compassion. One of the plates – of prisoners exercising in Pentonville jail – was later to impress van Gogh so much that he translated it into a painting.

But by this time Doré's health was broken through overwork and disappointments. He was depressed by the death of his mother and distressed at the loss of his native Strasbourg after the Franco-Prussian war. He died suddenly in Paris, aged 51, a romantic who had exploited the monster of industrial production and was finally destroyed by it.

Photograph circa 1855

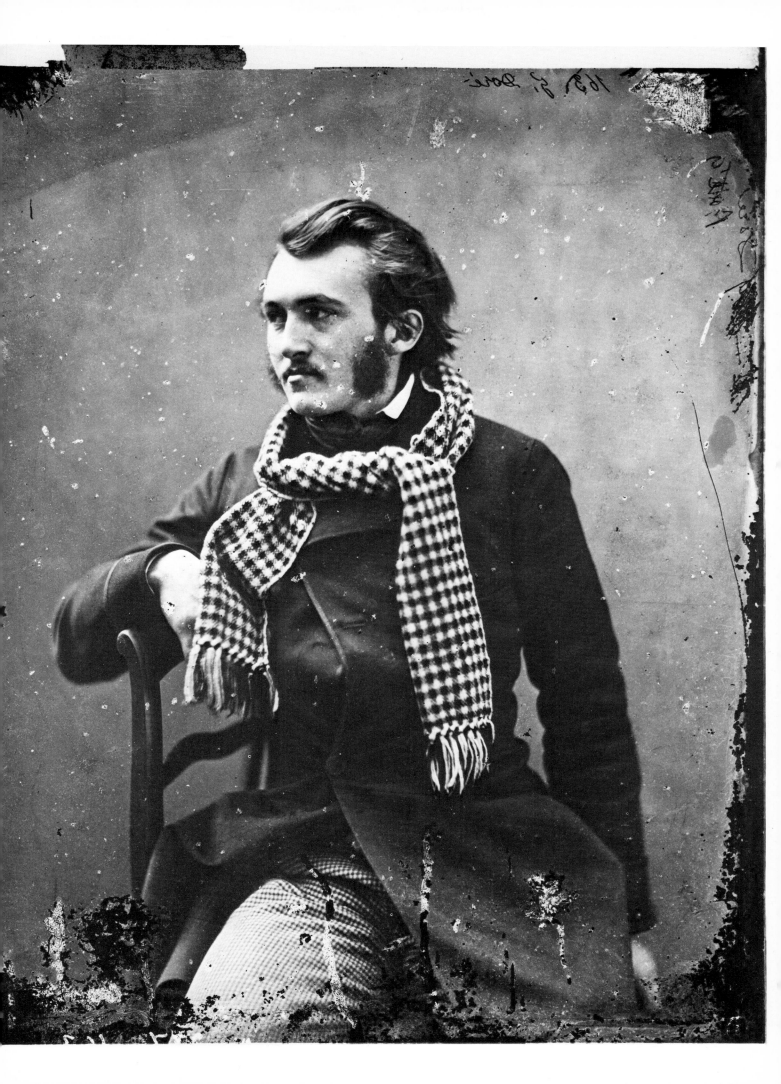

Constantin Guys

1802–1892

OF all the artists Nadar knew, Guys seems to have been the one with whom he felt most at home. They met first in London in 1851 when Guys was working with *The Illustrated London News* and Nadar was suggested as a contributor to a French edition. They evidently became friends immediately. Guys was sent to the Crimea in 1854 to cover the war for the magazine, and this photograph – in which Guys wears his usual look of an old trooper – may have been taken after his return to Paris. It is unusually informal for a Nadar portrait, with an appropriate suggestion of the open air.

Ernestus Adolphus Hyacinthus Constantinus Guys was born in Flushing in 1802, the son of the Chief Commissioner of the French Navy. He probably accompanied his father on his travels and acquired very early a roving disposition; for in 1824, at 18, he was a volunteer in the Greek fight for liberty beside Lord Byron and involved in the Missolonghi disaster. On his return to France he joined the Dragoons for a few years; after leaving them he seems to have taken up drawing, for he was engaged in 1842 by the celebrated English artist Thomas Girtin as tutor in French and drawing to his grandchildren, and executed a very passable example of his hussar-drawings in one of their notebooks.

He probably had private means, and became deeply imbued with the ideals of the English dandy of his time. In 1848 he joined *The Illustrated London News,* though anonymously – he was deeply offended when Thackeray wrote an article praising him by name. Travelling backwards and forwards between Paris and London, he became a brilliant and much sought after chronicler of the elegant life of the period. His drawings were collected not only by Nadar (who one day refused an offer by Delacroix to exchange two of his own for a Guys sketch) but by Manet – who painted a touching portrait of him in his old age – and by Baudelaire, who devoted one of his most celebrated essays to him under the title 'A Painter of Modern Life', praising his use of contemporary local subjects instead of historical, mythical or exotic material.

But even in this tribute, published first in *Le Figaro,* Guys was alluded to only as 'M.G.', and he remained little known to the general public. After the 1870 war he withdrew from social life and concentrated on drawing the underworld, neglected by all but a few friends. The most faithful of these was Nadar, and it was while crossing the rue du Havre after dining with him one summer night in 1885 that Guys was knocked down by a cab, and both his legs were broken.

Nadar accompanied him to the Maison Dubois hospital where he lay for seven years in great misery. 'Dearest Nad,' he wrote in 1887 to Nadar, who was one of his few regular visitors, 'your kindness carries you away – it's too much I shall leave this place only to enter the eternal arms of the Père Lachaise'; and it was to that cemetery that Nadar followed his coffin, almost alone, in 1892.

Nadar's loyalty did not end there. It was he who wrote a glowing obituary in *Le Figaro* two days later and in 1895 he organized the first major exhibition of his work, at the Galerie Charpentier, an occasion which firmly established Guys' artistic reputation. Yet he did not allow devotion altogether to cloud his judgement. 'His old-soldier manner was absolutely insupportable', Nadar wrote in his last year in *Les Nouvelles,* 'and in spite of the friendship I felt for him to his death, I still cannot forgive him for his ingratitude towards Baudelaire, to whom he owed so much.' Perhaps, as Nadar added gruffly, 'he had no soul, only a paw – but a marvellous paw'.

Photograph circa 1855

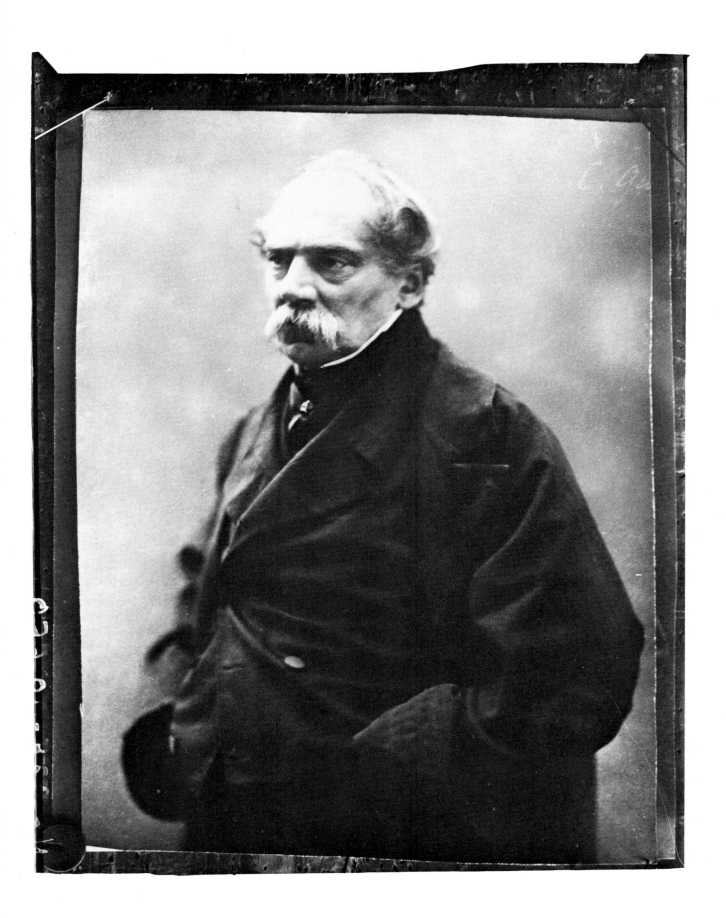

Mme Kalkbrenner

1828–1869

MME Kalkbrenner was the wife of a composer of light music who frequented the Bohemian world of which Nadar was a member as a young man. He was the son of a popular pianist, Frederick Kalkbrenner (when Chopin arrived in Paris in 1831 he had played his E minor Concerto for him, to be greeted with the suggestion that he become a pupil for three years). Kalkbrenner lived and worked in his youth in England, before coming to Paris where he launched a number of mazurkas, quadrilles, and other dances as well as a light opera, *L'Amour*. Cheerful and elegant, he was described as 'always with plenty of pocket money but perpetually on the hunt for a 100 franc note'. The Goncourts accused him, improbably, in 1858 of paying out 160,000 francs to buy the privilege of frequenting the elegant foyer in the Opéra. Nadar was evidently an admirer of Mme Kalkbrenner whom he photographed several times.

Photograph circa 1855

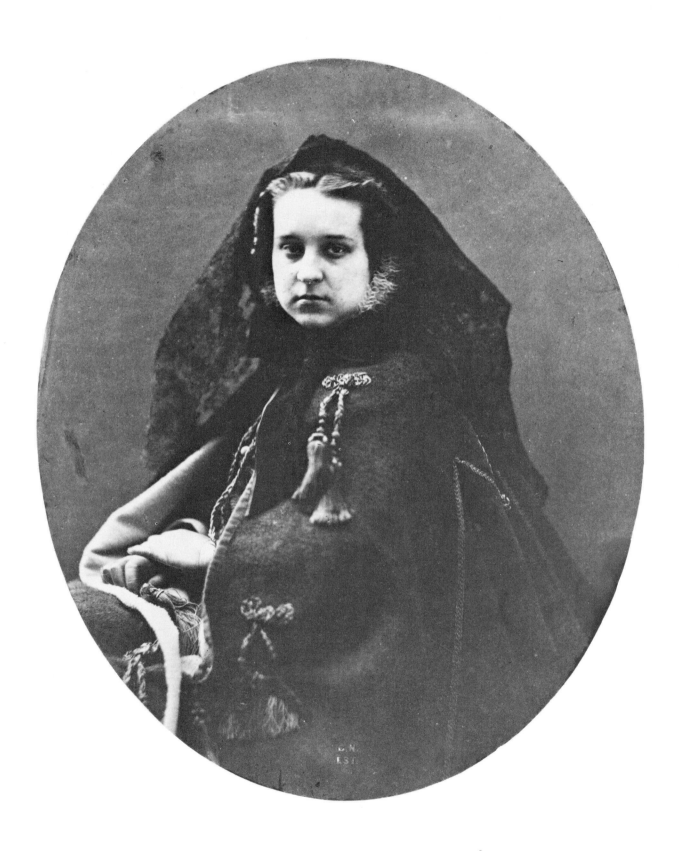

Alfred Musard (*fils*)

1828–1881

THE most popular musician in Paris in Nadar's youth was the founder and director of the Concerts Musard in the rue Vivienne. Here, in an informal atmosphere later to be known as the 'promenade concert', the audience was served programmes made up of tunes from many sources arranged as light entertainment. Musard was a master of this craft – 'he could make a quadrille out of the *Dies Irae*', wrote one commentator. He had both imagination and skill, and did not hesitate to introduce pistol shots or the smashing of chairs into his score as a way of enlivening it.

He directed the Bals de l'Opéra which were the most successful of all the many dance-hall entertainments of the period, conducting his orchestra in waltzes, quadrilles, cotillons, polkas, and friskas with a dash which led to the coining of the word 'musarder' – to frolic. The Goncourts were jolted into uncharacteristic enthusiasm by his playing at a masked ball in 1857. 'That baton of Musard's which kept whipping up from the drums and fifes a world containing all worlds, a jostling concatenation, a liquid flash of repartees, a pleasure without purpose or consequence, a fine frenzy laughing at itself, a furious embodiment of Youth kicking Tomorrow with the boot of a horsewoman.'

His career was cut short by an attack of paralysis in one arm, and he retired to Auteuil, of which he became mayor. After his death, his son Alfred tried to take over his baton, and in 1856 he revived the concerts in a series of *soirées musicales* in the rue Vivienne. This portrait, which – a rare phenomenon in Nadar's work – shows Musard *fils* ostensibly in action on the rostrum, was doubtless taken on one of those occasions. Nadar also photographed the conductor's two daughters.

Photograph circa 1856

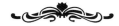

Isidore Severin, Baron Taylor
1789–1879

BARON Taylor represented the best side of the nineteenth-century bourgeoisie. He was born in Brussels, with a naturalized Englishman as father and a mother of Irish descent. His parents were distinguished but not rich. As a young man he worked in a bookshop in Paris, before studying drawing in the studio of Suvée. However, he was able to travel widely in Germany, Italy and England as a young man and became familiar with several cultures.

When he was called up to the army, he served as a *sous-lieutenant*, perhaps because he was the nephew of a general; and in 1823 he became aide-de-camp to the Comte d'Orsay, during his expedition to Spain. But he had already (in collaboration) produced an adaptation of Maturin's play *Bertram* which had run for 200 performances (in 1821) and he was more attracted to the arts than to a military career. On his return to Paris he was appointed Royal Commissioner to the Théâtre Français, and in this capacity he was an important influence in promoting the cause of the Romantics; it was he who was responsible for the crucial production of Hugo's *Hernani* in 1830.

At the same time his travels had made him a keen connoisseur of architecture and archaeology, and in 1833 he obtained permission to visit Egypt, returning with several treasures including the Luxor Obelisk, which was erected in the Place de la Concorde the following year. He was sent abroad on similar buying expeditions to Spain and England and was created Inspector of Fine Arts in 1838. He used his official position not only to preserve and purchase works of art but to help living artists; he founded several benevolent societies, such as the Société des Gens de Lettres, and supported them himself besides raising funds through concerts, galas, and lotteries. He was admitted to the Académie in 1867 and became a Senator in 1869.

A well-loved figure in cultural circles – he was known as 'le Père des Artistes' – he himself wrote several plays and many travel books, of which the most notable was *Voyages Pittoresques et Romantiques de l'ancienne France, 1820–1863*. It was illustrated not only by his own drawings but by Géricault, Isabey, Ingres, Vernet, Viollet-le-Duc, and the theatre designer, Ciceri. He was a loyal friend and supporter of Nadar, who had included him in his first 'Panthéon' of 1854; in 1863 he became an honorary president of the 'Society for the Encouragement of Aerial Locomotion by Heavier-than-Air Machines' of which Jules Verne was secretary and Nadar's studio the headquarters. The photograph dates from the studio in the rue Saint Lazare between 1855 and 1860.

Nadar expressed his gratitude to him in *Les Mémoires du Géant* and, later, in *Le Monde où l'on Patauge*. He asked wistfully: 'Why has Taylor, who left millions to the Société des Lettres et des Arts – why, O Coquelin, friend of the gods, has our benefactor still no statue?'

Photograph circa 1858

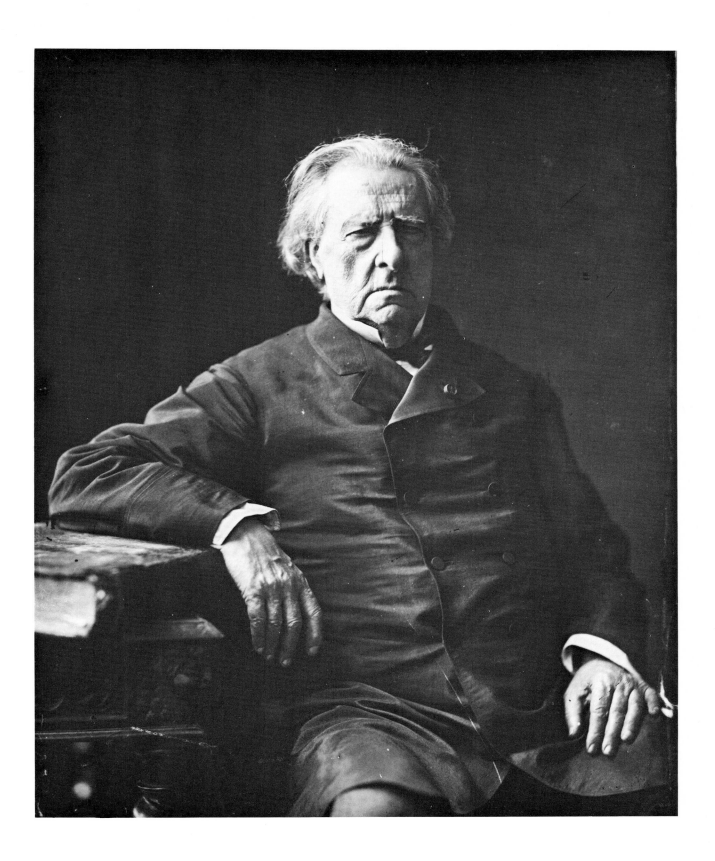

Louis François Veuillot

1813–1883

THE friendship between Louis Veuillot and Nadar was a curious one; in fact Nadar himself was aware of the paradoxical sympathy between two men whose views were so diametrically opposite, and seems to have savoured the contradiction. To Nadar's easy-going atheistic radicalism Veuillot opposed a violent, sometimes vicious right-wing Catholic orthodoxy which even alarmed parts of the Church. As editor of the *Univers Religieux* for nearly forty years he was the scourge of any backsliders towards moderation or reform. But the two men – both passionate proselytizers and untiring journalists (they had met when Nadar was publishing his 'Panthéon') – seem to have been able to take each other's sincerity lightly. Nadar claimed that Veuillot was more put out by his having married a Protestant than by not baptizing his son; and, as the *Géant* took off for its first flight in 1863, it was Veuillot who wrote to Nadar: 'If you seem to be coming down too fast, throw out your anchor up there!'

Veuillot came from a poor family; his father was a cooper and he taught himself to appreciate literature by stealing time as he carried books from school to a library. He met professional writers like Scribe and Bayard and at 17 made his debut in a modest provincial paper, the *Echo de la Seine Inférieure* in Rouen. He at once adopted a provocative tone, and his drama reviews resulted in two duels.

During the next few years he published several novels in the popular style of Paul de Kock and travelled around the provinces, writing and quarrelling. In 1837 he was back in Paris and in the following year joined *La Paix*, in which he launched attacks on Thiers from a conservative point of view. A journey to Italy that year, and a visit to the Vatican, made him into a virulent Catholic, a characteristic which he aired publicly on his return. He became a well-known, if not well-liked, figure (the Goncourts detested his self-satisfaction and coarseness) and he found himself, rather improbably, chosen to accompany General Bougeaud to Algeria as a propagandist. But he proved totally incompetent and was sent home. 'Veuillot is only good as a polemicist; he is a pamphleteer and that's all', was the report on him.

But on his return in 1843 he was made editor of the Catholic *Univers Religieux*, a pulpit which he was to use for many years for fulminating against religious slackness. 'The friends of my youth, like Mürger and de Banville, are being given a pasting', complained Champfleury sadly, and Veuillot's fierce attacks on the teaching at the University landed him briefly in prison. In 1851 he hailed Napoléon's *coup d'état* with delight, but found his loyalty waning when the Italian wars broke out. His *Univers* was suppressed and briefly turned into *Le Monde*; but it soon reappeared and Veuillot continued his thundering and sniping (for he would readily stoop to personal scandals) for the rest of his career. Nadar never took offence, consented to take this photograph, and published a friendly reminiscence of him in 1895.

This photograph contradicts Charles Edmond's description of Veuillot as 'looking like a poisonous mushroom' and betrays Nadar's undinted affection for him.

Photograph circa 1856

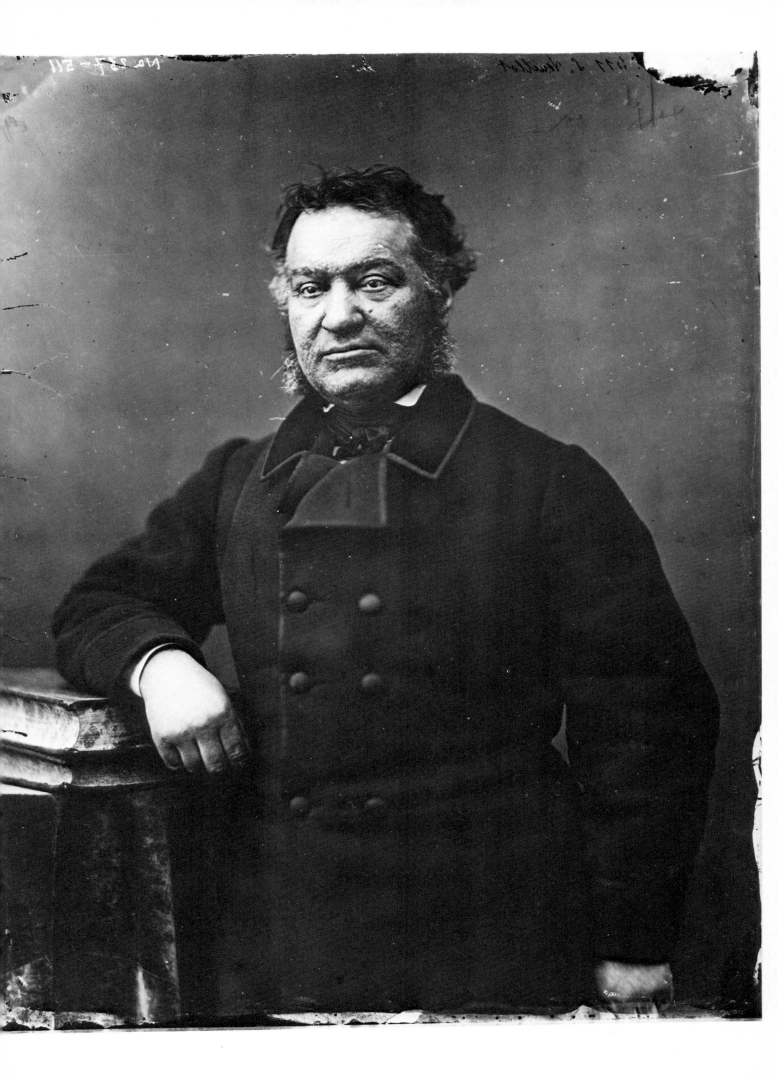

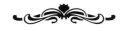

Jules Janin

1804–1874

DURING Nadar's youth Jules Janin was one of the most powerful of all dramatic and literary critics in Paris, whose judgements – sometimes reputed to be swayed by personal relationships (Sainte-Beuve accused him of 'mischief based on venality') – could make or break a reputation and whose brilliant style was both admired and attacked. The younger Goncourt, Jules – who undertook the actual writing of the diaries until his death – was, according to his brother, much influenced by it.

In 1836 he joined the *Journal des Débats* and here he remained as drama critic (also embarking on literary comment) for forty years, becoming the 'king of critics'. He had, besides a superficially dazzling vocabulary, a gift for predicting the shifts of popular taste and, by his articles, perhaps also encouraging them. It was he who in 1837 spotted a dark, skinny little actress at the Gymnase, a 16-year-old whom the next year he hailed as 'stunning' – her name was Rachel. And it was he who, seventeen years later, knocked her off her unchallenged pedestal by hailing a new young talent from Italy, Adelaide Ristori.

He published several volumes of his collected articles and became a famous literary figure. In 1852 Victor Hugo wrote to him jokingly offering his Chair in the Académie, which he guessed might shortly be available after the publication of a book, which he enclosed, *Napoléon le Petit*. Janin also published a number of stories, novels, a translation of Horace, and a life of Béranger, a popular *chansonnier*. But it was probably in his capacity as a journalist that Nadar, then fresh from a similar career, got to know him.

Photograph circa 1855

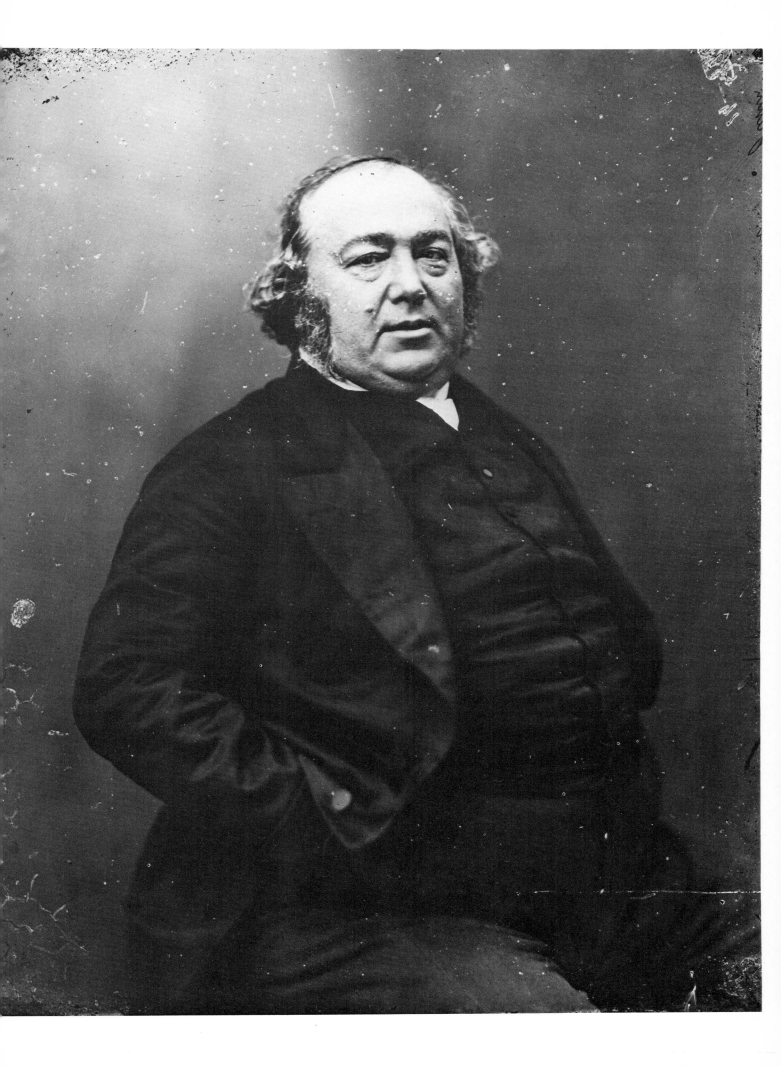

Maurice-Gottlieb (Moses Saphir)
1795–1857

MOSES Saphir was a Hungarian-born satirical journalist and cartoonist with whom Nadar presumably came in contact through his own work in that vein. He may have been in Paris to look out for material, writers and artists (Nadar himself perhaps included) for the journal *Der Humorist* which he published in Munich.

Born into a Jewish family in Pesth, Moses entered a brokerage house in Vienna at a very tender age; but his sharp tongue and sarcastic character made him so many enemies that he had to leave not only the firm but the city. He moved to Berlin and entered journalism, founding the *Diligenz von Berlin* with some success. Moving to Munich he took part in the disturbances of 1848, and started up two journals, *Munich Bazaar* and the *Deutsche Dämmerung*, whose contents were disruptive enough to earn him a spell in prison. He later changed his name to Maurice-Gottlieb and published two collections of his writings in 1832, and a volume called *Drolleries, Portraits and Caricatures* in 1837.

Photograph circa 1857

Gioachino Rossini

1792–1868

THE genial warmth and human sympathy of the celebrated Italian composer can be felt in this photograph, which was actually taken when he was failing physically and mentally. He had recently returned from a spell in Italy and had installed himself in an apartment near the Opéra. Here, with his second wife, he became a much loved and well-respected host; his 'Saturdays' were thronged with guests, assembled to greet the famous man (who inclined to stay in a back room) and to listen to impromptu performances by his musical guests. Nadar, who was sufficiently associated with the Italian school to earn him the enmity of Wagner, was probably invited at least occasionally to these rather formidable occasions.

Born in Pesaro, the son of a trumpeter, Rossini slipped into his career while still a schoolboy. His first opera, arranged for a family of friends who were all singers, was composed when he was 14. In the next twenty-two years he wrote over forty more; then, at the age of 37, he suddenly stopped and never composed another.

His life until that moment had been a series of operatic successes. At 18 he had an opera put on in Venice, at 19 he tried his first *opera buffa*, at 20 he mounted two more in Venice and one for La Scala in Milan, *La Pietra del Paragone*. In the next few years he triumphed in Naples and failed in Rome – ironically with his most popular work, *Il Barbiere di Siviglia*. In 1817 came *La Cenerentola* and in 1822, with his new wife, the singer Colbran, he travelled to Vienna to make the acquaintance of Beethoven. In 1823 he had a setback; his *Semiramide* in Venice was a failure. Abruptly he left Italy for France and England.

Rich, agreeable, and celebrated, he was fêted everywhere, including fashionable Paris. He composed a cantata for the coronation of Charles X in 1825; in 1826 Berlioz was admiring his *Siège de Corinth*; in 1829 his *Guillaume Tell* was a triumph. It was to have been the first of a series of five operas, but the revolution came and the new government cancelled the contract. It thus became his last opera.

The sudden cessation of such a strong creative current can hardly be explained either by natural laziness, which has been ascribed to him, or by jealousy of his almost exact contemporary, Meyerbeer. The cause may have been the same psychological disturbance which was eventually to affect his mind and health. But meanwhile he settled down to a relaxed life in Paris. 'He has the disposition to be found only in people from the south', wrote a contemporary, Ferdinand Hill. 'For children as well as for the old, for the mighty as well as for the humble, he always finds the right words without changing his manner. He is one of those happy creatures born with everything and in whom all modifications occur naturally and organically.'

Modifications did occur over the years. In 1845 his wife died. Two years later he remarried. He turned from a vital creative artist into an institution. His powers began to fail and he became vague and weak. He was too ill to attend a season of his operas at the Théâtre Italien or his *Stabat Mater* in March 1856. He struggled to Germany for a cure and returned to Paris well enough to enjoy being serenaded by Alfred Musard's dance orchestra. It was probably about this time that he visited Nadar's studio, 'an old bit of rococo', as he described himself, with twinkling eyes and his well-known wig (which he said he wore only for warmth, sometimes two on top of each other) neatly combed. He was to live on, cheerful but ailing, for another twelve years.

Photograph circa 1856

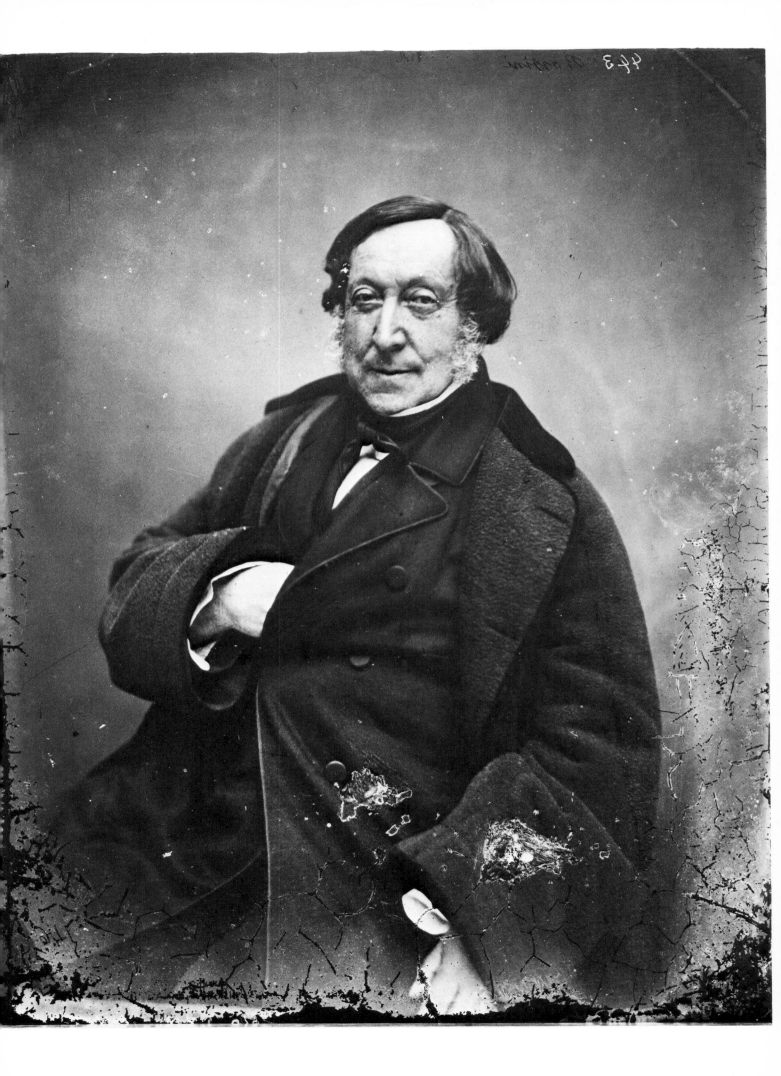

Théophile Gautier

1811–1872

NADAR photographed Gautier several times at the very start of his career, in his studio in the rue Saint Lazare. They had become friends during Nadar's earliest days in Paris when he invited the already celebrated writer to contribute to his magazine *Le Livre d'Or*.

Born in Tarbes in the Pyrenees, Gautier was the son of a tax officer. But his family moved north when he was only 3 and he grew up a complete Parisian. Starting his education in the Lycée Louis-le-Grand, he continued it as a day-boy in the Lycée Charlemagne where he became the close friend of another clever boy, Gérard de Nerval – a friendship lasting until the tragic death of the poet.

After school he decided to be a painter and entered the studio of L. E. Rioult. Here, according to Commerson in his sketch of Gautier in *Les Binettes* of 1860 (for which Nadar did the drawings), 'he concentrated on form and contour', in other words on the classicism of Ingres. Evidently the discipline did not suit him at this age (though it may have served him for his later Parnassian period), for he abandoned art for literature, and Classicism for Romanticism. At 19 he became famous for the zeal with which he applauded Victor Hugo's play *Hernani*, which was regarded as a clarion call for Romanticism, and for the red waistcoat which he wore on this occasion (later he insisted that it was merely russet). In the same year, 1830, he published his first poems.

Soon he was installed in a studio behind the Louvre which he shared with de Nerval, a painter, and innumerable cats, and which became a meeting place for young writers and artists. Boisterous and friendly he had huge appetites in every way – nothing in art, he told Doré, was as beautiful as a woman. He had the vitality of 'a hairy Basque fresh from the woods and mountains', as Houssaye described him, and a colossal appetite for work. In 1835 he finished a novel in six weeks; it was called *Mademoiselle de Maupin* and proved a popular success, perhaps because of its striking new message: 'Only what is useless is beautiful.'

The next year he joined *La Presse* and became the most powerful critic in Paris. His views on the theatre and on ballet were expressed in elegant prose which he wrote rapidly and with hardly an alteration. In 1841 he collaborated on the most famous of all Romantic ballets, *Giselle*, and became equally respected in the worlds of literature and art, always remaining the idol of the young. In 1849 he met Baudelaire for the first time and a close relationship began; together they helped to form the 'Club des Hashischiens' where they experimented with drugs. Baudelaire complained that 'nobody but Gautier understands me when I talk of painters and painting', and dedicated his *Fleurs du Mal* to him as 'le maître impeccable'.

But Gautier's romantic vein was passing. In 1852 he published *Emaux et Camées*, a collection of verses cut and polished like diamonds, and became a leader of the perfectionist Parnassian school. He travelled freely, in England, Spain, and later, in 1858, in Russia (after which Nadar photographed him in a fur hat). He joined *Le Moniteur* and took on the editorship of the influential *L'Artiste*. He turned out a flood of novels, travel books, criticisms, plays, and poetry, and became a familiar figure in the literary salons, giving enormous and eccentric parties himself in his villa at Neuilly. The Goncourts describe a dinner with twenty guests speaking forty languages, including Chinese – and there was often much singing and dancing, with Flaubert doing comic *pas de deux* with his host.

This portrait was taken during these happy years. They lasted right up to the 1870 war, his novel *Capitaine Fracasse* scoring a late success in 1868. But the siege of Paris and the defeat of France broke his health and spirit. He died in 1872.

Photograph circa 1856

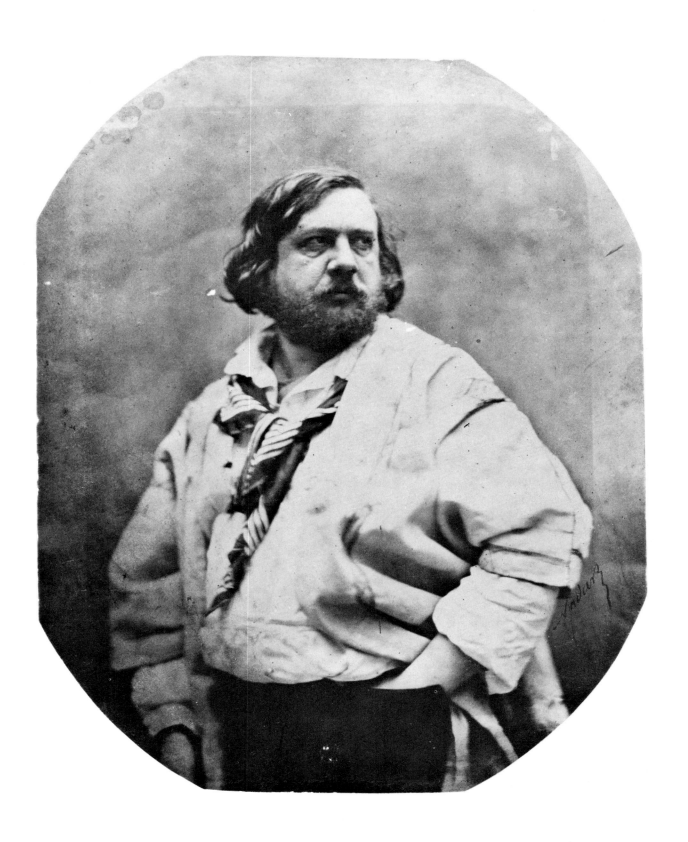

Marceline Desbordes-Valmore

1785–1859

Aminor poetess with a gift for vague melancholy, Madame Desbordes-Valmore was a whole generation older than Nadar and probably about 70 when this photograph was taken. Very different from his robust male portraits, it conveys something of her gentle personality and the frail charm of her poetry.

She was born in Douai and became an orphan in her childhood when the Revolution wiped out her family. To support herself she joined the theatre, but her sensitive, introverted nature seems to have been quite unsuited to show business, and after an unhappy love affair which caused her great suffering she married a mediocre actor called Lanchantin. She had several children by him and remained a devoted wife.

She seems to have been plagued by minor misfortunes and consoled herself by writing poetry: *Elégies et Romances* (1818), *Elégies et Poésies Nouvelles* (1824), *Les Pleurs* (1833), *Pauvres Fleurs* (1839) and *Bouquets et Prières* (1843). The titles suggest her prevailing mood, which leaned towards a refined and rather conventional pathos. But the feeling behind her writing was genuine, and she had a musical ear which gave her lines a simple, languorous grace which was to appeal strongly to later tastes. Robert de Montesquiou, the literary dandy of the nineties, planned a poetic monument to her memory, and Verlaine claimed that he was influenced by her.

Ma Chambre	*My Room*
Ma demeure est haute	My dwelling is lofty
Donnant sur les cieux	And gives on the sky
La lune en est l'hôte	The moon is my host
Pale et sérieux	Pale and serious:
En bas que l'on sonne	Down below a bell rings,
Qu'importe aujourd'hui?	What matter, today?
Ce n'est plus personne	It is no one at all
Quand ce n'est pas lui!	If it is not he!
Aux autres cachée	Hidden from others
Je brode mes fleurs	I embroider my flowers;
Sans être fâchée,	I show no grief
Mon âme est en pleurs:	But my soul is in tears;
Le ciel bleu sans voiles,	The clear blue sky,
Je le vois d'ici:	I can see it from here;
Je vois les étoiles:	I can see the stars;
Mais l'orage aussi!	But also the storm!
Vis-à-vis la mienne	Opposite mine
Une chaise attend:	A chair awaits:
Elle fut la sienne	Once it was his,
La nôtre un instant:	For a moment ours:
D'un ruban signée,	Marked by a ribbon
Cette chaise est là,	The chair stands there,
Toute resignée	Resigned
Comme me voilà!	Like me.

Photograph circa 1857

Farouk Khan

d.1871

WHEN the Shah of Persia first opened an embassy in Paris in January 1857 Farouk Khan was appointed Ambassador. Two months later the new envoy signed a peace treaty with Lord Cowdray, the British Ambassador, to end the current hostilities between their two countries. He was recalled the following year to become a minister in Teheran. His birthdate is unknown, but it is recorded that he had three sons and died in 1871.

Photograph circa 1857

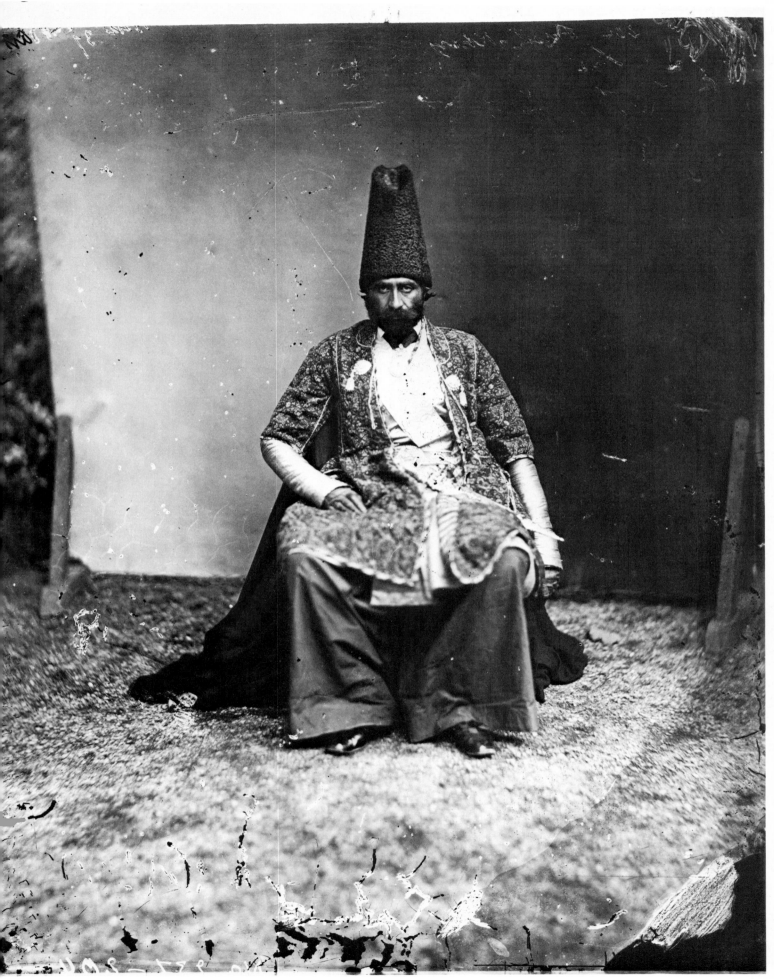

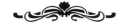

Alexandre Dumas (*père*)

1802–1870

OF all the figures in Nadar's gallery of portraits, the most characteristic of his period and circle is Alexandre Dumas – known for most of his career (to distinguish him from his almost equally celebrated son) as 'Dumas *père*'. Phenomenally hardworking, inventive and productive, blessed with a thousand talents and no genius, he was a one-man literary industrial revolution.

Curiously, he was a slow starter. His father, a general in Napoléon's army and the bastard son of a negress, died in 1805. Alexandre was given a sketchy education which led to a humble job as lawyer's clerk. At the age of 21 he came to Paris through the interest of an old army friend of his father. Three books resulted, and two plays written in collaboration. His first success came when he was 27, with a historical drama called *Henri III et sa Cour*. The next year, 1829, saw another collaborative success (this time with Victor Hugo and de Vigny), but the political upheavals deflected him from his writing career. He entered enthusiastically into the rioting, so much so that after their success he was sent into the provinces to organize support for the new régime.

But for Dumas the excitements of politics seem to have been more important than the principles, and he was recalled. Abandoning contemporary preoccupations, he plunged into historical romance, in which his gifts for dramatic plots and lively dialogue quickly made him a reputation. After writing a play about Napoléon he had to leave France for his health, but on his return he made a popular hit with *La Tour de Nesle*.

He was now established as a dramatist. In 1837 Gérard de Nerval called him in to help him write an operetta for his beloved Jenny Colon, and two years later they together produced *L'Alchémiste*. From then on he turned out a play every year, sometimes more, besides a torrent of novels, articles, and stories. His industry became proverbial; 'he works non-stop, produces punctually day or night and aims only at the posterity of tomorrow', wrote Commerson in the *Binettes,* which Nadar illustrated.

At the same time he led an active private life and mixed freely in society. Too old to join the bohemian gatherings in the cafés (he was anyway a teetotaller) he was an ubiquitous guest at theatres and receptions. Ebullient and kind-hearted, he was not embittered by the condescension with which the literary world treated his work. He was happy to be a best-seller. This status was conferred decisively on him in 1844 and 1845 during which he produced the picaresque stories by which he is still best known – *Les Trois Mousquetaires, Le Comte de Monte Cristo*, and *La Reine Margot*. In 1847 he was appointed director of the Théâtre Historique, where he could mount adaptations of his own novels.

But the events of 1848 fired his political imagination once again. He joined actively in the revolution, and even became a candidate for the Assembly. After the *coup d'état* he felt obliged to exile himself to Brussels, where he spent his time writing his memoirs. He returned to Paris in 1854 and it was not long after (in 1857, as we know from a letter) that this photograph was taken. He resumed his career with unabated energy, a well-loved celebrity; when Nadar founded his Société des Aéronautes in 1866 Dumas gallantly became a member. But he was hardly in a state to go ballooning. His son had taken over his mantle as supplier of entertainment to the public, and four years later he died.

Photograph 1857

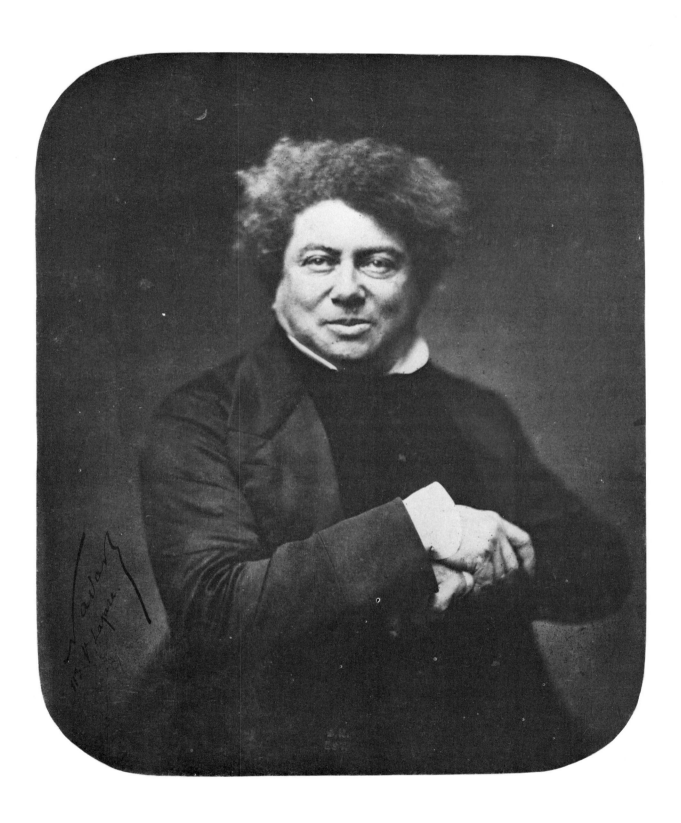

Jean François Millet

1814–1879

NADAR'S tastes in art were flexible. He detested the classical coolness of Couture and Ingres (quoting with approval Préault's description of the latter: 'a Chinaman lost in Athens'), worshipped the colourful romanticism of Delacroix, and admitted almost unwillingly the realistic power of Courbet. In the last his democratic sentiments must have struggled with his love of drama and movement. It may have been the touch of sentimentality which creeps into some of Millet's painting and his touchingly unaggressive temperament which melted Nadar's heart. At all events he showed himself more perspicacious than Baudelaire in accepting the Realists and especially Millet whom, in his 'Nadar - Jury' on the Salon of 1857 (where Millet had exhibited his *Gleaners*), he praised unreservedly as 'one of the most sincere talents of the French school'. It was very likely that he took this portrait at this time.

Millet had brought to the Parisian art scene a breath of country air even more pungent than that of Courbet (five years his junior). He had been born in Normandy into a peasant family and he worked in the fields all his childhood and youth. But he showed artistic talent and entered a painting studio in Cherbourg. At 23 he came to Paris and entered the École Supérieure des Beaux-Arts where he acquired skills which he employed in portraiture, and then in sensual nudes and pastiches of Italian painting with titles like *An Offering to Pan*.

He was a slow developer and it was not until 1844, when he was 30, that he surprised the Salon public with a study of the subject which he was to make his own – peasant life. The picture was called *La Laitière* and it was followed four years later with another sample of rustic realism, *Le Vanneur*. He was now dedicated to the celebration of the dignity of manual labour, and this was accentuated the next year, 1848, when he withdrew to a village outside Paris on the edge of the Forest of Fontainebleau, Barbizon, to escape from an outbreak of cholera.

Poor, serious and unsophisticated, he never returned to the feverish café society of Paris but became the centre of a whole circle of landscape painters (of which Théodore Rousseau, a loyal friend and helper, was one) who acquired the name of the Barbizon School. From this retreat he sent in to the Salon a series of paintings like *The Gleaners* and *The Angelus* which began to attract public favour. In 1862 the Goncourts were noting in their *Journal*: 'It is amazing the way in which Millet has caught the outline of the peasant woman – a woman of toil and weariness . . . no hips, no bust, a worker in a sheath, the colour of which seems to come from the two elements in which she lives, the brown of the earth and the blue of the sky.' He was to have a powerful influence on van Gogh and, later, on Socialist Realist art.

Photograph circa 1857

'Rosine' Stoltz

1813–1903

APART from Rachel and Bernhardt, Nadar photographed few actresses (he never, for instance, did a portrait of Marie Dorval, the famous friend of George Sand) and few singers. 'Rosine' Stoltz is an exception, though he did not photograph her until her singing career was over. He caught very vividly the tigress element in her character and her art. Rose had been born in Spain and brought as a child to Paris, where her mother, Madame Niva, became a concierge in the Boulevard Montparnasse. She must have been a persuasive woman for she contrived to convince an acquaintance, the Duchesse de Berry, that the coincidence of her husband's death and little Rose's birth was a reason for patronage. The Duchesse took the child under her protection and arranged that, besides her normal education at a convent, she should attend the Conservatoire.

Rose scored some success as a singer in the concerts given by the pupils between 1829 and 1832, especially in the role of a character called Rosine, whose name she adopted professionally. In 1834, at the age of 21, she embarked on a tour of Belgium and Holland, singing in such famous operas as Meyerbeer's new *Robert le Diable* and Rossini's *Il Barbiere di Siviglia*. A strong contralto, she was never very proficient technically but her dramatic acting and fiery temperament brought her success and she was engaged by the Théâtre de la Monnaie in Brussels from 1835 to 1837, returning in triumph to make her debut at the Paris Opéra in 1838 as Rachel in *La Juive*. (It was probably from this performance that the actress Rachel took her stage name.)

She scored further successes in *Les Huguenots* and as Donna Anna in Mozart's *Don Giovanni* and clinched her reputation when the part of Leonore in Donizetti's *La Favorita* was written for her. She remained the acknowledged star of the theatre for seven years with a salary of 60,000 francs a year, fighting off rivals with every weapon. But finally during a performance of *Robert Bruce* her voice faltered and she was greeted with boos; she left the stage – and the theatre – in a fury.

A few years later, in 1856, she returned for a final appearance in *La Favorite* and then retired. The following year she took over the direction of a variety theatre, the Delassements Comiques, the step which probably inspired this portrait. But her relations with her star, the celebrated mime Debureau, caused scandals (Baudelaire, who dedicated one of the poems, 'Le Martyre', in his *Fleurs du Mal* to her, accused her also of lesbianism) and the venture failed. She survived for many years, having been married several times – to M. Lecuyer in Brussels, to M. Stoltz, and finally to the Prince de Godoy.

Photograph circa 1857

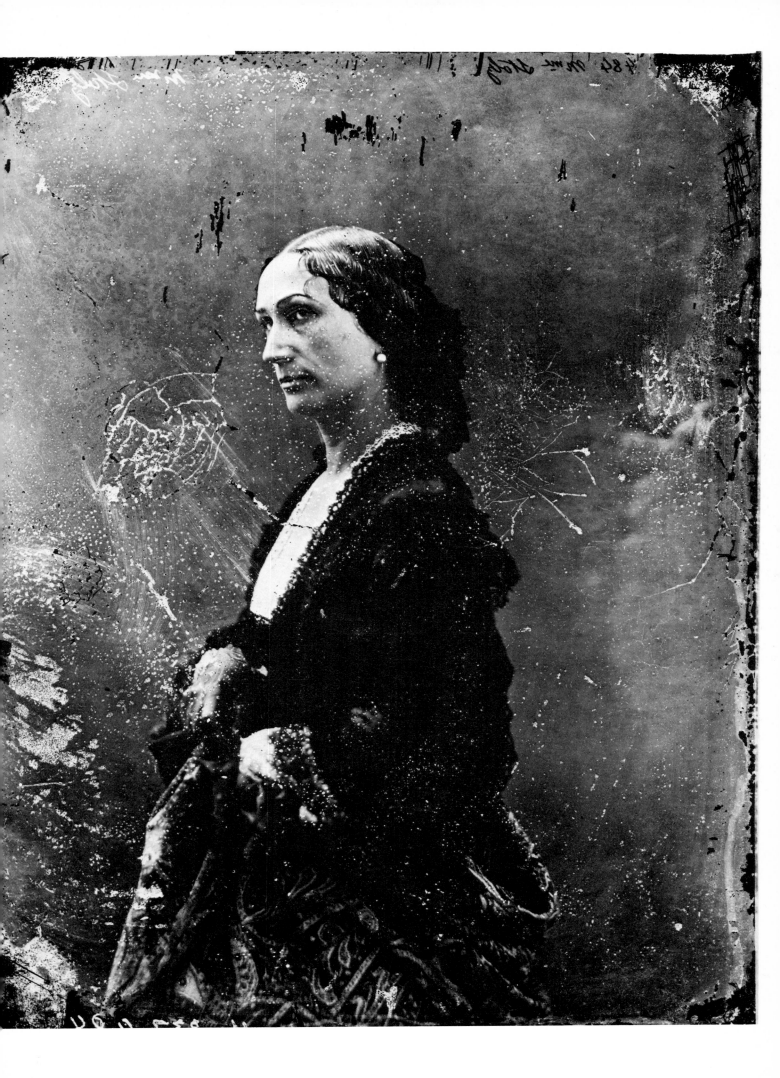

Paul-Marc-Joseph Chenavard

1807–1895

CHENAVARD had a long career as a painter, culminating in official honours – he was made an Officer of the Légion d'Honneur at the age of 80 – but clearly failing to achieve his artistic aims. He was (like Gustave Doré) an example of an artist misled by fashionable idealism into pitching his ambitions to levels which brought only disappointment. He was the son of a well-to-do Lyon industrialist and entered the École des Beaux-Arts in Paris when he was 18; he studied in the ateliers of both Ingres and Delacroix and seems to have tried to combine the cool discipline of the first with the romantic fire of the second. The result was, in fact, something nearer to German 'Nazarene' painters like Cornelius and Overbeck, with whom he shared a lofty philosophical idealism.

He spent his private income on trips to Rome, where he made copies of the Italian school, and on his return to Paris he embarked on enormous canvases which often remained unfinished. He succeeded in having one of them, a historical scene, accepted for the Salon of 1833, but unfortunately it contained the likeness of 'Philippe Egalité' chatting to the revolutionary Marat, and King Louis-Philippe demanded that it should be withdrawn.

Discouraged by this setback, Chenavard turned his interests towards history and social philosophy, in which he became a follower of the teachings of Guizot and Victor Cousin at the Sorbonne. He worked out an aesthetic in which art would become an agent of civilization and humanitarianism. To illustrate his theory he proposed a series of enormous drawings and, to equip himself for this massive undertaking, embarked on an extensive tour of the museums in Italy, Germany, Belgium, Holland and Spain.

In the Salon of 1841 he illustrated *The Martyrdom of St Polycarp* and in 1844 exhibited a large *Hell* in the style of Michelangelo. He welcomed warmly the noble sentiments of the 1848 Revolution and immediately formed the idea of covering the whole interior of the Paris Panthéon, the national memorial shrine, with colossal decorations depicting the complete history of humanity. The dome was to be supported by statues of Homer, Plato, Galileo and Moses and allegorical panels would adorn the entire structure.

He set to work enthusiastically on the scheme, drawing as payment only ten francs a day for himself and each of his assistants. He toiled for three years and was making good progress when, in 1851, the *coup d'état* overthrew the Republic, the Panthéon was made over to the Church, and all his schemes were abruptly abandoned. The only consolation to be derived from this catastrophe was to be made a Chevalier of the Légion d'Honneur (1853) and the award of a Gold Medal, for the now unneeded drawings, at the Universal Exhibition of 1855.

Though he was to contribute to one more Salon, this last blow had extinguished his ambitions as an artist, and he devoted the rest of his years to travel and philosophy. He was more gifted as a theoretician than as an executant – a contemporary critic, Théodore Sylvestre, called him 'an orator in paint' – but pictures like his enormous *Divine Tragedy* for the 1869 Salon are extremely competent, and he had some influence on critics like Thoré and Gautier. When he died in Paris in 1895 he left his collection of paintings to his native Lyon and his fortune to a fund for indigent artists.

Nadar's photograph – one of the most dramatically psychological of all his portraits – was taken in 1857 as we know from a note by the photographer. The melancholy of disappointed ambition is evident in the features of the gold medallist.

Photograph 1857

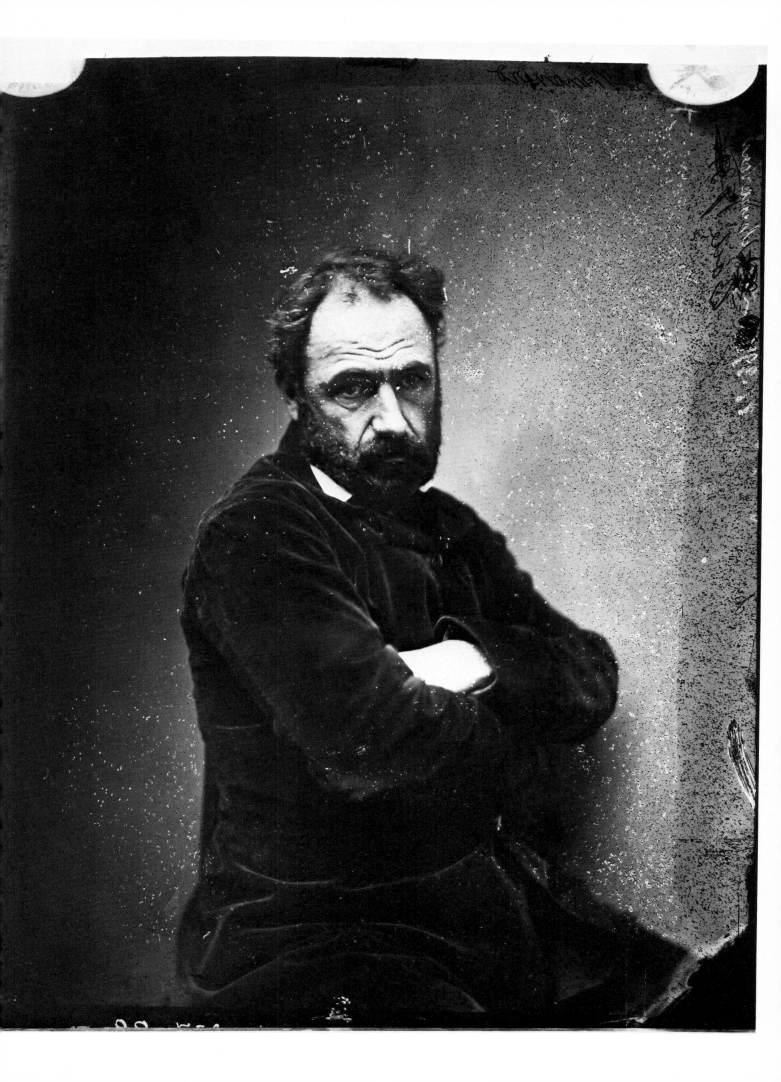

Jean Journet

1799–1861

THE pose of this eccentric sitter is too melodramatic to have been adopted by a professional actor. Jean Journet called himself 'the Apostle' and had cast himself quite sincerely as an evangelist, elected to carry the time-honoured message of salvation through brotherly love into the troubled world of nineteenth-century France. He was a familiar figure round the cafés of Paris when Nadar was a young man, but this portrait must have been taken in his last years, perhaps after the publication of his *Poèmes et Chants Harmonieux* in 1857 or his *Documents Apostoliques et Prophéties* in 1858.

Journet had originally arrived in Paris to study pharmacy, but he became involved in a revolutionary secret society called 'I Carbonari' and had to flee to Spain. There he joined the Army of Independence but was captured, brought back to France and imprisoned at Perpignan. After eighteen months he was acquitted, married, and settled down nearby as a chemist.

But a book by the socialist writer, Claude Fournier, fell into his hands. Journet's impressionable nature was fired, he set off to Paris to visit the author (whom he found ill and impoverished) and determined to abandon his family to preach the revolutionary gospel throughout the land. He settled in Paris and supported himself by selling brochures to the public; but when he delivered a shower of them from the gallery during a performance at the Opéra in 1841 he was seized, consigned to an asylum at Bicêtre (later to be the scene of Nadar's first aerial photograph) and rescued only through the good offices of a descendant of the famous balloonist, Montgolfier.

Undeterred by this mishap, Journet decided to concentrate on the power-holders in society, and travelled around presenting to them his message: 'Prosperity, order and liberty can be achieved for all only by harmonious cooperation between all'. He had little success with high officials but some writers like Chateaubriand, Hugo, and Lamartine combined to give him a small income. In 1849 he had another brush with the authorities when he repeated his pamphleteering, this time in the Théâtre Français, and found himself back in Bicêtre. He was soon released – he had many sympathizers in Paris, such as Courbet, who painted him as an apostle in 1851 – and rejoined his family in the country. He returned occasionally to visit his bohemian friends in Paris and died there in 1861, leaving affectionate memories and a number of writings with titles like *Cris d'Indignation* and *Cris de Détresse*.

Nadar never lost his admiration for him. He wrote:

> I felt a profound sympathy for the goodness of his heart, an immense respect for this unshakeable spirit whom I had seen so often mocked and insulted by miserable wretches, and finally I felt a kind of naturalist's curiosity about the admirable obstinacy which never left him for a second during the thirty years of his impossible struggle.

Photograph circa 1857

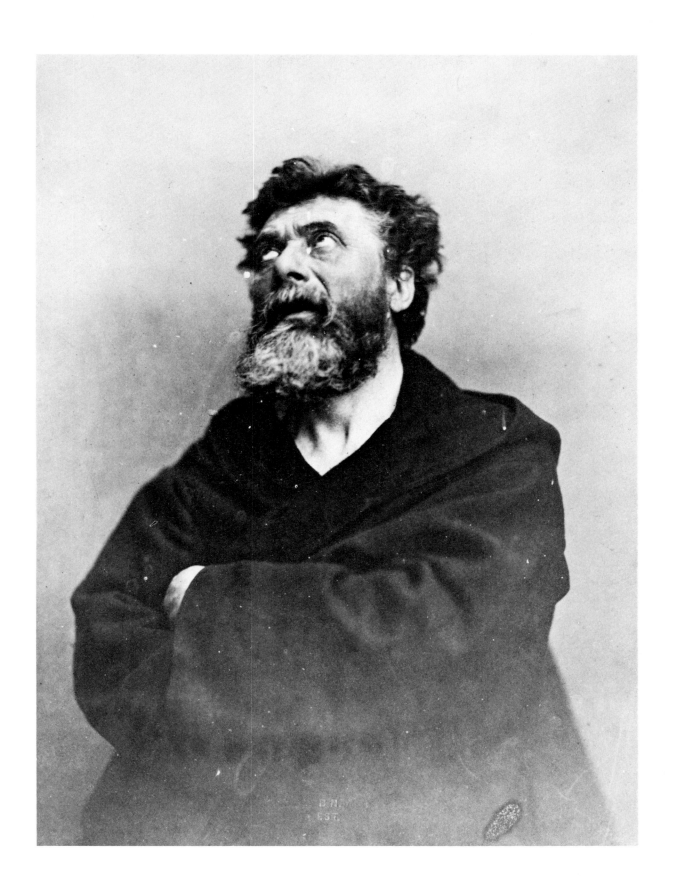

François Guizot

1787–1874

GUIZOT was born into politics; his father, a Protestant lawyer in Nîmes, was executed under the Terror and it was his mother who took him to Geneva to be educated, where he seems to have absorbed an atmosphere of moderation and tradition.

Already married at 25, he was appointed to the Chair of Modern History at the Sorbonne in Paris and became famous for his lectures, in which he put forward the idea of a limited monarchy somewhat on the English model. In 1814 he joined the administration of the newly restored Bourbons as Secretary-General of the Minister of the Interior. He followed Louis XVIII to Ghent during the Hundred Days of Napoléon's attempted return, and as a reward was made Secretary-General to the Minister of Justice. His moderation was not heeded and the régime ended abruptly in 1830. Guizot accepted the new Orleanist régime and became responsible for Education, in which he effected many reforms. He was noted for his eloquence in which he was matched only by his colleague Thiers, whose views were somewhat to the left of his own.

In 1840 Thiers became Premier and Guizot was moved abroad, becoming Ambassador in London. But Thiers' policies ended in alienating Britain, and the king, alarmed at France's isolation, recalled Guizot to be premier. In the next few years he set the tone of the régime of Louis-Philippe, which was marked by vigorous policies abroad and the encouragement of peace and prosperity at home. 'Get rich through work and saving', he advised – and he staunchly backed the middle classes, believing that with property came responsibility.

But in 1847 financial scandals were followed by a severe economic crisis, and the next year, 1848, the whole régime suddenly collapsed in the face of attacks from the left. Guizot fled to London, where he turned to the study of history, especially that of the Cromwellian revolution in England. He was able to return to France after only a year, but took no further active part in politics. He retired to Normandy and published some of the books on which his reputation mainly rests, besides nine volumes of memoirs. He supported the war of 1870, and died soon afterwards.

An austere and upright man, his policies paradoxically led to greed, materialism, and corruption. 'He gives me the impression of an honest woman running a brothel', wrote Victor Hugo in *Choses Vues*. Hardly one of Nadar's heroes (though he had drawn him for his 'Panthéon' of 1854), this photograph shows him posed as a celebrity; it may have been taken as an aid to Nadar's caricature in Commerson's *Binettes* of 1858: in that year the Goncourts mention seeing a copy of it. By this time he was more writer than politician.

Photograph circa 1857

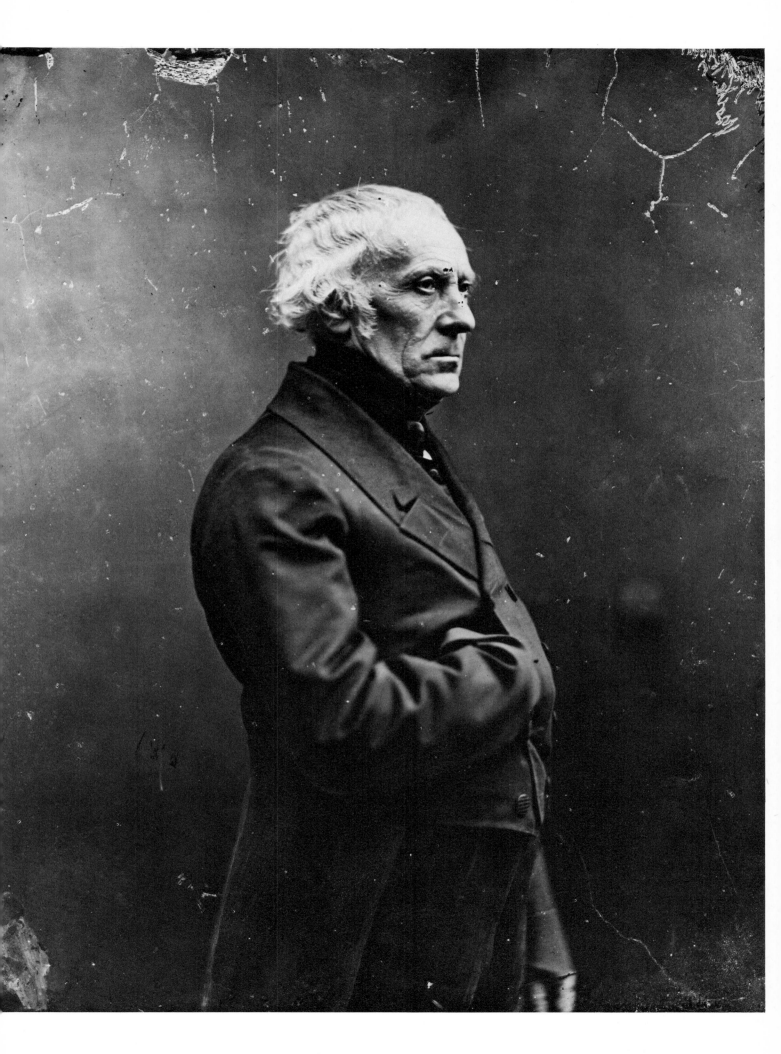

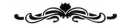

Athanase-Laurent Coquerel

1795–1868

IT must have been politics, or at least shared views on society, which linked Nadar with Coquerel, a man of egregiously pious and puritan virtues. He had had an English mother called Cecile Williams, and when both his parents died in his infancy, he and his younger brother were brought up in England. He was given a strict Protestant education, which was continued in Geneva.

When his training was finished he was offered the curacy of St Helier in Jersey; but his conscience would not stretch so far as to allow him to accept the doctrines of the Church of England, and he refused.

Instead he went in 1817 to Paris where he became an assiduous and popular preacher. He was also in demand in Holland; his collected sermons were published in Amsterdam. In 1832 he was appointed chaplain at the Collège Henri IV and an intensely active career began. It has been calculated that in fifty years he preached 1600 sermons, besides publishing many pious books and pamphlets.

He was a staunch republican and after 1848 was elected a member of the Assembly, in which he spoke in support of solidly liberal measures such as public assistance and the abolition of the death sentence. The *coup d'état* of 1851 ended his political career and he returned to church affairs. It was during this strictly benevolent period, when which he no doubt moved in the left-wing circles frequented by Nadar, that this photograph was probably taken. He took on an assistant in 1863 and retired in 1867. He died the next year, leaving a younger brother, Charles-Augustin, who also wrote religious books as well as helping Philarète Chasles to found the *Revue Britannique,* and a son who wrote his biography.

Photograph circa 1858

Eugène Delacroix

1798–1863

IN a postscript to his 'Nadar au Salon de 1857' Nadar wrote of Delacroix:

I do not know if it is necessary to avow here my warm respect, affection and admiration for this great genius. There would only be the danger of repeating the many magnificent appreciations which have been made of him, which will remain for ever as resplendent reminders of the first pilgrims who opened up the way – Thiers, Haussard, Michiels, Thoré and, above all, in one of the finest pieces of writing on art in existence, 'The Salon of 1846', by Charles Baudelaire A little canvas by Delacroix tucked away in the corner of a gallery among two hundred paintings would draw me to it straight away, even if my back was turned to it.

Such praise was not new at this stage in the career of Delacroix and Baudelaire, but it was still not bestowed by everybody. Nadar was a real child of Romanticism and he became a passionate champion of Delacroix's worship of colour and movement as opposed to what he found the cold artificiality of Ingres.

Delacroix was born at Charenton in 1798 into a family of slightly shadowed distinction; his father was Ambassador in Holland, a post which he had received from Talleyrand. The appointment coincided significantly with Talleyrand becoming Mme Delacroix's lover, and it is fairly certain that it was the famous statesman who was the real father of Eugène.

He was educated at the Lycée Louis-le-Grand, lost his father, mother, and eldest brother, and entered a private studio as a pupil at the age of 17. Thence he moved to the Beaux-Arts, from which he had to withdraw owing to bad health; the turning point came when he entered the studio of Géricault the next year. Here he found a strong influence, a friend, and a patron.

He was a success from the beginning. His *Dante et Virgile* in the Salon of 1822 was a sensation, and he was picked out by Thiers (then an art critic) in an article in the *Constitutionel*. In 1824 his *Massacre at Chios* was bought by the state. In 1827, with his *Death of Sardanapulos* – 'my second massacre', as the artist joked – he reached the turbulent summit of his generation's obsession with mingled sex and death.

From then on he was the centre of the battle between the rival supporters of the Romantic, Classical, and Realist schools, irresistibly successful but always a target. He suffered from the controversy, but his talent and energy were undeniable and in the Universal Exhibition of 1855 he was given a special room to himself. Two years later he was commissioned to decorate the baptistry in the church of Saint Sulpice.

But the agitations of the Paris art scene affected his always delicate constitution and in 1858 he bought a house in the Forest of Sénart outside the city – Nadar was later to take refuge nearby. The labours of his commission and the daily journeys put a strain on his health as this photograph shows. Its haggard and portentous dignity – perhaps designed to illustrate an article by Louis Blanc who had commissioned the Saint Sulpice decorations – did not please Delacroix who wrote to Nadar (9 July 1858) begging him 'in heaven's name' to destroy the plate. Not only did Nadar not carry out these instructions, he used the picture as a basis for his lithograph portrait in his new 'Panthéon' sheet. Delacroix himself often used photographs as aids to his figure studies.

His declining strength and the continuing attacks of many critics are movingly recorded in his *Journal*. In his last six months he shut himself up in his studio, guarded by an old housekeeper, and died in 1863, as Edmond de Goncourt remarked, 'like a dog in his hole'.

Photograph 1858

Juliette Adam

1836–1936

THE daughter of a doctor, Juliette Lamber started writing soon after her first marriage, signing herself 'Juliette de la Massine'. She had a considerable success with a tale called *Blanches de Coucy*, which was published in 1858 and was doubtless the reason for this portrait. She followed this the next year with a life of Garibaldi, in 1860 she was writing on the Papacy, and in 1862 she published a book with a title which was to become famous, *War and Peace*, besides a feminine protest called 'Idées anti-Proudhonniennes sur l'Amour, les Femmes et le Mariage'.

In 1868 she married again, this time to a prefect of the police called Adam. She continued writing stories and a play under her new name, and in 1879 founded the *Nouvelle Revue*. She was still editing it in 1889, and lived to be one hundred years old.

Photograph circa 1858

Jean-François Berthelier

1830–1888

A star of light entertainment, Berthelier was the son of a solicitor from the Loire Valley. He started soberly in a bookshop in Lyon but his natural performing gifts led him into the world of the café-concert, first there and then in Paris. He was spotted by Offenbach, the new director of the Bouffes Parisiens in the Champs-Elysées, and in 1855 he made his debut, with huge success, in *Les Deux Aveugles*. It was doubtless during this season that he sat – or rather stood – for his portrait, which was photographed in the studio in the rue Saint Lazare.

He was later engaged by the Opéra Comique for a time, then returned to the Bouffes Parisiens. After seasons with the Variétés and the Palais Royal he joined the Renaissance theatre in 1877 to appear in operettas. His later career included work at the Nouveautés (in 1879) and the Gaieté (in 1887). He had a dry, cool style which was supported by a voice which, though small, was subtle and true.

Photograph circa 1858

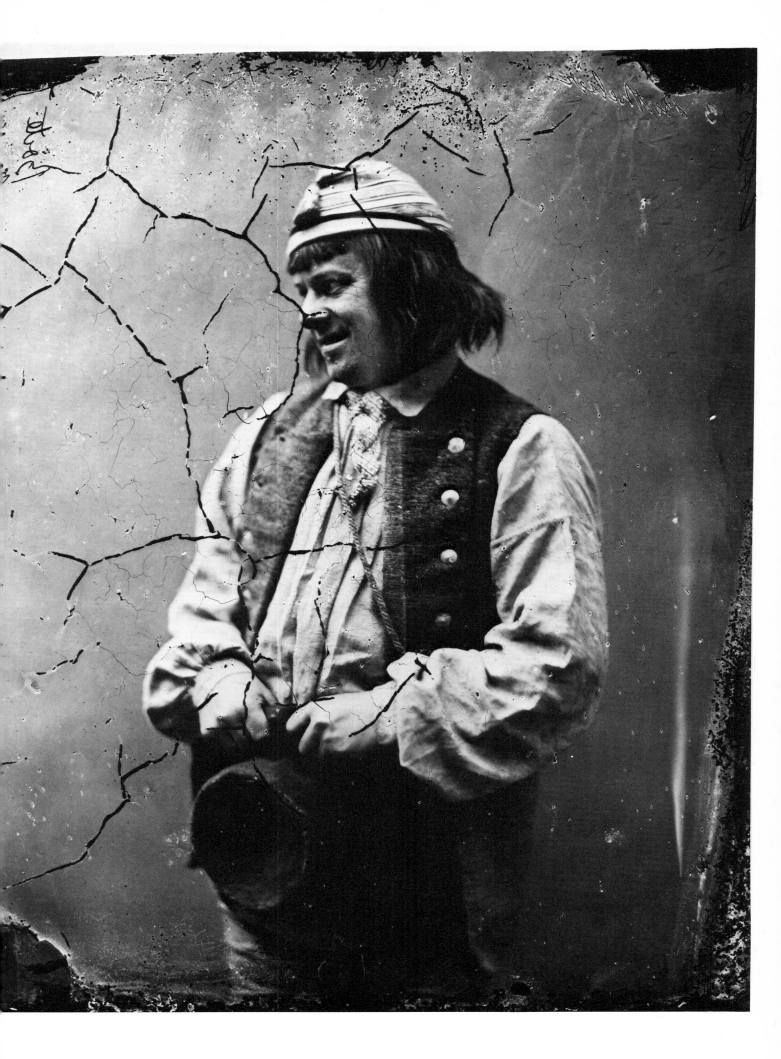

Pierre-Alexis, Vicomte Ponson du Terrail

1829–1871

BORN near Grenoble, Ponson du Terrail was intended for the navy, but he had literary inclinations and, after a short experience of activity as a *garde mobile* during the 1848 revolution, devoted his life to writing. He published his first work at the age of 21, and two years later scored a public success with a novel, *Les Coulisses du Monde*.

He was now launched and contributed to many journals, besides publishing several more novels, including *Les Cavaliers de la Nuit* (1855), *Bavolet* (1856), and a vast series in several volumes called *Les Exploits de Rocambole*. It was just before this achievement, perhaps his most successful, that this portrait was taken, as we know from a letter. He was an assiduous worker, having nearly thirty books to his credit, but he never lost his aristocratic habits. He would rise at four in the morning and write until ten; after that the day was given over to the pursuits of a healthy country gentleman. His last exploit, in fact, was to raise a band of volunteers on his property near Orléans against the invading Germans, in 1870.

Photograph 1858

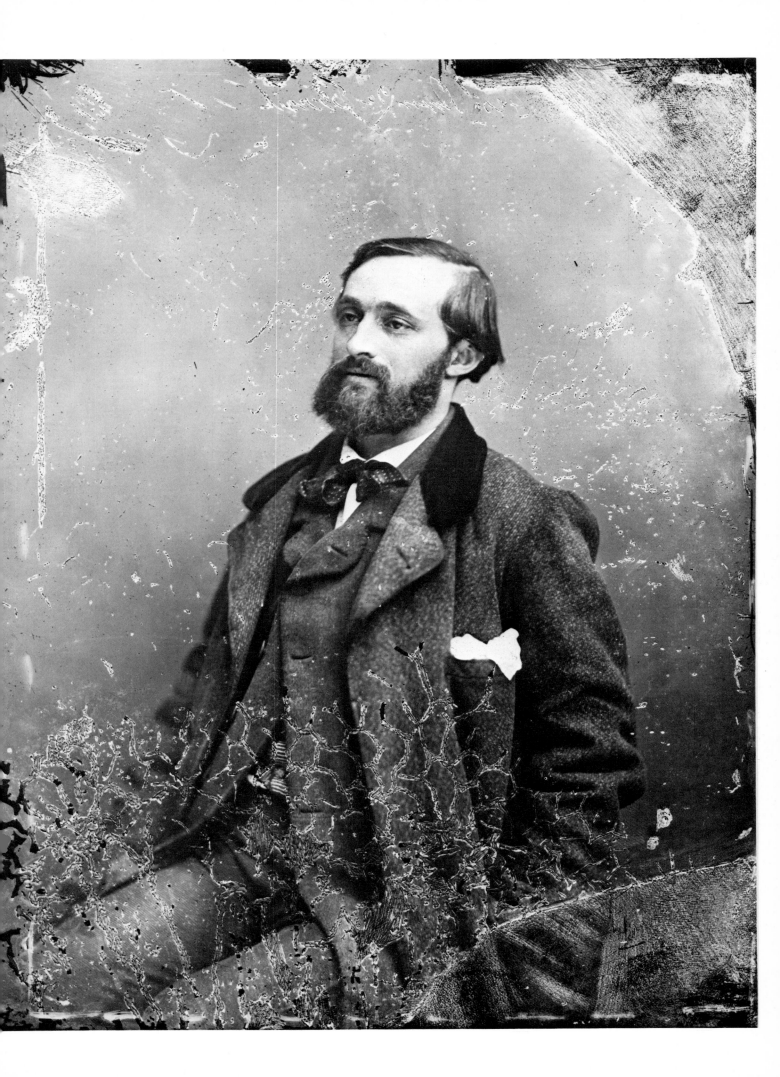

Alphonse Karr

1808–1890

NADAR first met Alphonse Karr in 1848, as Karr himself related: after founding *Le Journal* that year,

> I hastened to seek out Gérard [de Nerval] who for several months had helped me with both talent and affection. He produced Félix Tournachon who had just returned from an expedition against Germany and Russia Tournachon was in charge of the miscellany in the paper but Gérard kept a close watch on him; for some reason he had a profound dislike of Lamartine, perhaps because he had not supported the Polish expedition. Anyway, he came back one night to insert some aggressive lines attacking Lamartine He expressed the most violently anarchic political opinions, but he was an excellent fellow for the rest, amusing, honest and devoted to his friends.

They had already been colleagues. Nadar had invited him to contribute to his *Livre d'Or* in 1839 and in 1846 they worked together on the *Corsaire-Satan*. Karr was twelve years older than Nadar and already an experienced journalist when they met. He had been born in Paris into the family of a Bavarian pianist and minor composer, and became a pupil at the Collège Bourbon, where he stayed on as a teacher. But he soon began to write articles for *Le Figaro* and in 1832 he published a novel, *Sous les Tilleuls*, which enjoyed a popular success, being described as combining 'the caprice of Sterne with the passion of Rousseau'. He had struck a personal note – a mixture of charm and sentiment – which made him a favourite novelist among the young, and for several years he turned out one a year. 'He does not believe in women but he believes in love', wrote Gautier. 'He intoxicates, so why bother about the bottle?'

He was a born journalist with a quick brain and a mischievous pen. In 1835, after a marriage which ended in some scandal, he became the director of *Le Figaro*. In 1839 he founded his own paper *Les Guêpes* in which he stung his contemporaries with satirical attacks. (It had been these disrespectful articles which no doubt tempted Nadar to invite him to work for his *Livre d'Or*.)

In 1848 he stood unsuccessfully for the Constituent Assembly, and it was in this year that he founded his *Journal* and engaged Nadar and de Nerval. After the *coup d'état* of 1851 he fled to Nice (then independent). When it was annexed in 1860 he embarked on a business involving the cultivation of violets and selling them in Paris. In 1853 he was back in Paris writing for the Goncourts' literary review, *Paris* (a job which almost immediately landed him in a lawsuit), and the same year he joined *Le Siècle*. It was at this period that he sat for Nadar.

He tried his hand unsuccessfully in the theatre, but continued his journalistic articles, which were eventually collected into more than a dozen volumes. He was an entertainer rather than a thinker, but he could wound as well as tickle: on one occasion the lady writer Louise Colet, whom he had offended, was driven to attack him with a knife.

Photograph circa 1858

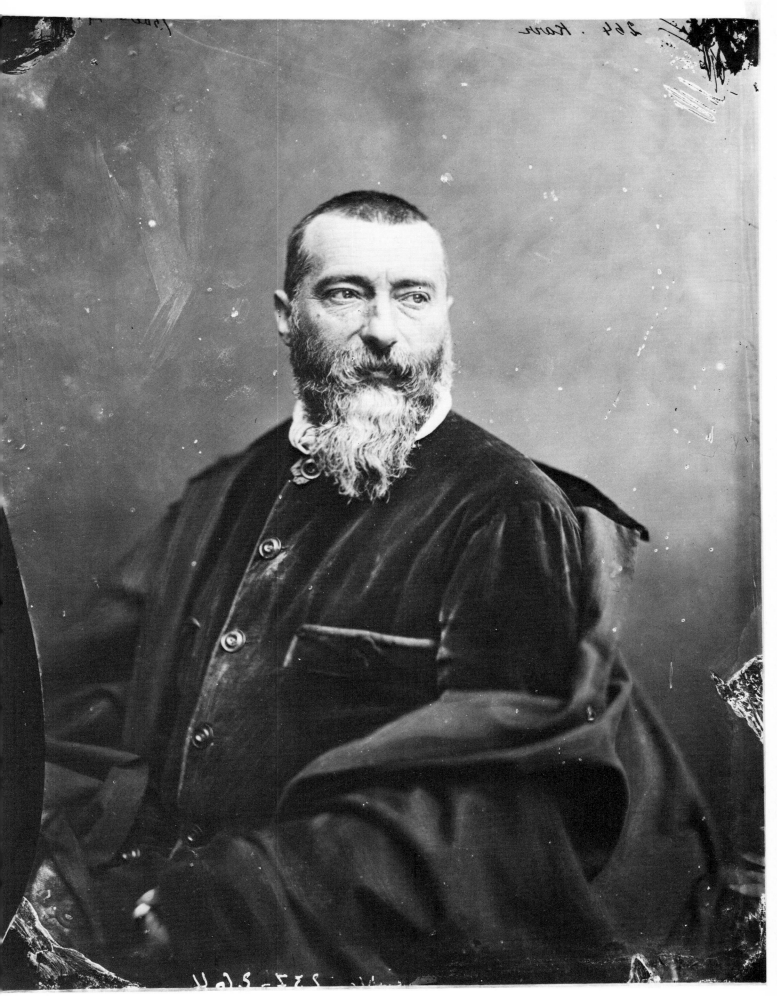

Adolphe Crémieux

1796–1880

ADOLPHE Crémieux was a left-wing politician whose views must have endeared him to Nadar. He had been born in Nîmes, the son of a silk-merchant who went bankrupt after being imprisoned in 1793. However he managed to send Adolphe to the Lycée Impérial in Paris in 1808, where he became a passionate Bonapartist. He studied law and then returned to Nîmes in 1817 where, after paying off his father's debts, he threw himself into fighting for the Jews who were being persecuted after the Restoration.

By 1830 he was back in Paris, active in the defence of liberal journalists, Protestants, socialists, and other minorities – especially the Jewish community which he helped to organize. In 1840 he undertook a journey to Egypt and the Near East with an English colleague called Montefiori, to fight for Jewish interests. In 1842 he was elected to the Assembly where he became an eloquent champion of the under-privileged and a keen anti-monarchist.

In the revolution of 1848 he became an influence for moderation. He was chosen to negotiate with the king and was present when he finally left the palace – thus earning the reputation of having 'seen off the monarchy'. In the following years he became a well-known advocate of freedom of speech and worship and moved to the left to become a supporter of the socialism of Louis Blanc. He was briefly a supporter of Louis-Napoléon but opposed him when his authoritarian aims became clear.

After the *coup d'état* of 1851 he was arrested; but on his release he continued his activities through a salon for left-wing intellectuals (where Nadar may have met him). In 1869 he entered active politics again and was one of the few who voted against the war in 1870. He became a benevolent Minister of Justice in the Provisional Government after the collapse of France, in spite of his age and was made a Senator in 1875.

Photograph circa 1858

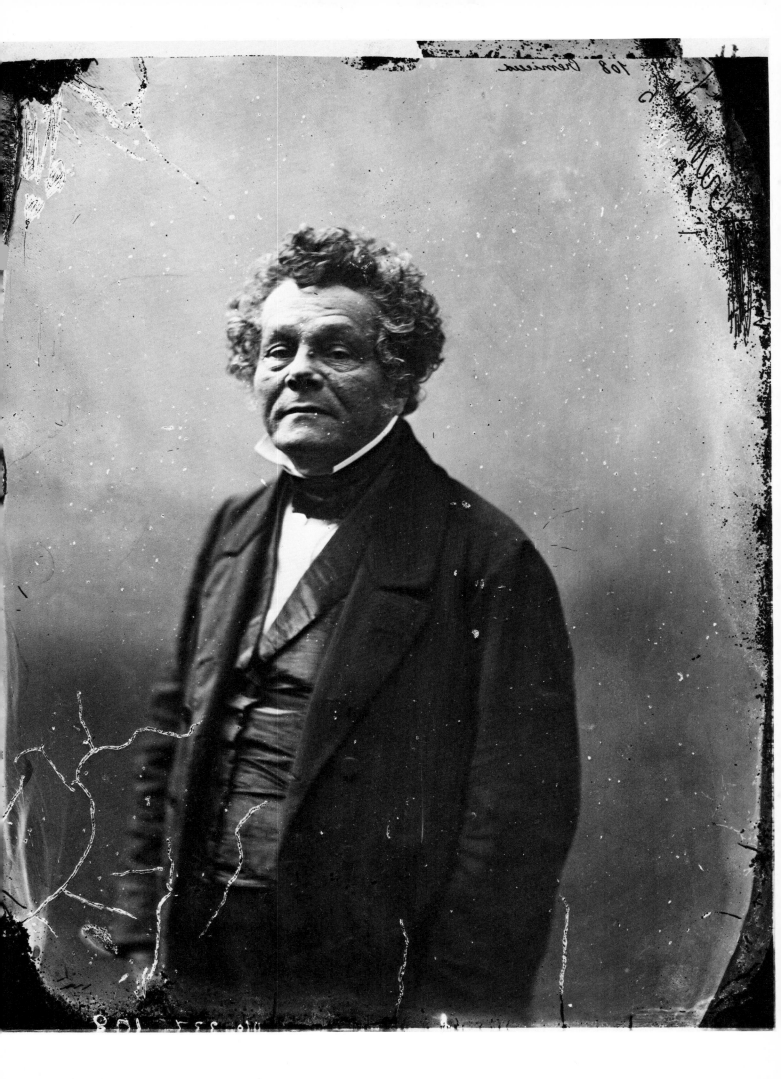

Edouard Lefèbre-Laboulaye

1811–1880?

EDOUARD Laboulaye was a liberal-minded constitutional lawyer who may have met Nadar during the early years of the Second Empire when he was rallying democratic opinion through his lectures at the Collège de France and on republican committees. Called to the Bar in Paris in 1842, he had started as a specialist in German law and wrote a number of elegant theses on the subject which gained him a place in the Académie in 1845. Besides his social interests he had a gift for writing which he exercised in a rather improbable novel with an Arab setting called *Abdallah*, which was published in 1859 and may have been the pretext for this portrait.

Laboulaye's cool pragmatic approach temporarily lost him his popularity with his students in 1870 when he wrote nonchalantly that 'the best constitution is the one you have got, provided that you use it'. He was suspected of imperialist sentiments and had to suspend his lectures. But after the trouble had died down he was finally elected to the Assembly as a left-centre supporter of Thiers, and exerted his influence as a moderate but consistent enemy of despotism in all its forms.

Photograph circa 1859

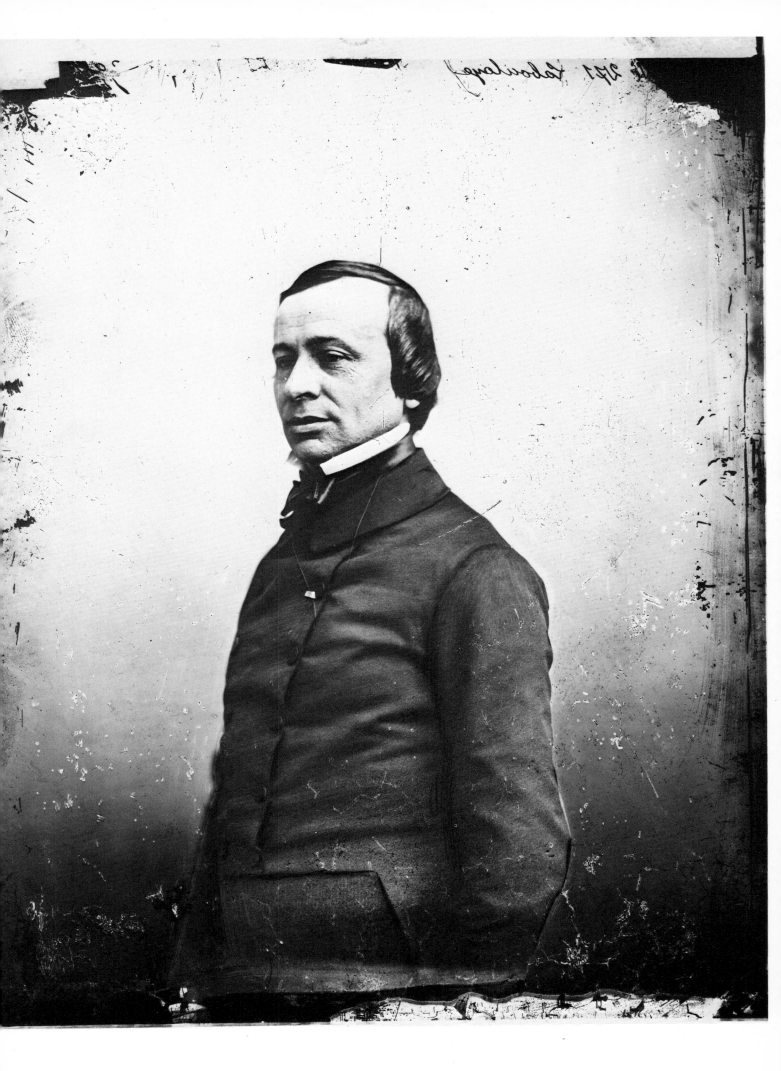

Jules Renard

1813–1870

RENARD was an amateur dramatist who, in a period with an insatiable demand for entertainment and for novelties, made a modest reputation for his comedies. He began as a banker in Versailles, but in 1850 he began to write vaudeville diversions for theatres like the Palais Royal and the Délassements Comiques. His successes included *Embarras d'un Mari* (1851) and *Allez-vous Asseoir* in 1859 which may have been what inspired this photograph, if it was not a musical called *Hôtel des Haricots* which he wrote for the composer Delibes in 1861.

Photograph circa 1859

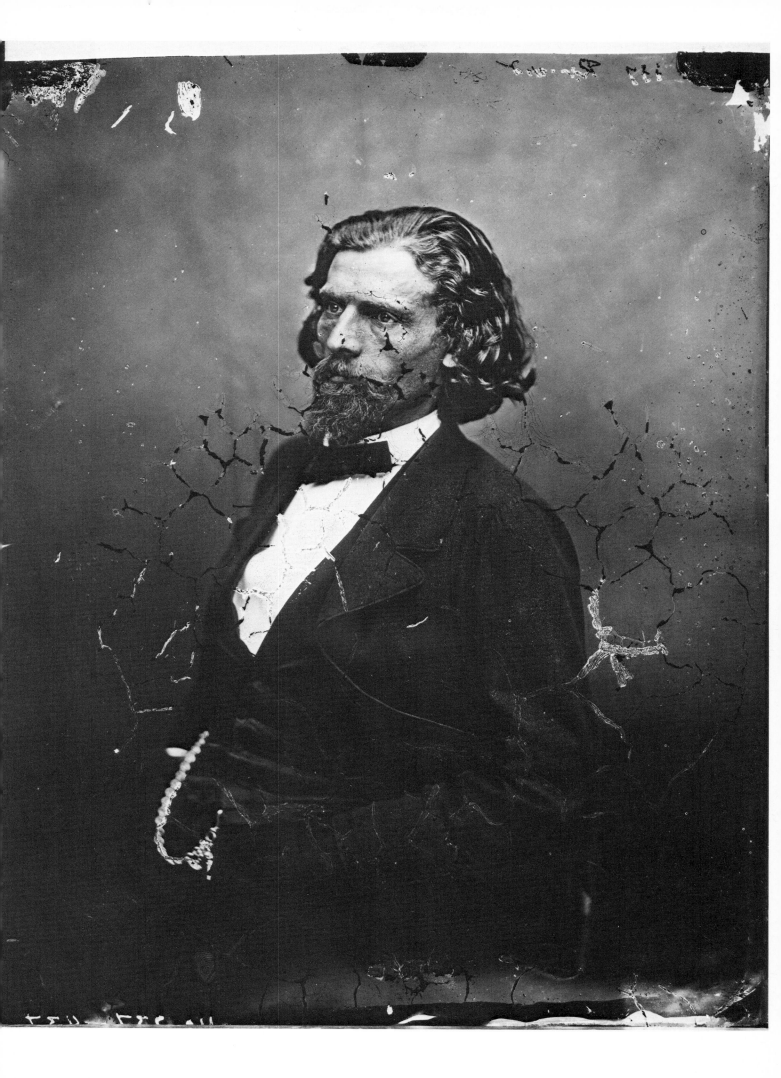

Jean Guillaume Viennet

1777–1868

ALREADY a veteran writer when Nadar arrived in Paris, Viennet was over 80 when this photograph was taken. He had an adventurous beginning to his career. After a promising start at school he entered the naval artillery and was serving in the *Hercule* when the ship was captured by the British. At 22 he found himself shut up in a Plymouth prison, where he helped to pass his seven months of captivity by writing plays, which were acted by his fellow prisoners, with midshipmen and cabin boys taking the female parts.

By 1812, after further service in the Navy, he arrived in Paris with his kitbag well loaded; it contained fifteen epistles, two tragedies, four novels, and a heroic epic. His *Clovis* was in rehearsal at the Odéon when he was called up again, this time to the army – and again he was captured, this time at the Battle of Leipzig. He remained a prisoner until the Restoration next year secured his release.

On his return to Paris he took up journalism (not unnaturally he supported the monarchy) and in 1820 his *Clovis* was finally produced, with considerable success. An opera, *Sardono-poulos*, which he undertook with Rossini, was less fortunate, never seeing the light of day. His political opinions seem to have been flexible, as in 1827 he became leftist *deputé* for Hérault, while the following year he published a romantic royalist poem 'La Philippide', and in 1830 he enthusiastically greeted the arrival of Louis-Philippe – thus making himself the target for the radical writers and cartoonists of *Charivari* and *Le Caricature*.

But his efforts were rewarded by being made a member of the Académie for an attack on Romanticism called 'Epitre aux Muses', and fame came to him in 1846 when his play *Michel Bremond* enjoyed a popular success, helped by the celebrated actor Frédéric Lemaître. He was becoming a symbol of resistance to the disturbing tendency towards romantic idealism and popular democracy, and in May 1859 a classical tragedy in the old style, *Selma*, enjoyed a huge success. He was 82 and it was probably this occasion which led him to the studio of a photographer of whose views he must have deeply disapproved.

Photograph circa 1859

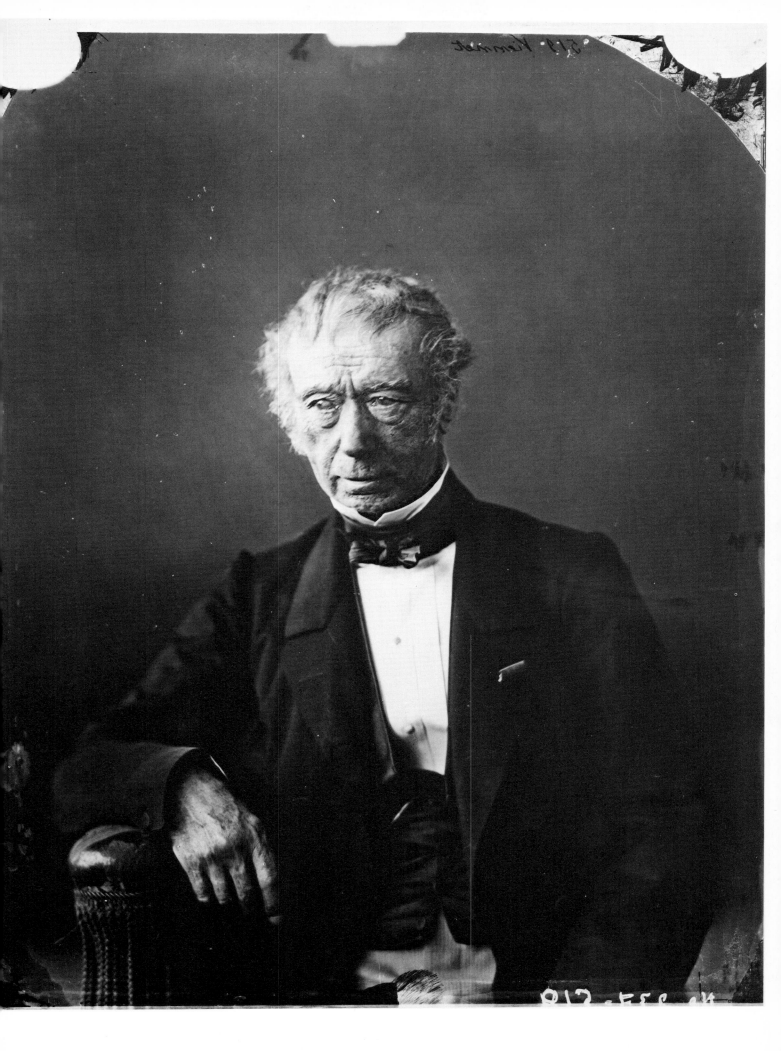

Emma Livry

1842–1863

LIKE a ghost from the Romantic age of ballet, when Taglioni and Gautier set the fashion for ethereal spirituality in place of voluptuous vivacity, Emma Livry darted with tragic briefness across the already coarsening scene of Second Empire ballet. The illegitimate daughter of a 16-year-old dancer in the Opéra *corps-de-ballet*, and a member of the Jockey Club, she became a pupil of one of the Opéra teachers, Mme Dominique.

Exceptionally delicate and lyrical, she made her debut at the age of 16 as 'La Sylphide', and was hailed as a reincarnation of the old tradition. Marie Taglioni, the famous dancer who had created the role a generation earlier, came from her retirement in Venice to see her perform. She was deeply impressed and took the young dancer under her wing. When she left she gave her a portrait of herself, beneath which she had written: 'Make me forgotten but do not forget me'.

In 1859, Livry appeared as Erigone, a Bacchante, in a *divertissement* in Félicien David's opera *Herculaneum*. It was in this costume with vine leaves in her hair that she visited Nadar's studio. As an assiduous theatre-goer he grasped her style instinctively, turning the conventional studio-posed likeness current at the time into an image which touchingly conveys the short hard life of a dancer at a time when many of them died from tuberculosis as a result of malnutrition and overwork. It is hard to believe that this thin, haunted creature was only 17 years old.

Three years later she was rehearsing for a ballet called *La Muette de Portici* (a part later to be made famous by Pavlova) when her dress caught fire and she was severely burned. After eight months of great agony, borne with heroic sweetness and patience, she died in Neuilly, aged 21. A huge crowd attended her funeral, whose expenses were carried by the State.

Théophile Gautier, the librettist of *Giselle* and formerly the most passionate admirer of Taglioni, made her the subject of one of his 'Portraits Contemporains':

> She belonged to the chaste school of Taglioni, which turns the dance into an almost immaterial art through its modest grace, decency, reserve and diaphonous virginity. Her silent flight passed through space without an audible tremor of the air. In what was, alas, the only ballet she created, she took the role of a butterfly She resembled it too much; she burned her wings in the flame and as if they wished to escort the funeral procession of a sister, two white butterflies kept fluttering above her white coffin all the way from the church to the cemetery. What epitaph could be written on the simple tomb of the young dancer except the one composed by a poet in the Anthology for some Emma Livry of antiquity: 'O Earth lie lightly on me; I have weighed so little upon you!'

Photograph circa 1859

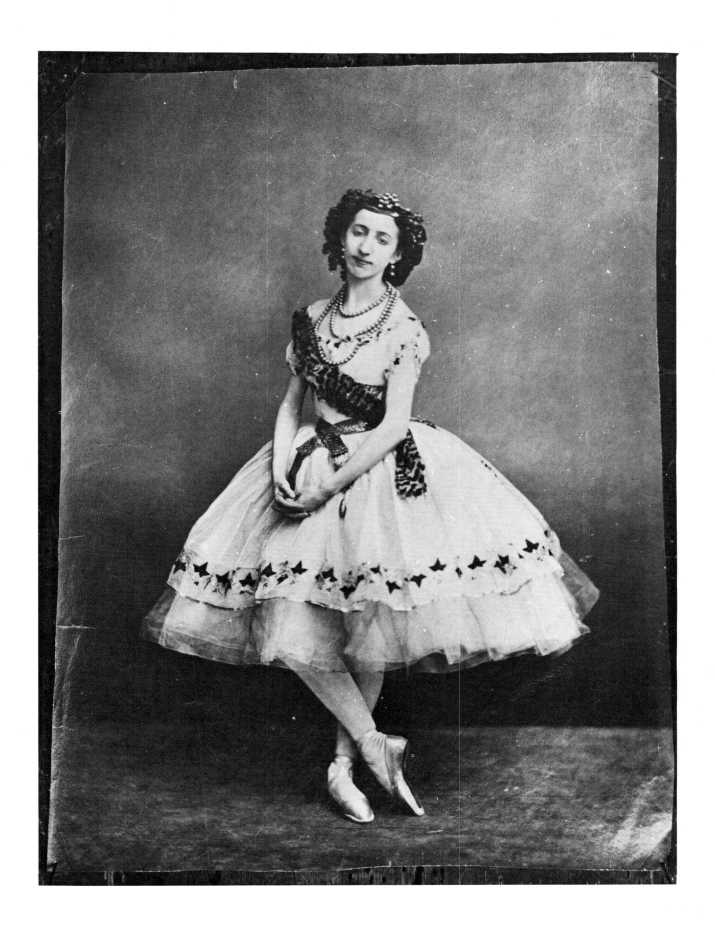

Ernesto Camillo Sivori

1815–1894

THE first real international superstar instrumentalist was an Italian violinist, Paganini, who died in 1840. Ernesto Sivori was one of his successors, performing frequently in Paris. Edmond de Goncourt describes lunching with him when he was over 70 and listening to his stories: he had begun his career at 11 as an infant prodigy and travelled all over the world. He recounted how he was one day crossing the Isthmus of Panama in a small boat when he felt the urge to improvise on his violin. This so alarmed the native boatmen that they wanted to throw him overboard as a wizard, and only desisted when he handed over his box of cigars.

He seems to have been an imaginative, entertaining, and temperamental little man – 'no taller than the leg of a guardsman' according to one writer – who played in a wide range of styles, stretching from the melancholy to the diabolical.

This portrait appears to show him at the age of about 45.

Photograph circa 1860

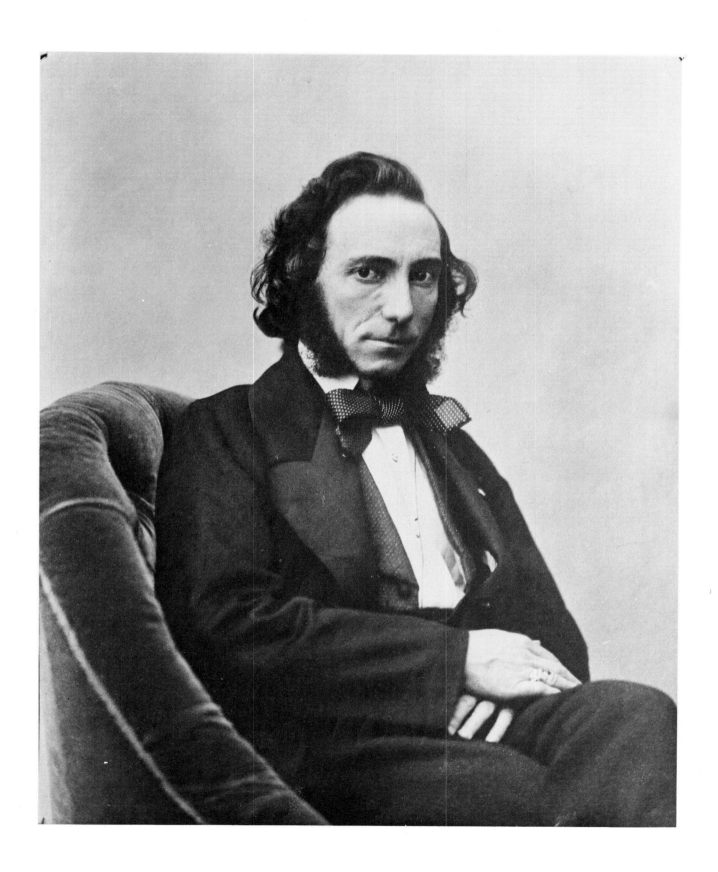

Unknown Old Woman

1860

LIKE the portrait of Rachel – though in a totally different way – this photograph is a maverick in Nadar's work. Nothing is known of the sitter, who may have been the servant of one of his friends. She has not been dressed up in a studio costume but is evidently wearing her own provincial dress.

Photograph circa 1860

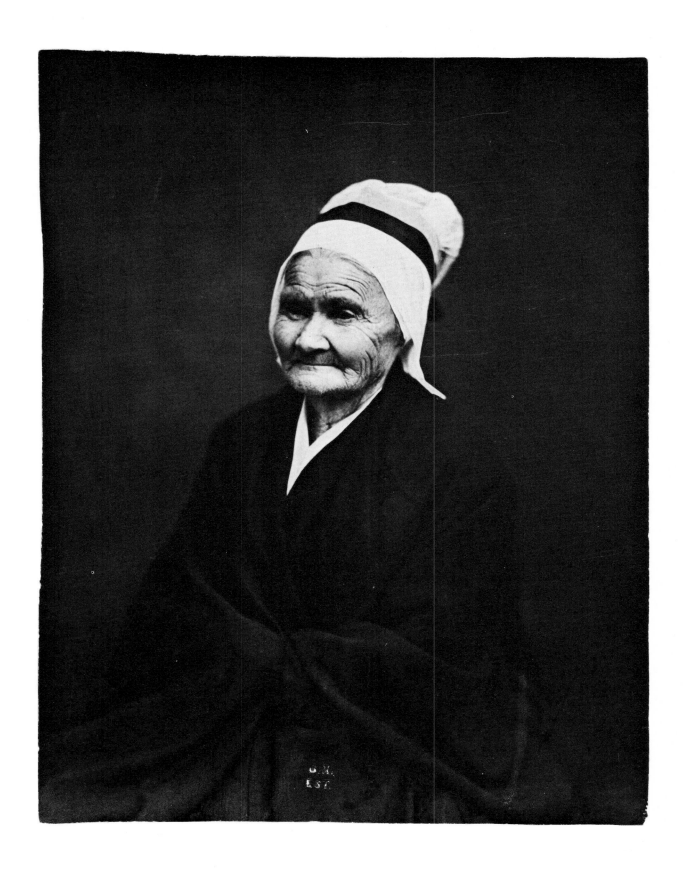

Marquis de Boissy

1798–1866

IT was probably his opposition to the Emperor which brought the Marquis de Boissy into Nadar's ken – one of his very rare aristocratic sitters (smart society mostly patronized Disdéri). At the age of 19 he joined the Bodyguard of Louis XVIII, and at 23 he transferred to the diplomatic corps, serving in London under Chateaubriand. In 1822 and 1823 he was in the embassies at Verona and Florence; in 1828, at the age of 30, he retired.

The bourgeois reign of Louis-Philippe was evidently not to his taste, for in 1839 he emerged in the Chambre des Pairs (House of Lords) as a champion of free speech and a continual thorn in the side of the government; in 1842 he even founded a magazine, *La Législature,* and in 1848 he was a guest at the Banquet of the 18th Arrondissement which sparked off the revolution.

After the *coup d'état* of 1851 he served in the Senate, stoutly maintaining his opposition to the establishment. This portrait may have been taken on the publication of his *Mémoires.* He was married to the famous hostess, Comtesse Guiccoli. He died in 1866.

Photograph circa 1860

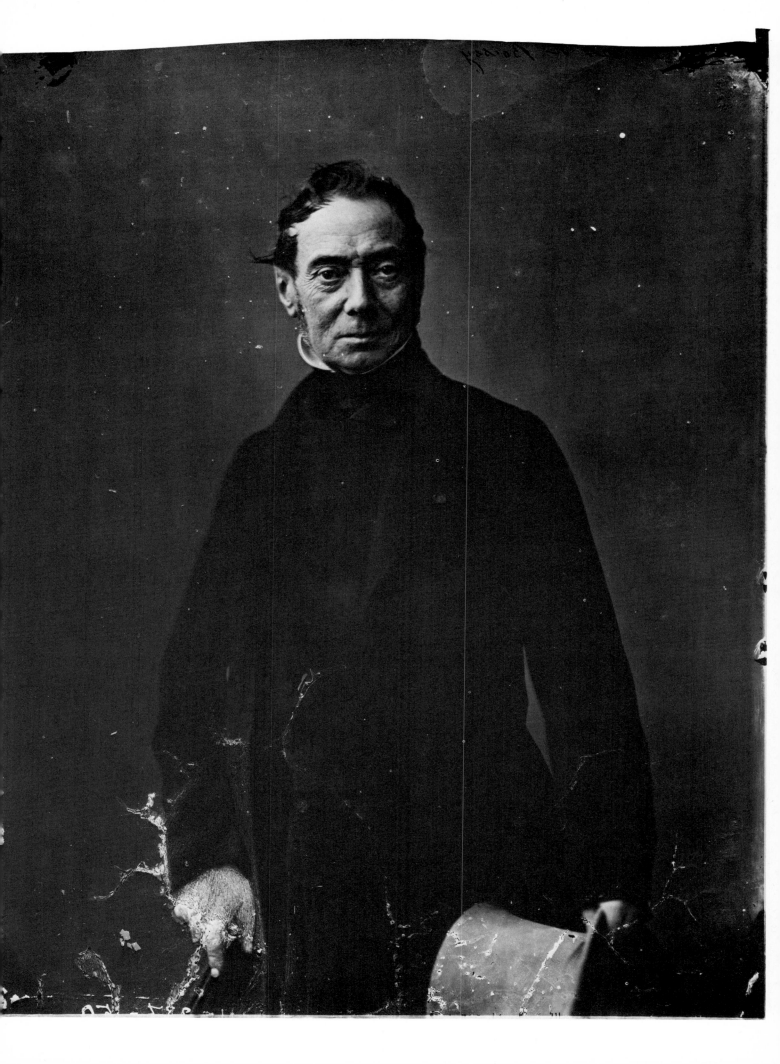

Ernest Legouvé

1807–1903

THE son of a minor poet and dramatist, Gabriel Legouvé, Ernest carried off the poetry prize at the Académie for a composition devoted to the invention of printing, and his life was dedicated to the written word. After a series of novels (*Max, Les Vieillards, Edith de Falsen*) he became known for a play, *Louise de Lignerottes* produced in 1838, but his big success came eleven years later with a collaboration with Scribe at the Théâtre Français, *Adrienne Lecouvreur* (1849), in which Rachel took the star rôle.

But his talent was evidently not firmly established, for the same actress willingly broke her contract and paid a fine of 5,000 francs to avoid appearing in his next play, *Médée* (nowadays considered to be one of his best works). Legouvé gallantly passed on the money to a charitable society for actors.

In 1855 he was elected to the Académie for his *Par Droit de Conquête*, another collaboration with Scribe. 1855 brought a novel, *Béatrice*. And in 1861 he scored a new success (which probably justified this photograph) with a one-act verse comedy at the Odéon, *Un Jeune Homme qui ne fait Rien*. A popular, upright man, a first-class shot who never fought a duel, he died at the age of 94.

Photograph circa 1861

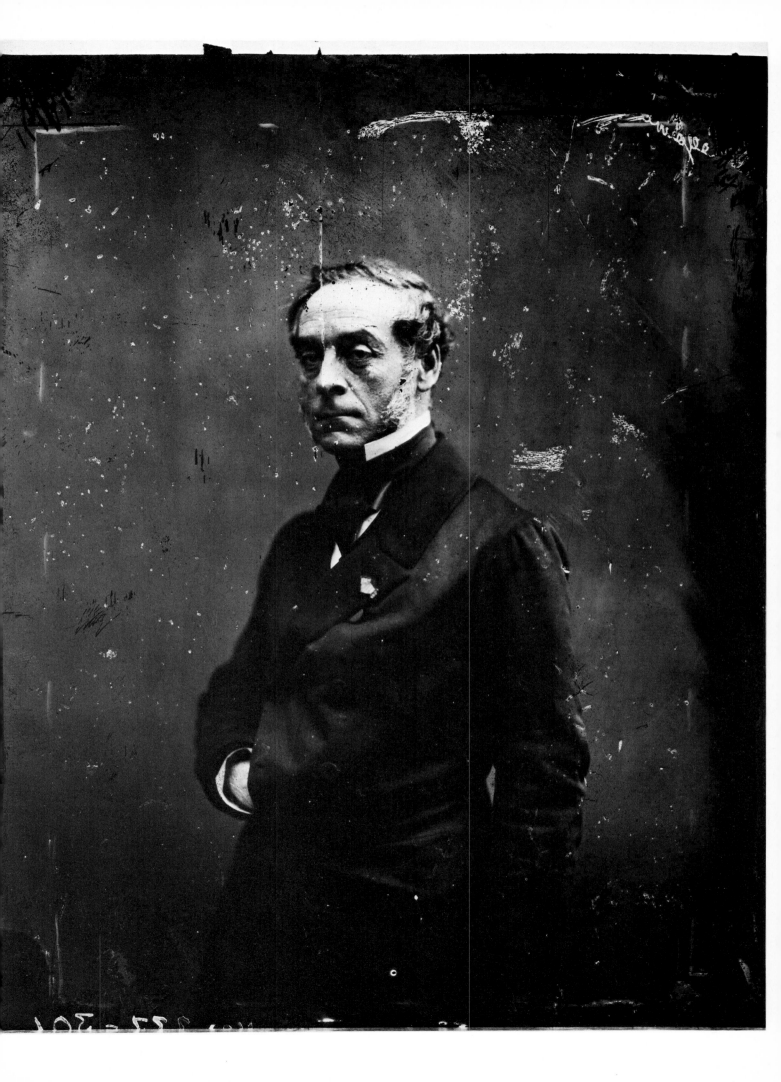

Pierre Ciceri

1782–1868

THE most celebrated stage designer of his generation, Pierre Ciceri was one of the Italians who dominated the Paris Opéra during its greatest period. He came from Milanese stock and was born in Saint Cloud. At 14 he was already a proficient violinist, but his pleasing tenor voice led him to enrol as a singer in the Conservatoire where he trained for several years. A severe carriage accident cut short his prospects as a singer and he turned his attention to design, entering the studio of the architect Bellenge.

He was so successful that in 1810 he was engaged by the Opéra as Chief Designer. He was summoned to Westphalia by King Jérôme to decorate the theatre in Kassel, and two years later received an official appointment from Napoléon. War and politics did not interrupt his career. When Charles X was crowned in 1825 it was Ciceri who carried out the decorations inside Rheims Cathedral for the ceremony, for which he was decorated.

He had already made his mark in the Opéra. As early as 1815 he had designed one of the last of the classical-style ballets, Didelot's *Flore et Zéphyre* and in 1822 he introduced a novelty which was to prove a strong influence not only on stage design but indirectly on painting – gaslight. This was in a production of *Aladdin*, for which he entrusted the designs to a young man called Louis Daguerre – subsequently to become one of the heroes of photography and the inventor of the daguerreotype.

In 1828 he was in Milan studying Italian techniques for the volcano scene in the opera *La Muette de Portici*. He was also responsible for the décor of the first production of Rossini's *Guillaume Tell* (1829) and scored a triumph with the cloister scene in Meyerbeer's opera, *Robert le Diable* (1831), which inspired a painting by Manet. This décor illustrated to perfection the new Gothic mood of moonlit mystery which had become fashionable with the cult of Germany among the Romantics, and led to a work the following year which was to usher in the whole long reign of romantic 'ballets blancs', Taglioni's *La Sylphide*.

Though he carried out over 400 sets for operas and ballets, Ciceri did not confine himself entirely to stage design. He several times exhibited watercolour landscapes of Italy and Switzerland in the Salon which no doubt influenced his theatrical vision; he also carried out some of the lithographs for Baron Taylor's *Voyages Pittoresques et Romantiques*. He seems to have run a teaching atelier as well. The miniaturist Isabey sent one of his pupils to him, where (according to the Goncourts) he stayed for fifteen years and learned 'to grind things down'. He married one of Isabey's daughters.

Nadar had done a caricature of Ciceri in his heyday at the Opéra; he must have been nearly 80 when this photograph was taken. He died in 1868.

Photograph circa 1860

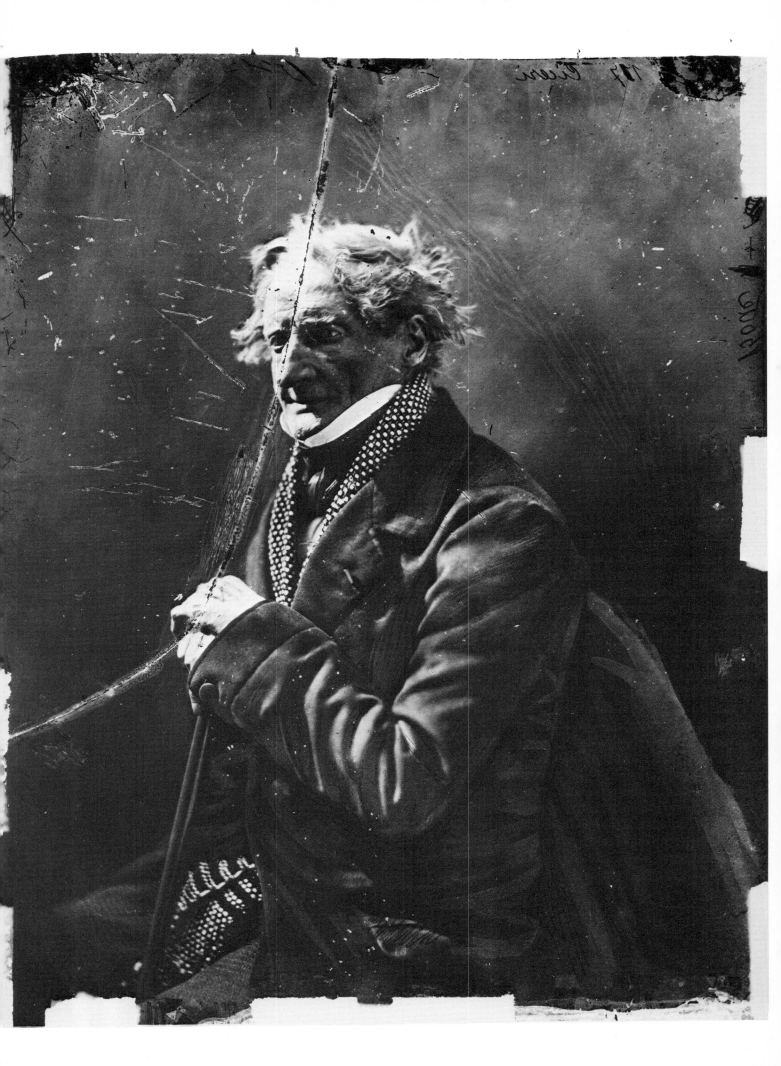

Giacomo Meyerbeer

1791–1864

MEYERBEER (who had added the prefix Meyer to his real name, Beer, in honour of his maternal grandfather) was enjoying his first Paris successes when Nadar was still a schoolboy, and this photograph shows him in the evening of his career, when the rising tide of German music was beginning to threaten his reputation. He was of German origin, the son of a rich Berlin banker with cultured tastes. He studied the piano under Clementi and became a child prodigy – he was playing Mozart's D minor Concerto in public at the age of 7.

At the age of 19 he moved to Darmstadt, where he studied composition with Carl Maria Weber, five years older than himself, who became a life-long friend. He made such progress that after two years he was appointed Court Musician in Darmstadt. However, his first attempt at an opera there was a failure, as was its successor in Vienna. On the advice of the Italian composer Salieri he moved to Venice to study the Italian style, and immediately scored a series of successes with works in the manner of Rossini. Now established and popular, he returned briefly to Berlin, where he married.

In 1826 he set out for Paris, the capital of cultured Europe and now in the throes of the Romantic Revolution. For five years he absorbed its intoxicating atmosphere, then produced a work which perfectly expressed the new mood. With the aid of a libretto by the experienced Eugène Scribe, he launched *Robert le Diable* at the Paris Opéra – a piece which combined romantic spectacle (conveyed by Ciceri's picturesque sets), melodrama, a strong element of Gothic magic, and a ballet in the new lyrical vein. It was an instant hit not only with the public, but with the artistic world, as a painting by Manet of the production shows.

Though now a celebrity, Meyerbeer wrote no new opera for five years. Then, in 1836, he produced *Les Huguenots* – more than an equal musically to his earlier work but less rapturously received by the public, who perhaps expected another helping of the supernatural. In the next years he returned to Berlin, where the Emperor Frederik Wilhelm IV made him Director of Music, and where he produced not only his own operas but works by others, including those of his friend Weber who had now been dead for over fifteen years.

But his biggest successes were still in Paris, for which he began to plan two more operas, *Le Prophète* which was produced (again with Scribe's collaboration) in 1849 and *L'Africaine* which did not appear until after his death. In 1859 he produced a new work at the Opéra Comique, *Le Pardon de Ploermel* (it had originally been called *Le Pardon de Notre Dame d'Auray* but the censor objected to the mention of the Virgin). It was a big social occasion, and a wreath was tossed from the Imperial box at the feet of the 68-year-old composer; but it was not a great success, and there are traces of disappointment and sadness in the expression of this portrait taken soon after – a sadness soon to be increased by the death of his friends and collaborators, Scribe and Rellstab.

He lived to compose a cantata for the Schiller centenary celebrations later in the year, and to begin work on an opera inspired by a play at the Odéon on Goethe. But his health was failing and he died in 1864 – perhaps only a theatre-musician (though he also wrote many songs and orchestral pieces) and lacking in true originality, but a vivid symbol of the times and place – a period which coincided with Nadar's most active years.

Photograph 1860

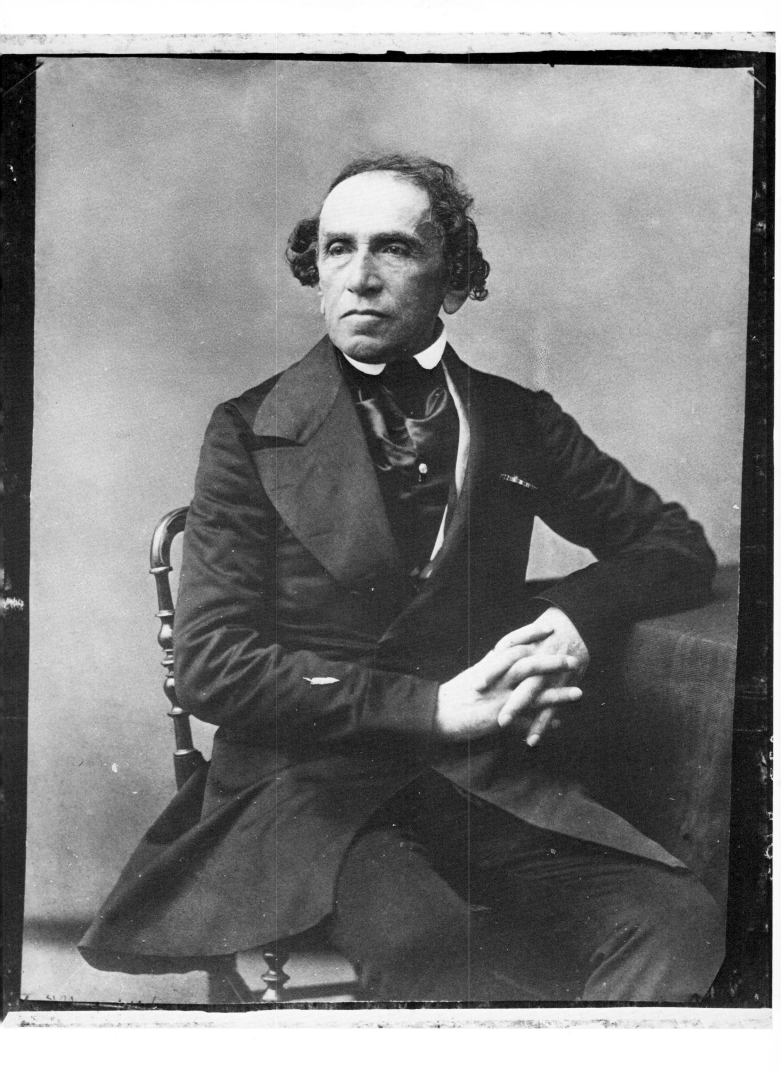

Auguste Clésinger

1814–1883

A CHARACTERISTIC figure of his period – post-Romantic with one foot firmly
planted in Realism – Clésinger was a minor sculptor who contrived to make a major
impact through his personality as much as through his talent. He was a buccaneer who
craved respectability and, to his misfortune, finally achieved it.

He was born in Besançon, the eldest of nine children of a humble craftsman sculptor. At
the age of 18 he visited Rome to learn his father's profession in the studio of the famous
Norwegian neo-classical sculptor, Thorwaldssen. His unruly temperament evidently showed
early, for he had to leave abruptly, and after his return home he soon disappeared again to
Switzerland to avoid his creditors. He arrived in Paris in 1838 but was off again to Italy after
two years, sending his first contribution – a portrait bust – from there to the Salon of 1840.

In the succeeding Salons he exhibited more busts, attracting some attention for a likeness
of Eugène Scribe. He realized that a famous sitter was an aid to critical attention, for in
March 1846 he approached the well-known writer George Sand, asking permission to im-
mortalize her 'in eternal marble'. When she consented, he wrote: 'May happiness be yours,
madame, and pride, for the blessing you have brought upon a poor young man [he was 32].
He will cry it to the housetops.'

He did more than that, he swept his sitter's daughter Solange off her feet by sheer vitality
and within a year he had married her. 'He gets everything he wants by pure persistence,'
wrote Sand to her intimate friend, Marie Dorval. 'He seems able to go without sleep or food.'
Her lover Frédéric Chopin was alarmed. 'Next year we shall be treated to a view of Solange's
little behind in the Salon', he remarked. He was wrong, but Clésinger did have a big success
in that year's Salon, a dramatic sculpture combining romantic sadism and realism called
Femme Piquée par un Serpent which was much praised by Gautier.

But he was too rough a diamond even for the easy-going household of Sand – wild, drunk,
loaded with debts, and unfaithful to Solange. His career was flourishing. In 1848 he jumped
onto the bandwagon with busts of the revolutionaries and in 1849 he was commissioned,
ironically, to carry out the memorial to Chopin. Busts of Gautier and the actress Rachel in
her famous role of Phèdre followed. But his private behaviour was not improving; he had
even set Solange against her mother. 'The devilish couple took themselves off yesterday
evening, crippled with debts and glorying in their impudence', wrote Sand. 'They shall
never cross my threshold again.' Sure enough, in 1851, the marriage was ended. He would
not give up little Nini, their daughter, to her mother, and she later died in an institution.

His career was taking a turn for the worse. In 1856 a bust of Francis I, which had been
erected in Lausanne, was withdrawn. Affronted, Clésinger moved to Rome where he led a
life of leisure and fashion until money began to run short; in 1864 he moved back to Paris,
again in favour with the Establishment. His *Femme et le Serpent* in the Salon was bought by
the State, and he was commissioned to carry out statues of Napoléon I and Charlemagne.
A final twist of irony made him the sculptor of a bust of George Sand for the foyer of the
Théâtre Français (now the Comédie Française) where it still stands.

When the Franco-Prussian war broke out he joined in the defence of Paris, parading in the
uniform of a colonel. Though he resumed his career later his style had gone out of fashion,
and his success was over. He survived in virtual retirement until 1883.

Photograph circa 1860

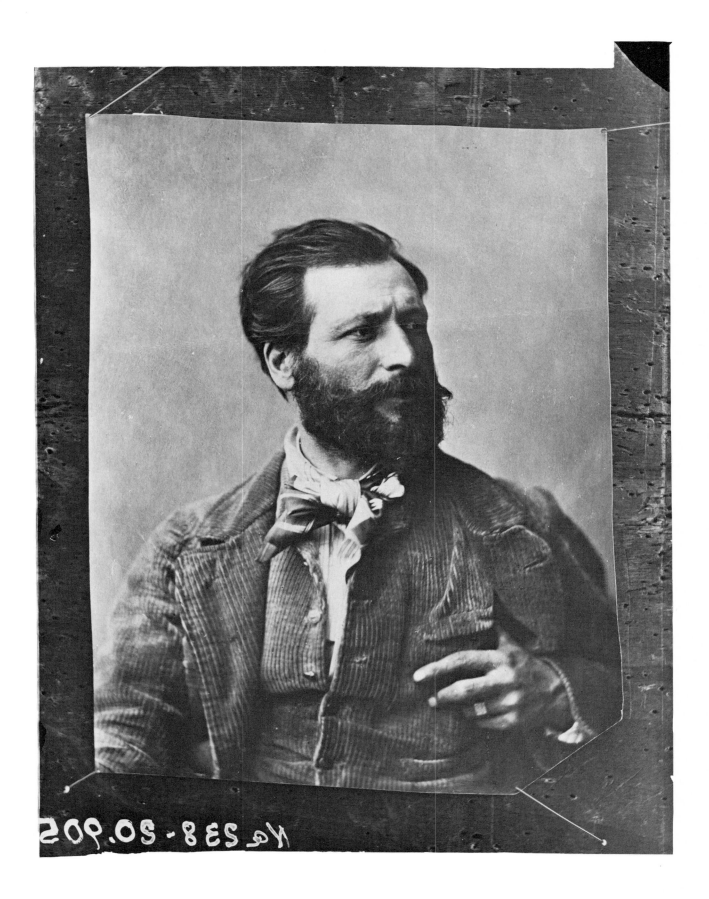

Prince Galitzine

1823–1872

THOUGH many aristocratic sitters appeared in the Atelier Nadar towards the end of the century, after its direction had been handed over to Nadar's son Paul, Prince Galitzine was an uncharacteristic visitor for Nadar himself. His appearance is explained by the fact that he was a musician and composer as well as a prince. His father had been the virtuoso to whom Beethoven dedicated many of his last works, and he himself was devoted to music.

After service as a page to the Imperial Court in his native Saint Petersburg, he had spent some time in Germany and served as a captain in the Russian forces during the Crimean War in 1854. On his return to Russia he was appointed Chamberlain at the Imperial Court, where he ran a private quartet and a choir, but his ideas were too liberal for the Tsar, and he was eventually exiled. He fell back on his musical talents, travelling through Germany, England, Ireland, Scotland, and France giving concerts of the music of his compatriot and friend, Glinka, and of his own compositions; these included a number of songs, ballads, and dances, besides two Masses and an unfinished opera called *The Emancipation of the Serfs*.

In London he had founded a series of soirées under the title 'The Princess Galitzine Concerts' and in Paris he organized a big concert in the Salle Hertz in 1862 to raise money for the victims of a fire in Saint Petersburg. This was probably the occasion of Nadar's portrait.

Photograph circa 1862

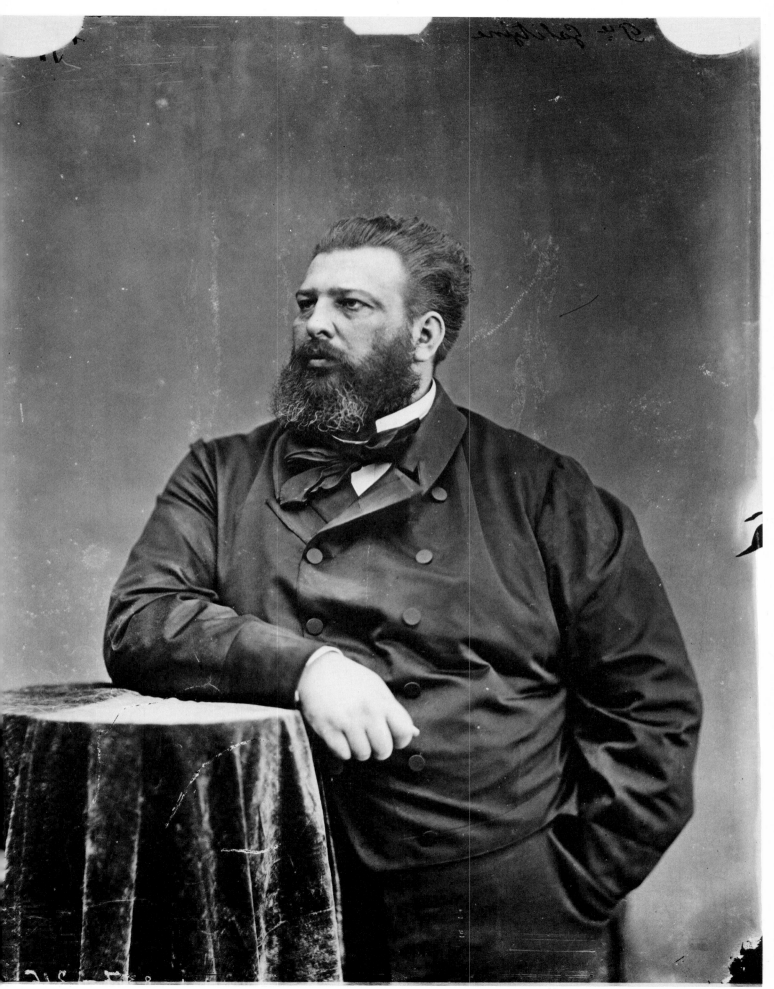

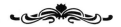

Armand Barbès

1809–1870

A PASSIONATE but somewhat quixotic fighter for socialism all his life, Barbès was an obvious hero for Nadar. They did not meet until late in his life, but he became a close friend, and godfather to Nadar's son Paul. The son of a liberal-minded doctor, he was born in Guadeloupe, but the family returned to Carcassonne when he was 5. Too sensitive to continue his first training as a medical student, the young Barbès took up law which, combined with his radical views, led him straight into politics.

At 25 he narrowly escaped prosecution when he was caught with some incriminating documents linking him to the anti-monarchist 'Société des Droits de l'Homme'; and the next year he formed, with Auguste Blanqui, a network of small revolutionary cells, the 'Familles'. This plot earned him two years in prison; he was released after one year, returned to Carcassonne and promptly received another short sentence for publishing an illegal pamphlet.

In 1838 he led (with Blanqui) a gallant but hopeless uprising in Paris, involving an attack on the Palais de Justice, the setting up of a 'provisional government' consisting of three revolutionaries and three politicians, and the eventual surrender of Barbès, wounded in the head. He took all the blame and was condemned to death. The news provoked riots among the students and a petition-poem by Victor Hugo to the king. With the extra help of a visit by Barbès' sister to the impressionable monarch, the sentence was commuted to life imprisonment. Release came with the success of the 1848 revolution. Barbès, ignoring a reception in his honour at Carcassonne, returned at once to Paris and accepted a post in the Garde Nationale, and was also appointed president of the Club de la Révolution; at its meetings, and through the columns of *La Commune*, he earned a wide reputation as propagandist.

But more trials lay ahead. Barbès discovered that Blanqui had betrayed him to the police, turning friendship into bitter enmity. And in a tragi-comical replay of the events of 1832, Barbès stalked out of the new Assembly when its dissolution was proposed, taking refuge with a colleague in the Hôtel de Ville, where he announced a 'provisional government'. His reign lasted for an hour, during which he had threatened Russia and Poland with instant war if they did not acknowledge the freedom of Poland. Then Lamartine arrived at the head of some troops; Barbès and his friend gave themselves up without resistance.

Once again Barbès took full responsibility. This time, in 1849, he was condemned to permanent exile, commuted to life imprisonment. While he was serving his sentence, war with Russia broke out, inciting Barbès to patriotic sentiments which were communicated to the Emperor who offered him a pardon. Barbès could not accept; but found a compromise in exiling himself to Belgium, England, Spain, and finally Holland, where he settled in The Hague.

It was here, on the occasion of the famous Victor Hugo banquet, that Nadar found him and took this portrait which had been especially requested by Barbès' old fellow-fighter Louis Blanc. Five years later Barbès was able to travel to Brussels to celebrate the ascent of the *Géant*; but in June 1870, just before the outbreak of the war between Prussia and France, he died. 'Barbès was lucky to die in time', wrote Louis Blanc to Nadar. His first strange memorial (an honour which he shared with George Sand) was to have one of Nadar's Paris siege-balloons named after him. Ten years after his death the normally cynical Edmond de Goncourt wrote of him: 'Truly I know nobody these days who has a genuinely disinterested love for the people, apart from Barbès.'

Photograph 1862

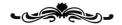

Pierre Joseph Proudhon

1809–1865

ONE of Nadar's first jobs as a journalist was on a paper – Alphonse Karr's *Journal* – specifically aimed at 'fighting the poisonous outpourings of Proudhon'. But Karr confined him to humble office chores where his political views would not cause offence; for Nadar was already a confirmed socialist, and the eminent anarchist writer and agitator must certainly have been one of his heroes. At the time Proudhon was occupied in journalism; in fact he had just published the *Manuel du Speculateur à la Bourse* designed to help investors – a surprising change from his normal writings which several times landed him in prison. He was rightly recognized as a powerfully disruptive influence, and indeed his thinking has affected all left-wing development even up to today.

He was deeply rooted in his childhood experiences. Born in Besançon, the son of an inn-keeper, he passed his early boyhood tending cows on the slopes of the Jura mountains. The simple self-contained joys of a rustic community impregnated his ideas for an ideal society. He developed these in his first job as an apprentice printer. Here he taught himself Greek, Latin and Hebrew, and talked with lively socialist thinkers such as Charles Fourier.

At 22 Proudhon left Besançon and travelled round France (including Paris), widening his experience. On his return to Besançon he won a scholarship from the academy to go to Paris; he arrived there in 1838 and next year rewarded his sponsors with an article on the institution of Sunday which won him a bronze medal. In 1840, he followed it up with a book which caused a sensation, and which the Besançon academy was quick to disown, *What is Property?* Proudhon's answer was simple: 'Property is theft' – a view which was to become the basis of Communism. But with his rural background he defined 'property' differently from Marx; he exempted such essential elements as the individual's tools and land and remained, in contrast to the Marxists, an enemy of centralized control.

However, he was anathema to the Government; his next book *A Warning to Proprietors* brought him to trial (he was acquitted on the grounds that his writing was unintelligible). In 1843 he left Paris for Lyon, where he worked for a time in a water-transport firm, and teamed up with a band of weavers who were experimenting in worker-ownership, called Mutualists. On his return to Paris he became friendly with Bakunin (who became a follower) and had discussions with Marx and Herzen. His relationship with these was less than cordial and Marx bitterly attacked his next book *The Philosophy of Poverty* in a pamphlet entitled 'The Poverty of Philosophy'.

In 1848 he turned to journalism and started several anarchist journals, chief of which was *Le Représentant du Peuple*. He was unenthusiastic about the Revolution, judging it to be weakly motivated; he was elected a member of the Constituent Assembly, but was antagonistic to its evident moves towards authoritarianism, and in 1849 was imprisoned for an attack on Louis-Napoléon. Conditions in gaol were not severe, and he spent the time writing *A General Idea of Revolution in the 19th Century* – and also got married.

In 1852 he was released and proceeded to turn out some harmless works such as his guide for investors and a book on railways; he had a peaceful streak, reflected in Nadar's benign portrait. But in 1858 an attack on the Church was seized, and he was condemned to three years' imprisonment. He fled to Brussels, where he remained for four years. But he was not quite accepted there; during some workers' riots he was taken for a French spy, and had to return to Paris when this photograph may have been taken. In 1865, the year of the First International, he died.

Photograph circa 1862

'Mogador' (Comtesse de Chabrillan)

1824–1909

WHEN this portrait was taken Madame Mogador, as she was known, was a rather notorious figure. She had been born in Paris into a poor working-class family. Her father died when she was very young and she was rescued from a life of misery with her mother and a new step-father, by a prostitute who worked in the Cité. The life of the girl developed as was to be expected, and in 1844, 'on Sept 26 at 9 pm', according to a mysterious account written some years later, she adopted the working name of Mogador.

A young woman of generous proportions, with a slightly pockmarked face, she evidently had great charm. By 1846 she was known as the 'Queen of the Prado' and she worked as an actress at the Variétés and as an equestrienne at the Hippodrome circus besides earning her living on the streets. The Goncourts relate (in 1857) a story of her early years when she announced at dinner: 'I'll spend the night with anybody who will buy me a beefsteak!'

She must have had either a remarkable brain (as well as enormous energy) or else a skilful collaborator, for her *Mémoires,* when they suddenly appeared in 1854, stretched to five volumes, describing in some detail her life as a courtesan. They were suppressed, reissued in 1858 and seized again.

They brought her not only public notoriety but a husband in the shape of a member of an old Dauphiné family, the Comte de Chabrillan. He married her the same year and took her off to Australia to make a fresh start. He himself took work in the mines and prospered enough to be made French Consul in Melbourne. But the strict society of the city would not recognize them and the Comtesse returned to Paris, alone and unhappy, in 1856.

After a period of serious illness she began to write again, and published three more novels, *Les Voleurs* (1857), *Sapho* (1858), and *Miss Pewel* (1859). In 1863 she took over the directorship of the Folies Marigny theatre (when this photograph may have been taken); in spite of, or perhaps because of, a play which she wrote herself, the venture failed within a year.

Photograph circa 1864

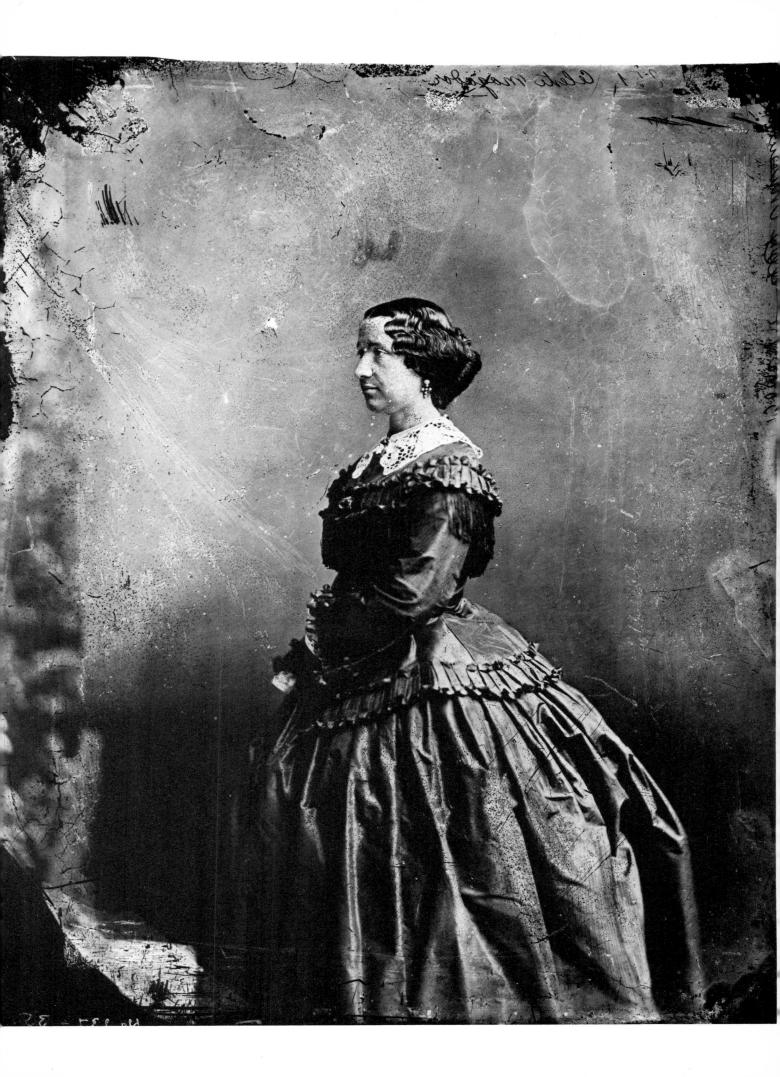

Mikhail Bakunin

1814–1876

BAKUNIN and Nadar had features in common. Both were shaggy, blue-eyed giants, both dominated their companions by a mixture of vitality and charm, both had rebellious temperaments fired by an instinctive and disorderly love of humanity – and both, incidentally, were involved in hopeless excursions to liberate Poland. Nadar may well have met Bakunin during the Russian anarchist's first stay in Paris, between 1844 and 1848. But this was before he purchased his first camera, and Bakunin probably sat for him either in 1861, during a brief visit to confer with a Polish emigré general, or – more likely – in December 1863, when Bakunin crossed over from London for a long-deferred encounter with his fellow revolutionary Alexander Herzen (whom Nadar, oddly, seems never to have photographed).

Bakunin symbolizes the romantic human heart of nineteenth-century social revolution as Karl Marx stands for its brain. 'A marvellous man, a deep, primitive leonine nature He loves ideas, not men. He wants to dominate by his personality, not to love', wrote Vissarion Belinsky, the sharpest of his Russian colleagues. He certainly exercised a magnetic influence on revolutionaries of his time in many countries, and will probably continue to do so wherever there are idealist young rebels.

His ideas were coloured by his origins. While Marx was the son of a German Jewish lawyer, an intellectual obsessed with the urban workers he knew best, Bakunin was the son of a country aristocrat. His emotional views sprang from active revolutionary participation and were rooted in a faith in the Slav peasant and his destiny as saviour of decadent Western society. Inevitably the two men disagreed. Marx won, and became the father of official Communism, while Bakunin is best remembered as an ancestor of anarchism, inventor of a much (and often wrongly) quoted phrase from his very first published article, in 1842: 'Let us put our trust in the eternal spirit which destroys and annihilates only because it is the unattainable yet eternally creative source of all life. The passion for destruction is also a creative passion!'

Bakunin's revolutionary zeal certainly reflects his childhood pressures; he was brought up by a reactionary couple in an isolated environment, and all his life he went on trying to liberate his fellow men from their oppressor, just as he had tried to protect his adoring sisters from enforced marriages. His intense feelings for one of his sisters may also have contributed to his permanent sexual impotence. He fled from home, first to Moscow where he read Hegel and worshipped Beethoven, then to Berlin, where he briefly captivated Turgenev.

In 1844 he was officially banished from Russia and spent the rest of his life writing, organizing, and plotting (very amateurishly) mostly in London, but also in Switzerland, France, and Italy. He was handed over to the Russian police after riots in Dresden in 1849 and spent four years in the dreaded Peter-and-Paul prison in Saint Petersburg. After four more years in another detention camp he was sent to Siberia, where he married; but soon after he escaped to San Francisco and thence to England – leaving his wife behind.

Back in Europe he was much involved in *emigré* bickering, particularly in opposition to the moderate Herzen and to Marx; as a result, he was expelled from the 'First International' in 1872. He contributed regularly to many revolutionary publications, replacing consistent argument by emotional intensity. 'I cleave to no system, I am a true seeker.' This approach, though it may prove more long lasting than rigid theorizing, made him intellectually ineffective and his faith in human goodness and the revolutionary ardour of Polish and Russian peasants was slowly eroded. He died in Switzerland in 1876, poor, disappointed, and stateless.

Photograph circa 1863

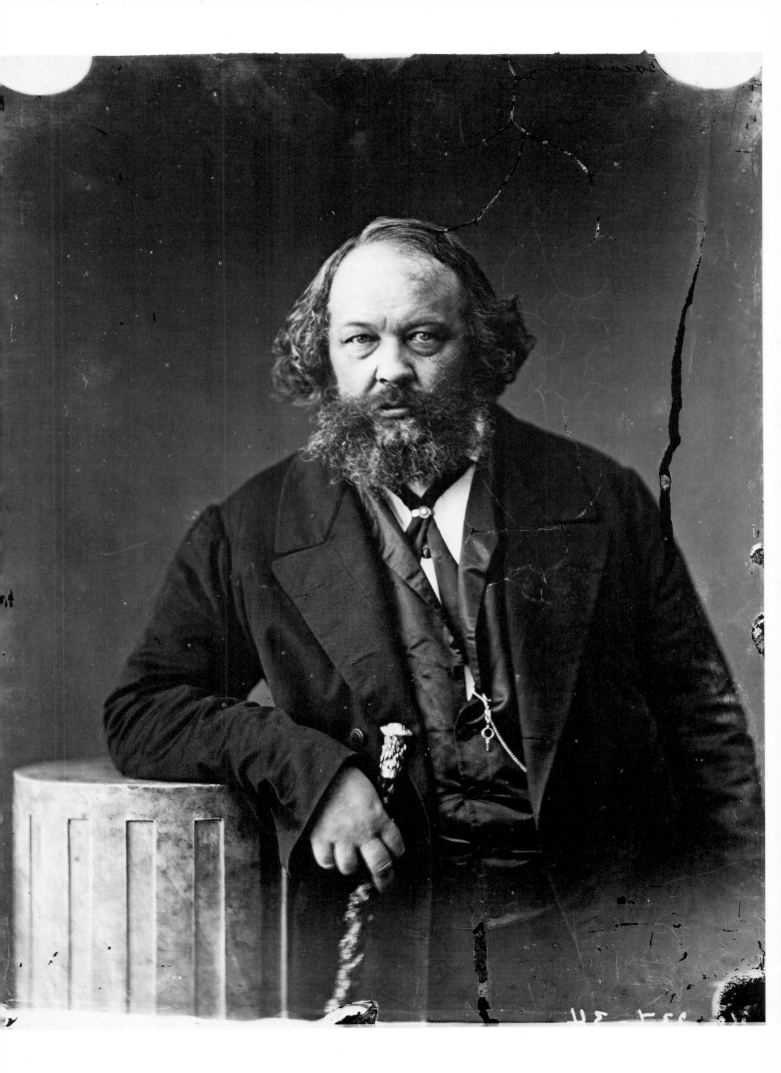

Hector Berlioz
1803–1869

THOUGH Nadar's musical tastes were conventional and few of his literary friends were music-lovers ('I prefer silence', remarked Victor Hugo), most of the well-known composers of his time were photographed in his studio (Brahms, Tchaikovsky and, oddly, Bizet, are exceptions). Berlioz was nearing the end of his career when this portrait was made. The fire of youth has gone; recognition was as far away as ever (the second half of his huge opera *Les Troyens* had just failed at the Théâtre Lyrique); but there is still a flash in the eye of the old eagle, a defiance brilliantly sensed and caught in the upright pose.

Berlioz was a doctor's son born in the Isère, who came to Paris at the age of 18 to study medicine. But after seeing Gluck's *Iphigénie* he became obsessed with music and entered the Conservatoire. His parents cut off his allowance and he had to support himself by teaching and journalism (especially in the *Gazette Musicale*) and by singing in the choir at the Gymnase. The old-fashioned teaching and discipline there offended him ('It is forbidden to make music against this wall', he wrote mockingly in one of the rooms) and he left half-way through the course.

A visit to Paris by Kemble's touring Shakespeare company was a revelation. 'It opened the heavens of art with a sublime crash', he recorded; and he fell passionately in love with one of the actresses, Harriet Smithson. Meeting no response, he left Paris for Italy with another girl; but, on hearing the report that Harriet was going to be married, he hurried back, after purchasing a supply of strychnine and laudanum and a disguise (which he lost *en route*). Back in Paris he staged a suicide in her presence which he later described: 'Fearful shrieks from Harriet – sublime despair – mocking laughter from me – desire to live revived by hearing frantic avowals of love – emetic – results which lasted for ten hours.'

The result of this melodramatic affair was his *Symphonie Fantastique* and, three years later, marriage. (It proved unhappy; Harriet began to drink and they parted after seven years.) He became one of the group of Romantics – de Vigny, Lamartine, Delacroix, de Nerval – who shouted applause at the famous first night of Victor Hugo's *Hernani*. He had meanwhile won the Prix de Rome and in 1837 composed his *Requiem* – 'beautiful and bizarre, wild, convulsive and painful' as de Vigny described it. In 1838 he finished his first opera *Benvenuto Cellini* with help from the violinist Paganini and the musical director of the Opéra, and in 1839, with the support of Liszt, he received an appointment at the Conservatoire.

He was beginning to make a name for himself, and was soon touring successfully in Germany, Austria and Russia as composer and conductor. In 1840 he completed his *Damnation de Faust* (using de Nerval's translation of Goethe's text). But his romantic heyday began to fade. He settled down to read the classics (hence *Les Troyens*, of which the first part was written between 1850 and 1854 and the second part a few years later) and began to prefer Shakespeare's comedies to his tragedies (hence *Beatrice et Benedict*, 1862). The childhood friend, whom he had married after his separation from Harriet Smithson, died after a period of paralysis, while the long-delayed production of part of *Les Troyens* had no success. Four years later his only son died too and Berlioz, broken at last, soon followed him.

Photograph circa 1863

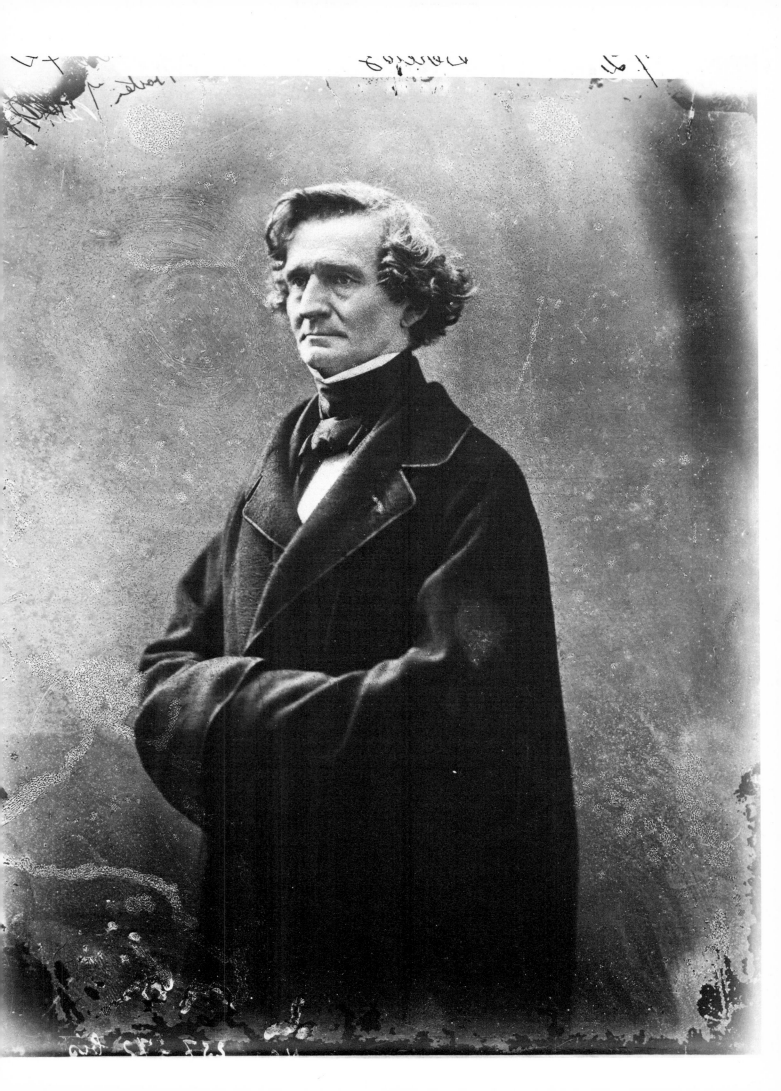

George Sand

1804–1876

'GEORGE Sand' (a pen-name) was 60 and a grandmother when this photograph was taken; she was basking, perhaps, in the success of an adaptation of one of her novels, *Villemer*, which had just opened at the Odéon. Nadar had long been a fervent admirer (she was godmother to his son Paul). When he had compiled his 'Panthéon' lithograph of celebrities in 1854, it was in front of a statue of Sand that they paraded. The solidity of her reputation was a tribute as much to her personality as to her literary gifts. At a time when women were expected to be models of modesty, chastity and conformity, she openly practised sexual permissiveness and political radicalism, advertising her defiance of tradition by wearing trousers, smoking cigars, and taking lovers like a man. 'It is not so easy as you think to accept dishonour', she wrote to her daughter.

She had been born Aurore Dupin in 1804. Losing her parents very early, she became an heiress and was married off while still young to a Baron Dudevant. The result was two children and sexual inhibitions which were to haunt her. She described them with great frankness in a novel *Lélia* (1853): 'His kisses brought me no relief. Desire in my case was an ardour of the spirit which paralysed the power of the senses.' She suffered, in fact, from frigidity and a need to dominate, leaving her with an emotional appetite which a succession of lovers failed to satisfy.

Though attracted to virile types like Clésinger, her sculptor son-in-law, and perhaps to young Nadar himself, she normally preferred delicate, sensitive, rather child-like men. (She also had a passionate affair with the actress Marie Dorval.) She left her husband first for a curly-headed 19-year-old writer, Jules Sandeau, and it was with a derivation of his name that she signed her first book in 1831. Her most famous lover was Frédéric Chopin to whom, when she was 33, she passed a note, 'I adore you'. He succumbed to her advances and lived with her for eleven years as a doting invalid, finally deserting her under the influence of her equally dominating daughter. He was replaced by, among others, the poet de Musset.

She was a woman of astonishing energy, turning out a stream of novels and stories in a romantic and sentimental vein, besides endless letters. She was an ardent republican, going so far as to write, 'If by Communism you mean the wish and determination to use every legitimate means . . . to destroy here and now the revolting inequality of extreme wealth and extreme poverty and to establish the beginnings of true equality, then we are Communists indeed.'

It was doubtless these sentiments which attracted Nadar to her. She responded by proffering a preface to a book which might seem remote from her normal interests – his defence of the heavier-than-air flying machine, *Le Droit au Vol* (1866), in which she declared that Nadar was 'neither a savant nor a speculator but, in my opinion, a great logician and a man of firm will'.

Though she consistently affronted public opinion Sand was accepted as she grew older. She now lived at her family home in the country, gardening, reading, embroidering, playing at theatricals, and writing through the night, with a favourite at hand. A Catherine the Great of literature, she possessed 'a man's qualities without a man's faults', as Louis Napoléon described her.

Her energy and appetite for life survived into old age, when Edmond de Goncourt recorded gossip of her 'eating late suppers, drinking champagne, fornicating and carrying on like a forty-year-old student'. She died in 1876 and Flaubert wrote: 'Only those who knew her as I did can realize just how much of the feminine there was in that great man.'

Photograph circa 1864

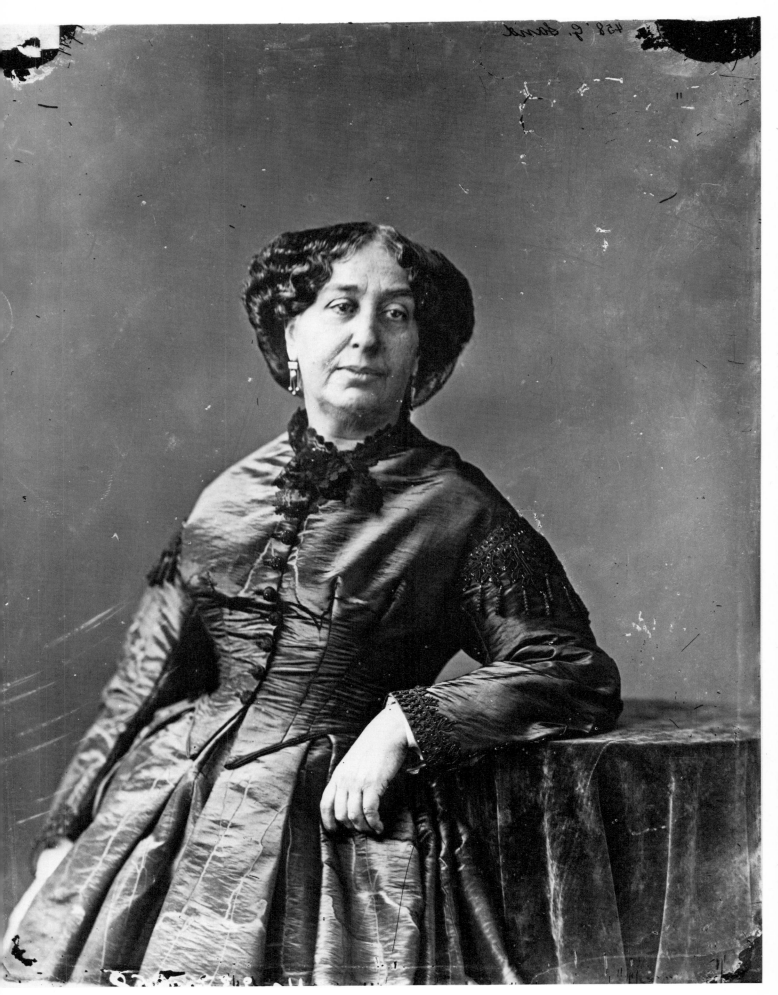

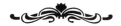

Alexandre Dumas (*fils*)

1824–1895

TO be born the illegitimate son (by a serving-girl) of a famous father and to compete with him in his own profession is a testing experience. That Dumas *fils* survived it so well is a tribute to his character. Far from being overshadowed by his father, he continued his tradition and even carried it to respectability by becoming – as Dumas *père* never did – a member of the Académie at the age of 50; he marked the occasion by making the memory of his father the subject of his official maiden speech.

He started with the unnerving ordeal of becoming, at the age of 7, the object of a dispute between his parents, finally being made a ward in chancery. However, he finally entered the Collège Bourbon, which Nadar had just left. At 18 he published his first verses in *La Chronique*. More poetry followed, and a novel – which remained unpublished in spite of efforts by his father. He was 24 when, in 1848, he burst on the public with a short novel based on a painful personal affair with a real courtesan, Marie Duplessis, *La Dame aux Camélias*.

Its success seems to have opened the floodgates, for during the next six years he published a book every year – usually about the *demi-monde* which he frequented himself, and written from a sympathetic point of view which alarmed the Emperor and the authorities. In 1852 a theatrical version of *La Dame aux Camélias* was produced, in spite of opposition from the censor, and became a sensation. Its appearance was due to the intervention of the Duc de Morny and the following year the Emperor himself stepped in to save another controversial drama, *Diane de Lys*.

From now on he turned out successions of plays, often at great speed, at the request of a management or a star like Sarah Bernhardt. He contrived to introduce social issues into pieces which remained on the level of entertainment, and was indeed widely regarded as a serious thinker. He did in fact take part on issues of his day – especially in the prefaces he wrote to his plays – such as divorce and women's rights. Fundamentally he was a conservative, strongly defending social tradition and the sanctity of the family, and disapproving of art which did not carry an improving message. In this he was influenced by the thinking of the Positivists. With age and success – he was rated higher than his father by his contemporaries – he moved politically to the right and found himself opposing the Commune in 1870. But he was a close enough friend of Nadar to be entrusted with the secret that the Communard General Bergeret was hidden in the Nadar household, and charitable enough to accompany Nadar on a visit to Thiers to arrange for his 'escape'. He was a broad-minded man who had moved all his life in the same intellectual circles as Nadar, a thorough professional who laboured equally hard over the writing of a novel or play, and over-publicizing it. He made a sizable fortune, became a collector of pictures and *objets d'art* and died at the age of 71.

Photograph circa 1864

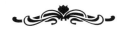

Carlotta Grisi
1819–1899

A MEMBER of a celebrated Italian theatrical family – she was a cousin of the singers Giulia and Giuditta Grisi – Carlotta Grisi became a pupil at a very early age at the school of La Scala, Milan where she studied singing and dancing. She made her stage début when she was only 5 years old, and joined the *corps de ballet* at 10. Four years later, while appearing at the Teatro San Carlo in Naples, she met the already celebrated dancer and choreographer Jules Perrot and became both his pupil and his mistress.

They embarked together on a tour of Europe which led them to London (1836), Vienna, Milan, and Munich. In 1840 they made their début in Paris at the Renaissance theatre in a piece called *Zingaro* in which Grisi both sang and danced. She was so successful that she was engaged by the Opéra where she first appeared in Donizetti's opera *La Favorita* with Lucien Petipa (brother of the famous choreographer). Her delicate *brio* and feminine charm, her red hair and violet eyes inflamed Gautier, who became an ardent admirer; his praises in the press confirmed her as a star.

However, it was her opera-singer sister Ernesta whom Gautier married, an event which the Goncourts described rather brusquely. 'While visiting Carlotta, he went through the wrong door, entered Ernesta and dropped in her a few children, who landed him in front of the mayor.' But his devotion to Carlotta also bore fruit when in 1841 he wrote for her (in collaboration) a ballet which was to prove a lasting success and the very symbol of the Romantic ideal of womanhood, *Giselle*.

She flourished at a time when enthusiasm for ballerinas reached unprecedented heights, and was one of the celebrated quartet which made a sensation in London in 1845 in Perrot's *Pas de Quatre*; her colleagues were Taglioni, Fanny Cerrito, and Lucile Grahn. She was a lively and versatile artist who could not only sing and dance but startled her admirers at the Opéra one evening by appearing on stage on a horse – she was a skilled equestrienne. She danced regularly in Paris and London from 1842 and made triumphant tours throughout Europe; her début in Saint Petersburg was in 1850 in *Giselle*.

At that time she had just left the Paris Opéra, and in 1853, at the age of 34, she retired altogether, settling in Switzerland outside Geneva, with a daughter she had had by Prince Radziwill. She withdrew happily into a pastoral tranquillity which is conveyed by this photograph, which was probably taken during a visit to Paris to see her sister and her famous brother-in-law, as well as her niece Judith Gautier – who had once thought of following her onto the stage.

Photograph circa 1865

Jules Champfleury

1821–1889

ONE of the most faithful members of the bohemian set in Nadar's early days in Paris was a young man called Jules Husson. He was a regular *habitué* of the Hôtel Merciol in the rue des Canettes where Mürger lived among the characters who were to emerge on the pages of his famous novel about 'La Bohème', and of the Café Momus in the rue des Prêtres, Saint-Germain-l'Auxerrois – haunt of Baudelaire and de Banville and Mürger, of de Nerval and Nadar. He came from Laon, where his father had worked in the town hall, and after an abbreviated education in the local college had arrived in Paris to work in a bookshop.

He had been called home to join a new printing business started by his father but was soon back in Paris. In 1844 he managed to get an article or two published in the *Corsaire-Satan* and in *L'Artiste* and in 1847 he published a novel *Chien Caillou* under a new name, which had developed from 'Fleury' to the more resounding 'Champfleury'. The novel was hailed by Victor Hugo and henceforth he was able to earn a living from newspaper articles, in the leftish style of his circle, and with playlets for the Funambules theatre. His chief contribution was as art critic, first at Baudelaire's invitation for *Corsaire-Satan*, then for *L'Evènement* and *Le Messager de l'Assemblé* in which he reviewed the Salons of 1848 and 1849. In these he enthusiastically praised one of his cronies at the Café de la Rotonde, Courbet (who later painted his portrait).

His character was not really bohemian; he was by nature practical, thrifty, and ambitious. When the *coup d'état* of 1851 made life difficult for left-wing journalists, he moved over to writing novels, of which he produced a great number in a style which was laboriously Realist. He was prolific and a good organizer – his books were regularly serialized in *La Presse* – but he lacked originality and style. He never succeeded in doing more than trail in the footsteps of Balzac; Flaubert unkindly remarked: 'I wrote *Madame Bovary* to annoy Champfleury. I wanted to show that bourgeois unhappiness and second-rate sentiment can survive good writing.'

After 1860 Champfleury abandoned fiction and withdrew into specialist studies more suited to his gifts. He published a number of books on porcelain and ceramics and also on graphics. It seems possible that the occasion of his portrait by Nadar (who was antipathetic to his ungenerous nature) was the publication of his *History of Modern Caricature* in 1865.

Champfleury was evidently an unlikable man. Victor Véron compared his writings with the lard confections in pork butchers' windows. But he championed Baudelaire, Courbet and Wagner and his final account must be favourable. He ended his days as Director of the Sèvres Museum.

Photograph circa 1865

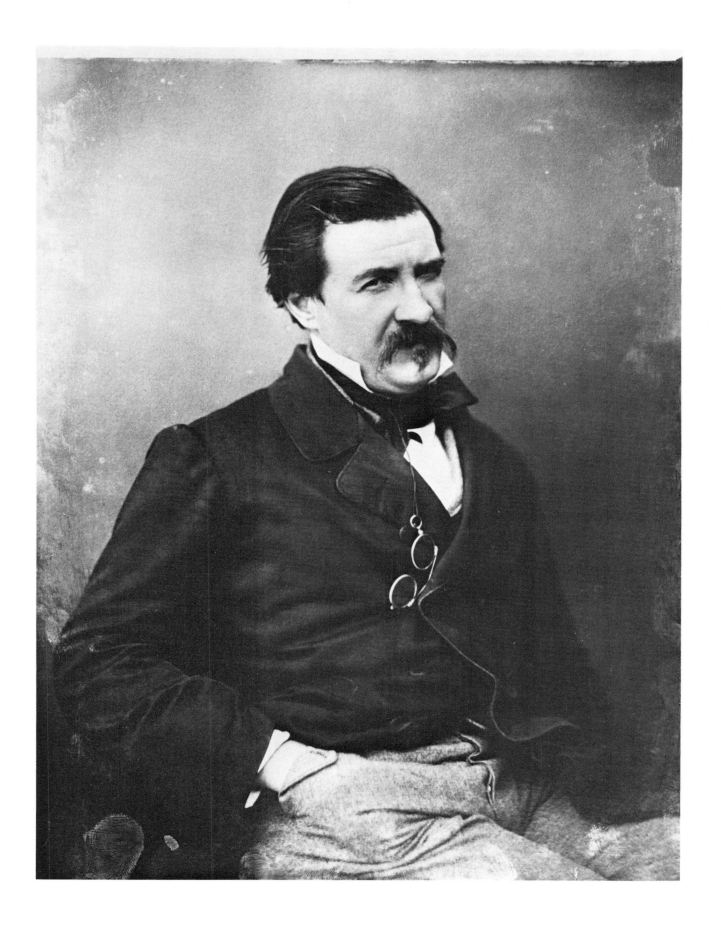

185

Antoine Samuel Adam-Salomon

1811–1881

LIKE Gustave Le Gray (and D. O. Hill and Rejlander in Britain) Salomon came to photography from the fine arts, not from caricature as did Carjat and Nadar. He started as a sculptor, specializing in portrait busts, and moved on to photography of the same genre in 1862. He was naturally much interested in modelling and sculptural effects, and is sometimes considered to have influenced Nadar, though he did not start professionally until Nadar's style was already established. But his work, though perhaps over-dependent on drapery, lighting, and retouching, has a certain gravity and he was much respected, becoming – with Nadar and Carjat – one of the contributors to the popular *Galerie des Contemporains* of celebrities.

Nadar himself praised his work in his *Quand j'étais Photographe,* describing him as being as chimerical and bizarre as Hoffmann's Dr Coppelius. He seems to have been an indefatigable punster, tiny and slightly sinister.

Photograph circa 1865

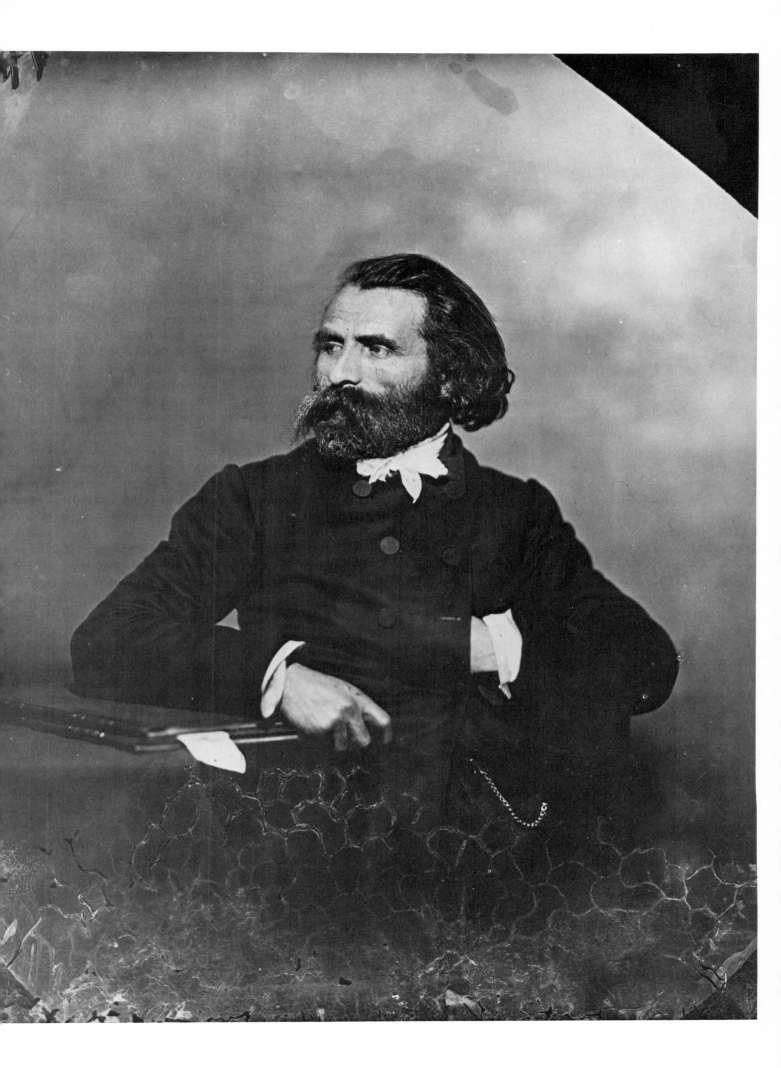

Edouard Manet

1832–1883

MANET, like Baudelaire and Degas, came from a fairly well-to-do middle-class background. By the time this portrait was taken Nadar had moved into more respectable circles. He had most likely met Manet at the smart Café Tortoni or with their common friend, Baudelaire.

In spite of the broad, flat way in which he applied his colours, Manet's early pictures owe much to photography; they are based, like photographs, on accurate records of different degrees of light and dark, or 'tones', and the effect of casual cut-off composition may also owe something to the camera's-eye view. But at the time of this portrait Manet was notorious for quite another reason; his work was regarded as a threat to public decency. In 1863 his *Déjeuner sur l'Herbe*, after being rejected by the Salon, had been hung in the Salon des Refusés; but there the Emperor had pronounced it an 'offence against decency' and a general attack on him in the press followed. The outcry against him was increased at the exhibition of his *Olympe* the following year, 1865. This kind of anti-authoritarian attitude was a sure passport into Nadar's studio.

Manet was the son of an official at the Ministry of Justice, who had tried to put him into law school and then into a naval college. But he failed the examination and at 16 sailed to Rio as an apprentice pilot. On his return to Paris he failed the exam again, and his father allowed him to embark on an artistic career. He started in the studio of the famous historical painter, Couture, but soon moved out to a studio of his own. He had an unhappy start when the child model for his *Garçon aux Cerises* hanged himself in the studio and he moved – the first of many changes of address.

In 1860, at Baudelaire's suggestion, he painted an outdoor study of contemporary smart society, the *Concert aux Tuileries* which includes portraits of friends like Offenbach, Gautier, and Champfleury; and the next year his *Chanteur Espagnol* was warmly praised by Gautier. In 1862 he dedicated to Nadar a painting *Jeune Femme étendue en costume espagnol* and also a lithograph called *Les Chats*. His father died and he married a young Dutch lady who had taught him the piano. The canvases which so shocked the public followed.

In 1867, after the rejection of most of the pictures he submitted for the Salon, he followed Courbet's example and mounted an exhibition of his own nearby. Here he showed fifty paintings; 'What a lot of Spaniards!' was Courbet's grudging comment. During the summer he painted a view of the Invalides in Paris (now in Oslo) showing Nadar making his last ascent in the *Géant*.

During the Siege of Paris Manet served as an officer in the Garde Nationale (under a fellow-artist, Meissonier) and took advantage of his friendship with Nadar by using his balloon-post to send out a letter to his friend and pupil Eva Gonzales. After the declaration of the Republic Manet became a hero to the public as well as to young artists. He was taken up by the powerful Galeries Durand-Ruel; his *Le Bon Bock* scored a huge popular success in 1873; and in 1874 he became a member of the Légion d'Honneur.

But in 1879, at the early age of 47, he suddenly collapsed in the street and was found to be suffering from ataxia. The use of his legs slowly left him, and he had to make a great effort to paint his last major work, the *Bar aux Folies Bergère* in 1882. Finally he took to his bed, and developed gangrene. Nadar, as he relates in his *Baudelaire Intime*, visited him on his deathbed.

He told us on the very day before his death of all his fine plans and discoveries while – a horrible memory – our eyes kept exploring, under the bulge in the blanket made by the dressings, the place left by the leg which had been amputated the day before under an anaesthetic, and whose removal our poor dear friend did not suspect to his last breath.

Photograph circa 1865

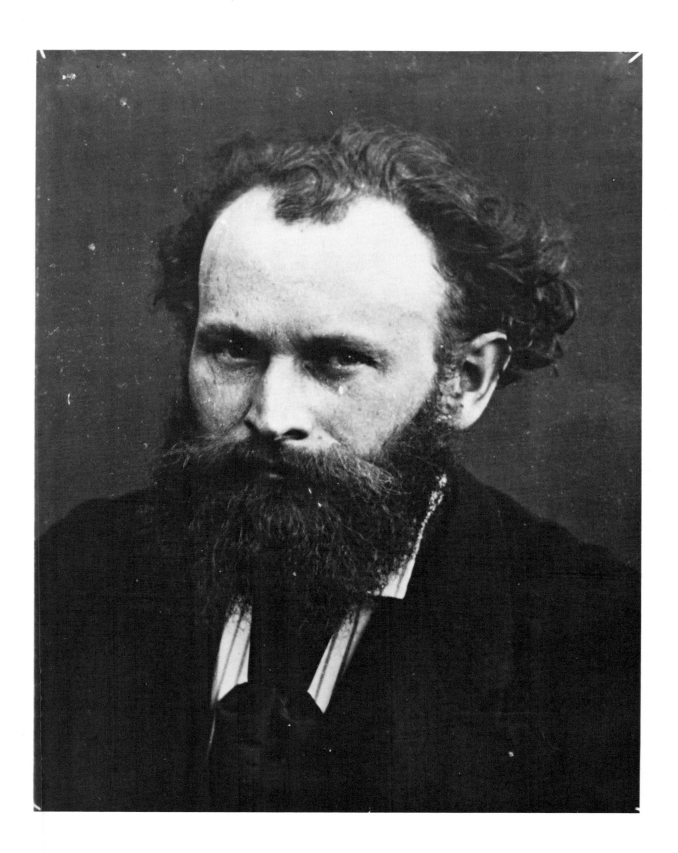

189

Alphonse Daudet

1840–1897

DAUDET was twenty years younger than Nadar; he had been a mere schoolboy during the first years of 'la Bohème' which he would surely have joined if he had been born earlier. He came from the south, the son of a silk-merchant in Nîmes, and kept strong links with his home region all his life. Educated at the lycée in Lyon to which his family had moved, he was a shy, dreamy, short-sighted boy who spent his time in reading and in writing poetry. An attempt to embark on a teacher's career was predictably disastrous.

Fortunately he had an elder brother Ernest (he also became a prolific writer, though overshadowed by Alphonse) who, after managing to get an article in the *Gazette de Lyon*, had set off to Paris to make a name in journalism. In 1857 Alphonse followed, and settled in with him. The very next year he published his first book of poetry, *Les Amoureuses*.

He was launched on a career which suffered hardly a setback. He was taken on by *Le Figaro*, published another book of verse, *La Double Conversion*, the next year, and through the interest of the Empress Eugénie became secretary to the culture-ambitious – although middle-brow – Duc de Morny. Delicate health obliged him to return briefly to the south, but he was soon back in Paris in a snug little house in the suburbs writing plays, stories, and articles. In 1867 he married Julia Allard.

His success never made him pompous, but it did encourage a wild and even coarse streak in his hot southern blood. He became an inveterate womanizer (he told Edmond de Goncourt that he became entangled with 'a crazy, wild woman inherited from Nadar') who revelled in mad sprees and preserved childlike high spirits and the charm of an open character. The house he had bought himself near Nadar's hideout in the Forest of Sénart (where he proved a warm friend) became the meeting place of many writers. He was a close friend of Flaubert and Zola, with whom he was linked as a member of the Realist school of writers. But on the way to Flaubert's funeral, in 1880, he suddenly pulled on his gloves and burst out laughing: 'To me a train means an outing, the joys of a vacation . . . and these black gloves are to remind me of where I am going.'

His first success had come in 1866 when he was still in his twenties, the stories of his beloved south contained in *Lettres de mon Moulin* (whose popularity may have occasioned this photograph), and this was followed by a sequel *Tartarin de Tarascon*. After this he adopted a more committed and realist style, as in *Contes de Lundi*, stories about the 1870 war. His blood was still running strongly – he fought a duel over an article in 1883 – but his health was giving out. In his last years he confined himself mainly to articles, memoirs, adaptations of his novels for the theatre, and books for children. He died in Paris in 1897. His son Léon was also to become a writer and a notorious right-wing politician.

Photograph circa 1866

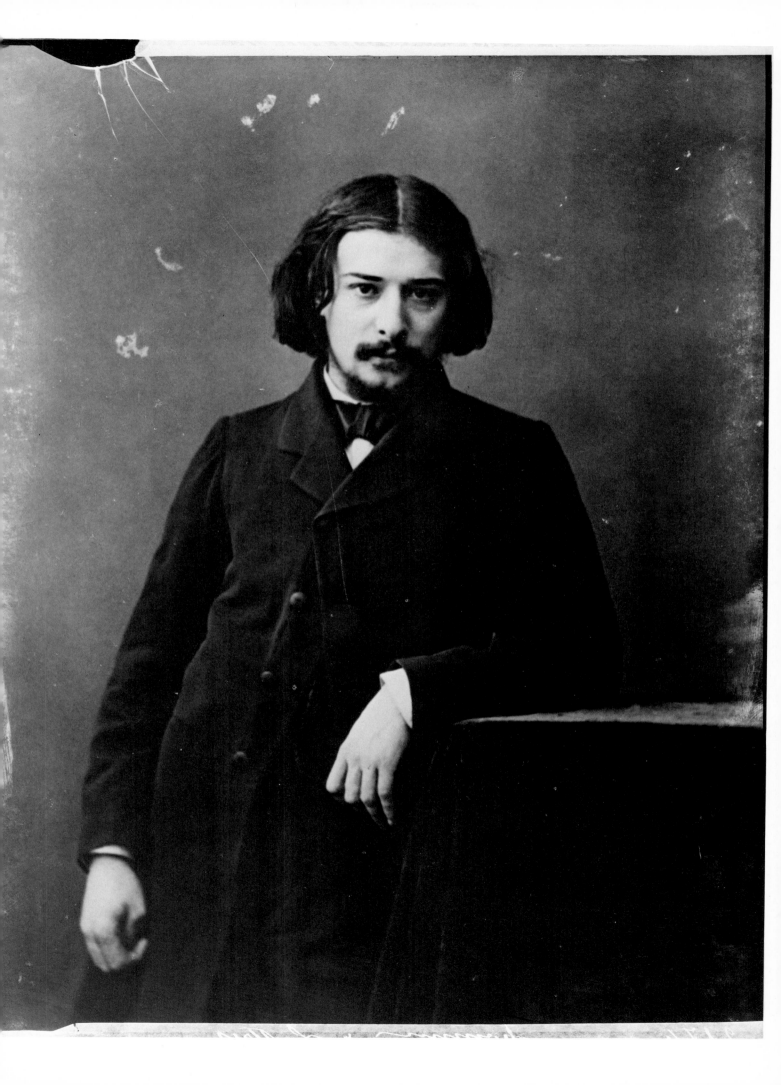

Gustave Courbet
1819–1877

THE untamed emperor of the Realists, Gustave Courbet was the leader of that school of painting in the sense that Ingres and Delacroix were of Classicism and Romanticism. His was a very different background to theirs, and he replaced their highly aesthetic ideals with aims which were more typical of the new society – tough, yet moralistic at the same time.

The son of a farmer near Ornans, he brought an air of rustic stubbornness, commonsense, and solidity into the feverish Paris scene. Educated at the college of Besançon, he was inexplicably set on becoming an artist. He came to Paris at 21 and worked in the Atelier Suisse (starting point for many artists, such as Corot), made copies at the Louvre, attempted romantic subjects without much success, and withdrew – frustrated but not defeated – to Ornans.

Driven back to his own roots, he found his future in their simple realism. A visit to Holland in 1847 gave him his first view of Rembrandt, whose honest vision became a prime influence. Back in Paris, he met Baudelaire and painted his portrait the following year, grumbling that he changed his appearance at each sitting. The suppression of the official jury for the Salon that year gave him his chance; he exhibited a series of straightforward views of his native countryside and became the nucleus of the little group of Realist artists and writers who used to meet in the Brasserie Andler.

His breakthrough came in 1850 with a large canvas, *Enterrement à Ornans,* for which neighbours and friends and members of his family had posed. It became a keen talking-point. The humble ritual portrayed, the unidealized portraits, and the hard, heavy handling offended many viewers. Of some nudes in the 1853 Salon Delacroix recorded: 'The vulgarity of the forms would not matter; it is the vulgarity and uselessness of the thought which are abominable.' The battle with the art establishment was on. For the Universal Exhibition of 1855 the jury rejected his *Enterrement* whereupon he built a rival pavilion nearby, paid for by a wealthy and loyal patron called Bruyas; here, under the Realist label, he exhibited forty paintings aimed at 'translating the customs, ideas, and look of the age – in fact making a living art'.

Two years later he showed at the Salon his *Demoiselles au bord de la Seine* which Nadar caricatured as a pair of broken puppets, the work of 'a balloon full of rustic conceit'. But he conceded that 'Monsieur Courbet knows how to paint. There is nothing mechanical or tricky in his handling.... If this painting lacks delicacy and refinement, at least it is honest and genuine'.

He may not have satisfied Nadar (nor Jules de Goncourt who described his painting as 'ugly without the beauty of ugliness') but he scored a big popular success in 1866 with his *Femme au Perroquet,* which the critic Castagnary compared to Titian. It seems probable that it was this which prompted him to order a portrait from Nadar.

He was now aggressively ambitious and organized a one-man show at the Rond Point de l'Alma in the heart of Paris; and in 1870 he had arrived sufficiently to be offered the Chevalerie de la Légion d'Honneur – which he promptly refused. The Proudhon-type socialism which he professed made him a natural leader in the brief reign of the Commune after the events of 1870. He became President of the Commission d'Artistes and both proposed and participated in the symbolic demolition of the imperial monument in the Place Vendôme.

In 1872 all his paintings were turned down by the Salon jury. Finally, in 1873 the new Assembly voted for the reconstruction of the Vendôme column, fining Courbet 323,000 francs to pay for the work. Quite unable to meet this enormous debt, Courbet fled to Switzerland. His goods were seized. A sale of his pictures in 1877 produced next to nothing. Depressed and impoverished, he died near Vevey a few months later.

Photograph circa 1866

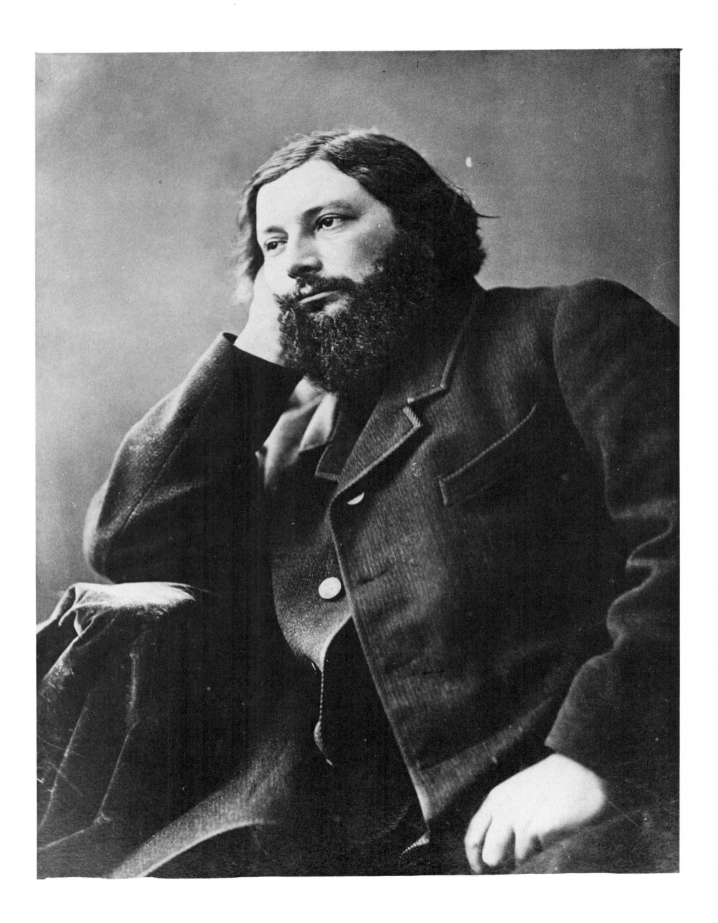

Sarah Bernhardt

1844–1923

CONSIDERING that Sarah Bernhardt's last appearance on the stage was in 1922 it was a lucky chance which led her to Nadar's studio for this portrait while he was still practising: evidently she enjoyed the experience, for she later became a regular client of his son Paul. By the standards of her time, she was excessively thin in her youth: Nadar has thrown a studio cloak round her skinny arms (it also appears in a portrait of an unknown girl).

Like her great predecessor Rachel, Henriette-Rosine Bernard was Jewish. She was the illegitimate child of an oculist's daughter and (probably) a naval officer in Le Havre. Her one advantage was a sister of her mother, Rosine, who made a successful career as a courtesan. It was this aunt who rescued her from the humble lodging where she was living after a short education in a convent in Versailles. Exalted influence helped her to be taken as a pupil into the Conservatoire; after her first year (1860) she was placed second for tragedy, after her third she came second for comedy.

She won an engagement with the Comédie Française in 1861 through influences which can be guessed from the fact that her aunt gave a dinner party to celebrate the event which was attended not only by the Duc de Morny but also the Minister of Culture; Rossini accompanied the new recruit as she recited a poem. She had a good send-off; but she made such poor progress that after two years she left, to join the Gymnase as an understudy. Even in this humble rôle her skimpy figure and difficult temperament proved too much, and she ran away to Spain, returning to Paris to a life that was not much different from that of a high-class prostitute. In 1864 she bore a child, Maurice.

Three years of disreputable living were ended in 1866 when the director of the Odéon, Camille Doucet, engaged her; after two unremarkable parts, she suddenly made a hit, in 1869, in a travesty rôle – as a page in Coppée's verse play *Le Passant*. She had become a star, with an original style of her own. In place of the severe classicism of Rachel she offered a frail and appealing girl with huge eyes, feminine charm, and a romantically seductive voice, a 'long caress of sound' as the critic Sarcey described it. Her popularity was increased when she led the transformation of the Odéon into a hospital during the 1870 Siege (one of her patients was later to become Maréchal Foch). When peace returned she had an overwhelming success at the Comédie Française in *Ruy Blas*. Her flamboyant manner and determined publicity became proverbial. She travelled to London in 1879 and hypnotized the English public with her talent and exotic personality.

But the following year she left abruptly after receiving a bad review, paying 143,000 francs fine for breaking her contract. She formed her own troupe and toured Europe and Russia with a repertoire dominated by a play which gave her one of her most touching roles, Dumas *fils' La Dame aux Camélias*. In 1887 she scored another big hit in Paris in Sardou's *La Tosca* before setting out on a world tour.

Turning her energies to organization, she became Director of the Renaissance Theatre in 1893 and in 1899 founded her own theatre, the Sarah Bernhardt. Here, at the age of 56, she revived her favourite roles in *Tosca*, Rostand's *L'Aiglon*, and Hamlet. Rich, famous, and sumptuously theatrical, she entertained in extravagant style, but her voice and her physique were failing and she had a severe operation on one leg. In 1922 she made her last stage appearance aged 78, in a play appropriately called *La Gloire* and the next year she died. Fifty thousand Parisians turned out to mourn the passing of a woman who had brilliantly impersonated the popular conception of an actress for two generations.

Photograph circa 1866

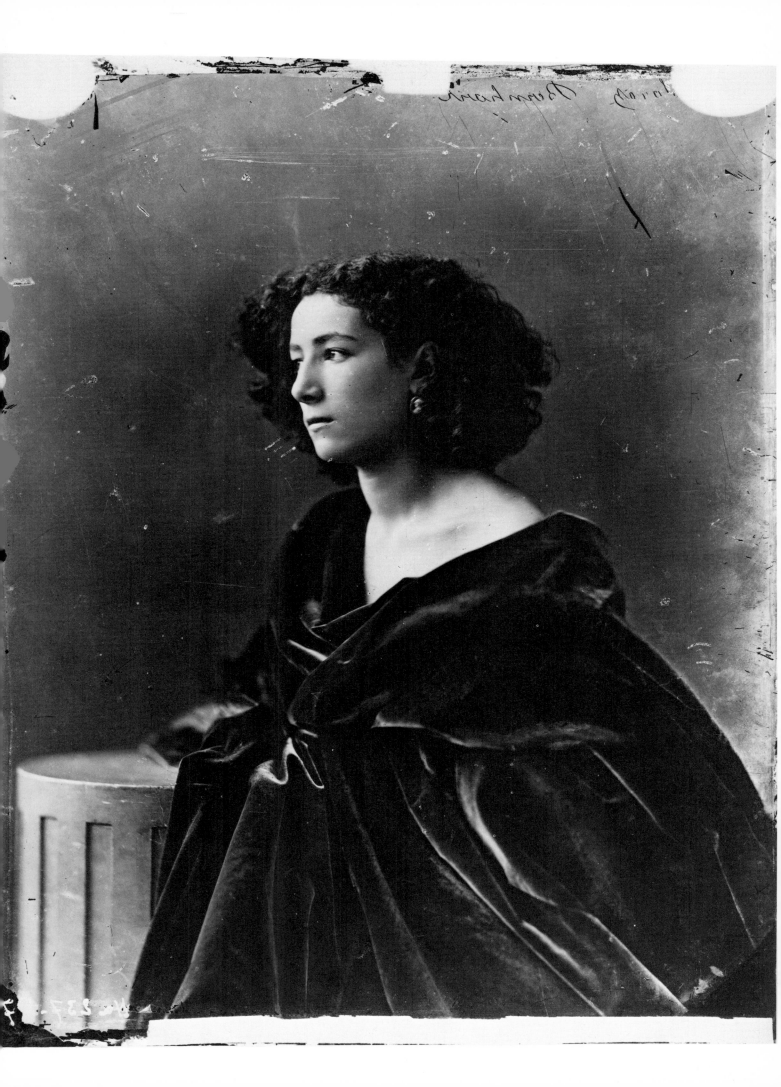

Giuseppe Verdi

1813–1901

VERDI was born near Busseto, in Parma, the son of an illiterate innkeeper; and technically – owing to Napoleon's invasions – he was a French citizen, though during his childhood he was to become an Austrian; he was christened in the name of Joseph-François. He showed musical promise very early, and at the age of 12 was appointed village organist. His musical education was continued in Busseto, though every Sunday he walked the four miles back home to play the organ. His talent was recognized by a rich wine-merchant who took him into his home, nurtured his talent and sent him at the age of 18 to study in Milan. That very first year, in 1831, he had a one-act opera produced at La Scala; but it was withdrawn after one performance (Verdi never loved La Scala again), and he returned to Busseto and married his patron's daughter.

The marriage did not last long; in 1837 his wife died at the same time as both his children. But a new opera, *Nabucco*, turned out a success; the audience identified the sufferings of the Jews with their own patriotic struggles against the Austrians and Verdi became (in the same way as his almost exact contemporary, Wagner) a symbol of national aspirations.

Further operas striking the same note – *I Lombardi, Ernani*, and *Giovanna d'Arco* – made him a popular hero. In 1846 *Ernani*, which was based on Victor Hugo's celebrated play, was given with great success in Paris, and was followed the next year by *Macbeth*. But his concealed liaison with a singer, Giuseppina Strepponi, and the themes of some of his operas began to cause official concern: the victim of *Rigoletto* (a king in Victor Hugo's story) had to be changed into a duke and in *La Traviata* (1853), in order to avoid offending public taste, the story of the courtesan in Dumas' story was moved back into the seventeenth century.

But by now Verdi was a rich man in big demand. Between 1855 and 1870 he worked mainly in Paris, producing spectacle-operas with substantial ballet interludes in the French manner. The *Sicilian Vespers* (1855) was followed by *Simon Boccanegra* (1857) and *Un Ballo in Maschera* (1859). In 1860 Italy was finally united and its composer, by now an international figure, became, rather reluctantly, a deputy in the new government. In 1861 he resigned and the next year took him to Russia and London, where he composed, for an exhibition, a hymn containing a contrapuntal combination of *God Save the Queen, La Marseillaise*, and an Italian tune called *Inno di Mameli*. However, the inclusion of the revolutionary *Marseillaise* prevented its performance.

In 1863 he was in Saint Petersburg for the première of *La Forza del Destino*, and in Madrid for its performance there. In 1871 came *Aïda*, a commission from the Khedive of Egypt to celebrate the opening of de Lesseps' Suez Canal. There followed a pause in his inspiration (he was in his 60s), broken by the two operas of his maturity – both with a new librettist, Boito – *Otello* (1887) and *Falstaff* (1893). These were his last major works. In 1897 his wife died (he had remarried in 1859) and in 1901 he followed her.

This photograph was probably taken when Verdi was in Paris in 1866 and 1867 putting on *Don Carlos* at the Opéra. He was never a favourite of the Paris literary set. Théophile Gautier once declared to the Goncourts that Verdi's style consisted simply of the principle that 'when the words are sad the music goes "tron, tron, tron" and when they are happy the music goes "tra, tra, tra"'.

Photograph circa 1866

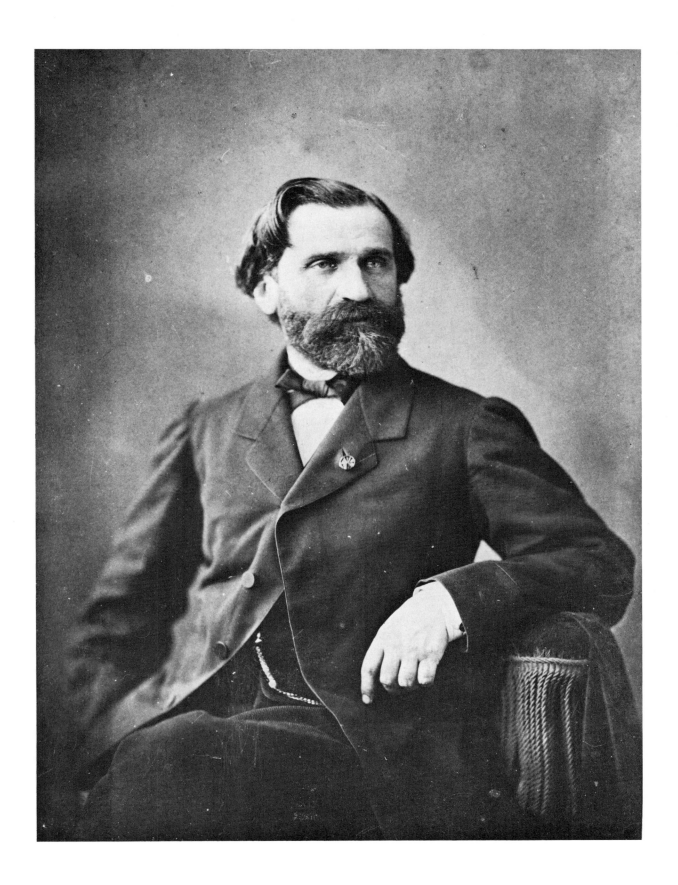

Jules Michelet

1798–1874

MICHELET had been Professor of History at the Collège de France when Nadar was an impressionable youth, and the passionate rhetoric with which he defended the cause of the French Revolution, which he portrayed as the triumph of justice over divine right, may have helped to spur Nadar to embark on the eccentric expedition to liberate Poland in 1848. As a martyr of the Establishment (he had been suspended in 1848 after lectures attacking the Church and dismissed from all posts by the Emperor after the *coup d'état*), he must have been a special hero when, in 1856 – as we know from a letter – this portrait was made.

Michelet was 58 at the time. He had been born in Paris, the son of a printer, and educated at the Lycée Charlemagne where he proved a brilliant pupil. At the age of 21 he was made a doctor of letters on the basis of a thesis concerned with Locke's concept of infinity. Two years later he had taken up a teaching post, a profession which he practised for many years. In 1826 he entered the remodelled Ecole Normale Supérieure as professor of both Philosophy and History – a blend which he expressed in his own *Introduction à l'Histoire Universelle*, published in 1831.

He was then appointed to the Archives Department, from which advantageous post he published over the next ten years the six massive volumes of his *Histoire de France*, in which his poetic vision of France emerging slowly and triumphantly from racial mists and geological confusion was eloquently expressed. In 1838 he took over the Chair of History at the Collège de France. In 1839 his wife died and a strain of pessimism entered his writing; in 1842 he renounced Christianity. His subsequent lectures were instrumental in fomenting the 1848 revolution.

In 1850 he married again, and shortly afterwards began work on further volumes of his *Histoire de France*. He kept up his hostility to Church and Monarchy and took a broad moral view of events, seeing them as symbols of social evolution. The Goncourts described him as 'a historian with opera glasses; he looks through the small end at big events and through the large end at little ones'. He in turn admired their use of minor documents in historical research and discussed with them the important role played through the ages by ladies' maids ('male servants had less influence').

The period of this portrait seems to have been a happy one; it was marked by the first of a series of charmingly moral nature books, *L'Oiseau*, *L'Insecte*, *La Mer*, and even a slightly erotic work called *L'Amour et la Femme*. In 1864 he discussed the universal quest for God in *La Bible de l'Humanité*, but the war of 1870 shattered his liberal hopes. He died at Hyères in 1874.

Photograph 1856

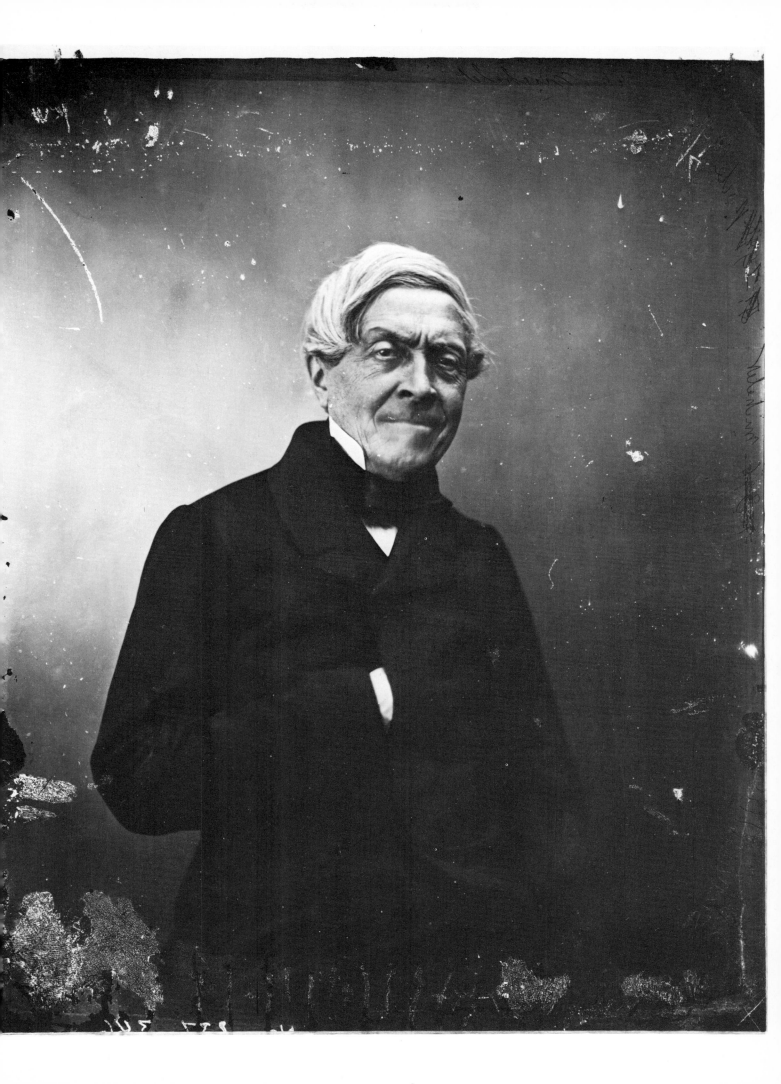

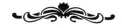

Alexandre Becquerel (*fils*)

1820–1891

BOTH the son and the father of distinguished physicists, Alexandre Becquerel, born in Paris, was accepted after college into the École Normale and the Polytechnique simultaneously; but he chose instead to help his father, with whom he published two books in 1847. In 1852 he was appointed Professor of Physics at the Conservatoire des Arts et Métiers; in 1860 he was made Professor of Chemistry in the Société Chimique de Paris; and in 1865 he became a member of the Académie des Sciences. Finally in 1878, like his father, he joined the Musée d'Histoire Naturelle and became the administrator.

He published a number of scientific works in his own field, which included electricity, magnetism, and optics. This involved him in a study of photography, to which he contributed by the invention of the first photometer. It may have been in this connexion that he made Nadar's acquaintance.

Photograph circa 1870

Elisée Reclus

1830–1905

ONE of a distinguished intellectual family, Elisée Reclus was a curious mixture – an ardent radical who became an outstanding geographer. His three brothers, Onésime, Elie, and Paul also made notable careers – the first as a fellow geographer, the second as the Director of the Bibliothèque Nationale under the Commune (he too was a staunch socialist), and the third as a doctor. Elisée seems to have spent much of his youth in politics, as in 1851 he was obliged to flee the country after the *coup d'état*.

He travelled widely in Europe and America and did not return until 1857. He devoted himself to study in Paris and in 1867 published the first of two massive and important geographical volumes called *La Terre*; the second volume appeared the following year.

His studies were interrupted by the war of 1870 in which, after taking part in the Siege of Paris, he fought for the Commune as a member of the extreme left-wing Internationale. After the defeat of the Communards he was condemned to deportation, and then to banishment, and it was from abroad that he sent home – between 1875 and 1880 – his monumental *Géographie Universelle*. In 1876 he was delivering an oration at the graveside of the anarchist Bakunin in Berne; but in 1892 he was officially adopted by the Belgian establishment, becoming a Professor at the University of Brussels.

Photograph circa 1870

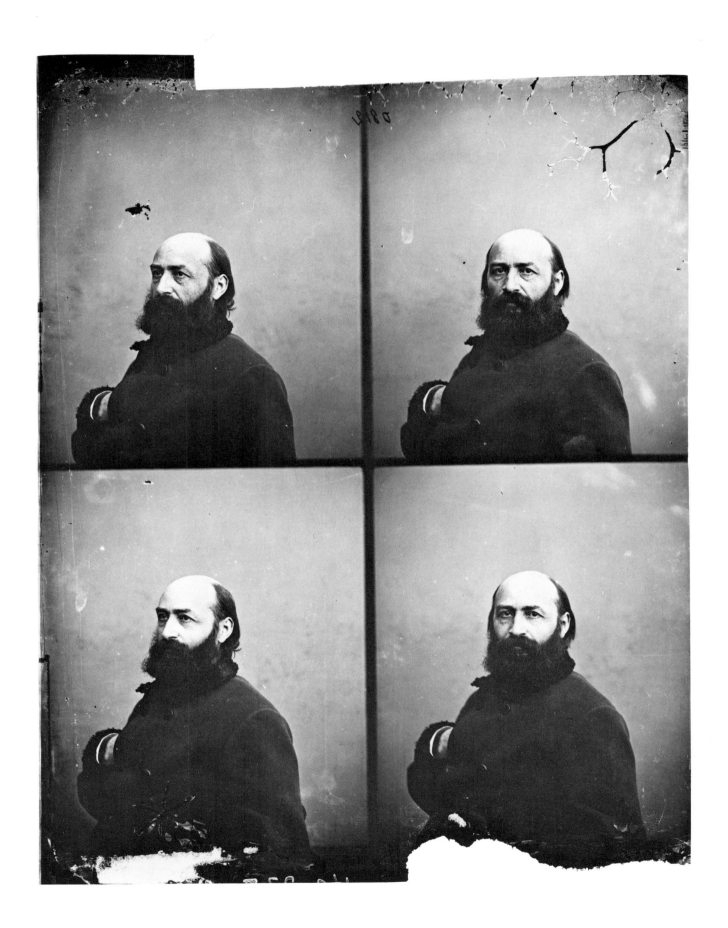

Jacques Offenbach

1819–1880

OFFENBACH was a key figure in the Second Empire – witty, hard-working and talented with a superficial social charm which took him into every salon in Paris. He was a centre of the world of actors, singers and journalists which Nadar frequented in his youth, and the two men became close friends. When Nadar formed his Société de Photographie Artistique in 1856 to launch his activities in the rue Saint Lazare, Offenbach was one of the founder members, and they were frequent guests at each other's parties.

Offenbach had been born in Cologne, the son of a synagogue musician, and showed his talents early, becoming a prodigy on the 'cello. When he was 14 his father took him to Paris to study at the Conservatoire. He abandoned the 'cello and took to composing, at which he showed a remarkable facility; his first big success was in London, where he performed before Queen Victoria.

In 1844 he returned to Paris and continued his career as provider of light music, a genre to which he brought both agility and elegance. He was converted to Catholicism, married, and became the musical director of the Comédie Française. He was so successful there that in 1855 he opened his own theatre, the Bouffes Parisiens, which became what the Goncourts called 'the Figaro of theatres', attracting a slightly raffish society, 'ranging from Commerson at the bottom to Morny, the Maecenas of Offenbach, the amateur musician, the typical man of the Empire, shopworn and soiled by all the corruption in Paris, representing its decadence without its grandeur'.

In the same year Offenbach wrote a one-act operetta called *Les Deux Aveugles* which scored a popular success – the first of a stream of light theatre entertainments. The most notable of these was *Orphée aux Enfers* which he composed in 1858 and which made him the undisputed king of his own world – as well as earning him a place in the revised edition of Nadar's 'Panthéon' (though the Goncourts described him that year as 'a skeleton in pince-nez who looks as if he is raping a double-bass'). Two years later he was awarded French citizenship by a special decree of the Emperor, and this was followed two years later by the membership of the Légion d'Honneur. In 1863 he was invited to spend a week in the imperial residence at Compiègne.

These were the peak years in his career, and they coincided with Nadar's main achievements as a photographer. In 1864 he produced *La Belle Hélène*, in 1866 *La Vie Parisienne*, and in 1869 *Les Brigands*, both at the Théâtre des Variétés and at the Opéra Comique. But the fall of the Empire in 1870 marked the end of his prosperity. His style lost the charm of novelty and his productions began to be less popular. In 1873 he took over the Théâtre de la Gaieté but fashions were changing and by 1875 he was near to bankruptcy.

It was about this time – perhaps after the première of yet another operetta called *La Créole* – that Nadar made this portrait of his old friend, the jaunty smile and dapper clothes concealing his financial worries. The following year he desperately undertook a tour in America, but it was a failure. He returned to France disappointed and four years later he died, leaving over a hundred works as his memorial.

Photograph circa 1875

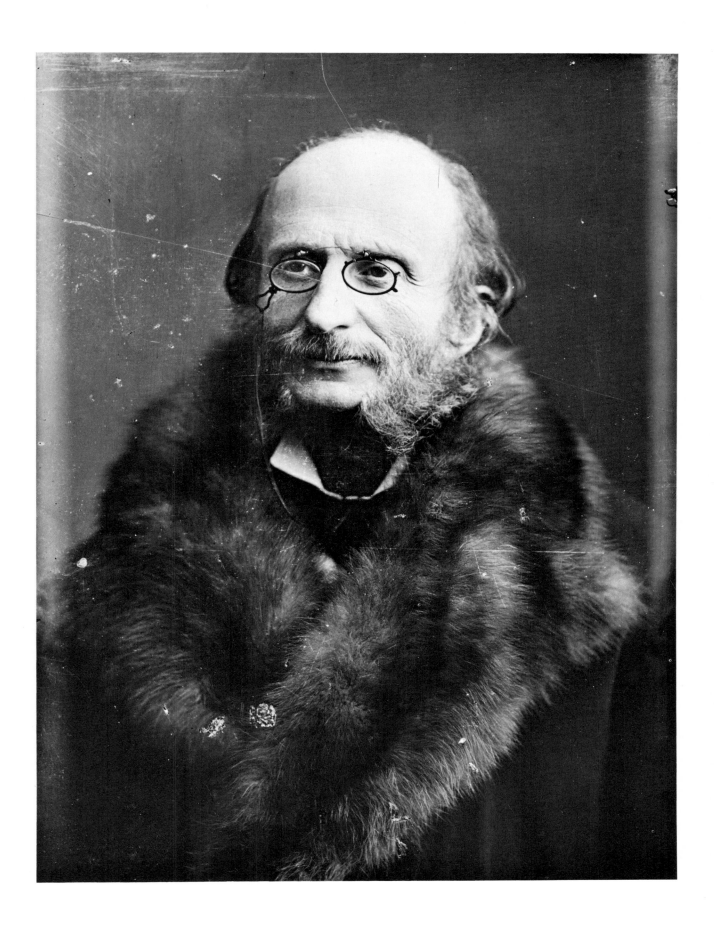

Charles Garnier

1825–1898

THE most eloquent monument to the Second Empire is the Paris Opera House. Its design was thrown open to competition the year when Nadar moved into his studio in the Boulevard des Capucines, and it was won by an almost unknown 35-year-old architect called Charles Garnier. The foundation-stone was laid the next year, but owing to its enormous scale and the intervention of the war of 1870, it was not declared open until 1875, when Garnier was 50. This portrait probably shows him shortly after this event.

Garnier was a Parisian, son of a wheelwright. He was supposed to enter his father's profession, but his health was delicate and his mother entered him in the Petite Ecole de Dessin in the rue de Médicine, in the hope that he might become a surveyor. At the age of 17 he was accepted by the École des Beaux-Arts; to support himself he worked most of the day in architects' offices, including that of Viollet le Duc.

In 1848 he won the Grand Prix de l'Architecture and the Prix de Rome, and found himself as a boarder in the Villa de' Medicis in Rome. From there he sent some notable academic reports on old Roman buildings; and in 1853 he carried out drawings for a restoration of the Temple of Aegina in Rome which attracted much attention. He returned to Paris and was appointed architect to the 5th and 6th arrondissements. It was from this humble post that, inspired no doubt by Roman grandeur, he submitted the design for the Opera House competition which passed first through the eliminating round, and then won the prize outright from the four other finalists. It was to take fourteen years to complete and cost thirty-five million francs.

From then on he was professionally established, and carried out a number of commissions. They included the Conservatoire de Musique and the Hôtel du Cercle de la Librairie, on the Boulevard Saint-Germain in Paris, the Observatory in Nice, and the Casinos in Vittel and Monte Carlo. For the last he commissioned statues of Music and Dance from two slightly surprising sculptors – Gustave Doré and Sarah Bernhardt.

He was awarded the Gold Medal of the RIBA in London in 1886, and became first a Commander and then, in 1895, a Grand Officer of the Légion d'Honneur – the first architect to receive this award.

Photograph circa 1877

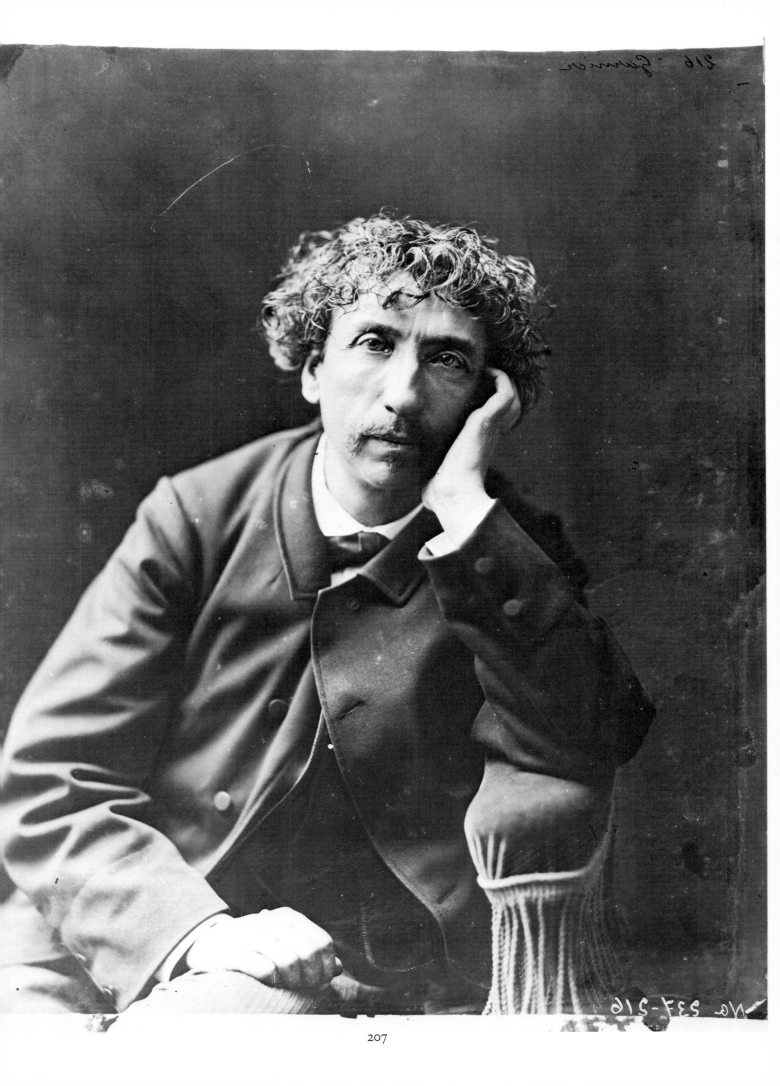

Victor Hugo

1802–1885

THOUGH he rarely carried it out himself, Nadar accepted deathbed portraiture as one of the normal duties of a photographer. At the time of this photograph he had moved his studio to the rue d'Anjou and his 29-year-old son Paul was helping him in such routine work. But when, one day in 1885, he received an urgent message from the Place des Vosges, he hurried there himself to make the final record of a man he had loved and venerated all his life, Victor Hugo. One of the few deathbed pictures which Nadar preserved, it was clearly a pious tribute. Only three years earlier he had dedicated one of the chapters in his *Sous L'Incendie* to the poet with the words: 'To the man who has suckled me and who will guide my taste until the tomb.'

Hugo had floated like a literary *Géant* over the whole careers of Nadar and his generation, embodying all their beliefs and dreams. It was his youthful play *Hernani* whose *première* in the very fortress of tradition, the Odéon, set the spark in 1830 to the Romantic movement: he became a literary lion in the 1840s and a socialist hero when he was banished after the 1851 *coup d'état*; and in his old age he was an ardent and generous champion of Nadar's favourite cause, heavier-than-air flight.

Hugo had been born in 1802, the son of a general; as his father was constantly on the move he was brought up mainly by his mother, in Italy and Spain as well as France. At 13 he was already writing poetry and at 17 he founded a literary review, contributing most of the articles himself.

When he was 19 his mother died and the next year he married. In 1821 his first book of poems appeared, followed by a fantasy-novel, *Han d'Islande,* and he became the leader of a literary group, the 'cénacle'. He had been brought up in a royalist atmosphere but his next poems *Les Orientales* revealed a Byronic sympathy with the Greek patriots and with republicanism. In 1827 he launched into the theatre with *Marion de Lorme*; it was suppressed by the censor and he retorted with *Hernani,* whose verses in praise of a young outlaw made it the symbol of all young romantics.

In the next year, 1831, another study of a social outcast appeared, *The Hunchback of Notre Dame*. It won him success and fame, but later his own story took a dark turning. In 1843 his married daughter was drowned. In 1848, revolution broke out and found him undecided; he had been a friend of Louis-Philippe and now, as a deputy for Paris, at first supported Louis-Napoléon. But he could not stomach the *coup d'état* of 1851 and, after protests he had to flee – first to Brussels, then to Jersey. He was to remain an exile for nearly twenty years and it was here – and later in Guernsey – that he produced some of his best work. It included the powerful poetry of *Les Châtiments,* the variety of *La Légende des Siècles,* and the novel *Les Misérables* which recalled the Paris of his youth. He turned to the turbulent world of Shakespeare in a famous 'Preface', dabbled in Spiritualism and explored his new environment in *Les Travailleurs de la Mer* (about Guernsey) and *L'Homme qui Rit* (about seventeenth-century England).

In 1868, his beloved wife died; after the proclamation of the Republic in 1870, he returned to Paris as an honoured sage. But next year his son Charles died; in 1872 his daughter Adèle returned from America insane; and in 1873 another son, François Victor, succumbed. In 1878 he suffered a stroke and died seven years later. His work – a characteristic nineteenth-century blend of noble aspirations and gigantic output – was over, leaving us only this picture of a man who in his own lifetime had become a monument to his age.

Photograph 1885

208

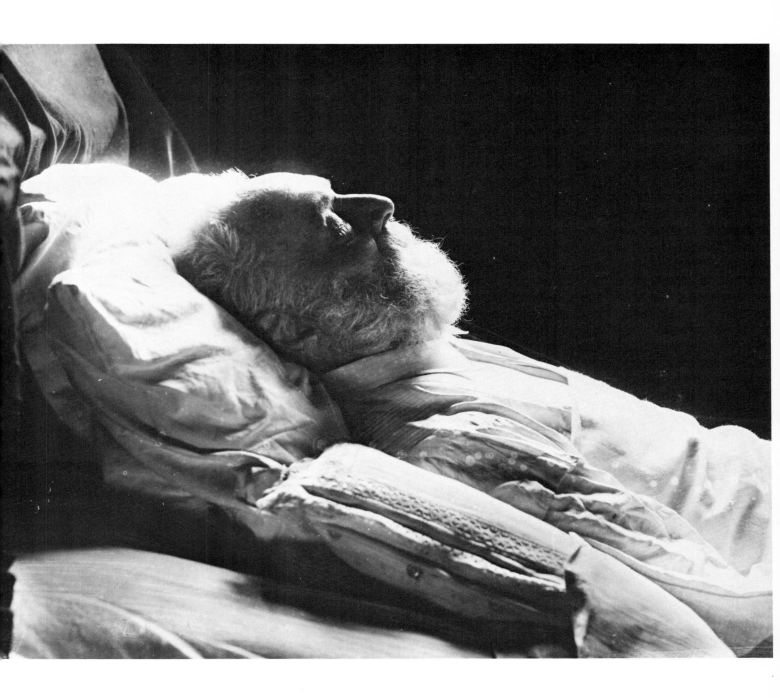

The Atelier Nadar

*Nadar, who had started by collaborating with his brother, ended by
collaborating with his son. By the time of the 'Chevreul
Interview' in 1886 Paul was handling the camera while his father
did the talking; and the next year, when Mme Nadar fell ill and
Nadar finally left Paris he entrusted his studio to his son. Paul quickly
developed the commercial side of the enterprise, launching into the sale
of equipment and embarking on publicity and society portraits. He was not
without talent, but the mechanical progress of photography exerted a steadily
glossifying effect and much of the work was carried out by assistants. He founded an
influential magazine,* Paris-Photographe, *became the French agent for the American
firm of Eastman Kodak in 1891, opened up branches outside Paris (including, it
seems, one in South America), and died in 1939. The selection which follows is drawn
from the whole active period of the Atelier Nadar, from its very beginning
in the rue Saint Lazare in 1854 up to its closure during the Second World War.
After Nadar moved his studio to the rue d'Anjou in 1871, father and son (as well
as uncle Adrien) were all working together and the authorship of the portraits
begins to become blurred. A date attributed to a photograph indicates
that it was almost certainly by Félix. The later ones are of course by Paul
and his assistants.*

Arts of the Belle Epoque
Painters and Sculptors

NADAR had the good fortune to live and work in Paris at a time when it was not only the artistic centre of the Western world, but when it was going through one of its most active and exciting periods of creativity. A man of strong enthusiasms, observant eye, and wide – if not deep – culture, he was involved in the revolutionary changes which convulsed the art world in his youth. In old age, when his mind was turned mainly towards the past, he doubtless lost sympathy with the latest experiments; but where his own generation was concerned he not only played a modest part in the intellectual battles but left moving records of many of its heroes.

Both by age and temperament Nadar fell naturally into the rôle of a champion of Romanticism at the moment of its triumph over the neo-classicism of painters like David and Ingres. The dashing, rapid style of the graphics in which he made his début contributed to the Romantic canon; and the preoccupation with daily life, as opposed to the idealistic dreams of studio painters, was one of the ingredients of its successor, Realism.

Nadar's contact with the serious art world began in 1852. In that year he published the first of his 'Nadar – Jury' features, in which he commented on the annual Salon exhibitions, illustrating his text with satirical drawings. In the manner of the time he worked his way steadily round a vast number of exhibits and he cannot be credited with any specially perceptive observation. But his remarks were never ridiculous, and intelligently revealed his sympathies. These were confined to the Romantic school, whose stress on colour and movement found echoes in his own character, while he correspondingly disapproved of what he found the frigid artificiality of the Classical painters. Delacroix was his great hero, with Ingres and his followers cast as villains, while he granted reluctant but generous recognition to the Realism of Courbet and, more readily, to Millet.

His support of Constantin Guys, both as man and artist, was unwavering; he owned a Don Quixote sketch by Daumier; and prided himself on his possession of a painting by Manet, as well as a number of landscapes in the Barbizon manner. He even tried his own hand, very amateurishly, at painting, and was much at home in the studio and the gallery.

His formative years were passed in the full flush of the victory of Delacroix and his followers, and he accepted the later rise of the Realists, especially those, like Millet, who reflected his own literary and altruistic feelings. It seems to have been chance rather than enthusiasm which earned him a place of honour in the history of the succeeding movement, Impressionism, when he allowed its first exhibition to take place in his old studio in 1874.

It can be guessed that he would have had little sympathy for the pale, exotic dreams of the Symbolists who followed the Impressionists; and by the time the Post-Impressionists had begun to make their mark at the end of the century, with men like Cézanne and Seurat pointing the way back to order and formal control, he was already beyond forming new allegiances. Van Gogh and Gauguin and the whole Fauve school which emerged from them must have seemed crude and violent to a taste trained in traditional styles.

He was to live, though he cannot have known it, through the final collapse of all the art-values he had believed in: born while echoes of Géricault's famous *Raft of the Medusa* were still rumbling round the Salon, he died in the year when far away in Moscow, the first abstract painting saw the light. Entrenched humanist that he was, he would surely have detested it.

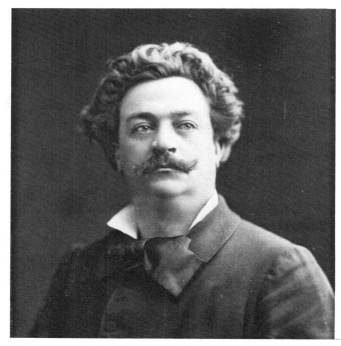

'Gill' (*Gosset de Guines*) (1840–85), cartoonist

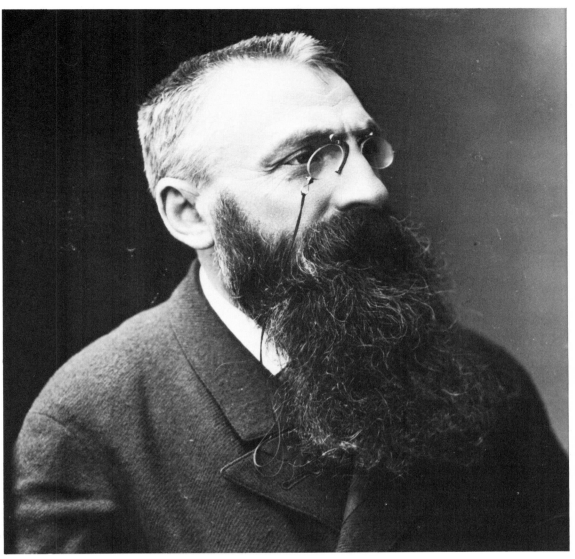

Auguste Rodin (1840–1917), sculptor

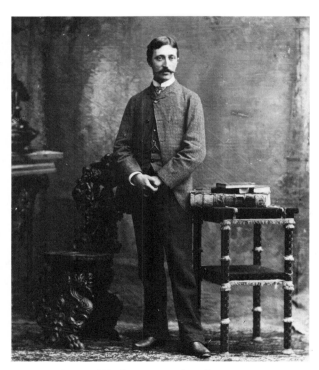

Edouard Detaille (1848–1912), painter

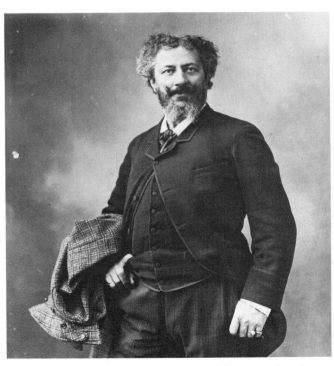

Carolus Duran (1837–1917), painter

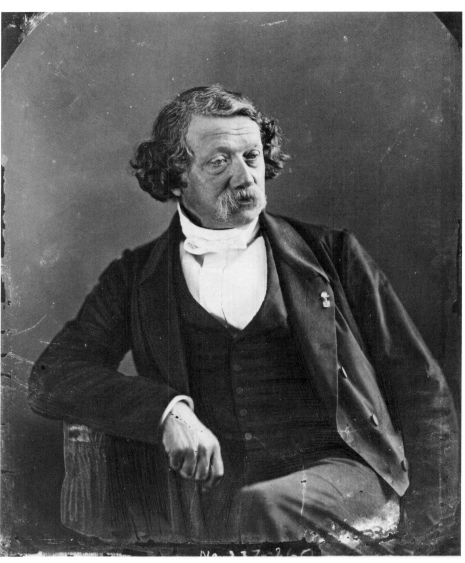

Philippe Auguste Jeanron (1809–77), painter, *c.*1860

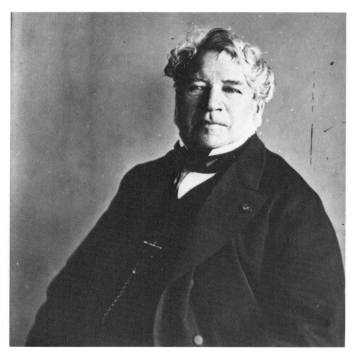

Eugène Isabey (1804–86), painter, *c.*1860

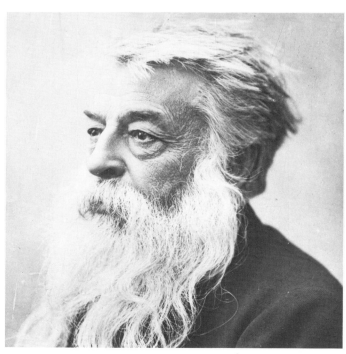

Ernest Meissonier (1815–91), painter

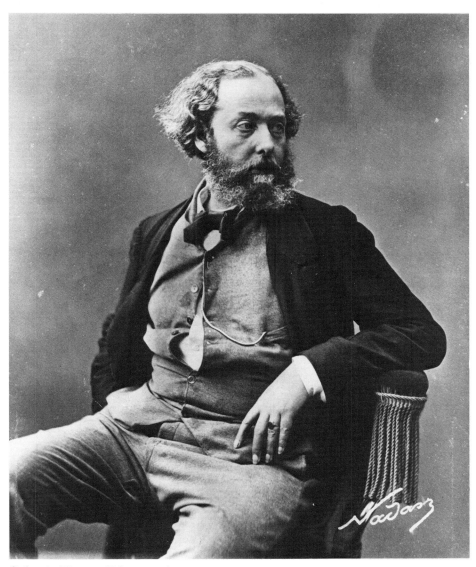

Celestin Nanteuil (1813–73), painter, *c.*1868

Théodore Rousseau (1812–67), painter, *c.*1857

Georges Rouget (1783–1869), historical painter

Antoine Barye (1795–1875),
sculptor, c.1860

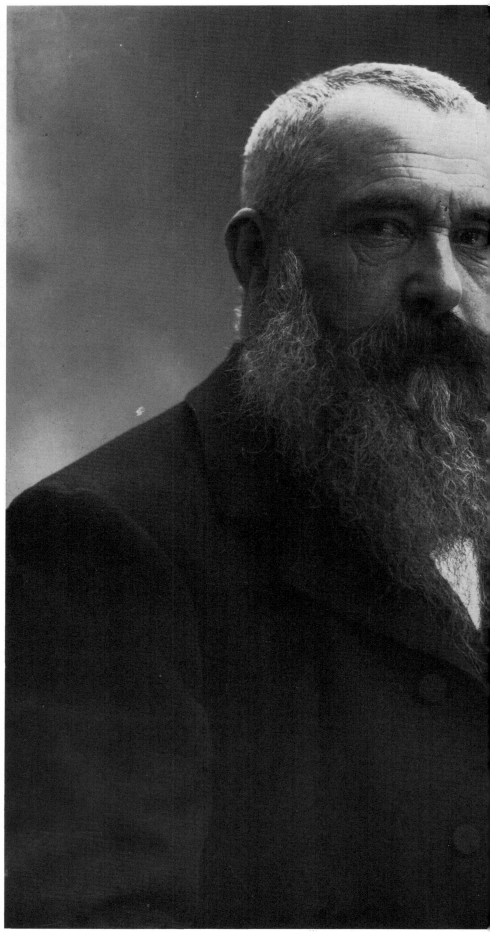

Claude Monet (1840–1926), painter

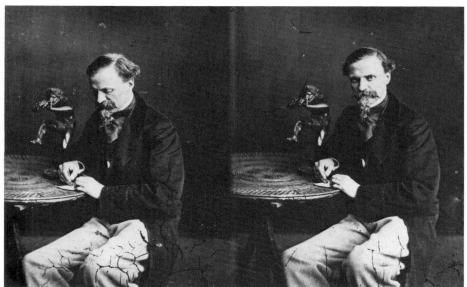

'**Cham**' (*Amédée Noé*) (1819–79), cartoonist, *c*.1870

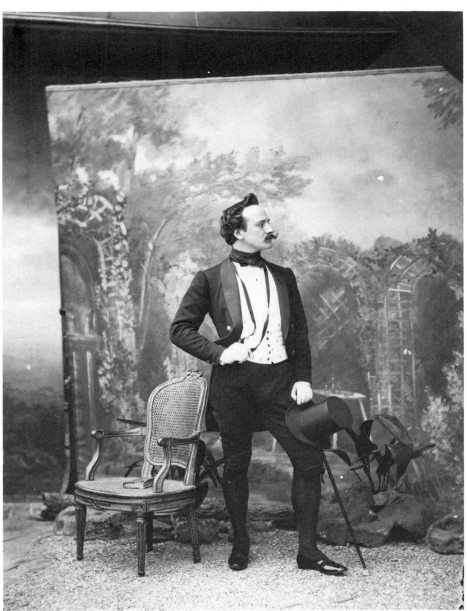

'**Caran d'ache**' (*Emmanuel Poiré*) (1858–1909), cartoonist

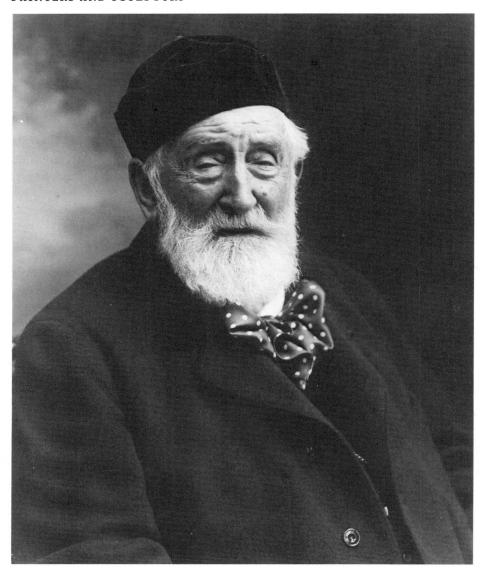

Henri Harpignies (1819–1916), painter

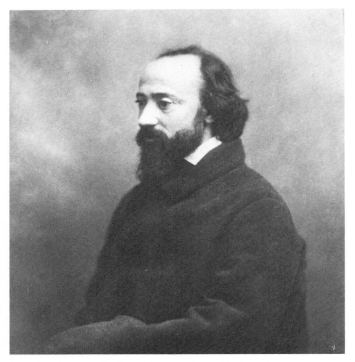

Charles François Daubigny (1817–1878), painter

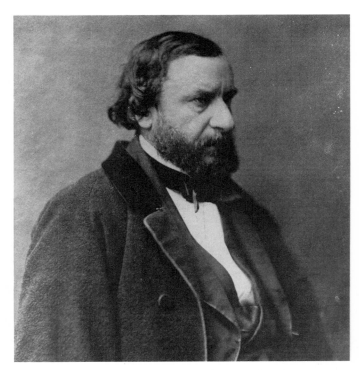

Constans Troyon (1813–65), painter, c.1856

Horace Vernet (1789–1863), painter, *c.*1858

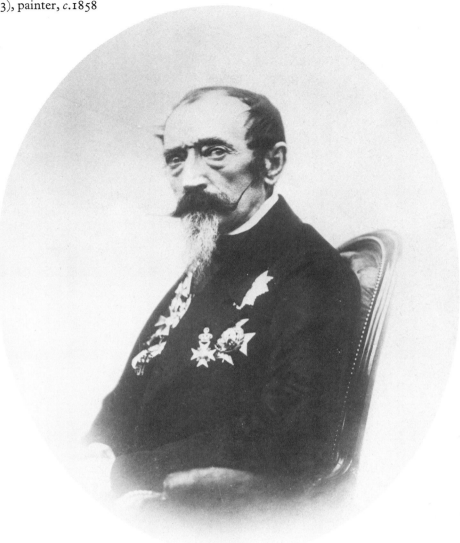

Eugène Viollet-le-Duc (1814–79), architect

Louis Boulanger (1806–67), painter, *c.*1854

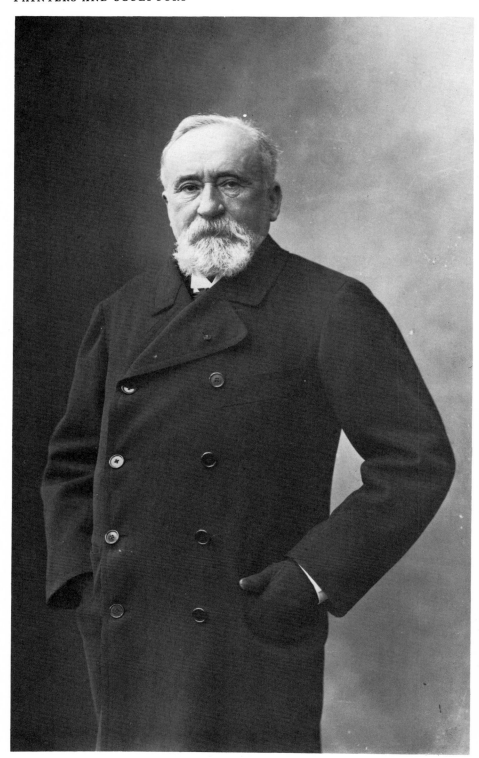

Pierre Puvis de Chavannes (1824–98), painter

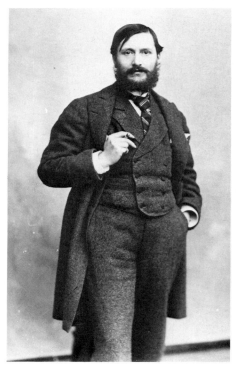

Jean-Louis Forain (1852–1931), painter

Leon Gérôme (1824–1903), painter,
*c.*1860

Théophile Thoré (1807–69), art critic, *c.*1865

Alfred Stevens (1828–1906), painter

Writers

NADAR was a writer, and a friend of writers, all his life. He wrote fifteen books and countless articles in a style which was almost exaggeratedly 'literary'; he seldom used two plain words where a fancy phrase was available. This manner was the journalistic echo of the real writing which was going on around him. He lived in a world of words – in talk, print, and correspondence, a world where journalism and literature, prose and poetry overlapped freely. The companions of his youth mostly lived by their pens and long after he had given up photography, Nadar was working on his (unpublished) Memoirs and contributing to journals and newspapers.

In the relatively small and compact Parisian society in which writers and artists mingled frequently and naturally, the trend of literature in Nadar's lifetime was inevitably analogous to that of art, from romanticism to realism. His heyday as a photographer – from about 1855 to 1870 – marked the divide. The heroes of his youth were Romantics – Victor Hugo, Lamartine, George Sand – and he became an intimate of Mürger, whose *Vie de Bohème* made a sensation in 1848, and a passionate admirer and friend of Théophile Gautier, de Nerval, de Banville, and Baudelaire, whose heady vapours rose from the twisting streets and smoke-filled cafés which Nadar knew so well.

But already the Romantic movement in literature was in a decline. The failure of Hugo's play *Les Burgraves* and Rachel's triumph in Racine's *Phèdre* in 1843 had been the signal of an imminent change of taste, while the success of Flaubert's *Madame Bovary* in 1857 announced its arrival. The picturesque tales of Alexandre Dumas, Alphonse Karr, Henry Monnier, and Paul de Kock were outdated. A new form of classicism which embraced the whole of human experience, and not only its lofty and general characteristics, was established – Realism. Two more novels, *Germine Lacerteux* (1865) by the Goncourts and Zola's *Thérèse Raquin* (1867) began a movement which was carried forward by the vivid descriptive novels of Alphonse Daudet.

It was to be another realist, J.-K. Huysmans, who in *A Rebours* (1881) introduced what he called 'supernatural realism', with occultism and magic as part of the subject. He was soon to be converted to Catholicism and joined a number of *fin-de-siècle* writers who reverted to themes of mysticism and religion. Nadar must certainly have been out of sympathy with these exotic Symbolists, who also included many poets. Already in 1853 his friend Gautier's *Emaux et Camées* had pronounced the beginning of the end of Romantic poetry (though Victor Hugo was to carry on the tradition for many years more) and the birth of a new school which, following the examples of Baudelaire and de Banville, sought to enshrine exact observation in cool and limpid verse. They were christened 'Parnassians' and centred round the *Revue Fantaisiste* of Catulle Mendès who published poems by Herédia, de L'Isle d'Adam, François Coppée, and Sully-Prudhomme, and, later, Mallarmé and Verlaine.

Verlaine's young friend Rimbaud echoed in many ways the defiantly unconventional bohemians of Nadar's youth, but the far-out theories and style of the poet must have been alien to him. He had been a faithful pupil of Guizot and Michelet with their humane philosophy of history, and of Renan with his dismissal of anything which could not be experienced through the senses or grasped by reason. He passionately believed in science; he held to ideals but they were based on faith in a perfectible human society. He would have had no more use for the social subtleties of Proust than for Freudian psychological theory or the inhumanities of the machine age. His literary aspirations remained those of one of his first heroes, Hugo – philosophically progressive but aesthetically conservative.

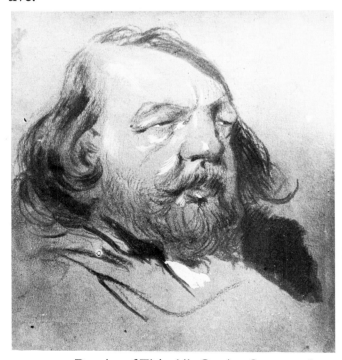

Drawing of Théophile Gautier. *Crayon, c.*1850.

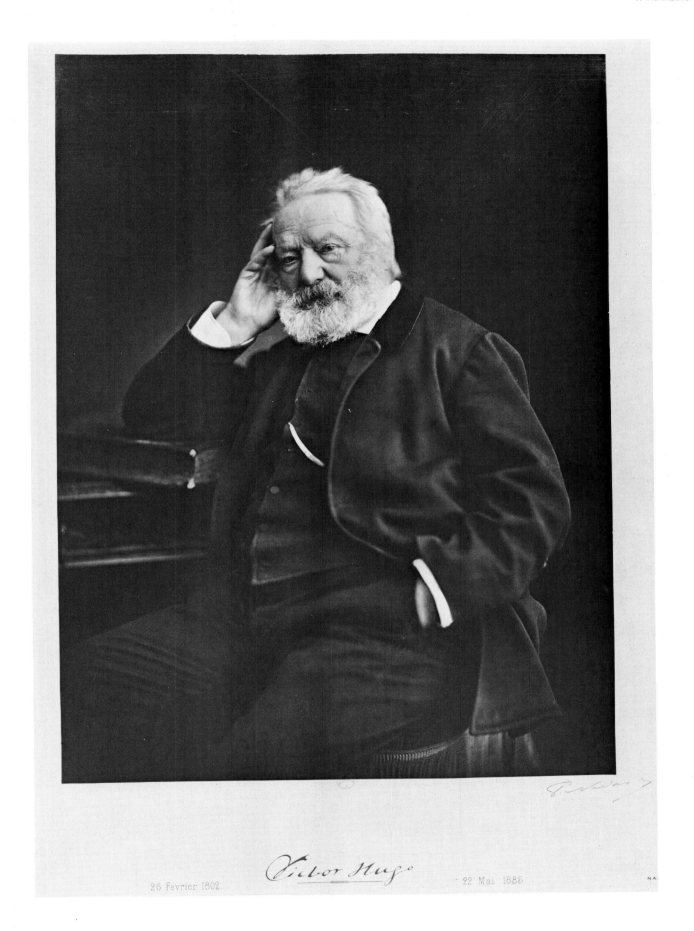

26 Fevrier 1802 22 Mai 1885

Victor Hugo (1802–85), poet, novelist and dramatist

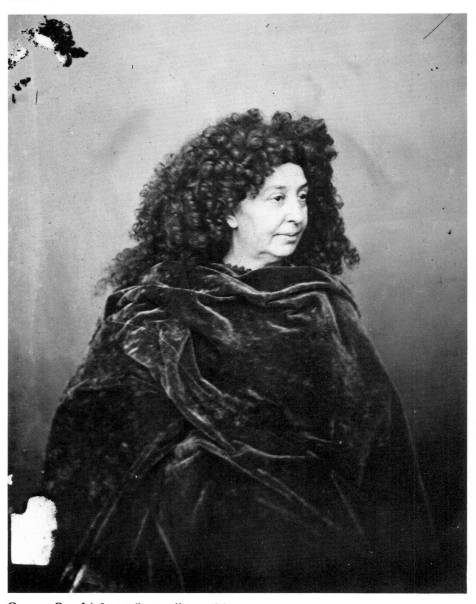

George Sand (1804–76), novelist, *c*.1864

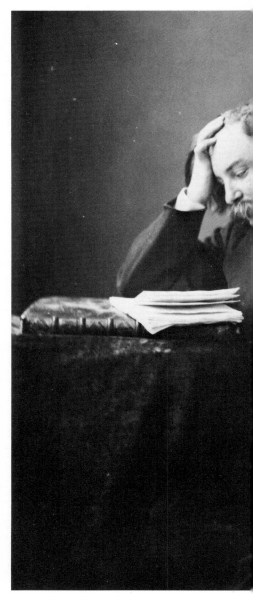

Charles Asselineau (1821–7

Edmund About (1828–85), journalist

Paul de Saint-Victor (1827–81), critic

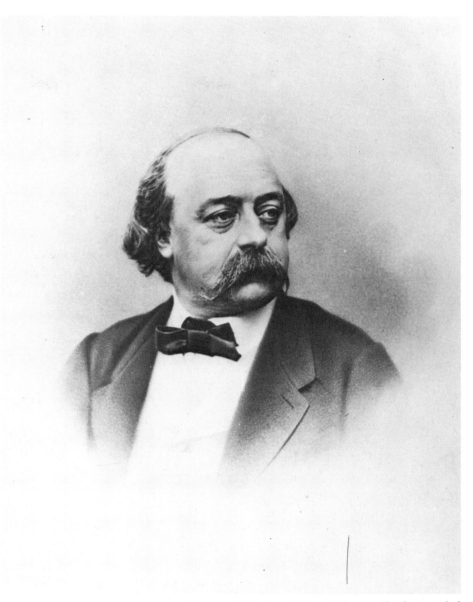

...ayist and librarian, *c.*1857

Gustave Flaubert (1821–80), novelist (*copy print*)

Emile Littré (1801–81), positivist philosopher, *c.*1860

Léon Cladel (1835–92), novelist

Stephane Mallarmé (1842–98), poet

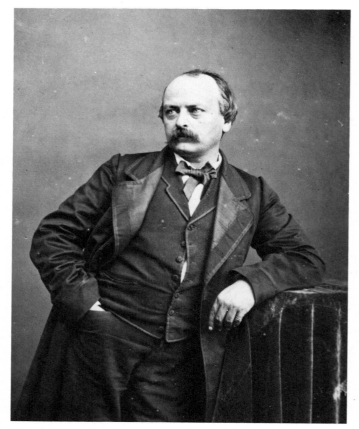

Henri de Kock (1819–92), novelist and dramatist

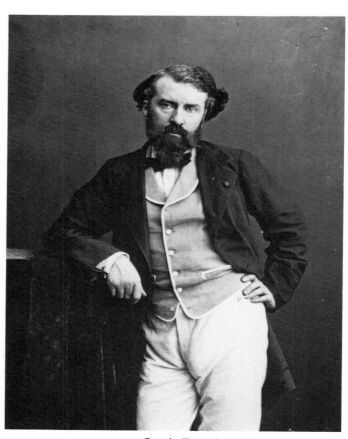

Louis Enault (1824–1900), novelist

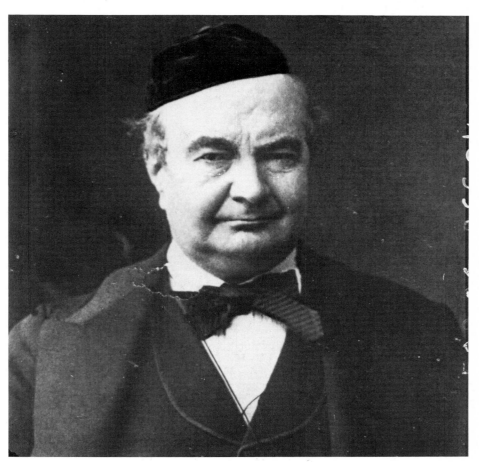

Charles Augustin Sainte-Beuve (1804–69), critic

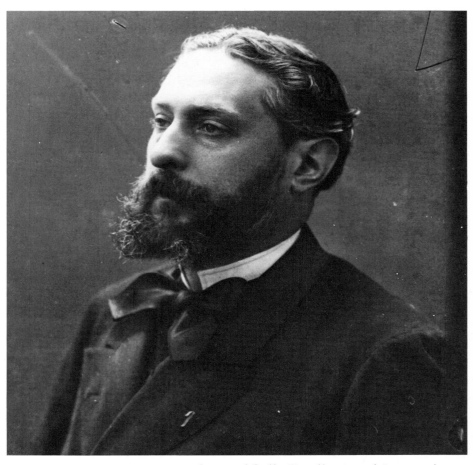

Armand Sully-Prudhomme (1839–1907), poet

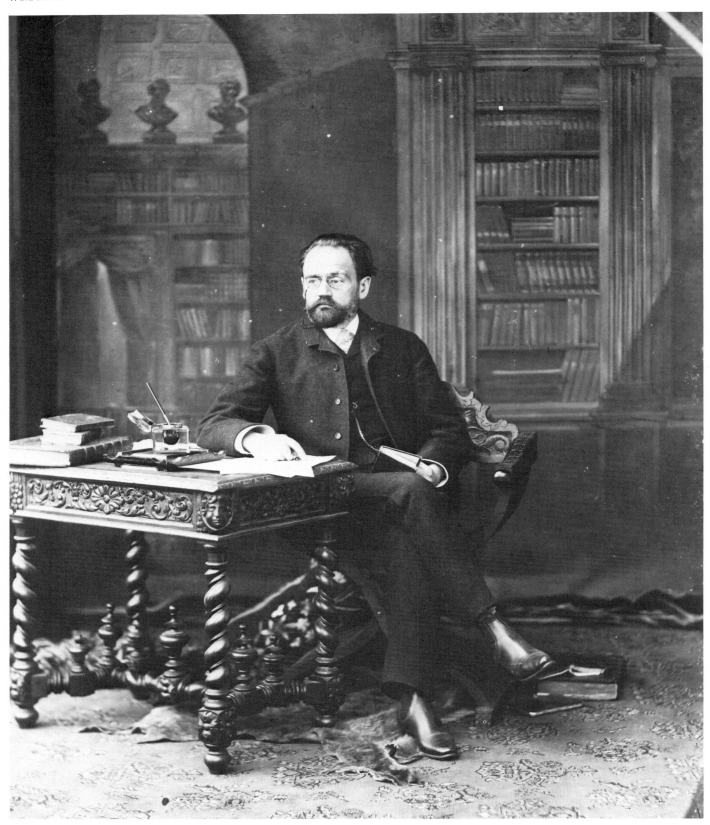

Emile Zola (1840–1902), novelist

Henri Monnier (1805–65), journalist, painter and actor, *c.*1860

Maxime du Camp (1822–94), travel-writer and photographer, *c.*1857

A. Léon-Noel, writer and engraver, *c.*1860

Marie, Princesse de Solmes (1829–1902), literary hostess

229

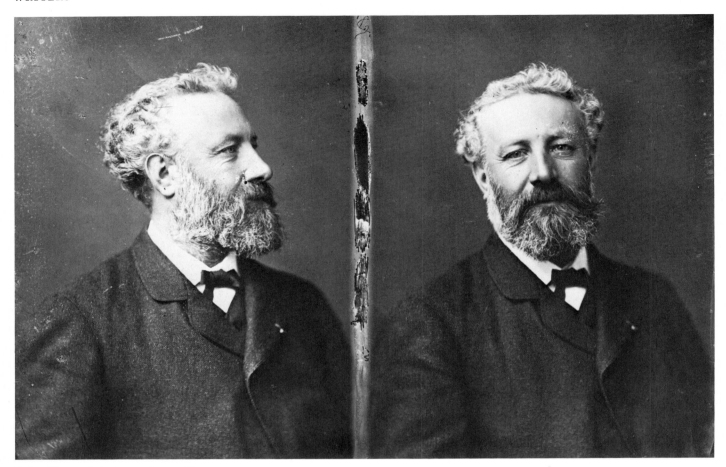

Jules Verne (1828–1905), novelist

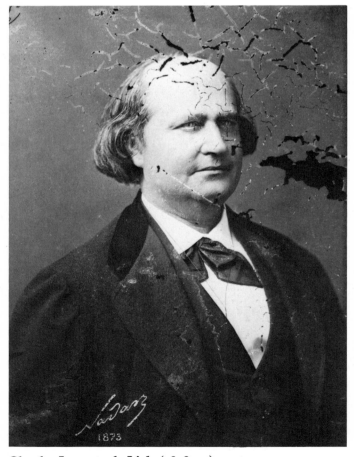

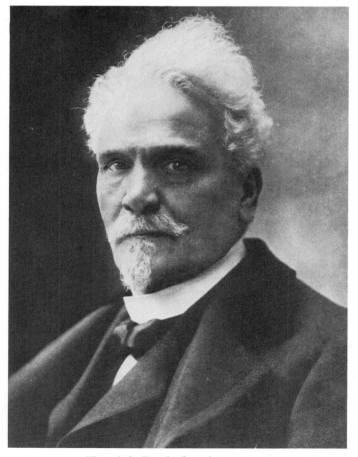

Charles Leconte de Lisle (1818–94), poet

Henri de Rochefort (1830–1913), pamphleteer

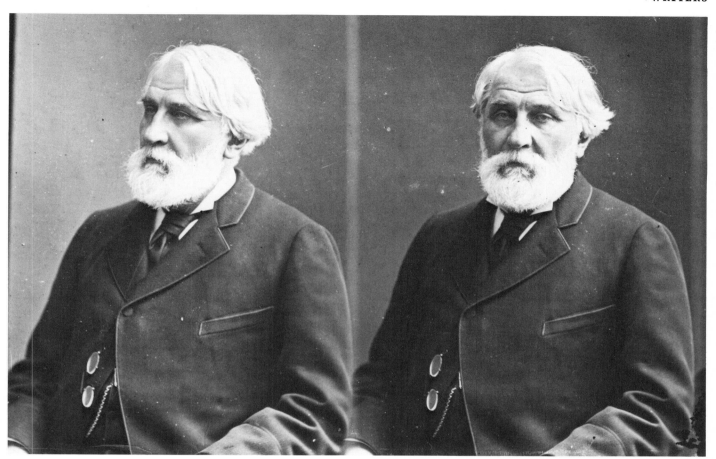

Ivan Turgenev (1818–83), Russian novelist and dramatist

Arsène Houssaye (1815–96), essayist, *c.*1860

Larévellière-Lepeaux (1797–1876), traveller, *c.*1865

Catulle Mendès (1841–1909), poet and dramatist

Guy de Maupassant (1850–93), novelist

Claude Genoux (1811–74), traveller and journalist, *c.*1857

Joris-Karl Huysmans (1848–1907), novelist

Edmond Rostand (1868–1918), dramatist

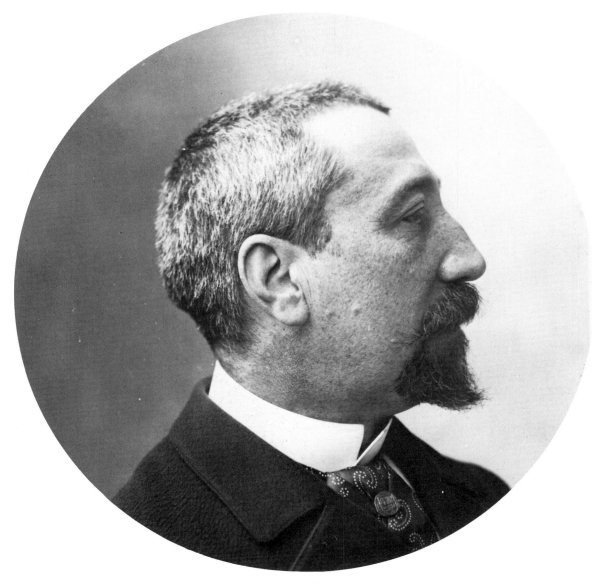

Anatole France (*François Thiboulet*) (1844–1924), novelist and essayist

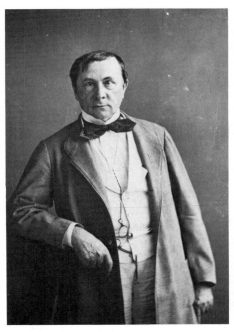

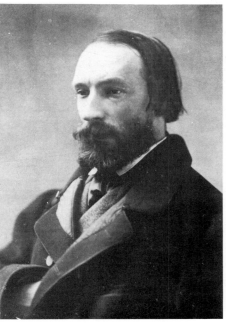

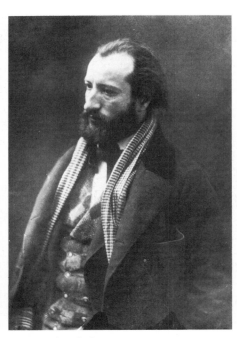

Emile de Girardin (1806–81), editor, *c.*1856

Auguste Vacquerie (1819–95), journalist and dramatist (*copy-print, after Charles Hugo*)

Alexandre Schanne

Charles Cros (1842–88), poet and inventor

Judith Gautier (1845–1917) novelist, dramatist and poet

François de Croisset (1877–1937), journalist and dramatist

Victor Cousin (1792–1867), philosopher, *c.*1858

235

Maurice Barrès (1862–1923), right-wing journalist and politician

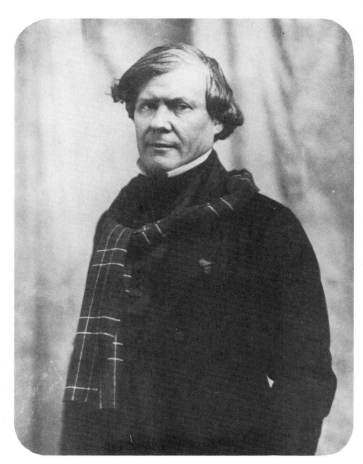

Paul Lacroix, 'Bibliophile Jacob' (1806–84), journalist and essayist, *c.*1854

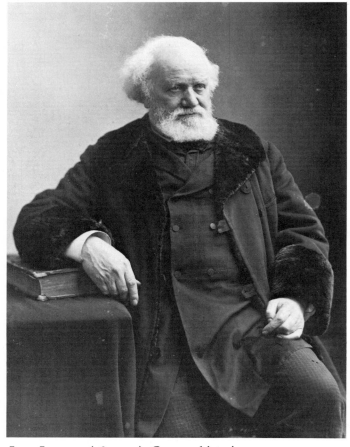

Jean Janssen (1829–91), German historian

Auguste Villiers de L'Isle d'Adam (1840–89), poet

Charles Baudelaire (1821–67), poet, *c.*1860

François Coppée (1842–1908),
poet and dramatist

Tristan (Paul) Bernard (1866–1947),
novelist and dramatist

Musicians

IN the Romantic mood in which Nadar spent the formative years of his youth, it was assumed that all the arts sprang from a single source and flowed towards a single ocean. To be interested in poetry and drama was to be involved in painting and music. Such interest did not always imply a discriminating taste, and Nadar's inclinations seem to have been towards the tuneful popular style of the music-hall and the Opéra Comique rather than towards classical orchestral or chamber concerts.

In this he typified the main feature of French music in his time – the decline of pure music in favour of compositions with a dramatic or literary background and a frankly theatrical approach to opera. This was the age of Grand Opera – an art-form virtually invented in Paris, though its first exponent was a German, Giacomo Meyerbeer.

In Nadar's childhood the musical hero of Paris was Rossini, who delighted his audiences year after year with his lively and melodious operas. But in 1827 he suddenly stopped composing; one reason may have been the arrival in Paris of a new style of lyric-drama to which he was unsympathetic. In 1828 Daniel Auber's *La Muette de Portici* opened the doors to a combination of emotion, spectacle, melodrama, and light entertainment (a ballet interlude was *de rigueur*) which was to be exploited even more successfully three years later by Meyerbeer in his *Robert le Diable*.

For thirty years, right through Nadar's working life, the artful confections of Meyerbeer and his librettist, Eugène Scribe – like him the son of a rich man – dominated the new middle-class public of Paris with operas like *Les Huguenots* (1836), *Le Prophète* (1848) with its roller-skate ballet, and the posthumous *L'Africaine*. Auber and Jacques Halévy also contributed popular and lavish productions of a style which was to reach

Vautier and **Garnier** in Offenbach's *Orfèe aux Enfers*, 1858

Dame Nellie Melba (*Helen Mitchell*) (1859–1931), singer

its peak in Berlioz's almost unstageable *Les Troyens* (1858), and find a symbol in Garnier's giant Opera House which was finally opened in 1872.

Such massive experiences outshone the more modest productions of the Opéra Comique by composers like Hérold and Adam, which were more to Nadar's taste. He was an assiduous frequenter of music-hall and vaudeville and his long friendship with Offenbach was surely bound up with a love for light entertainment which was widely shared; even *La Dame aux Camélias* sometimes had a few songs thrown in.

A later generation was to effect a happy marriage between the two genres: Bizet's *Carmen* (1875) skilfully blended the spectacle and lyricism of one with the dramatic realism (with spoken interludes) of the other, and later composers like Gounod, Massenet and Ambroise Thomas developed a rather sentimental version of this combination to great effect.

Instrumental music was, of course, by no means neglected. Nadar must certainly have attended the Conservatoire concerts, and recitals by star performers like Liszt, Friedrick Kalkbrenner, Sigismund Thalberg, and the violinist Ernesto Sivori. He seems to have shared the general alarm at Berlioz's extravagant experiments, and Wagner considered Nadar – rather incongruously – as a particular enemy.

Nadar was born in the heyday of Cherubini and Rossini and died a few months before the first night of Stravinsky's *Firebird*. He lived through a period when Paris dominated the musical world through its lyric theatres, and then succumbed to the overpowering influence of Wagner and the German school. To Nadar music seems to have been a diversion; he was more at home dancing the polka to Musard's band or humming a tune out of *La Belle Hélène* than meditating over an oratorio. But he, and his son after him, were evidently well aware of the musical life around them and left many records of it.

Claude Debussy (1862–1918), composer

Felicien David (1810–76), composer, *c.*1855

Charles Gounod (1818–93), composer

Pablo Casals (1876–1974), cellist, with
Harold Bauer (1873–1951), accompanist

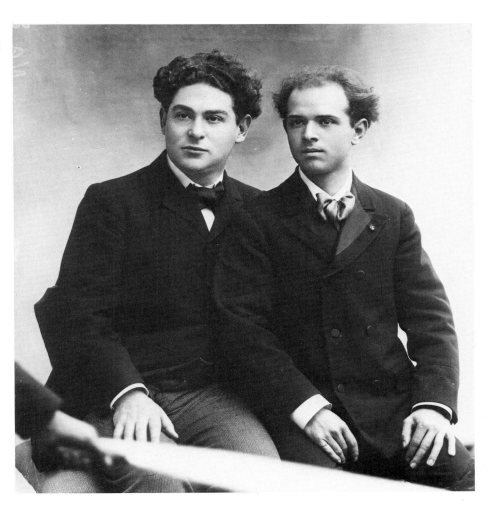

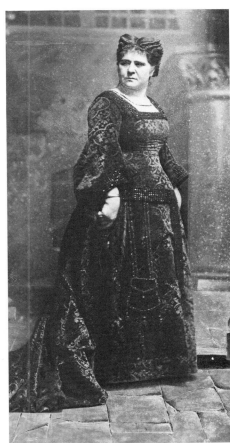

Marie Laurent (1826–76), singer

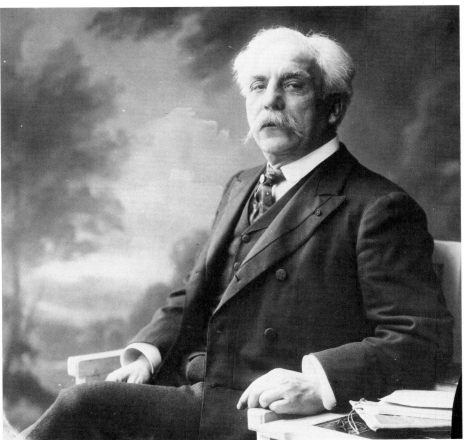

Gabriel Fauré (1845–1924), composer

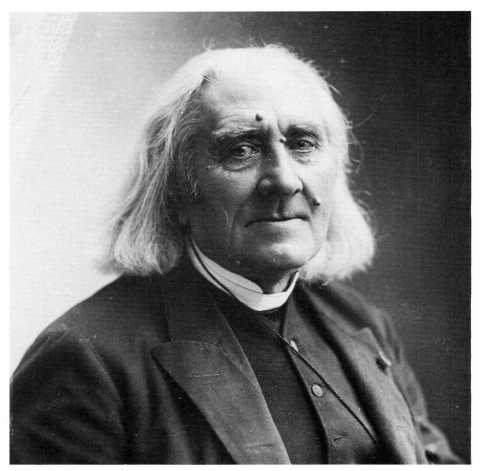

Franz Liszt (1811–86), composer

Madame Godard, violinist

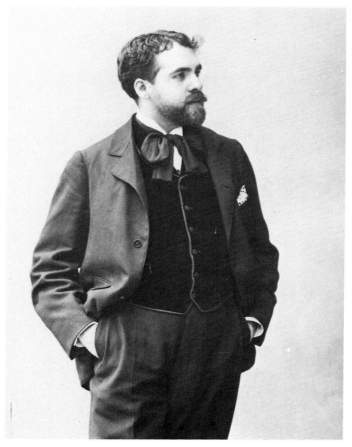

Reynaldo Hahn (1874–1947), composer

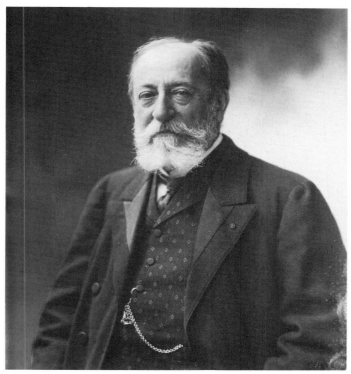

Camille Saint-Saëns (1835–1921), composer

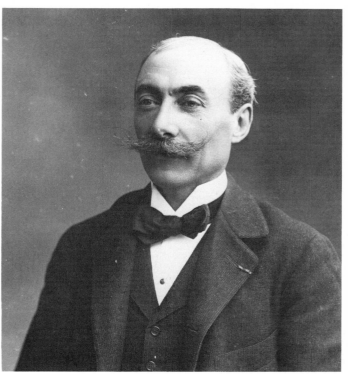

André Messager (1853–1929), composer

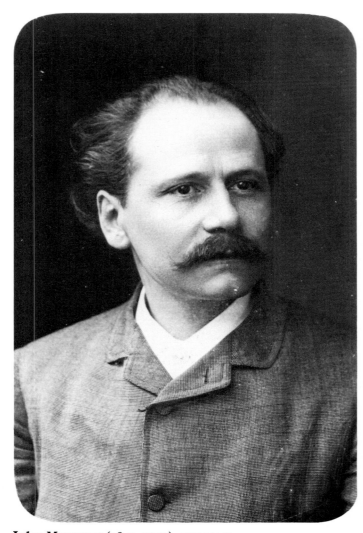

Jules Massenet (1842–1912), composer

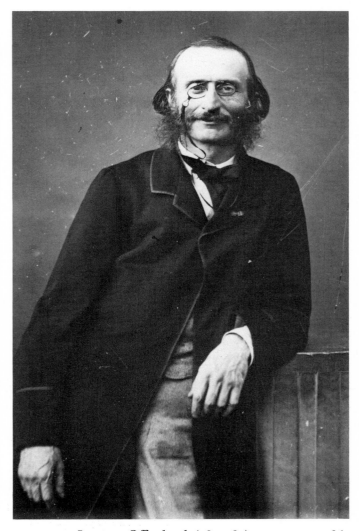

Jacques Offenbach (1819–80), composer, *c.*1860

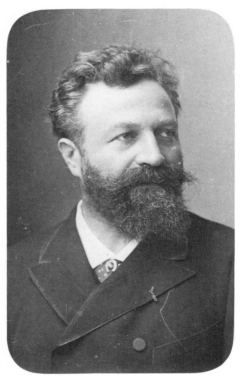

Edouard Colonne (1838–1910), concert organiser

Lucien Muratore (1878–1954), in *Faust*

Jean de Reske (1850–1925), singer

Emma Calvé (1858–1942), singer, in *Carmen*

Adelina Patti (1843–1919), singer, 1862

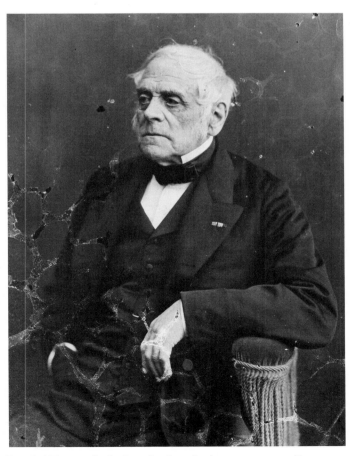

Daniel François Auber (1782–1871), composer, *c.*1870

Marie Carvalho (1827–95), singer, in *Faust*

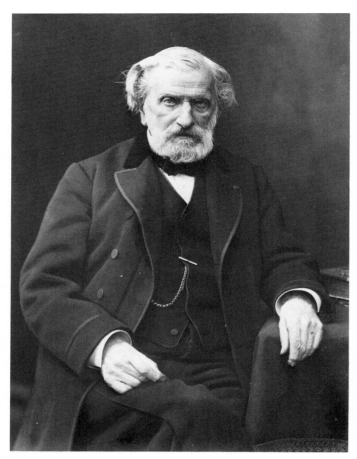

Ambroise Thomas (1811–96), composer

Jacques François Halévy (1799–1862), composer, *c.*1855

Pablo Sarasate (1844–1908), Spanish violinist

Sigismund Thalberg (1812–71), pianist, *c.*1852

Theatre Personalities

IN 1822, when Nadar was 2, Kemble's touring Shakespeare company visited Paris and was so successful that it was asked back in 1827. One result was Berlioz's infatuation for one of the company, Harriet Smithson; another was Victor Hugo's *Préface à Cromwell* which sounded the first fanfare for the Romantic movement. This seminal explosion found one of its most eloquent, but also shortest, expressions in the theatre; it is fair to mark its birth in the triumph of Hugo's *Hernani* in 1830 and its demise in the failure of his *Les Burgraves* in 1843. Nadar was thus only 23 when the tide began to turn; but in the other arts Romanticism remained strong for many years, and he himself was ineradicably stamped with its character.

The natural haunt for the lively but impoverished young men who made up the bohemian circle to which Nadar belonged was the café and the cheap vaudeville: entertainers from this world, such as Debureau and Berthelier, were among his first sitters. But we can guess that as he grew older the legitimate theatre interested him more. At this period even responsible managements like that of the Odéon were ready to give a showing to totally unknown and untried talents; reputations were easily made in the theatre, and there were few poets and novelists who did not try their hand at a play. Nadar himself is reported as collaborating with Gautier on a 'féerie' and he doubtless took part in the amateur theatricals which were a frequent form of diversion in households like those of George Sand.

During Nadar's lifetime the French theatre enjoyed one of its most brilliant periods, slowly moving, in a succession of striking plays, from romantic dramas set in remote times and places to objective and documentary pieces depicting contemporary life and everyday problems. Realism, first attempted in mid-century by Balzac, the Goncourts, and Daudet without popular success, finally triumphed with Zola, de Maupassant, and Huysmans.

Among the most notable playwrights had been Eugène Scribe, who wrote literally hundreds of plays and libretti and helped to break the strict classical forms in the early half of the century. Emile Augier produced a long series of comedies invoking solid bourgeois values – loyalty, family life, commonsense, and liberal principles – and later tackled more serious moral themes. These were influenced by Alexandre Dumas *fils* who – after starting with the sensational success of *La Dame aux Camélias* (1853) – became increasingly absorbed in social reform. He used the stage as his pulpit, preaching greater freedom from social convention and above all a higher status for women. Victorien Sardou shared these subjects in his light comedies – witty and well constructed but rather superficial. Vaudeville flourished with writers like Eugène Labiche and Théodore Barrière.

In the expanding and entertainment-hungry society of the Second Empire the theatre was both popular and lucrative. Stage personalities found their way naturally into Nadar's studio. We find among his sitters not only Rachel, the prophetess of the classical revival in his early years, but her most formidable successor, Sarah Bernhardt, as well as many of the dramatists.

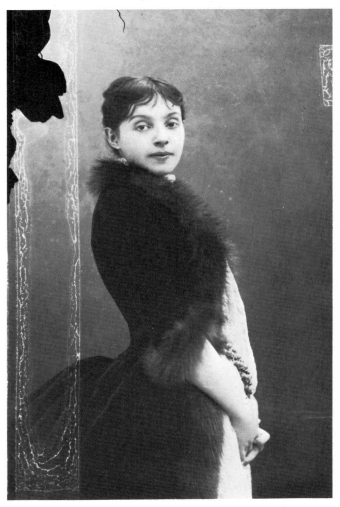

Réjane (*Gabrielle Réju*) (1857–1920)

'Mistinguett' (*Jeanne Bourgeois*) (1875–1956), actress

It was to be Paul Nadar in the last part of the century who recorded the older Bernhardt, together with the delightful Réjane, as well as a crowd of lesser stage stars. By this time the serious theatre had moved into the hands of the avant-garde directors. In 1887 André Antoine founded the Théâtre Libre (later Théâtre Antoine) which for nine years became the home of the new realist and naturalist drama, introducing Ibsen, Tolstoy, and Gérard Hauptmann to French audiences before collapsing with debts of 100,000 francs. In 1893 Lugné-Poe took over the Théâtre de l'Œuvre from Paul Fort and presented Symbolist plays by writers like Maeterlinck. In 1897 Edmond Rostand injected a last gleam of popular patriotism with his *L'Aiglon*. The 53-year-old Bernhardt triumphed as the amorous young archduke; but time was running out. A new century and a new Paris, which Nadar would not have understood, was waiting in the wings.

Réjane (*Gabrielle Réju*) (1857–1920)

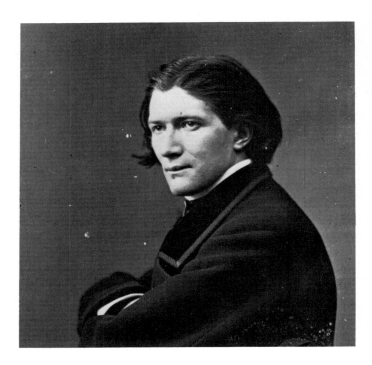

Victorien Sardou (1831–1908), dramatist, *c.*1856

Mlle Langoix

Ernest Alexandre Coquelin (*cadet*)
(1848–1909), actor, brother of Constant

Victor Capoul and **Mlle Ritter**
in 'Paul et Virginie' 1878

Georges Feydeau (1862–1921), dramatist **Lucien Guitry** (1860–1925), actor, father of Sacha

251

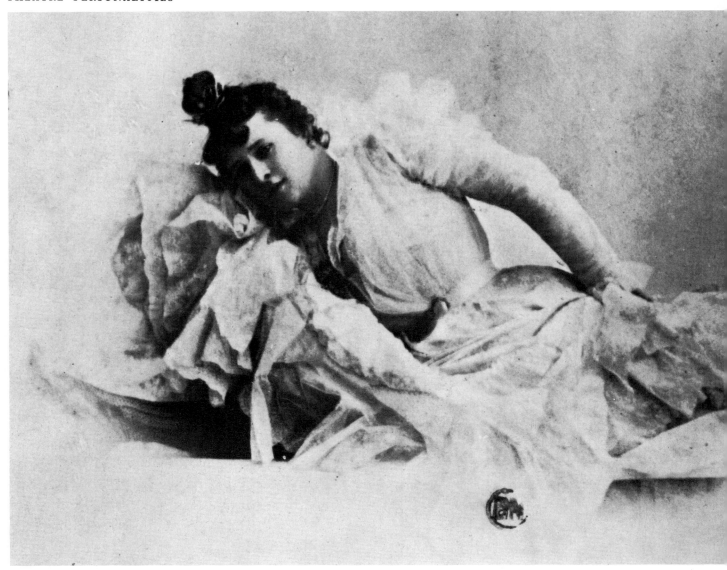

'La Goulue' (*Louise Weber*) (1869–1919), music-hall dancer

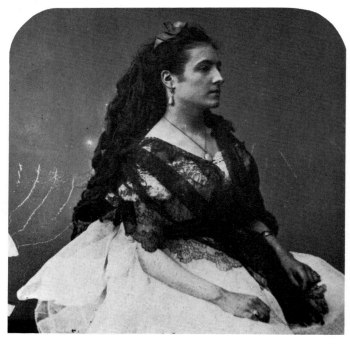

Mlle Laslin, dancer at the Opéra, *c.*1861

Louis-François Clairville (1811–79), dramatist, *c.*1860

Groupe de Poules, Folies Bergère

Ernest Feydeau (1821–73), dramatist, *c.*1859

Gabrielle Krauss in 'Polyeucte'

Japanese actor

M. Yaxs, comedian

Japanese actress

M. Pierson's performing dog

Constant Coquelin (1841–1909), actor

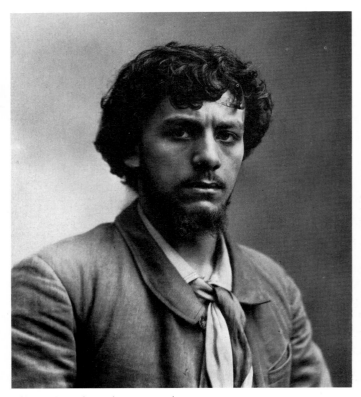

Albert Lambert (1865–1941), actor

Louis Hyacinthe (*Duflort*) (1814–87), actor, *c.*1854

Cléo de Mérode (1878–1965), dancer and model

Eugène Scribe (1791–1861), dramatist, *c.*1858

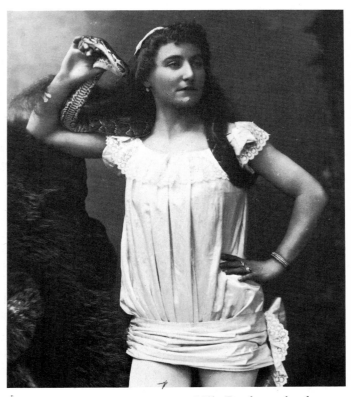

Mlle Paula, snake charmer

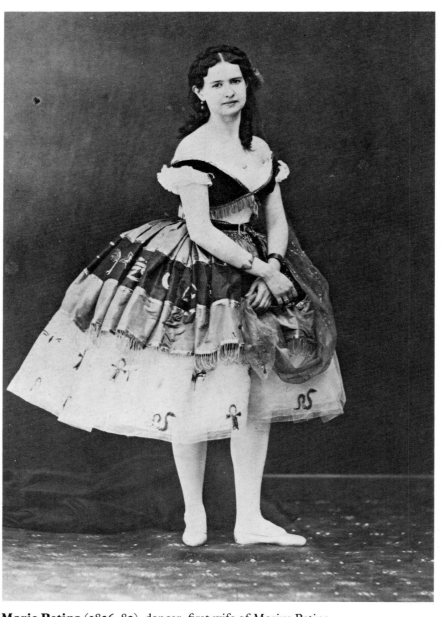

Marie Petipa (1836–82), dancer, first wife of Marius Petipa

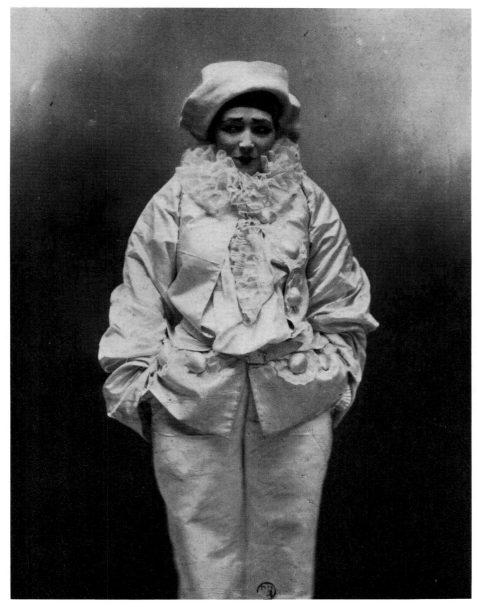

Lillie Langtry (1853–1929), British actress

Sarah Bernhardt (1844–1923), actress

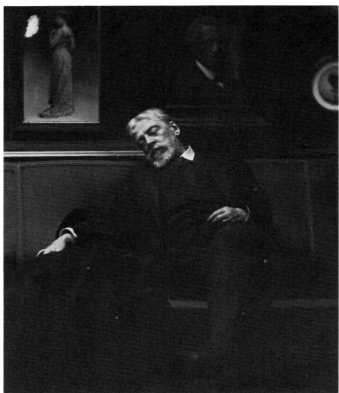

Jean Mounet-Sully (1841–1916), actor

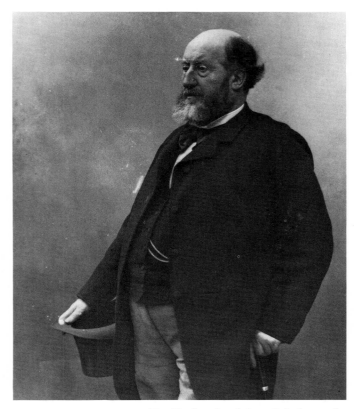

Emile Augier (1830–89), dramatist

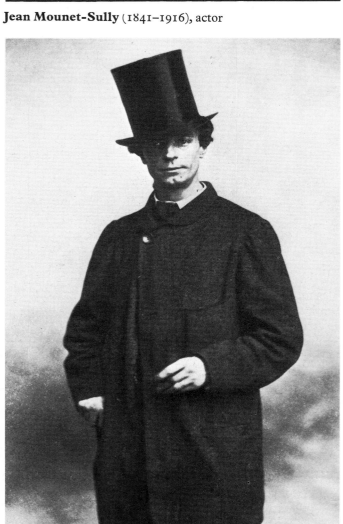

François Louis Lesueur (1820–76), actor, *c*.1854

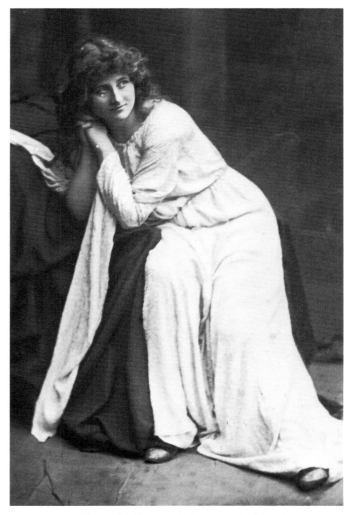

Mary Anderson (1859–1940), American actress

260

Leading Figures of the day

NADAR'S most fruitful period as a photographer coincided with the most prosperous years of the Second Empire, and the fact that he drew most of his sitters from the ranks of the successful gives the impression that he worked against a background of social and political peace. Nothing is further from the truth. As a staunch radical, many of his friends suffered sentences of prison or exile for political offences, and until his old age he lived under the shadow of war and revolution.

Nadar's first introduction to violence, a memory which was to haunt him, came with the Three Glorious Days of 1830 when the thin glaze of establishment order cracked open, leaving a gap which was temporarily plugged by Thiers and the bourgeois, liberal-minded Louis-Philippe. His bohemian years in Paris coincided with Louis-Philippe's most cynically commercial period when, under the rallying cry of 'Get rich!' he and his minister Guizot were trying to bury the sufferings of the poor under a blanket of middle-class prosperity. But in 1848 came an explosion which blew the whole, flimsy monarchical structure to pieces. Louis-Philippe fled, Guizot resigned, Lamartine proclaimed a republic – and Nadar doubtless celebrated with his left-wing friends.

The outcome, however, was inconclusive. A moderate Assembly was returned by the new election and efforts to overturn it by a mob led by Barbès, Blanqui, and Raspail were easily turned aside by the National Guard. There was plenty of social aspiration but no leader. 'France needs a Napoleon', remarked Wellington cynically. He was not far away. An election by universal suffrage gave a huge majority to the grandson of the great emperor; in December 1851 he organized a *coup d'état* and only a year later a plebiscite voted him supreme power as Emperor, with the title Napoléon III.

Relying on the magic of his name the new Emperor ruled by a series of plebiscites, setting up a system of government that came near to dictatorship. One of its first fruits was a search for military glory in the Crimean War of 1853, in which Napoléon joined with England against the Russians. At first fortune favoured him. Victory came, gold flowed from California and Australia into commerce and industry, there was a boom in railways and simultaneously prices actually fell. The Universal Exhibition in Paris of 1855 – to which Nadar contributed a photographic section – marked the peak of this prosperity.

But then things began to go wrong. In 1859 the Emperor thought he would gain prestige by declaring war on Austria, 'to set Italy free'. After an imposing parade – during which he was photographed by Nadar's rival Carjat – he set out for Italy where he asked Nadar to help him with observation balloons (as a stout anti-imperialist Nadar refused). He won the battles of Solferino and Magenta but then lost heart and concluded an abrupt treaty with Austria, leaving the Italians feeling they had been let down.

Next year his international ventures proved even more unsuccessful, while at home opposition to the Emperor grew; even Veuillot's Catholic paper *L'Univers* joined in the campaign. Prussia won an alarming victory over Austria; the Tsar Alexander was attacked during a visit to Paris; Maximilian, the French appointee, was executed in Mexico. Paris tried to distract itself with scepticism and frivolities but, in spite of warnings from Proudhon, the workers turned toward Bakunin's anarchism and Marx's Communism and there

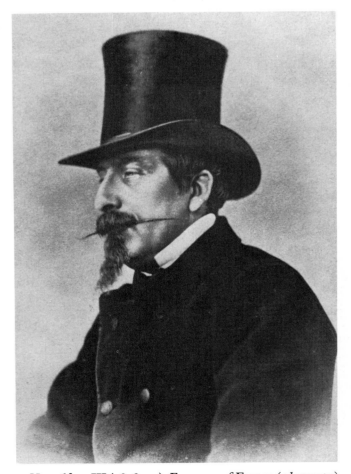

Napoléon III (1808–73), Emperor of France (*photocopy*)

261

was an outbreak of strikes. In 1870 the Emperor again had recourse to a plebiscite to confirm him in power.

But a few months later the rivalry with Prussia came to a climax. Bismarck changed the wording of a telegram to the French Emperor, making it inexcusably insulting and, in spite of warnings from Thiers and Gambetta, the Assembly voted for war. Within a few weeks the Prussians had annihilated the French armies at Sedan, the Emperor was captured, and France was invaded. By September Paris was surrounded, with Nadar's balloons the only link with the outside world. In 1871 a shaming armistice was signed, to be followed by an indignant uprising which gave brief power to the Paris Commune. But Thiers put it down with fearful bloodshed and an exhausted peace was restored. It lasted a generation, broken only by such minor interruptions as General Boulanger's abortive *coup d'état* in 1889, and served at least to cushion Nadar's old age. Happily, he did not live to see its terrible collapse in 1914.

The period was marked by the rise of Socialism – clearly reflected in Nadar's choice of sitters, since he was steadily sympathetic to this cause – but during most of it the fate of France was still decided by a tiny élite of crowned heads and aristocrats. Many of these visited the Nadar Atelier, particularly after it was taken over by Paul.

Science was a natural subject for Nadar's lens. He took a practical interest in the subject, and his experiments in photography and aeronautics involved him actively with its theoreticians. He numbered several scientists among his close friends.

Lord Lytton (1831–91), Ambassador to Paris and Viceroy of India

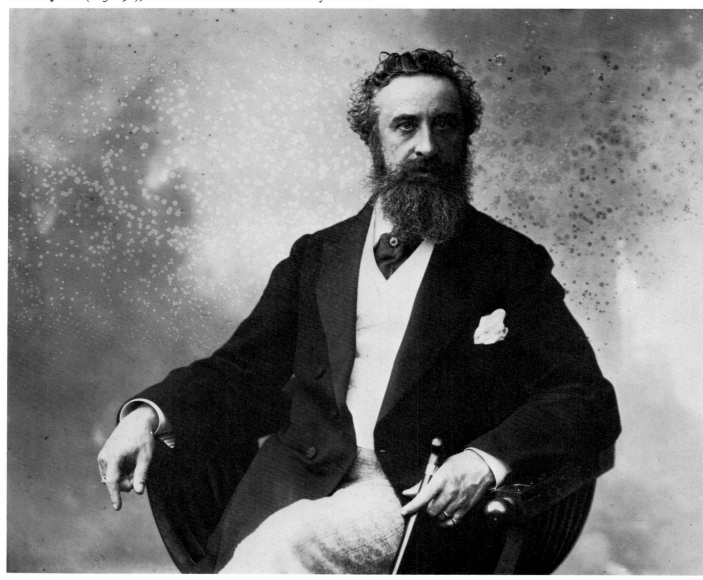

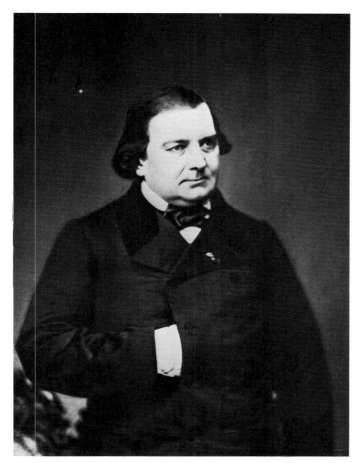

Prince Jérôme Bonaparte (1828–1904), *c.*1868

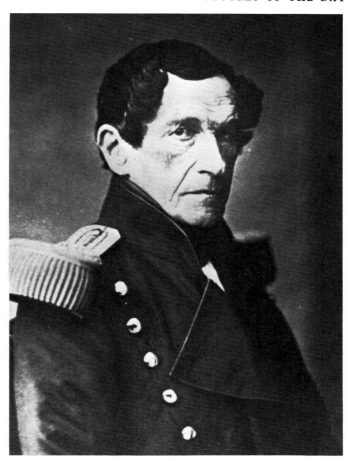

Léopold I (1790–1865), King of Belgium 1831–65, *c.*1860

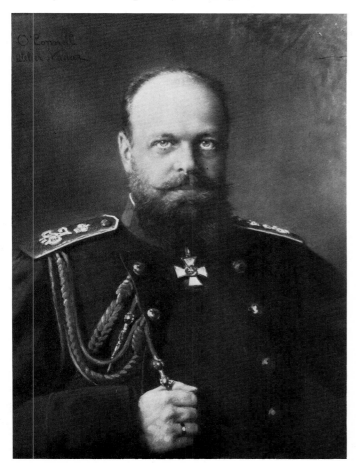

Alexander III (1845–84), Tsar of Russia.

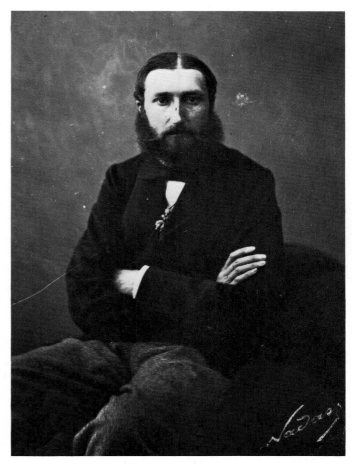

Léopold II (1835–1909), King of Belgium 1865–1909, *c.*1875

Adolphe Thiers (1797–1877), President of France 1870–73, *c.*1870

Jules Grévy (1807–91), President of France 1879–87

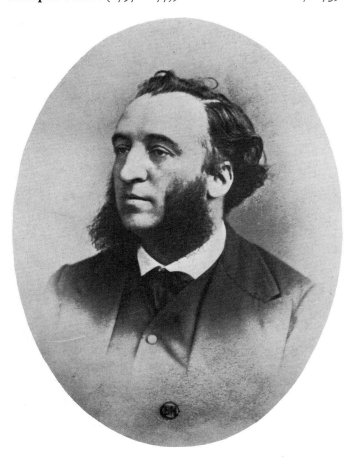

Jules Ferry (1832–93), statesman

Raymond Poincaré (1860–1934), President of France 1913–20

François Sadi-Carnot (1837–94), President of France 1887–94

Félix Faure (1841–99), President of France 1895–99

Léon Gambetta (1838–82), Prime Minister 1881–82, *c*.1870

Georges Clemenceau (1841–1929), twice Prime Minister, 1906–09, 1917–20

Adolphe Monod (1802–56),
Danish pastor, *c.*1856

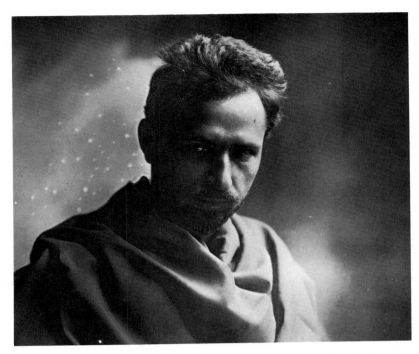

George Gapon (1870–1906), Russian revolutionary, organiser of 'Bloody Sunday' in 1905

Monsignor Darboy (1813–71), Archbishop of Paris (shot by the Communards), *c.*1868

Henri de Jouvenel (1876–1935), political writer

Joseph Pietri (1820–?), Prefect of Police, *c.*1866

Chaix d'Est Ange (1800–76), Procureur-Général, *c.*1857

Allon, Barrister, *c.*1860

Prince Peter Kropotkin (1842–1921), Russian anarchist

Jules Favre (1809–80), left-wing lawyer and politician, *c.*1865

Louis Blanc (1811–82), socialist writer, *c.*1858

Maréchal Certain de Canrobert (1809–95),
Commander-in-Chief in the Crimea

Giuseppe Garibaldi (1807–82), Italian patriot,
co-founder of united Italy, 1861, *c.*1870

Général Georges Boulanger (1837–91),
attempted a *coup d'état* 1889

Elie Metchnikoff (1845–1916), embryologist

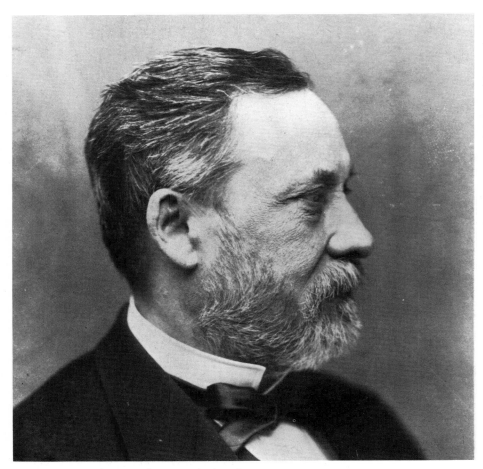

Louis Pasteur (1822–95), research chemist

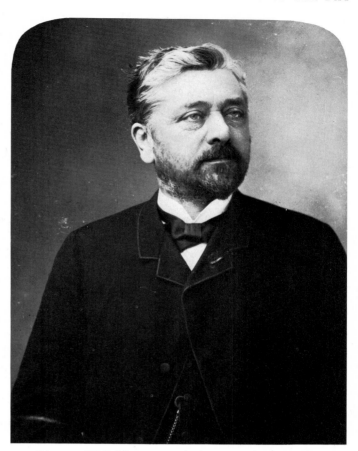

Gustave Eiffel (1832–1923), designer of the Eiffel Tower

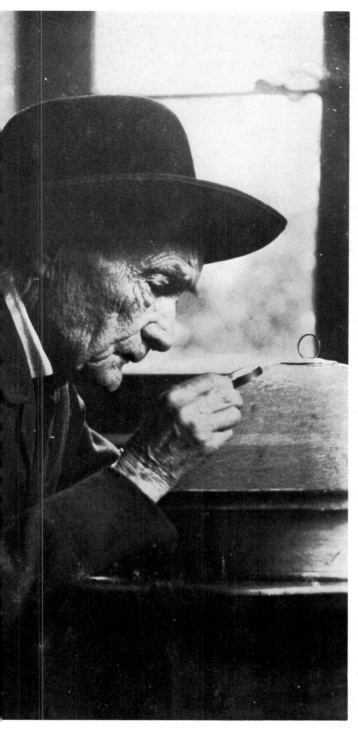

Jean-Louis Fabre (1823–1915), entomologist

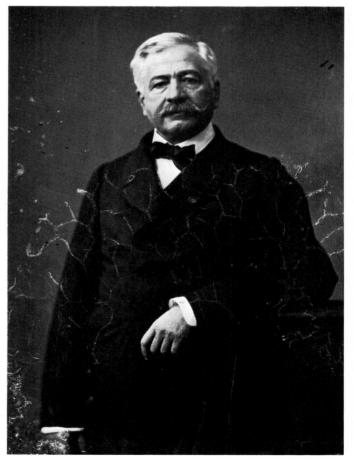

Ferdinand de Lesseps (1805–94), engineer, constructor
of the Suez Canal, *c.*1869

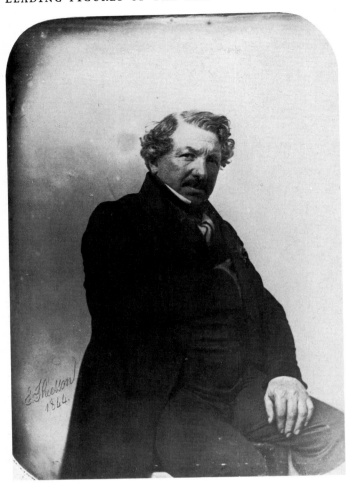

Louis Daguerre (1789–1851),
artist and photographer (copy of daguerreotype of 1844)

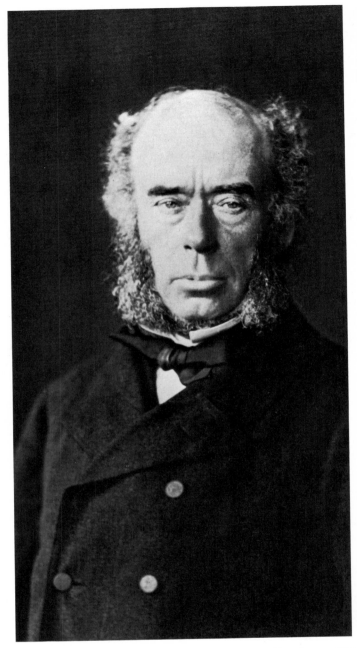

Sir Joseph Whitworth (1803–87), British metallurgist, *c.*1868

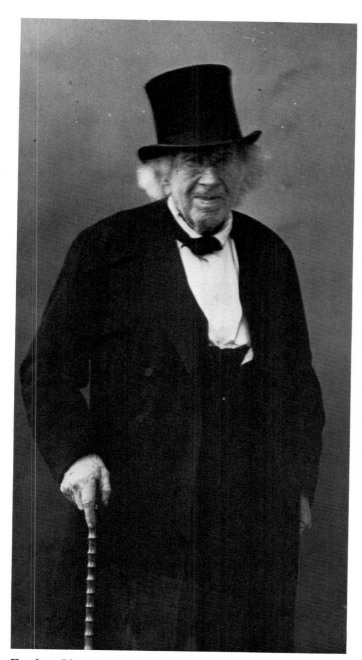

Eugène Chevreul (1786–1889), research chemist

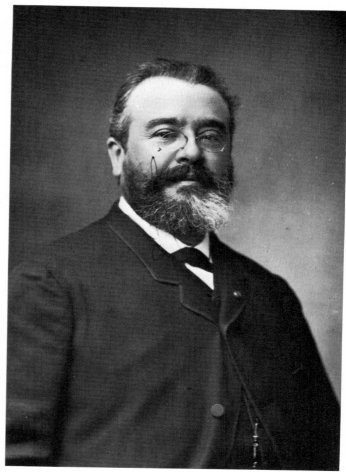

Adrien Proust (1834–1903), physician, father of Marcel Proust

Pierre Savargnan de Brazza (1852–1905), explorer

Doubs, explorer

Fernand Foureau (1850–1914), explorer

Sir Ernest Shackleton (1874–1922), Antarctic explorer

Admiral Robert Peary (1856–1920), American explorer, discovered the North Pole 1909

Jefferson Davis (1808–89),
American statesman, President of the Confederate States

George Eastman (1854–1932), director of Eastman Kodak

Catherine Booth (1829–90), wife of
General Booth of the Salvation Army

General Ulysses Grant (1822–85), Commander-in-Chief of the North in the
Civil War, President of the U.S.A. 1868–76

Robert MacLane (1815–98),
American statesman

La Vie Parisienne

THIS final section includes many different types of sitter and covers a range that would not have been possible when Nadar himself was in charge of the studio. But Paul, when he took over, either chose or, more likely, was forced by competition, to accept any commission which was profitable. Like his father, he rarely moved outside his studio – the news picture of the visit to Paris of the Russian Tsar in 1896 (p.281) seems to be something of an exception. But inside the *atelier* few limits, apart from those of decorum (there is no record of any picture catering for the sex-appeal market), were set to the subjects before the camera.

Paul Nadar continued to furnish some fine portraits of distinguished sitters, but after the turn of the century he worked with some of the top Paris fashion houses, with notable success. The contrast between their elegance and the crudeness of much of the theatrical work evidently carried out by his assistants is marked. He also made some charming studies of children, and these too carry the stamp of his personal touch.

Pictures such as these do not convey the Rembrandtesque dignity and gravity of the best of Félix's early studies, but they have an attraction of their own and accurately reflect the way in which photography was moving at the time, as cameras became faster and more flexible and dark-room techniques more sophisticated. The catholic nature of some of these last pictures from the Atelier Nadar truthfully reflects the ever-open sympathies and ever-enquiring mind of its founder.

Liane de Pougy (1873–1935), actress and model

Edward, Prince of Wales (1841–1911)

Albert, Duc de Broglie (1821–1901)

King George V of Hanover (1819–78)

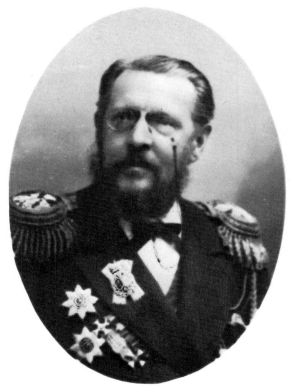

Grand Duke Vladimir (1847–1909),
brother of Alexander III

Grand Duke Constantine of Russia
(1827–92), son of Nicholas I

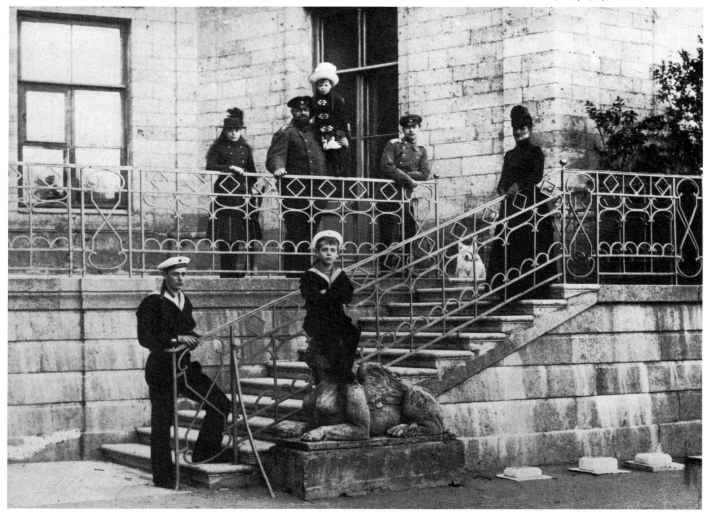

Alexander III with **Olga, Xenia,** the **Tsarevitch, Marie Feodorovna, George** and **Michael,** *c.*1886

Prince Anatole Demidoff (1812–70), *c.*1869

Prince Troubetskoy (1866–1938)

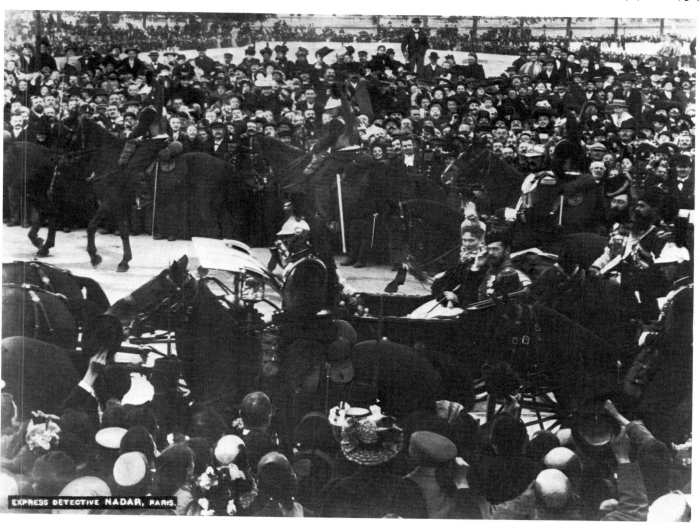

EXPRESS DETECTIVE NADAR, PARIS.

Nicholas II (1868–1917), Tsar of Russia

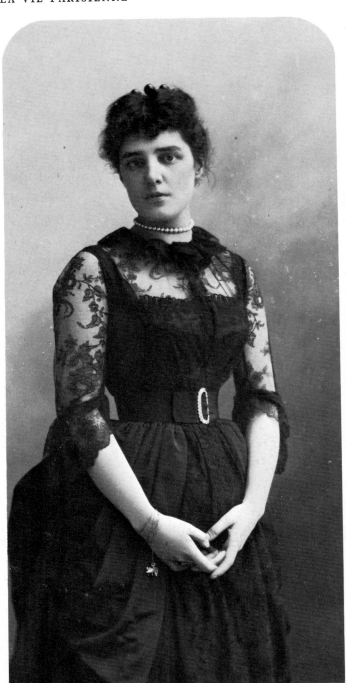

Lady Randolph Churchill (1854–1921)

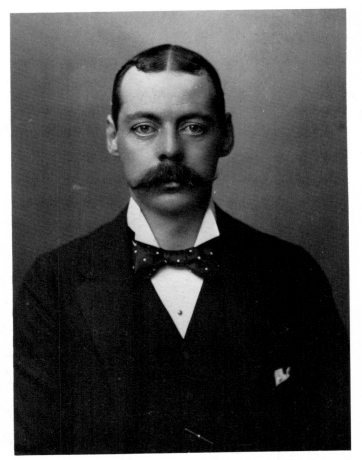

Lord Randolph Churchill (1848–95)

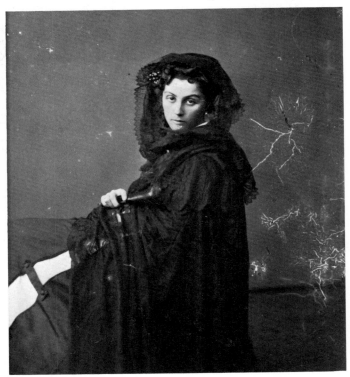

Mme de Montgolfier, *c.*1860

Negro servant

Maison Reveillon dress, *c.*1900

Maison Toré hat, *c.*1905

Queen Isabelle II of Spain (1830–1904)

The de Lesseps family

The Polaire children

Bertrand de Lesseps

Solange de Lesseps

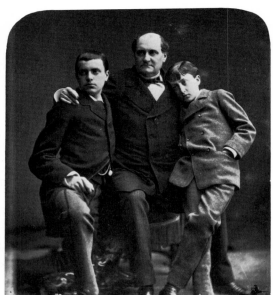

Prince Joseph Bonaparte and sons **Victor**
(1862–1926) and **Louis** (1864–1926)

Empress of Brazil, Teresa Christina Maria (1822–89)

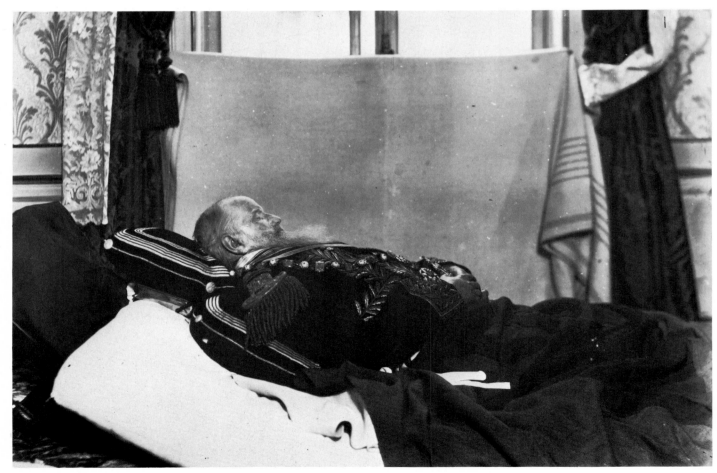

Dom Pedro II of Alcantara, Emperor of Brazil (b.1826), on his deathbed, 5 December 1891

Queen of Portugal, Marie-Amélie

Mlles Musard, *c.*1862

Lolla Montes, comedienne and model

Comtesse de Paris

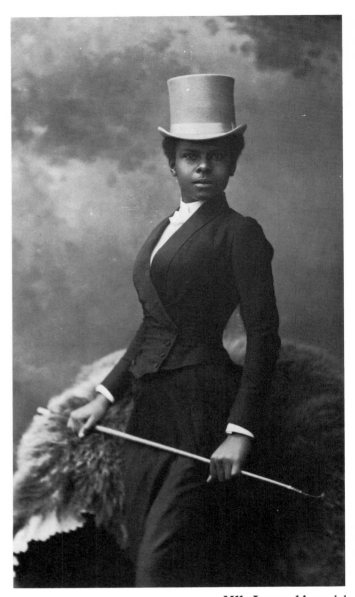

Mlle Lauzeski, model

Prince Kung Pao-yun, Chinese Ambassador

Master Porel

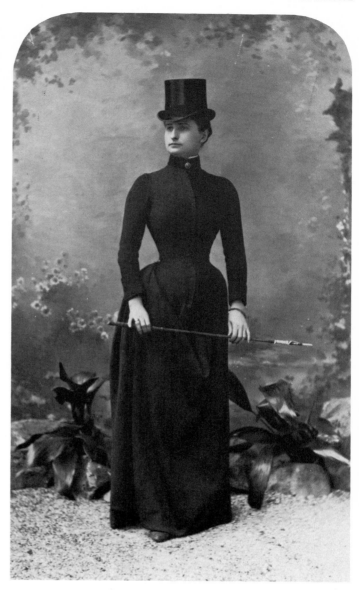

Mlle Jenny

Paul Nadar, son of Fèlix, *c.*1862

Cléo de Mérode (1875–1965), dancer and model, *c.* 1890

A dress from **Maison Lanvin**

Japanese visitors to Paris, *c.*1865

Prince Albert of Monaco (1848–1922)

A hat from **Maison Lanvin**

Nassr-ed-Din, Shah of Persia (1830–96)

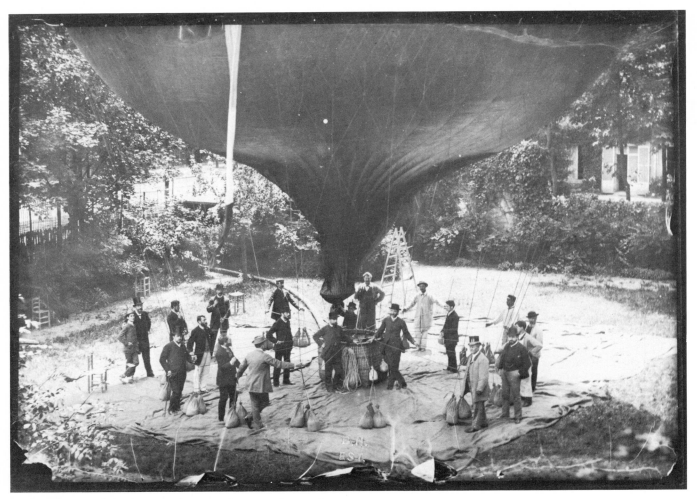

Launching a balloon by an unknown photographer

Madame Dréau, displaying a Hausard hat

Eugène, Vicomte de Vogue (1848–1910), author, diplomat, and academician, *c.*1888

292

Princess Frederika (1848–1926), daughter of
George V of Hanover

A dress from **Maison Lanvin**

Don Carlos (1848–1901), Pretender to the Spanish throne

293

The daughters of Théophile Gautier, *c.*1862

Arlette Dorgère, actress, photographed in costume, *c.*1909

Renée Maupin, model, *c.*1897

Prince George Bibesco (1834–1902)

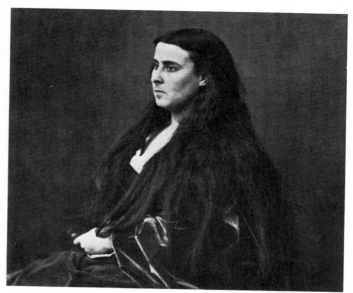

Duchesse de Medina Coeli, *c.*1855

Prince Henri d'Orléans (1867–1901), explorer, *c.*1867

295

Mlle G. Réjane, daughter of Réjane

Index

*Pages indexed in italic numerals refer to
photographs of the subjects*

About, Edmund, *224*
Adam, Auguste Villiers de L'Isle de, 222,
 236
Adam, Juliette, 134, *135*
Adam-Salomon, Antoine Samuel, 35,
 186, *187*
Albert of Monaco, Prince, *291*
Alexander III, Tsar, 72, 261, *263*, *280*:
 family of, *280*
Allard, Julia, 190
Allon, *267*
Amécourt, Vicomte Ponton d', 13, 32, *33*
Anderson, Mary, *260*
Anelle, Karol d', 3
Antoine, André, *248*
Arago, François, 16, 23, 28
Archer, F. Scott, 29
Asselineau, Charles, 74, *224–5*
Auber, Daniel François, 238, *245*
Augier, Emile, 56, 247, *260*

Babinet, Dr, 13
Bakunin, Mikhail, 170, 174, *175*, 202, 261
ballooning, 13, *14*, 15, *15*, 16, *16*, 17, 18,
 18, *19*, 20, 28, 32, 72, 102, 104, 118,
 168, 188, 261, 262, 292
Balzac, Honoré de, 2, *2–3*, 86, 90, 94, 184,
 247
Banville, Théodore de, 3, 11, 27, 50, 62,
 63, 68, 104, 184, 222
Barbès, Armand, 18, 168, *169*, 261
Barrès, Maurice, *236*
Barrière, Théodore, 52, 56, *57*, 247
Barye, Antoine, *216*
Bataille, Charles, 4
Baudelaire, Charles Pierre, 1, 2, 5, 6, 11,
 12, 16, 25, 28, 29, 39, 60, 62, 66, *67*, 72,
 90, 96, 112, 120, 122, 132, 184, 188,
 192, 222, *237*
Bauer, Harold, *241*
Becqerel, Alexandre (*fils*), 200, *201*
Belinsky, Vissarion, 174
Bellenge, 160
Beluze, Françoise, 92, *93*
Béranger, Pierre Jean de, 70, 106
Bergeret, General, 20, 180
Berlioz, Hector, 6, 43, 110, 176, *177*, 239,
 247
Bernard, Tristan (Paul), *237*
Bernhardt, Sarah, 28, 64, 122, 180, 194,
 195, 206, 247, 248, *259*
Berthelier, Jean-François, 136, *137*, 247
Bertsch, Adolph, 8, 30, 39
Bibesco, George, Prince, *295*
'Bibliophile Jacob', *236*
Bisson brothers, 10, 32
Blanc, Louis, 20, 28, 76, 132, 142, 168, *268*
Blanqui, Auguste, 168, 261
Blavier, Emile, *44*, 45
Blériot, Louis, 26
Boissy, Marquis de, 156, *157*
Bonaparte, Jérôme, Prince, *263*
Bonaparte, Joseph, Prince, *286*
Bonaparte, Louis, *286*
Bonaparte, Victor, *286*
Booth, Catherine, *277*
Boudin, Eugène Louis, 21
Boulanger, Georges Ernest Jean Marie,
 General, 262, *269*
Boulanger, Louis, *219*
Brady, Matthew, 32
Brazza, Pierre Savargnan de, *274*
Broglie, Albert, Duc de, *279*
Brontë, Charlotte, 54
'Buveurs d' Eau, Les', 11

Calvé, Emma, *244*
Cameron, Julia Margaret, 35
Canrobert, Certain de, Maréchal, *269*
Capoul, Victor, *251*
'Caran d'ache', *217*
Carjat, Antoine, 29, 35, 186, 261

Carlos, Don, *293*
Carnot, Marie François Sadi-, *265*
Carvalho, Marie, *245*
Casals, Pablo, *241*
Cézanne, Paul, 21, *212*
'Cham', *217*
Champfleury, Jules, 28, 43, 68, 104, 184,
 185, 188
Charles X, 110, 160
Chasles, Philarète, 84, *85*, 130
Chauna, *34–5*
Chavannes, Pierre Puvis de, *220*
Chenavard, Paul-Marc-Joseph, 124, *125*
Chevreul, Michel Eugène, 21, *22–3*, 211,
 273
Chopin, Frédéric, 98, 164, 178
Churchill, Jenny, Lady Randolph, *282*
Churchill, Lord Randolph, *282*
Ciceri, Pierre, 102, 160, *161*, 162
Cladel, Léon, *225*
Clairville, Louis-François, *252*
Clemenceau, Georges, 18, *265*
Clésinger, Auguste, 164, *165*, 178
Colbran, Isabella, 110
Colon, Jenny, 74, 118
Colonne, Edouard, *244*
Commerson, 4, *4*, 5, 112, 118, 204
Comtesse de Paris, *288*
Constantine, Grand Duke, *280*
Coppée, François, 194, 222, *237*
Coquelin, Constant, 102, *256*
Coquelin, Ernest Alexandre Honoré, *250*
Coquerel, Athanase-Laurent, 130, *131*
Corot, Jean-Baptiste Camille, 11, 78, *79*,
 90, 192
Couder, Auguste, 4
Courbet, Gustave, 11, 29, 43, 90, 120,
 126, 184, 188, 192, *193*, 212
Cousin, Victor, 124, *235*
Couture, Thomas, 120, 188
Crémieux, Adolphe, 142, *143*
Croisset, François de, *235*
Cros, Charles, *235*

Daguerre, Louis Jacques, 29, 160, *272*
Darboy, Monsignor, 266, 278
Darcier, Joseph, 29, 82, *83*
Daubigny, Charles François, *218*
Daudet, Alphonse, 18, 24, 28, 62, 76, 190,
 191, 222, 247
Daudet, Ernest, 190
Daudet, Léon, 26, 28, 190
Daumier, Honoré, 5, 12, *18*, 21, 24, 58,
 90, *91*, 212
David, Félicien, 150, 212, *240*
Davis, Jefferson, *276*
de la Landelle, Gabriel, 32
de Lisle, Charles Leconte, *230*
Debureau, Charles, *38*, 40, *46*, 47, 122,
 247
Debureau, Jean-Gaspard, 47
Debussy, Claude, *240*
Degas, Edgar, 21, 188
Degrandi, Elisabette André, 28
Delacroix, Eugène, 6, 29, 60, 78, 90, 96,
 120, 124, 132, *133*, 176, 192, 212
Delvau, Alfred, 10, 68
Demidoff, Anatole, Prince, *281*
Desbordes-Valmore, Marceline, *12*, 13,
 76, 114, *115*
Detaille, Edouard, *213*
Detaille, Fernand, 25
Disdéri, André, 28, 35, 37, 156
Doré, Gustave, 4, 5, 6, 11, 58, 94, *95*,
 112, 124, 206
Dorgère, Arlette, *294*
Dorval, Marie, 50, 122, 164, 178
Doubs, *274*
Dréau, Mme, *292*
Du Camp, Maxime, *229*
Dumas, Alexandre (*fils*), 16, 20, 54, 56,
 180, *181*, 194, 196, 247
Dumas, Alexandre (*père*), 2, 11, 16, 74,
 94, 118, *119*, 222
Duran, Carolus, *213*
Duval, Jeanne, 1, 28 (n. 4), 66

Eastman, George, *276*
Edward VII, Prince of Wales, *279*

Eiffel, Alexandre Gustave, 13, *271*
Enault, Louis, *226*
Est Ange, Chaix d', *267*

Fabre, Jean-Louis, *270–1*
Farouk, Khan, 116, *117*
Faure, Félix, *265*
Fauré, Gabriel, *241*
Favre, Jules, *268*
Fenton, Roger, 32
Feodorovna, Marie, *280*
Ferry, Jules, *264*
Feydeau, Ernest, *253*
Feydeau, Georges, *251*
Flaubert, Gustave, 112, 178, 184, 190,
 222, *225*
Forain, Jean-Louis, *220*
Foureau, Fernand, *274*
Fox-Talbot, William Henry, 29, 68
France, Anatole, *234*
Frederika of Hanover, Princess, *293*

Galitzine, Prince, 166, *167*
Gambetta, Léon, 20, 28, 43, 262, *265*
Gapon, George, *266*
Garibaldi, Giuseppe, 134, *269*
Garnier, *238*
Garnier, Charles, 206, *207*, 239
Gautier, Judith, 182, *235*
Gautier, Théophile, 2, 52, 54, 62, 74, 78,
 86, 112, *113*, 124, 140, 150, 164, 182, 188,
 196, 222, *222*, 247: daughters of, *294*
Gavarni, 2, 4, 5
Géant Le, 13, *14*, 15, *15*, 16, *16*, 18, 32, 72,
 102, 104, 168, 208
Genoux, Claude, *233*
George V of Hanover, *279*, 293
Gérôme, Léon, *220*
Gilard, Marie, 25
'Gill', *212*
Girardin, Emile de, 28, 70, *234*
Godard, Mme, *242*
Godard brothers, 13, 15, 18
Goncourt, Edmond and Jules de, 5, 11,
 24, 29, 35, 52, 62, 72, 76, 77, 82, 90, 92,
 94, *98*, 100, 104, 106, 112, 120, 128, 132,
 140, 152, 160, 168, 172, 178, 182, 190,
 192, 196, 198, 204, 222, 247
Gonzales, Eva, 188
'Goulue, La', *252–3*
Gounod, Charles François, 239, *240*
Gozlan, Léon, 86, *87*
Grandin, Victor, 3
Grant, Ulysses, General, *277*
Grévy, Jules, *264*
Grimmer, Georges, 28, 68
Grisi, Carlotte, 182, *183*
Guines, Gosset de, *212*
Guitry, Lucien, *251*
Guizot, François Pierre Guillaume, 84,
 124, 128, *129*, 222, 261
Guys, Constantin, 4, 5, 12, 21, 24, 96, *97*,
 212

Hahn, Reynaldo, *242*
Halévy, Jacques François, 54, 238, *246*
Harpignies, Henri, *218*
Hausard hat, *292*
'heavier-than-air' machines, 12, 13, 26,
 32, *33*, 102, 178, 208
helicopters, 32, *33*
Herzen, Alexander, 170, 174
Hetzel, Jules, 4
Hill, David Octavius, 28, 186
Houssaye, Arsène, 112, *237*
Hugo, Victor, 1, 6, 13, *15–16*, 20, 28, 43,
 50, 102, 106, 112, 118, 126, 128, 168,
 176, 184, 196, 208, *209*, 222, *223*, 247
Huysmans, Joris-Karl, 222, *232–3*, 247
Hyacinthe, Louis, *256*
Ingres, Jean Auguste Dominique, 29, 54,
 60, 68, 102, 112, 120, 124, 132, 192, 212
Isabella II, *283*
Isabey, Eugène, 72, 102, *214*
Isabey, Jean Baptiste, 160

Janin, Jules, 54, 106, *107*
Janssen, Jean, *236*

Jeanron, Philippe Auguste, *214*
Jenny, Mlle, *289*
Johannot, Tony, 4
Journet, Jean, 126, *127*
Jouvenel, Henri, de, *267*

Kalkbrenner *fils*, 98
Kalkbrenner, Mme, 98, *99*
Kalkbrenner, Frederick, 98, 239
Karr, Alphonse, 4, 140, *141*, 170, 222
Karzy, de, *34*
Kock, Henri de, *226*
Kock, Paul de, 104, 222
Krauss, Gabrielle, *253*
Kropotkin, Peter, Prince, *268*
Kung Pao-yun, Prince, *288*

Labiche, Eugène, 247
Laboulaye, Édouard Lefèbre-, 144, *145*
Labrunie, Gérard, 2, 4, 74, *75*, 112, 118, 140, 176, 184, 222
Lacroix, Paul, *236*
Lamartine, Alphonse de, 3, 70, 126, 140, 168, 176, 222, 261
Lamber, Juliette, 134, *135*
Lambert, Albert, *256*
Lamenais, Hugues Felicité Robert de, 3
Langoix, Mlle, *250*
Langtry, Lillie, *258-9*
Lanvin, Maison, *290, 291, 293*
Larévellière-Lepeaux, *231*
Laslin, Mlle, *252*
Laurent, Marie, *241*
Lauzeski, Mlle, *288*
Le Gray, Gustave, 10, 32, 39, 186
Le Prévost, 39
Lefèvre, Ernestine, *see* Nadar, Ernestine
Legouvé, Ernest, 158, *159*
Lemaire, Joseph, *82, 83*
Léon-Noel, A., 2, 52, 229
Léopold I of Belgium, *263*
Léopold II of Belgium, *263*
Lesseps, Bertrand de, *285*
Lesseps, Charles de, 3
Lesseps, de (family), *284-5*
Lesseps, Ferdinand de, 88, 196, *271*
Lesseps, Solange, *285*
Lesueur, François-Louis, 80, *81*, 260
Liszt, Franz, 43, 176, 239, *242*
Littré, Emile, *225*
Livry, Emma, 150, *151*
Louis XVIII, 128, 156
Louis-Philippe I, 58, 90, 124, 128, 148, 156, 208, 261

MacLane, Robert, *277*
Mailliet, Louis, 92
Mailliet, Thérèse, 1, 92, *93*
Maison Lanvin, *290, 291, 293*
Maison Reveillon, *283*
Maison Toré, *283*
Mallarmé, Stephane, 62, 222, *226*
Manet, Edouard, 21, 24, 29, 96, 160, 162, 188, *189*, 212
Marie, Princesse de Solmes, *229*
Marie-Amélie, Queen of Portugal, *287*
Marx, Karl, 35, 170, 174, 261
Massenet, Jules Emile Frédéric, 239, *243*
Maupassant, Guy de, *232*, 247
Maupin, Renée, *294*
Medina Coeli, Duchesse de, *295*
Meissonier, Jean Louis Ernest, 188, *214*
Melba, Dame Nellie, *239*
Mémoires du Géant, Les, 18, 28, 102
Mendès, Catulle, 62, 222, *232*
Mérode, Cléo de, *34-5, 257, 290*
Messager, André, *243*
Metchnikoff, Elie, *270*
Meyerbeer, Giacomo, 6, 110, 122, 160, 162, *163*, 238
Michelet, Jules, 198, *199*, 222
Mickiewicz, Adam, 3
Millaud, Polydore, 6
Millet, Jean François, 120, *121*, 212
'Mimi', 11, 68
'Mistinguett', *249*
'Mogador', Mme, 172 *173*
Mohammed Sa'id Pasha 88, *89*
Monet, Claude, 21, *216-17*

Monnier, Henry, 222, *229*
Monod, Adolphe, *266*
Montes, Lolla, *287*
Montgolfier, Joseph Michel, 15, 126
Montgolfier, Mme de, *282*
Morisot, Berthe, 21
Morny, Duc de, 180, 194, 204
Mounet-Sully, Jean, *260*
Muratore, Lucien, *244*
Mürger, Henri, 1, 2, 3, 11, 12, 28, 52, *53*, 56, 68, 104, 184, 222
Musard (*père*), 100
Musard, Alfred (*fils*), 100, *101*, 110, 239
Musard, Miles, *287*
'Musette' (Christine Roux), 11, 68, *69*
Musset, Alfred de, 11, 178
Muybridge, Eadweard, 24

Nadar, Ernestine, his wife, 8, 15, 21, 24, 25, 26, 211
Nadar, Félix: books by, 28; photographs of, *frontispiece*, 11, 23, 27
Nadar, Paul, his son, 15, 20, 21, 24, *24*, 26, 28, 166, 168, 178, 194, 208, 211, 262, 278, *289*
'Nadar jeune', his brother, *see* Tournachon, Adrien
'Nadar-Jury', 5
Nanteuil, Celestin, *215*
Napoléon I, 54, 74, 118, 128, 160, 164, 196,
Napoléon III, 18, 76, 104, 142, 170, 178, 180, 204, 208, 261, *261*, 262
Nassr-ed-Din, Shah of Persia, 116, *291*
Nègre, Charles, 32
Negro servant, 283
Nerval, Gérard de, 2, 4, 11, 74, *75*, 76, 112, 118, 140, 176, 184, 222
Nicholas II, Tsar, 278, *281*
Niépce, Joseph Nicephore, 29
Noé, Amédée, *217*

O'Connell, Mme, 72, *73*, 263
Offenbach, Jacques, 6, 8, 10, 11, 16, 28, 43, 82, 136, 188, 204, *205*, 239, *243*
Orléans, Henri d', Prince, *295*

Panthéon Nadar, Le, 2, 5, 6, *6-7*, 8, 39, 58, 60, 78, 102, 178, 204
Pasteur, Louis, 22, *270*
Patti, Adelina, *245*
Paula, Mlle, *257*
Peary, Robert, Admiral, *275*
Pedro II of Alcantara, Dom, Emperor of Brazil, *286*
Pelletan, Eugène, 70, *71*
Péreire brothers, 10
Persia, Shah of, 116, *291*
Petipa, Marie, *258*
Petipa, Marius, 258
Philipon, Charles, 4, 5, 6, 8, 11, 28, 58, *59*, 90, 94
Pietri, Joseph, *267*
Pissarro, Camille, 21
Poincaré, Raymond, *264*
Poiré, Emmanuel, *217*
Polaire children, *284*
Ponson du Terrail, Pierre-Alexis, Vicomte 138, *139*
Porel, Master, *289*
Pougy, Liane de, *34-5, 278*
Préault, Auguste, 60, *61*, 90, 120
Proudhon, Pierre Joseph, 170, *171*, 192, 261
Proust, Adrien, *273*
Proust, Marcel, 76, 222, 273
'Rachel' (Elizabeth Félix), 54, *55*, 72, 106, 122, 154, 158, 164, 194, 222, 247
Reclus, Elisée, 202, *203*
Réjane, 247, 248, *249*
Réjane, Mlle. G., *296*
Rejlander, O. G. 186
Renard, Jules, 146, *147*
Renoir, Pierre Auguste, 21
Reske, Jean de, *244*
Reveillon, Maison, *283*
Rimbaud, Arthur, 62, 222
Ristori, Adelaide, 54, 106
Ritter, Mlle, *251*

Rochefort, Henri Victor, Marquis de Rochefort-Luçay, 11, *230*
Rodin, Auguste, 2, *213*
Rossini, Gioachino, 6, 43, 110, *111*, 122, 160, 162, 194, 238
Rostand, Edmond, 194, *233*, 248
Rouget, Georges, *215*
Rousseau, Théodore, 120, *215*
Rozen, Alix, *34-5*

Sadi-Carnot, Marie François, *265*
Saint-Saëns, Camille, *243*
Sainte-Beuve, Charles Augustin, 50, 106, *227*
Saint-Victor, Paul de, *224*
Sallenave, Gracieuse, 24
Sand, George, 6, 11, 16, 18, 122, 164, 168, 178, *179*, 222, *224*, 247
Saphir, Maurice-Gottlieb (Moses), 108, *109*
Sarasate, Pablo, *246*
Sardou, Victorien, 11, 54, 194, 247, *250*
Schanne, Alexandre, 28, 68, *234*
Scribe, Augustin Eugène, 104, 158, 162, 164, 238, 247, *257*
Severin, Isidore (Baron Taylor), 13, 102, *103*
Shackleton, Sir Ernest, *275*
Silvy, Camille, 2
Sisley, Alfred, 21
Sivori, Ernesto Camillo, 152, *153*, 239
Smithson, Harriet, 176, 247
Solmes, Marie, Princesse de, *229*
Stevens, Alfred, 16, *221*
Stoltz, Rosine, 47, 122, *123*
Sully-Prudhomme, Armand, 222, *227*
Swinburne, Algernon Charles, 16

Taglioni, Marie, 150, 160, 182
Taylor, Baron, 13, 102, *103*, 160
Tchaikovsky, Peter Ilich, 176
Teresa Christina Maria, Empress of Brazil, *286*
Thalberg, Sigismund, 239, *246*
Thiers, Louis Adolphe, 20, 104, 128, 132, 144, 261, 262, *264*
Thomas, Ambroise, 239, *246*
Thoré, Théophile, 124, 132, *221*
Toré, Maison, *283*
Tournachon, Adrien, 1, 3, 6, 8, 10, 24, 28, 35, *39, 39, 40*, 43, 45, 47, 62, 74, 76, 92, 211
Tournachon, Alban-Adrien, *see* Tournachon, Adrien
Tournachon, Gaspar-Félix, *see* Nadar, Félix
Tournachon, Thérèse, *see* Mailliet, Thérèse
Tournachon, Victor, 1, 92
Troubetskoy, Prince, *281*
Troyon, Constans, *218*
Turgenev, Ivan, 174, *231*

unknown girl, 64, *65*
unknown old woman, 154, *155*

Vachette, 8
Vacquerie, Auguste, *234*
Vautier, *238*
Verdi, Giuseppe, 196, *197*
Verlaine, Paul, 62, 114, 222
Verne, Jules, 13, 102, *230*
Vernet, Horace, 219
Veuillot, Louis François, 104, *105*, 261
Victoria, Queen, 54, 204
Viennet, Jean Guillaume, 148, *149*
Vigny, Alfred de, 2, 6, 50, *51*, 118, 176
Villedeuil, 5
Viollet-le-Duc, Eugène, 102, 206, *219*
Vladimir, Grand Duke, *280*
Vogue, Eugène, Vicomte de, *292*

Wagner, Richard, *42*, 43, 110, 184, 196, 239
Whistler, James Abbott McNeill, 16
Whitworth, Sir Joseph, *272*

Yaxs, M., *254*

Zola, Emile, 76, 190, 222, 228, 247